Pervasive Games
Theory and Design

Pervasive Games
Theory and Design

Markus Montola,
Jaakko Stenros, and Annika Waern

CRC Press
Taylor & Francis Group
Boca Raton London New York

CRC Press is an imprint of the
Taylor & Francis Group, an **informa** business

CRC Press
Taylor & Francis Group
6000 Broken Sound Parkway NW, Suite 300
Boca Raton, FL 33487-2742

First issued in hardback 2017

© 2009 by Taylor & Francis Group, LLC
CRC Press is an imprint of Taylor & Francis Group, an Informa business

No claim to original U.S. Government works

ISBN 13: 978-1-138-42779-2 (hbk)
ISBN 13: 978-0-12-374853-9 (pbk)

Visit the Taylor & Francis Web site at
http://www.taylorandfrancis.com

and the CRC Press Web site at
http://www.crcpress.com

Library of Congress Cataloging-in-Publication Data

British Library Cataloguing-in-Publication Data
A catalogue record for this book is available from the British Library.

Morgan Kaufmann Game Design Books

Better Game Characters by Design (9781558609211)
Katherine Isbister

Game Design Workshop, Second Edition (9780240809748)
Tracy Fullerton

The Art of Game Design (9780123694966)
Jesse Schell

Game Usability (9780123744470)
Katherine Isbister & Noah Schaffer (Eds.)

Game Feel (9780123743282)
Steve Swink

The IGDA "Stamp of Approval"

The International Game Developer's Association is the largest non-profit membership organization serving individuals that create video games. The mission of the IGDA is to advance the careers and enhance the lives of game developers by connecting members with their peers, promoting professional development, and advocating on issues that affect the developer community.

A big part of the IGDA's mission is to arm game developers with the information they need to succeed in the industry. With this in mind, there are great synergies between the work that the IGDA does and the work that Morgan Kaufmann (an imprint of Elsevier, Inc) does, as the leading publisher in the areas of game development and game design.

IGDA and Morgan Kaufmann are proud to work together to present these game development and design titles to you, in the hopes of advancing your career within the game industry.

All of the proposals in the game series have been reviewed and vetted by relevant IGDA community leaders and volunteers to ensure top quality and relevance. We are proud to offer the IGDA sponsored Morgan Kaufmann game development and design books for your trusted library.

For more information on the IGDA and to become more deeply engaged with the game development community, check out www.igda.org.

Contents

Theory ... 1

Society ... 191

Disclaimer

This book discusses numerous forms of play. The fact that they are discussed should not be read as encouragement or an endorsement. Some of them are very dangerous, illegal, or both. While we discuss some of the hazards and safety considerations, we do not cover all the problems and dangers of any form of play. Only the organizers and participants of a game can take responsibility on how a game turns out. The authors or the publisher do not take any responsibility regarding the use of this book.

Please visit the book's official website and blog at http://pervasivegames.wordpress.com

Foreword

Sean Stewart

Fall 2000. Jordan Weisman and Elan Lee were talking about a new kind of game, one that couldn't be confined inside a video-game console. Jordan's phone rang, as it does constantly, but this time both men stared at it, and then Jordan said: "Wouldn't it be cool if that was the game calling?"

From the classic college campus assassination game *Killer* and the simple short message service-based *BotFighters*, which allow players to fight one another as they move through their regular lives, to intensely immersive theater pieces like *Momentum*, in which players were possessed by the spirits of dead revolutionaries around the clock for 36 consecutive days, pervasive games are entertainments that leap off the board, console, or screen and into your real life. The authors of this book have created the definitive history of the genre, as well as a compendium of case studies, design directions, and moral questions for the next generation of people interested in the intoxicating mixture of game and real life.

I was introduced to the concept of The Game That Would Call You in January of 2001 when I was hired as a lead writer to work with a giant project for Steven Spielberg's upcoming movie *A.I.: Artificial Intelligence*. Jordan's plan was to build the whole world of *A.I.* online and then let the audience walk into it, like Alice falling down the rabbit hole into Wonderland.

The game world would be vast and elaborate. Hundreds of linked Web pages would form the skeleton: personal blogs, avant-garde art hangouts, the entire online catalog of a manufacturer of geisha robots, political action groups, government agencies, and not one but two complete universities with dozens of departments. The first time we wrote a list of all the things we would need to bring this world to life, it was 666 items long; that's where the project earned the nickname *The Beast*. Along with Electronic Arts' *Majestic*, *The Beast* would spawn an entire subgenre of pervasive games called alternate reality games (ARGs). These are interactive stories in which you, in the audience, are also a crucial character, and your decisions drive the narrative.

We had a few basic design principles:

Come into the players' lives in every way possible. We hosted Web sites for you to browse, sent emails to your inbox, and arranged for faxes to be sent to your office "by mistake." We got a gravel-voiced Microsoft employee to record a menacing message from a robot revolutionary and then called players on their phones, which was electrifying,

particularly at the home where a player's grandmother answered the call. (Then we had a polite conversation with the police, but that's another story.) We even held live events where, for the duration of the meeting, you were a citizen of 2142, talking to actors playing the part of other people in that time.

Make it interactive. Let players affect the world. Of course, when you have a story you want to tell, this is difficult, but we evolved many different strategies for letting players touch the world. The basic rhythm of the game was "players solve a puzzle to get the next piece of the story." For instance, players might find a password-protected secret diary, so they would need to figure out the password to get the next piece of information. We encouraged player-generated content by having *Metropolitan Living Homes* magazine host a competition for designing the best sentient home. We introduced Loki, a rogue AI who fed on nightmares. We knew he could be killed if he went to a certain Web site, but we let the players design a plan for luring him there. Dozens of them compiled a list of their own most terrifying nightmares and used it as "bait." Within hours of them posting that information, we had written and recorded a flash movie of Loki's death soliloquy stitched together from pieces of their dreams, so the players, shocked, heard a game character speaking words *they had written only 2 days before.*

The larger political narrative that ran through the game was about a referendum on whether AIs should remain slaves or be granted citizenship. We filmed two alternate endings to the game and let the players' real, unmanipulated vote decide the issue.

Embrace community. The nature of the Internet is that as soon as one person knows something, everybody knows it. Instead of fighting this, we tried to use it to our advantage. By forcing the players to interact, after all, we could "populate" our world of 2142. And interact they did. For instance, starting with only three photographs of kitchen utensils and an audio file of a dripping tap, they slowly broke a message written in the original Enigma code the Nazis used during World War II. We put half a chess problem in *the New York Times* one day and the other half in the *Los Angeles Times* a few days later, confident that players would see both, assemble them, and identify the right next move correctly. When a crucial clue went missing from a live event, leaving one puzzle impossible to solve, players built a distributed processor—literally linking more than 400 of their computers together—to hack into an encrypted site by brute force.

For players, community interaction was the most intense and rewarding part of the game. My evidence for that assertion? In my career as a novelist, at best I have gotten the occasional fan letter. After several of our ARGs, I have been invited to the weddings of people who met and became engaged in the course of the game.

* * *

The nature of a pervasive game, in all the many varieties discussed in this book, is to make the "magic circle" of a game not a barrier, but a membrane; to let game and life bleed together so that game becomes heavy with the reality of life, and life becomes charged with the meaning of game. As Elan said, "The player's *life* should be the game board." An interviewer, talking to one of the players, asked, "When you are playing one of these games, who are you pretending to be?" To which the player replied, "Basically, you're playing someone who is exactly the same as you in every way, except they think it's real."

For instance, within 24 hours of posting a blog entry about her grandmother's death, the protagonist of *The Beast*, Laia Salla, received *hundreds* of condolence emails.

Nobody writes to Madame Bovary or Anne of Green Gables. But Laia was different. Laia had a phone number you could call; she wrote you email and you could write back. She treated you as if you were just as real as the rest of her friends in the year 2142, and it was hard not to repay the favor. Laia admittedly lived in the 22nd century, but in many ways she was every bit as real as your cousin who lives in Cleveland; more real, actually, or at least polite enough to write you more often.

In the spring of 2002, Elan gave a famous talk at the Game Developers Conference. The title was taken from our in-house motto for *The Beast*: This Is Not a Game.

Our driving goal was to make that game feel real. Not because we wanted anyone to think it *was* real—all the Web sites were dated 2142, after all—but because the depth and care with which we created our alternate world served as a token of good faith to the players. It was our way of saying, "Come. Play with us. If you are willing to suspend your disbelief, we will make it worth your while."

To live, this kind of entertainment needs access to your life. Pervasive games, like vampires, can only enter if you let them in.

Of course, "This Is Not a Game" is only half the equation, and probably the less important half. It is easy to extend a game into real life once you make that a goal, but doing so raises many questions. Just as a good movie is more entertaining than a 90-minute slice of your regular life, a good game has rules that make it fun to play. There are even moral questions. If, in the course of a narrative game, an actor "dies" on a public bus, how does that affect passersby that don't realize that the death is "only a game?" For that matter, what responsibilities do game designers undertake when they ask their players to play in the real world? For instance, in 2004, Elan and I worked on a game called *I Love Bees*. The core mechanic required players to go into the real world to answer pay phones. On one occasion, one of our players went to answer a phone on a Florida beach only hours ahead of a hurricane landfall. Without meaning to, our game had clearly put him in harm's way.

The issues that arise when you extend the magic membrane of game into real life are what make this book so compelling. Markus Montola, Jaakko Stenros, and Annika Waern have done an admirable job in creating the definitive resource for students, researchers, and designers of pervasive games. The wealth of case studies in this book, its understanding of issues in game design, and its willingness to tackle even the field's hard ethical questions make it an invaluable resource for everyone interested in playing in the real world.

Contributors

(Full Contributor information can be found on the companion website)

Matt Adams, Artist, Blast Theory, UK

Rafael "Tico" Ballagas (PhD), Interaction Designer and HCI Researcher, Nokia Research Center, USA

Joe Belfiore, Vice President, Zune Software and Service Team, Microsoft, USA

Staffan Björk (PhD), Associate Professor, Göteborg University and Senior Researcher, Interactive Institute, Sweden

Eric Clough, Founder, 212box LLC, USA

Martin Ericsson, Creative Director, The Company P, Sweden

Jussi Holopainen, Principal Scientist, Nokia Research Center, Finland

Fredrik Lange (PhD), Assistant Professor, Stockholm School of Economics, Sweden

Frank Lantz, Creative Director, area/code, New York, USA

Frans Mäyrä (PhD), Professor, Department of Information Studies and Interactive Media, University of Tampere, Finland

Markus Montola (M.Soc.Sc.), Researcher, Nokia Research Center, Finland

Johan Peitz (M.Sc.), Technical Director, Muskedunder Interactive, Sweden

Olli Sotamaa (MA), Researcher, Department of Information Studies and Interactive Media, University of Tampere, Finland

Jaakko Stenros (M.Soc.Sc.), Researcher, Department of Information Studies and Interactive Media, University of Tampere, Finland

Sean Stewart, Lead Writer and Designer, Fourth Wall Studios. Lead writer of ARGs such as *The Beast* and *I Love Bees* and author of *Cathy's Book* series, USA

Mattias Svahn (LL.M., M.Soc.Econ.), Senior Media Analyst, go/communication, Sweden

Annika Waern (PhD), Research Leader, Mobile Life Center, Stockholm University and Studio Director, Interactive Institute, Sweden

Steffen P. Walz (PhD), Founder, sreee! and an editor of *Space Time Play* and *Computer Games, Architecture and Urbanism: The Next Level*, Switzerland

We love games.

We love board games, party games, role-playing games, digital games, online games, and all kinds of games. We all had our first strong experiences of pervasive games—of games that felt somehow more real, more encompassing, and more engaging—over ten years ago. These games were played among everyday people living their everyday lives. Markus and Jaakko remember fondly their first pervasive larps, role-playing around the city, looking at the streets through fantasy glasses and seeing things ordinary people had no idea of. Annika often reminisces about her visits to Medieval Week on Gotland, how regular tourists went in hiding as the whole city was transformed by hundreds of celebrating people wearing elaborate historical costumes.

Traces of pervasive playfulness can probably be found in all civilizations, even though in this book we only look at the last few decades. Mysteries, scavenger hunts, and ludic pranks have long been a part of modern society. Yet it was the recent advances in communication technologies—in particular the adoption of the Internet, mobile communication, and positioning technologies—that opened new design spaces for pervasive play. The very term *pervasive game* was probably coined in the year 2001, when *The Beast*, *Majestic*, and *BotFighters* were launched. These were games that shamelessly defied the usual boundaries of play. Since then experimental and commercial pervasive games have spawned everywhere, and today they form a varied landscape. An important goal of this book is to map new terrain and to find the design tricks, philosophies, and techniques that make pervasive games tick. In the process of writing this book, we have discovered countless exciting styles, genres, and traditions that we have enjoyed dwelling into and trying out. We are constantly surprised by the novel pervasive activities people come up with.

As we have become more aware of the pervasive forms of play, we have learned to see them all around us. In part this is because we look for them, but we feel that society is also changing. This shift is brought into focus when we tune in to watch *The Amazing Race* players compete around the world, when advertisement campaigns for films, cars, and burgers adopt the form of games that blur fact and fiction, but also in everyday interactions when we receive Facebook invitations to join *geocaching* expeditions. Every week we read about a new, daring Banksy painting, witness some jackass climb a skyscraper wall on YouTube, or hear of a new flash mob turning a public square into 2 minutes of carnival on an ordinary Thursday afternoon. Researchers and companies around the globe come up with new playful ways of using mobile and positioning technologies. Even mainstream conventions of what it is to play a game are shifting. Playfulness is seeping into the ordinary. Everyday life is becoming interlaced with games.

This new family of games has been called by many names: *adaptronic games, alternate reality games, ambient games, appropriative games, augmented reality games, big games, brink games, context aware games, crossmedia games, geogames, hybrid games, immersive games, invasive games, location-based games, locative games, massive games, mixed reality games, mobile games, pervasive games, reality games, supergames, total*

games, *transreality games*, *ubiquitous games*, *urban games*, and so on. The plethora of similar yet not identical labels illustrates not only that pervasive games are part of the zeitgeist, but the difficulty of grasping this new playing field.

This book is our best attempt at connecting the dots and drawing a big picture of pervasive games.

How to Use This Book

This book is intended for game researchers, game designers, and pervasive game enthusiasts. It is also relevant for people who have a general interest in the cultural shift fostered by the increasing presence of games in our lives.

The book has therefore been divided in three parts: Theory, Design, and Society. The very first chapter should be an interesting read for all readers, but with the other chapters it is possible to pick and mix based on one's tastes. (Unless you are a student and your teacher has chosen the relevant chapters— in which case you have our sympathies.)

The first section on *Theory* explains what pervasive games are, where they came from, and what forms they take. These three first chapters lay the foundation for understanding what comes after. In the first chapter, the concept of pervasive games is defined and their relation to games in general is discussed. The second chapter looks at how pervasive games can be divided into different genres. The third chapter charts the historical influences, looking at neighboring and preceding phenomena that have laid the groundwork for the current surge of pervasive games.

In the second section, *Design*, we look into what we can learn from the pervasive games that have been designed and staged previously. This section is targeted primarily at the pervasive game designer, but these tools are also useful in the study and analysis of pervasive games. As with all game design, pervasive game design is second-order design: The designer does not design play but the structures, rules, and artifacts that help bring it about.

Chapters Four, Five, and Six look at pervasive games spatially, temporally, and socially, charting opportunities and highlighting challenges. Chapter Seven looks at pervasive games from a holistic perspective, even giving normative design guidelines for particular kinds of pervasive games. Chapter Eight explores the use of technology as a design tool. Chapter Nine focuses on mobile phones, the most widely used platform for pervasive games.

In the third part, *Society*, we take a step back and view pervasive games in a wider societal context. Games are always political, but play that transgresses the boundaries of games is even more so. This part of the book is an important read for anybody who produces, markets, or studies pervasive games.

Chapter Ten tackles the ethics of pervasive games. Activities that blur the border between ordinary life and game are almost automatically packaged with numerous ethical issues. The chapter gives few definite answers to what makes a pervasive game ethically acceptable or unacceptable, but outlines the dilemmas each designer must address and provides the conceptual tools that allow us to discuss them. Chapter Eleven looks at the challenge of marketing pervasive games to a wider audience. As these games can be difficult to pitch in a few words, it is helpful to consider how to better categorize them. In Chapter

Twelve, pervasive games are discussed as a form of art and as a political tool by three distinguished designers. Finally, Chapter Thirteen ties pervasive games to the media culture in general and sees major shifts in how the struggle for public space, the blurring of fact and fiction, and the rise of ludus in society are changing the way we perceive the world.

It is almost impossible to fully appreciate games without playing them. Unfortunately, in the case of pervasive games, it is often difficult to play all the interesting ones as many games are run only once, in private, or staged on faraway continents.[1] We have tackled the problem through a portfolio of case descriptions that represent the broad spectrum of pervasive games, each illustrating the central themes of the following chapter.

Throughout the book, we need to bring up various social distinctions that are all too easy to problematize with postmodernist argumentation. For instance, we talk about game worlds and virtual worlds as the domains where ludic action takes place. The difficulty in such concepts is defining their opposites: The real world is a very problematic term, as a game world and the physical world can be argued to be equally real. Restricting ourselves to discussing the physical world would be equally problematic, as our ordinary life spans many virtual areas—and all virtual worlds are based fundamentally on physical existence. Even talking about gaming versus ordinary life is problematic, as for many of us gaming is an everyday activity that plays a central role in our ordinary lives. Nevertheless, we use ordinary life as the opposite of play time, actual and factual as opposites of fictional, physical as an opposite of virtual, and so forth. We could have highlighted the social nature of these distinctions by adding quotation marks to all occurrences of words such as real, actual, and ordinary, but we omitted them in the interest of readability.

Working with this book turned into an exploration of countless cultural trends and local niches of play. We started writing this book to document what we had learned during three and a half years of researching pervasive games, only to discover that we had barely scratched the surface. Whenever we felt we had mastered a particular facet of our subject, we discovered several new aspects that could not be left untouched. Every time we studied the origins of one game, we found another lurking behind it. Eventually, every thread could not be followed, every idea could not be explored in equal depth, and every game we researched could not be included. Throughout the process the words of Johan Huizinga gave us hope. In the foreword to his classic *Homo Ludens* he writes:

> *The reader of these pages should not look for detailed documentation of every word. In treating of the general problems of culture one is constantly obliged to undertake predatory incursions into provinces not sufficiently explored by the raider himself. To fill all the gaps in my knowledge beforehand was out of the question for me. I had to write now, or not at all. And I wanted to write. (Huizinga, 1938)*

It is hoped that others will stumble through our web of concepts, descriptions, and assumptions to find themselves inspired to design, stage, and study pervasive games. It is our humble hope that we have not written the last word on the subject, and that others will pick up where we have left off.

Helsinki and Stockholm, January 1, 2009
Markus Montola, Jaakko Stenros, & Annika Waern

Note

1. We have not added dates to the games presented in the text: Many games (*tag*) are impossible to date, whereas others (*scavenger hunt*) are reinvented every time they are staged, and some (*basketball*) have been played in countless variations. Whenever available, the year of the game can be found from the ludography of the book. This book is also packed with borderline cases that can sometimes be seen as games and sometimes as something else: For example, *skateboarding* is a playful leisure activity and a competitive sport, whereas *Abstract Tours* is a participatory art performance and a playful challenge.

Acknowledgments

From 2004 to 2008 we were working in the Integrated Project on Pervasive Gaming IPerG. We thank the European Commission's IST programme (FP6-004457) for funding the research project that brought together people from academia, the industries, and the art world in four different countries. We are excited and honored to have been offered the opportunity to work with the wonderful people from Blast Theory, Fraunhofer FIT, Gotland University, It's Alive!/Daydream, Sony NetServices, Swedish Institute of Computer Science, and the University of Nottingham and from our home bases University of Tampere Hypermedia Laboratory, Interactive Institute, and Nokia Research Center.

Markus Montola also thanks the Finnish Cultural Foundation for a grant, which at one time enabled him to work on the book. Jaakko Stenros thanks the Games as Services project and Tekes, the Finnish Funding Agency for Technology and Innovation. Annika Waern thanks Mobile Life center and Vinnova.

We are also indebted to a huge number of people whose support, criticism, help, and comments have made writing this book possible. For pointing us toward interesting research lines, for commenting on our manuscripts, for opening up their invaluable game design processes, and for helping us get our work published, we especially want to express our gratitude to Lars Andersen, Steve Benford, Amanda Bernsohn, John Paul Bichard, Emil Boss, Christy Dena, Marie Denward, Stéphane Donikian, Tina Ellerkamp, Pasi Falk, Eirik Fatland, Joel Fischer, Mary Flanagan, Martin Flintham, Tracy Fullerton, Sabiha Ghellal, J. Tuomas Harviainen, Mikko Hautakangas, Satu Heliö, Kristina Höök, Staffan Jonsson, Oskar Juhlin, Anu Jäppinen, Hanna Järvinen, Johanna Koljonen, Hannu Korhonen, Jussi Kuittinen, Peter Kullgard, Anna-Kaisa Kultima, Jussi Lahti, Petri Lankoski, Ari-Pekka Lappi, Craig Lindley, Irma Lindt, Donald L. Luskin, Carsten Magerkurth, Mirkka Maikola, Jane McGonigal, Johannes Niemelä, Eva Nieuwdorp, Timo Nummenmaa, Andie Nordgren, Elina Ollila, Janne Paavilainen, Eetu Paloheimo, Itamar Parann, Kalle Partanen, Celia Pearce, Juhana Pettersson, Mikko Rautalahti, Ju Row Farr, Laura Ruggeri, Hannamari Saarenpää, Christopher Sandberg, Anna Shepherd, Kevin Shields, Lori Shyba, Adriana Skarped, Walther Smith, Ulrike Spierling, the Stenros family, Daniel Sundström, Riku Suomela, Jonas Söderberg, Tom Söderlund, Nick Tandavanitj, Dare Talvitie, Alexander Thayer, Tutkimustie Oy, Mathy Vanbuel, Jonatan Waern, Love Waern, Mattias Waern, Richard Wetzel, Tobias Wrigstad, Karl-Petter Åkesson, and probably numerous other people we are taking for granted.

The Nordic role-playing community has offered us not only a vibrant game culture, but also a safe place to test our ideas, one where we can always count on a perfect combination of enthusiastic support and harsh criticism.

We also want to extend our gratitude to the Finnish National Audiovisual Archive, the Alternate Reality Game Researcher & Educator Mailing List, IGDA Alternate Reality Games SIG, Cloudmakers Internet community, and the *Kasa* and *Towleroad* blogs. They provided us with countless leads and clues; although they did not always end up in the book, they helped us sharpen our understanding of the subject.

Finally, we thank Wikimedia Foundation, Internet Movie Database, Flickr, and YouTube for providing us, and everyone else, with excellent, free databases that allowed us to discover several research lines that we would never have stumbled upon otherwise.

THEORY

Killer: The Game of Assassination

Markus Montola and Jaakko Stenros

You are an undercover assassin. You're living your everyday life: Going to work, school, home, performing your day to day tasks, hiding in plain sight. But in secret, you are stalking a target, always keeping a hidden weapon at hand. You build bombs and prepare weapons while trying to scrounge as much information on your target as possible. Taking the perfect shot at him requires you to wait for hours in a stairwell, trying to hide from his cautious gaze. Maybe you get close enough to poison his coffee, trying to act normal while serving the deadly dosage.

Yet you must look over your shoulder constantly; you are also somebody else's target. As the target, you are waiting for the dagger of another assassin, who might be your friend or someone you've never met before. You know there is someone out there intending to get you, and there is no way of telling how or when she will strike.

That is how you play *Killer*. The referees assign one player to be your target, someone who you, an assassin, must kill and remove from the game using toy weapons. You are given some basic information about the target and his habits—maybe a photo, name, and a home address. Using an arsenal including water guns, plastic knives, vinegar (poison), and alarm clocks (time bombs), you are supposed to stage a successful assassination. It is not always very easy; in fact it may take days of legwork to catch someone. Depending on the rules, various means may be acceptable; maybe you could call his girlfriend and ask how to find your target. When you score a kill, the referees assign you a new mark; typically you get to kill your victim's target. The last man standing wins, or sometimes the player who scored the most kills.

Killer is a decades-old game. No one really knows where it came from. J. W. Johnson (1981) has tracked its roots to *The Seventh Victim*, a short story written by Robert Sheckley in 1953, and especially the Italian cult film based on the story, *La decima vittima* (1965). It is a science fiction story about a future society where human hunts are staged, where participants alternatively adopt the parts of hunter and prey, killing each other as a part of a competition (see Figure A.1). After the film was shown in the United States, *Killer* games started to emerge in university campuses around the country. The game emerged as oral folklore; countless variations still exist with various names. When Steve Jackson Games codified the assassination games in *Killer: The Game of Assassination* in 1981, the rich oral tradition was condensed on paper, listing dozens of options on how to play the game.

In *La decima vittima*, the hunter can attack the victim wherever and whenever. The picture
is from the opening scene of the film where the rules of the game are explained.

It is easy to understand the reasons behind the quick spread and longevity of *Killer*. The
incredibly simple set of rules allows an endless number of variations. An ordinary environ-
ment is turned into a playground as players hide in bathrooms and spy through windows.
Outsiders get involved as they might see the game being played and find it suspicious or
they may be used as informants regarding the habits of a player. Creative, flashy, and theatrical
ways of assassination are often encouraged, such as smuggling a plastic spider into your tar-
get's shoe in order to poison him. As long as the referees approve, players can use any means
necessary to do the job.

Even though assassins seek to avoid public attention, *Killer* is a public performance and a
shared secret; only the participants know of the secret tensions of a lecture room, where they
know that anyone might be an adversary. Many players also perform for each other; stories are
told and respect is earned through perseverance, innovation, and flashy maneuvers. Prestige
is earned through tale telling: Taking a shot at close quarters might be the easiest option, but
playing around with subterfuge and costumes might reward you with a better story.

Perceived dangers of the outside world add to the thrill of *Killer*. Sometimes a bystander
opens the beeping package, accidentally triggering the fake bomb. Sometimes the thrill of a
chase on the streets may result in a scratch or a bruise. As the game is based on player reports
and human referees, a number of clever adaptations have been made to alleviate dangers:
Causing collateral damage is typically penalized in the game by assigning some players to play

A *Killer* player is using a long lens camera as a sniper rifle to kill his targets from a distance. The bananas represent pistols. Picture from *Deathgame*, Sweden.

detectives trying to catch the exposed criminal. Sometimes the referees leak more information on the overt assassin to other players or even assemble an entire police squad to arrest the murderer.

Rules on acceptable spying and use of outsiders vary as well: While breaking and entering is always forbidden, many groups accept peeking through windows. Sportsmanship is a necessity; you are often the only one who knows whether you took a sip of the poisoned drink. Common sense and being considerate are also essential virtues, as players hitting outsiders and exhibiting excessively suspicious behavior can cause conflicts with the world outside, with consequences ranging from bad press to police intervention.

Killer breaks the boundaries of games by using environments, people, and information from the everyday world. This creates a twofold attraction. First, *Killer* takes the fun of the game and brings it to everyday life: Wherever you go during the weeks of the scenario, you are a legitimate target, and all possible paranoia is justified. Second, it takes the tangibility and realness of everyday life into the game, spicing up the game. Whatever you want to do in *Killer*, you have to do it for real.

If you want to carry a fake weapon around the clock to protect yourself against an assault, you have to do it for real (see Figure A.2). You get to add sneaking, stalking, and watching your back to your everyday life, and when you manage to kill someone, you know you were able to do it for real. Even though killing is just pretend play, it is pleasurably *immediate*. No difficulty levels, no dice rolls, no simulation, no reloading the game. The game is not paused and it does not adapt to individual player preferences.

The simplicity and elegance of the core idea of *Killer* make it a game that is easy to adapt to diverse playing situations, environments, and preferences. Players can adapt the length and

intensity of the game from hours to weeks. Adding role-playing elements and story content allows making *Killer* a complex conspiratorial agent game focusing on social interaction and competition (see Tan, 2003). Time has made few fundamental changes to the basic gameplay: Nowadays the Internet is a great help in locating the victim and obtaining detailed information on the target.

In one very interesting variant of the basic *Killer*, Jane McGonigal and Ian Bogost turned the game into a public performance of goodwill. They changed the mechanic of assassination to complimenting the suspected victim. As they also removed all target information and set up a shorter game in a small area, the whole game was changed: Success in *Cruel 2 B Kind* requires the player to walk around the area, giving compliments to random people, hoping to hit another player with a specific compliment to score a kill. Killers and victims team up and go on hunting for new prey.

Cruel 2 B Kind illustrates how completely the basic theme of assassination can be turned upside down by tweaking the mechanics slightly. Indeed, hardcore *Killer* does not appeal to a mainstream audience, but its basic pleasures can be exploited in other gaming styles.

Killer is still running strong on many campuses around the world. Every year the murderous student groups get reinforced by a new generation of freshmen, so the lively and polyphonic culture is likely to survive for a long time. After all, it is unlikely that media technology could deliver equally real experiences any time soon. Indeed, the simplest games are often among the very best ones.

ONE

Games and Pervasive Games

Markus Montola

Pervasive games are a curious form of culture. They exist in the intersection of phenomena such as city culture, mobile technology, network communication, reality fiction, and performing arts, combining bits and pieces from various contexts to produce new play experiences. The family of pervasive games is diverse, including individual games ranging from simple single-player mobile phone games to artistically and politically ambitious mixed reality events. Some of these games seek to pass time for a few minutes while waiting for a bus, whereas others create persistent worlds that go on for months and where players can adopt alternate identities and engage in intricate gameplay. Some games use high-end technology, while others can be realized with no technology at all.

In order to understand pervasive games, we have to start by discussing games and play, and how *pervasive* games relate to other games. Johan Huizinga is often considered the forefather of game studies, based on his philosophical and anthropological work conducted back in the 1930s. He discusses play as something happening outside *ordinary life*. Huizinga's play is a ritual *activity* that takes place under rules that are separate from everyday reality. Huizinga describes play as a

> . . . *free activity standing quite consciously outside "ordinary" life as being "not serious", but at the same time absorbing the players intensely and utterly. It is an activity connected with no material interest, and no profit can be gained by it. It proceeds within its own proper boundaries of time and space according to fixed rules and in an orderly manner. It promotes the formation of social groupings, which tend to surround themselves with secrecy and to stress their difference from the common world by disguise or other means. (Huizinga, 1938)*

After Huizinga, Katie Salen and Eric Zimmerman (2004) picked up the idea of game being separate from everyday life, adapting the concept of *magic circle* from Huizinga's work. The magic circle of a game is the boundary separating the ordinary from ludic and real from playful (see Figure 1.1).

While Huizinga stressed that play happens in a certain dedicated area at a certain dedicated time, Salen and Zimmerman read magic circle much more metaphorically, as a conceptual boundary of game and real, as "shorthand for the idea of a special place

FIGURE
1.1

"All play moves and has its being within a play-ground marked off beforehand either materially or ideally, deliberately or as a matter of course. Just as there is no formal difference between play and ritual, so the 'consecrated spot' cannot be formally distinguished from the play-ground. The arena, the card-table, the magic circle, the temple, the stage, the screen, the tennis court, the court of justice, etc., are all in form and function play-grounds, i.e., forbidden spots, isolated, hedged round, hallowed, within which special rules obtain. All are temporary worlds within the ordinary world, dedicated to the performance of an act apart," writes Huizinga (1938). In Japanese *sumo wrestling* the magic circle is particularly prominent.

in time and space created by a game." As they point out, this boundary is not always an absolute one:

> *The boundary between the act of playing with the doll and not playing with the doll is fuzzy and permeable. Within this scenario, we can identify concrete play behaviors, such as making the doll move like a puppet. But there are just as many ambiguous behaviors, which might or not be play, such as idly kneading its head while watching TV. There may be a frame between playing and not playing, but its boundaries are indistinct. (Salen & Zimmerman, 2004)*

Conflicts staged within the magic circle are *artificial* in some sense. When boxers fight in the boxing ring, their conflict is artificial. Though the punches, the pain, the damage, and possibly even the motivation are real, the fight is given an artificial form negotiated by rules. Within the magic circle, different rules apply; lying, backstabbing, betrayal, and limited violence may be acceptable, whereas in ordinary life the same actions would result in serious repercussions (see Lastowka, 2007). According to Gregory Bateson (1955), the difference is in *metacommunication*.[1] Implicit metacommunication frames

ordinary actions and playful actions differently. Even though a *boxing* punch is a punch, it is viewed differently than a punch on a street. Quoting Bateson (1955):

> The statement "This is play" looks something like this: "These actions in which we now engage do not denote what those actions for which they stand would denote."

Erving Goffman (1961) discusses a similar idea, saying that games are enclosed within a metaphorical *interaction membrane*. The membrane selects, filters, and transforms events, actions, and properties outside the game. The game of *Monopoly*, for example, is not, or at least should not be, influenced by players' wealth or social status. These properties are excluded from the game. Other games, such as *Texas hold 'em*, filter outside properties more selectively: The player wealth has a limited influence on gameplay.

Taking the *artificial conflict* as the backbone of their definition, Salen and Zimmerman (2004)[2] define game as "a system in which players engage in an artificial conflict, defined by rules, that results in a quantifiable outcome."

Looking at this in detail, game is a system, not an activity, an event, or a physical object. However, it is inseparable from the players, who are needed to engage in the artificial conflict: A chessboard is turned into a game system as the players engage in conflict and start to enact the rules in order to reach an outcome. All games are not "won" or "lost," but this definition requires them to produce an outcome.

For comparison, Jesper Juul replaces conflict with effort in his definition. Artificiality is present in his definition through the optionality and negotiability of outcomes. He still requires valuation of outcomes (though not quantifiable valuation) and requires that players feel attached to the outcomes.

> A game is a rule-based system with a variable and quantifiable outcome, where different outcomes are assigned different values, the player exerts effort in order to influence the outcome, the player feels attached to the outcome and the consequences of the activity are optional and negotiable. (Juul, 2003)

As we compare these two definitions, we can say that they represent similar thinking, and both can also be combined with Salen and Zimmerman's idea of boundaries of game, expressed through the metaphor of the magic circle. Curiously, we should note that none of the three aforementioned approaches to games and play mentions *fun*. Even though most games are played for entertainment, excitement, and enjoyment, the purposes of games and play include everything from pleasure to learning and from artistic expression to societal exploration.

Roger Caillois (1958) classifies playful activities on an axis ranging from free play, *paidia*, to formal play, *ludus*. Paideic activities include very informal playful activities, such as *children's play*, *make-believe*, riding a *rollercoaster*, *pretend play*, and *mimicry*, wheres ludic activities are well defined and somewhat formal forms of play such as *chess* or *basketball*. A citation from Caillois shows how broad the scope of playful activities is:

> At one extreme an almost indivisible principle, common to diversion, turbulence, free improvisation, and carefree gaiety is dominant. It manifests a kind of uncontrolled fantasy that can be designated by the term paidia. At the opposite extreme, this frolicsome and impulsive exuberance is almost entirely absorbed or disciplined by a complementary, and in some respects inverse, tendency to its anarchic and capricious nature: there is a growing tendency to bind it with arbitrary, imperative, and purposely tedious conventions, to oppose it still more by ceaselessly practicing

the most embarrassing chicanery upon it, in order to make it more uncertain or attaining its desired effect. This latter principle is completely impractical, even though it requires an ever greater amount of effort, patience, skill, or ingenuity. I call this second component ludus.

It is notable that Salen and Zimmerman, and especially Juul, focus their definitions on ludus rather than paidia, stressing the role of rules in games. These contemporary ludologists define games as rule systems, whereas Huizinga discusses play as "free activity." This book focuses on pervasive games, and thus ludus is dominant in our thinking. However, as forthcoming chapters will show, paideic elements are not only central to many pervasive games, but pervasive activities rich in paideic elements have been around for a long time. This stance toward paidia sets us slightly apart from most ludologists, who craft their definitions especially in order to inform about the design and study of computer and console games.

Although all definitions of games have been thoroughly criticized from various perspectives, we can take these fairly established models as a basis for looking at how pervasive games are *different* from games as defined by Juul, Salen, and Zimmerman.

Magic Circle as a Contract

The metaphoric magic circle discussed earlier is a ritualistic and contractual boundary, which is most often based on a somewhat implicit agreement. The reality of a game is different only if both the participants of play and the society outside recognize the playground as something belonging outside of ordinary rules. Games are not entirely free, at least not in contemporary society: Many forms of violence are unacceptable even if they take place within a game contract. A game using the rules from the movie *La decima vittima* (1965) could not be applied in isolation, as a mutual contract or interaction membrane does not protect a murderer against legal repercussions. Similarly, engaging in bloody fisticuffs in a hockey rink can land the participants in court.

When Huizinga discussed playful activities 70 years ago, the cultural positions of games, sports, gambling, and children's play were different from today. For instance, games were largely multiplayer activities, and very few people played games for a living. Juul stresses that his definition of game applies to "classic" games and that many recent games break some of the criteria used in his definition.[3] According to him, the era of classic games lasted until the 1960s; games before that tended to conform to a certain model, but newer game genres such as computer games and role-playing games broadened the concept of game.

Even though the concept of a magic circle is the most fitting for classic games, it is a useful metaphorical tool when trying to understand most kinds of games. Boxers might be serious about punching each other as hard as possible, but the seriousness is different from beating each other up on a street. Ritualistic practices and dedicated zones are typical for games; if a player of *World of Warcraft* watches TV while playing, she still separates ludic from ordinary, fictitious from actual, and game from everyday life. Eva Nieuwdorp (2005a) considers this to be a difference in *semiotic domains*; for a player the transition from the lifeworld domain to the domain of a game is clear.[4]

Cindy Poremba (2007) further emphasizes the way the magic circle extends to the rules of socially acceptable behavior. One of her examples is the party game *Twister*,

which involves close physical and social interaction. The redefined social conventions of the magic circle provide the players with an alibi for intimacy, as they can always dismiss the events of *Twister* as "just a game."

The idea of a magic circle of gameplay has recently faced criticism. According to Daniel Pargman and Peter Jacobsson (2006), the magic has gone: For hardcore players, gaming is an everyday activity that no longer happens in a reality of its own. The "proper boundaries of time and space" are not relevant in the age of computer gaming, where a gamer might spend a day playing a game while simultaneously engaging in several other tasks as well. Similarly, Thomas M. Malaby (2007) argues that games are not separate from other everyday experiences: "Any game can have important consequences not only materially, but also socially and culturally (in terms of one's social network and cultural standing)." Already Huizinga (1938) noted that games build communities, secret societies of players, and thus spill in to the ordinary.

In his ethnographical study of tabletop role-players, Gary Alan Fine (1983) looked into discourse that takes place during gameplay. Using Goffman's (1974) frame analysis as a basis, he found that role-playing takes place in three distinctive and usually clearly separable discursive frames, which can help understand how the magic circle exists as a metaphorical boundary.

In Fine's *primary framework,* the players discussed entirely game-external matters, ranging from eating pizza to arriving late at a game session. In the *secondary framework,* the players discussed game issues, such as the hitpoints of elven rogues, using game terminology from combat rounds to experience levels. And in Fine's *tertiary framework,* the players discussed the game world, things that exist within the *diegetic*[5] reality of the role-playing game. One of Fine's key observations is that players move between these frames swiftly, intuitively, easily, and often. Even though his transcripts seldom show any explicit frame shifts, the frame-distinguishing metacommunication is clear in implicit patterns of speech, gestures, and mannerisms.

Fine's primary framework includes everything that happens outside the game and everything outside the magic circle or the interaction membrane. The second and third frameworks exist within it. If a participant steals money from another participant in the primary framework—outside the magic circle—she commits a crime, which is likewise resolved in real life outside the magic circle. However, if a halfling rogue steals money from an orc warrior in the tertiary framework, the crime does not exist outside the magic circle. The playing contract states that players should not bring disputes through the magic circle, in either direction, and doing so is often socially frowned upon (see also Sihvonen, 1997). It does happen from time to time, but such mixing of the diegetic world and ordinary life is usually seen as bad sportsmanship.

Following this kind of thinking, we understand the magic circle as a metaphor and a ritualistic contract. The function of the isolating contractual barrier is to forbid the players from bringing external motivations and personal histories into the world of game and to forbid taking game events into the realm of ordinary life. While all human activities are equally real, the events taking place within the contract are given special social meanings.

Blurring the Magic Circle

It is clear that a game of *Killer* does not "proceed within its own proper boundaries of time and space according to fixed rules and in an orderly manner"—quite the opposite.

The magic circle of *Killer* is intentionally blurred in many ways: The game is played wherever the players go. During the weeks of the game, the players must stay alert at all times, watching signs of danger. They can freely choose when to look for other players, and they might accidentally stumble upon their victims. The pleasure of playing is largely derived from the interactions of the game and ordinary life, sharing a secret with other players, and trying to avoid witnesses when conducting murders.[6]

We argue that this way of breaking out of the proper boundaries of time and space makes pervasive games fundamentally different experiences that can utilize a novel set of aesthetics for creating engaging and meaningful experiences.

This book uses the following definition of pervasive games:[7]

A pervasive game is a game that has one or more salient features that expand the contractual magic circle of play spatially, temporally, or socially.

Pervasive games are games, even though the contract that forms them is different from the ones defined by Juul, Salen, and Zimmerman. In pervasive games, the magic circle is *expanded*[8] in one or more ways: The game no longer takes place in certain times or certain places, and the participants are no longer certain. Pervasive games pervade, bend, and blur the traditional boundaries of game, bleeding from the domain of the game to the domain of the ordinary.

Nieuwdorp (2007) divides the ways of understanding pervasive games into technological and cultural approaches. The technological perspective looks at how games utilize pervasive computing, whereas the cultural perspective focuses on the game itself and how it relates to the ordinary world.[9] We have intentionally chosen the cultural perspective, as we believe it better suits a book that discusses theory, design, and cultural significance of pervasive gameplay. Naturally, moving away from technology-based definitions causes some games to fall out of the scope and others being included.

Spatial Expansion: Whole World as Playground

Huizinga positions play within dedicated areas and proper boundaries that separate it from the ordinary. Increasingly often this ritualistic spatial separation needs to be seen metaphorically: A console gamer plays alone in a small semiotic sphere of a single-player game, whereas the spatial boundaries of play-by-mail *chess* are strictly defined by the conceptual game board. Still, most gamers are conscious of the areas where games are played: The socially constructed ludic space does not have to be a physical one.

When discussing spaces as social constructions, it is clear that people are perceived to inhabit many spaces simultaneously and alternatively. A player of *Super Mario Bros* shifts between and simultaneously inhabits the two-dimensional game world with mushrooms and tortoises, her playing environment, and also the ordinary world. A player can simultaneously go for a mushroom in the game world and talk with her friend about everyday matters.

Pervasive gamers inhabit a game world that is present within the ordinary world, taking the magic circle wherever they go. Unlike nonpervasive games, which seek to be isolated from their surroundings, pervasive games embrace their environments and contexts (see Figure 1.2).

Space needs to be understood broadly; in addition to physical architecture, pervasive games can appropriate objects, vehicles, and properties of the physical world into the

FIGURE
1.2

Players of *Manhattan MegaPUTT* used the whole of Manhattan as their mini-golf track in the Come Out and Play 2006 festival.

game. As anything residing in the physical space where the game takes place can be included in the game, it can be said that talking about game-specific tokens or props (such as footballs, chessboards, and cards of a collectible card game) is inappropriate in pervasive games: Even though the main interface to the game might be a mobile phone or a water gun, the random environment plays its part in the game as well. Bo Kampmann Walther (2005) notes that in pervasive games, the concept of *game entity* becomes complicated, as it is very hard to determine whether something holds relevance for the game. It is hard to determine whether an elevator is "a token of game's passage from one level to the next connected through a network of sensor technology; or is it simply an element of the building's non-pervasive construction," he writes.

To illustrate spatial expansion in a simple way, it is easy to add spatial expansion to the traditional game of *tag* by entirely removing the spatial boundaries of the playground. Allowing players to run wherever they want keeps the basic game mechanism intact, but also changes it dramatically, as players can use their surroundings in infinite ways, ranging from running away to taking a bus or hiding somewhere. When the game commences, no one can predict which places will be included in the play: This inevitably leads to surprises, as the play area is unknown. The environment can change, and it can also be dangerous.

Pervasive games can exploit aesthetics from run-down factory areas to high-class restaurants, but they can also reach beyond physical space: The expansion can also be created through expansion in cyberspace. Pervasive games can invade all sorts of virtual environments, ranging from message boards to virtual realities. Game-related discussions and role-play can take place among bystanders on the Internet just as in the physical world, and you can even stage a treasure hunt within a virtual reality (see Brown, 2007). Many pervasive games experiment with augmented reality, as such an interface could be a perfect way of adding game content to the physical-world.

All games combining physical spaces and cyberspaces are not pervasive, only those that take the game to unpredictable, uncertain, and undedicated areas. Few pervasive games employ any persistent three-dimensional virtual worlds.[10]

Temporal Expansion: Renouncing the Play Session

In their approach to discussing games as systems, Jussi Holopainen and Staffan Björk define the concepts of *game instance*, *game session*, and *play session* as follows:

> *A game instance defines the complete collection of all components, actions, and events that take place during the playing of single game. A game session is the whole activity of one player participating in such a game. A play session is the uninterrupted stretch of time when one player is actively playing a game.* (Björk & Holopainen, 2005)

For a nonpervasive, unexpanded game, this kind of conceptual discussion is valid: Players play *Monopoly* or *Super Mario Bros* for a while and then take a break and resume later. Sometimes these sessions might overlap if players engage in several activities simultaneously, and quite often there might be dozens of very short subsequent play sessions as players freely mix gameplay with everyday small talk, switching between Fine's frames rapidly.

However, these "proper boundaries of time" can hardly explain the way *Killer* is played. The ideas of game instance and game session remain relevant, but distinguishing play sessions is impossible. Everyday life and gameplay are merged for the duration of the game instance; still, it would be pointless to claim that the whole duration of the game instance was part of one play session. In that case, a play session may include sleeping, working, and talking with nonparticipants. The game rather moves from the center of attention to periphery and back again. An assassin trying to kill her brother during a family dinner is not having an "uninterrupted stretch of playing a game," but is rather in an in-between state trying to fit together the ordinary world and the game objective.

The players may also lose their power to decide when to play intensively and when not to. While typical gameplay requires the players to volunteer in order to participate, *Killer* works differently: In the beginning of the game instance, the player volunteers to participate in all possible intense gameplay during the duration of the play. The consent to play is acquired in advance, but the exact times of play remain uncertain, ambiguous, and hard to define. In a fashion strictly contradictory to Huizinga's magic circle, the proper temporal boundaries of play are *uncertain* to participants (see Figure 1.3).

Social Expansion: Playing with Outsiders

The direct consequence of temporal and spatial configurations used in pervasive games is that outsiders tend to get involved with pervasive games. Outsider participation can come in many shapes and sizes, ranging from spectatorship to full participation. Nonparticipants, who come in contact with players situated within their personal magic circles, may be seduced by the game and enter the magic circle or shrug off the encounter as a run-in with a weirdo.

Killer features one of the simplest forms of outsider involvement: Players seek to *avoid* involving bystanders in their game. As most sets of rules penalize assassins who

FIGURE
1.3

A rigged blender has just exploded. This illustration of temporally expanded gameplay is from Steve Jackson's *Killer: The Game of Assassination*.

conduct murders with witnesses present, the players have a clear incentive to keep the game to themselves. Bystanders are challenges and obstacles, but the players are not expected to overtly interact with them.

Cruel 2 B Kind takes a slightly more extrovert position, as the players need to interact constantly and actively with people they hope will be players in order to succeed in the game. Players need to give their murderous compliments to everyone they suspect could be participating in the game in order to hit their targets: Only the victim knows if he has been hit.

Even stronger forms of social blurring exist, done in the fashion of Augusto Boal's (2002) *invisible theater*. Invisible theater is prescripted political drama that is performed in a public space without any visible labels of being drama, thus luring outsiders to participate. Richard Schechner (2002) discusses *dark play*, where some of the players do not know they are playing. These paideic activities involve risk, deception, and thrill. For example, one of Schechner's informants said that she played a form of *Russian roulette* in traffic by crossing streets without pausing to see whether cars were coming. Both *invisible theater* and *dark play* are based on omitting the metacommunicative message declaring them nonordinary. Pervasive games can use similar solutions, providing

FIGURE
1.4

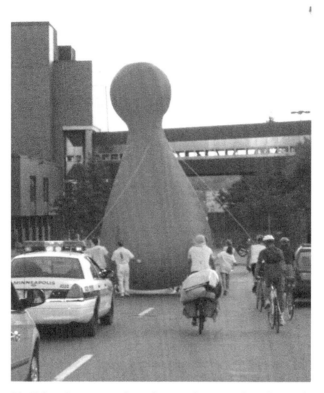

Big Urban Game was a board game that was played on a citywide board in Minneapolis and St. Paul. Most of its interaction with outsiders took the form of spectatorship. In this picture, *Big Urban Game* is played in the middle of everyday street traffic.

outsiders with differing amounts of information and different positions ranging from passive spectators to full player participants.

The definitions of game and play typically stress the voluntary and artificial nature of play. Blurring the social boundary of games compromises these properties, as a bystander cannot willingly decide whether to witness a water-pistol assassination or not. This makes the use of bystanders an attractive, versatile, powerful, and dangerous way of designing games.

Due to the lack of voluntariness, the *unaware participants*[11] are *not* players. They are not shielded by the *protective frame* of playfulness: Michael J. Apter (1991) asserts that people engaged in play are protected by a psychological barrier providing a feeling of confidence saying that no harm can come to them from participating in play. However, the unaware participants are in a different position, as they are unaware of the semiotic domain of the game, and thus interpret game-related events within the semiotic domain

of ordinary life. Thus, a foolish *Killer* player pointing an authentic-looking gun at an unaware outsider would be treated as a real, scary, armed threat.

The unaware participants also lack the *lusory attitude* (Suits 1990) toward the game: Unlike aware game players, unaware participants do not limit their actions according to any game rules. Lacking the lusory attitude, an unaware police officer encountering the said *Killer* player would take her down with real violence.

Rethinking Play for Pervasive Games

As pervasive games can be played anytime, anyplace, and by anyone, game actions are often inseparable from nongame actions. A player of *Killer* might be drawn into the game wherever she goes and whatever she does, and this possibility also influences all her behavior. If she sees a suspicious character out of a window, she might choose to postpone doing her grocery shopping in order to avoid a possible assassination attempt. In a sense, avoiding gameplay is part of the gameplay.

This is again a clear difference compared to nonpervasive games, which often rely on explicit interfaces. *Chess* moves are explicitly defined maneuvers on the board, and there are even clear rules on when a decision has been made. The official *Laws of Chess*[12] provide extremely detailed rules on how the physical act of moving a piece must be conducted and how the physical action exactly relates to changes in the game state. For example, if a player deliberately touches a piece on the chessboard without giving prior notice of merely adjusting its place on the grid, she must use her turn to move that particular piece. Similar rules also apply to casually played, friendly board games, even though the meticulous formalism is replaced with friendly negotiation or aggressive bickering.

Games with more physical resolution systems, for example, *basketball*, also define and control the physical acts of playing as precisely as possible. Even though there is no turn-taking in *basketball*, acceptable and unacceptable actions are carefully defined, and acting in a wrong way is penalized: Rules may come from oral tradition or they can be defined very formally,[13] but the intent is to reduce the complex physical action to a playable sport by limiting the legal forms of action. While *chess* has a limited number of possible game states, there is no limit to the possible game states of *basketball*. Also, it is impossible to exactly reproduce any past state of a *basketball* game.

Even though some level of uncertainty is an essential part of any game, pervasive games are even more unpredictable than regular games. Just like there is a qualitative difference between *chess* and *basketball*, there is a qualitative difference between *basketball* and *Killer*. Anything and everything can influence the state of a pervasive game: The concept of a "game move" is meaningless in relation to *Killer*, as it is impossible to distinguish game actions and ordinary life actions. In the semiotic domain of the game, all actions are game moves; in the semiotic domain of everyday life, none of them is.

Jane McGonigal (2006a) addresses this ambiguity of game moves with the idea of *infinite affordances*: Players can use any property in their environment to conduct infinite variations of game moves. Donald A. Norman's (1988) idea of affordance refers to "the perceived and actual properties of the thing, primarily those fundamental properties that determine just how the thing could possibly be used [. . .] A chair affords ("is for") support and, therefore, affords sitting." In games such as *basketball* and *Leisure Suit Larry in the Land of Lounge Lizards* the affordances are limited; while a basketball affords dribbling and throwing, a proficient adventure gamer tries to pick up everything for further

use. In a pervasive game the affordances are unlimited, as any object can hold game significance, whether incidental or designed, and whether or not the participants realize it.[14]

Goffman (1961) discusses the *rules of irrelevance*, determining things that are irrelevant for the game. For instance, the players are "willing to forswear for the duration of the play any apparent interest in the esthetic, sentimental, or monetary value of the equipment employed," as such physical and social properties of objects are not essential for the rule system of the game. Expanded games tend to abolish many of the typical rules of irrelevance applied in games. Most games forbid using external resources to win the game, but *Killer* does not: If you own a car, you can use it to play more efficiently. If you build fences around your house, you will be a bit safer in your garden. Ultimately, nothing is irrelevant to *Killer*; even your favorite foods make a difference to anyone trying to poison you. Outside of the mere scoring schema, *Killer* can never be understood as a state machine, as the game is always infinitely complex, and the possible inputs and states of the game system are endless.

Some games use events in the real world to determine progress in a game. In the Web-based *Hollywood Stock Exchange*[15] game, the players buy virtual stocks in Hollywood films. Ultimately, the worth of these investments is determined in real-world box offices. The films are not just thematic fillings or even random generators, but something that can be researched, evaluated, and predicted. While all the explicit changes in the game database are done in cyberspace, the game can be played through reading newspapers with Hollywood coverage. As ordinary world information invades the magic circle of *Hollywood Stock Exchange*, play easily overlaps with everyday life.

Even though *Hollywood Stock Exchange* is not a very pervasive game for a typical player, an extreme player can turn it into a highly pervasive experience. For example, if the player acquires secret information about Hollywood events, she can gain a competitive edge. Then again, it is possible to boost the value of your shares by spreading gossip. In addition, if directors, producers, critics, and actors enter the game, their work can directly influence box office success.

Pervasivity is not strictly a function of rules and game design, but playing styles can also make a substantial difference.

Emergent Gameplay

Looking at *Killer* again, the most rudimentary way of playing is just murdering the target with one of the predetermined weapons. However, as the game supports infinite affordances, the players are free to choose their own goals and utilize a wide array of methods in order to meet them. As stylish kills are highly appreciated, a gameplay experience might include anything from choosing a wig to disguise oneself to scaling a wall in order to spy on the target.

Pervasive games often produce *emergent gameplay*. The combination of infinite affordances and unpredictable environment leads to surprising coincidences and occurrences (see e.g. Reid 2008). These occurrences often lead to intensive and fun game experiences, which have not been planned by any designer or participant.

If we use *Killer* to illustrate the idea of emergence, we can imagine a situation where a player falsely assumes a bystander to be a player stalking her. When the outsider approaches the player in order to ask to borrow her mobile phone for a call, the player gets a real gameplay experience, even though she is playing a multiplayer game alone.[16]

Sometimes the emergent events can turn into very detailed and extended events, and as the players are unaware of whether or not the event is a planned part of the game, emergent events also often feel very authentic, realistic, and surprising. Players of many pervasive games (McGonigal, 2003b; Montola & Jonsson, 2006; Stenros, Montola, Waern, & Jonsson, 2007c) have considered instances of emergent play among the best parts of their experiences.

Between the Real and the Artificial

As pervasive games are games blurring the traditional boundaries of games, they also need to be studied as nongame phenomena. As discussed further in later chapters, pervasive games are closely related to many other phenomena blurring the boundary of real and fiction. *Candid camera* is a perfect example. It catches unaware participants in public places and surprising times, and persuades them to address game-like challenges. For the unaware participant, the game is not a game, and thus anyone interacting with an unaware participant is also outside the magic circle to some extent. When a *Killer* player takes a taxi to pursue a victim, the money, the ride, and the traffic are as real as ever.

When the three expansions of pervasive games are taken to extremes, the magic circle starts to lose its meaning as a contractual boundary between ludic and ordinary. Extreme temporal expansion leads to ordinary life becoming a pervasive game. The same happens with space if the ordinary world is seen primarily as a game world: There cannot be a game world without the ordinary world. And, finally, a game where everyone is only an unaware participant is no longer a game.

Professional sports are a practice perfectly illustrating the way games can lose their playfulness. The empiric results presented by John H. Kerr (1991) show that professionals tend to participate in games in a serious, goal-oriented manner, whereas amateurs play for the pleasure of play itself. For a professional who practices *cycling, soccer,* or *swimming* full time in order to earn a living, play is no longer separated from the sphere of the ordinary. If success in a game is a necessity in order to earn a living, the play is motivated by results instead of the process of play. This is a clear step outside both Huizinga's definition of play and Apter's protective frame of playfulness: A conflict motivated by material gain is much less artificial than playing for pleasure alone.[17]

For professional gamblers, athletes, and gold farmers,[18] the metaphor of the magic circle loses its meaning as a ritualistic separator of ordinary and playful, becoming only a representation of a code of conduct within the game. In terms of Fine's frames, the secondary and tertiary frames of gameplay have different rules, and disputes in them do not move to the first frame: A player of *EVE Online* is legally[19] allowed to extort other players, scam them, and steal their credits within the game, even if she subsequently sells them on eBay. However, if such activities are done professionally, the act of playing the game is only contractually isolated from ordinary life. Labor is labor, whether it is done in a factory, soccer field, or virtual reality (this is discussed further in Chapter Thirteen).

The temporal, spatial, and social expansions are not the only possible expansions of the magic circle; using the same conceptual framework, we can say that gambling games, professional sports, and persistent world games feature *legal–economical expansion*. These games have legal and economical consequences reaching beyond the magic circle.

Immediate Experiences

Any taste, sight, smell, sound, or touch in the world can be given a new meaning, thus making them parts of a pervasive game experience (Ericsson, 2003). The way pervasive games include nongame reality in gameplay allows *doing things for real* during the game. In *Killer*, the pleasure of sneaking is in the sneaking itself, not in an elaborate simulation of sneaking. Chasing, exploring, puzzle solving, and running can be done for real.

Holistically thinking, a game is still a mediated event (for mediation, see, e.g., de Zengotita, 2005), but individual occurrences and activities during the play can create seemingly immediate experiences (Montola, 2007). If a bypasser opens a discussion on weather, the discussion is as real and direct as discussions ever get. If an assassin goes hiking with her school class, the experience of hiking is only mediated through the context of school, even though she is still participating in a temporally expanded *Killer* game.

Looking at the immediacy through the glasses of semiotics, we can say that the experience of immediacy is partially created by an *indexical relationship*[20] between the physical world and the game world. Sneaking in *Killer* is accomplished indexically through the act of sneaking; the sneaking player has a direct relationship with the sneaking assassin. Many other games rely on a *symbolic relationship*, where the player action and game world action are connected through a contract or convention; in a board game, you would play a sneaking card to symbolically convey the act of sneaking. Finally, some games use an *iconic relationship*, where the player and the game world are connected through similarity, like when you push the "up" arrow in order to sneak ahead in digital games.

These relationships are two directional; the *Killer* player also experiences the game world indexically as the trees and buildings of the physical world are directly constructed into the game world. Instead of seeing the icons conveying the psychedelic world of *Super Mario Bros* or interpreting the symbolic descriptions of an adventure game, the player of a pervasive game can access the game world indexically.[21] It should be noted that symbols and icons are also used to construct *Killer* diegeses: Fruit can represent pistols and daggers both through similarity and through rule conventions (see Figures A.2 and 2.2).

Indexicality is not exclusively a property of pervasive games. While a *boxing* match could be seen as an elaborately symbolic and iconic representation of a fight, it is also a highly indexical struggle where a punch to the face is represented by a punch to the face. However, pervasive games open up the design space of indexicality for activities ranging from begging and exploring to lying and traveling.

As designers have noted this attraction, *reality fabrication* has also become a method for pervasive game design. Fabrication[22] is created to appear as the ordinary world to the player, but it often takes a sharp turn, suddenly changing into a game experience as the player realizes game elements in the fabrication.

A very simple element of fabricated reality takes place if an assassin asks her target on a date in order to kill him in a particularly nasty way. Only after the victim tastes the poison in his drink and notices that the assassin slipped out on her way to restroom does he comprehend the encounter with fabricated reality. Only the sour taste of vinegar conveys the metacommunication that retroactively frames the whole date as a *Killer* game event.

Conclusions

The contracts of pervasive games are different from the contracts of traditional, nonexpanded games. The magic circle is not an isolating barrier distinguishing the ludic from the ordinary, but a secret agreement marking some actions as separate from the ordinary world. While all human actions are real, those that happen within the contract of a game are given a special social meaning.

In conclusion, we can see that there is a twofold dynamic between the playful and the ordinary that provides pervasive games a reason to exist: Both play and ordinary life can benefit from the blurring of the boundary.

Pervasive games can take the pleasure of the game to ordinary life. Wherever the players move, they know that the game is on, and this sensation eventually colors their whole experience of the ordinary. At times the experience is in focus; at times it drifts into the periphery of attention.

Pervasive games can take the thrill of immediacy and tangibility of ordinary life to the game. Many people consider uncontrolled and unsafe pervasive games exciting and thrilling: It is fun to do cool things for real. Being successful in real-world challenges is

FIGURE
1.5

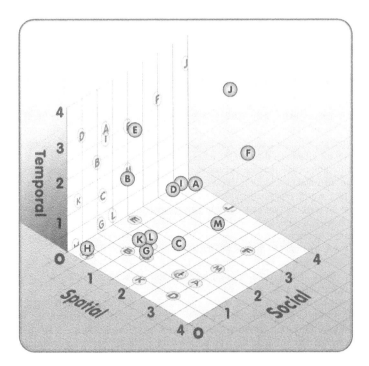

All 13 cases described in this book utilize the expansions differently. Classic games are located near zero, while the value of four indicates an expansion strong enough to question the ludic status of the piece. A: *Killer,* **B:** *The Beast,* **C:** *Shelby Logan's Run,* **D:** *BotFighters,* **E:** *Mystery on Fifth Avenue,* **F:** *Momentum,* **G:** *PacManhattan,* **H:** *Epidemic Menace,* **I:** *Insectopia,* **J:** *Vem gråter,* **K:** *REXplorer,* **L:** *Uncle Roy All Around You,* **and M:** *The Amazing Race.*

an extremely gratifying experience, as the players know that there is no simulation or rule system making the challenge artificially easy.

As the magic circle of a pervasive game is a blurry, porous structure, it is often hard or impossible to clearly differentiate the ordinary and the ludic. This makes pervasive games interesting and fun to play: The ludic and ordinary powerfully complement each other. As game designer Martin Ericsson (2003) has pointed out, this makes pervasive games very different from computer games:

> *The unique, extreme traits of mobile devices call for extreme gaming. This is the skydiving, wreck diving, rock climbing, street boarding of the imagination. The player of an extreme enchanted reality game needs to traverse the urban landscape efficiently, confront constant unexpected resistance, face real physical challenges, engage in character-driven social engineering, challenge her perceptions of the world and learn to follow rules very different from those society teaches her. Not quite the activities we associate with computer gaming today.*

In the following cases and chapters we put this theoretical discussion to use (see Figure 1.5). We discuss what pervasive games look like, how they feel like to play, how to create them, and what their position in the wider societal environment is.

Notes

1. Goffman (1974) uses the term *keying* for this metacommunication. A *boxing* match is a fight keyed as a contest.
2. Plenty of definitions for *game* exist. Both Juul (2003) and Salen and Zimmerman (2004) have done thorough comparative analyses of them before ending up with the definitions used in this chapter.
3. A "classic" game is a problematic concept. The way it excludes games recognized as such in natural language, simply because they fit the definition poorly, is suspect. Also, it is bold to claim that the definition is appropriate for all games through the ages up until the 1960s.
4. Similarly, Harviainen (2007) points out that for pervasive games, a *common interpretative framework* is more relevant than the magic circle.
5. We use *diegesis* to denote a world presented in fiction, whether that fiction has the form of a painting, a play, or a game. Everything that exists within a diegesis can be called diegetic.
6. Salen and Zimmerman (2004) call games blurring the magic circle "invasive games." Other academics who have contributed to discussion on games with blurred boundaries include T. L. Taylor and Beth Kolko (2003), as well as Jane McGonigal (2003a,b).
7. This definition has been discussed earlier in Montola (2005) and in Montola, Waern, and Nieuwdorp (2006). Staffan Björk (2007) has also published an alternate version, where ambiguity of interaction or interface is included as a fourth central defining criterion.
8. Things tend to get tricky when you apply a metaphor to another, so many words could be used to discuss what exactly happens to the magic circle in pervasive games—instead of "expanding," we could also discuss "bending," "blurring," "twisting," or "obfuscating." Sometimes the "expanded magic circle" has been interpreted in unintended ways, so we want to clarify that not all expanded games are such variants of unexpanded ones, even though some are (e.g. *Jagd nach Mr. X* is a pervasive street version of *Scotland Yard* board game). Also, we do not intend to imply that a player could exit the circle by traveling far enough or that the magic circle would be applied "evenly" or "consistently" throughout the gaming area (cf. Brown, 2007).
9. Works based on technological perspectives include Schneider and Kortuem (2001), Lindley (2005), and Walther (2005).

10. *Sanningen om Marika* being an interesting exception with its expansion to *Entropia Universe*.

11. Boal (2002) calls unaware participants *spect-actors*—spectators who also participate. Boal stresses that even if the spect-actor decides not to act, she is still an active participant choosing to remain passive.

12. E.I.01A *Laws of Chess* by World Chess Federation FIDE. In www.fide.com/component/handbook/ ?id=124&view=article, ref. September 24, 2008.

13. The *Official Rules of the National Basketball Association* illustrate how complex this can get. www .nba.com/analysis/rules_index.html, ref. September 24, 2008.

14. There has been some controversy over whether affordances are natural, learned, or cultural. After all, a rug affords lying on to a dog, but a basketball does not afford dribbling to a baby. Norman's (2007) revised stance is that affordances are about the communication between a designer and a user: A good industrial designer makes the affordances perceivable to the user. Affordances are also about relationships of agents and objects, as a chair does not afford sitting for an infant or an elephant. In many pervasive games the player challenge is to discover and utilize game-relevant affordances in an environment—whether these affordances are incidental or designed intentionally.

15. Similar games include *Monopoly Live* (players try to predict which hotels cabs frequent in London) and numerous fantasy sport leagues (build a team of real athletes and compete with others based on sport statistics).

16. Neil Dansey (2008) discusses emergence through the concept of *apophenia*. Apophenia is experienced by people who "mistakenly ascribe meanings to coincident occurrences which are unrelated or accidental," for example, when a horoscope strikes a chord with everyday life or when one sees a distinct shape in the clouds. According to Dansey, apophenic events cannot be designed directly, as deliberate occurrences are not unrelated or accidental. Nevertheless, he advocates designing ambiguity that creates *potential* for genuine apophenia.

17. Apter and Kerr look at play phenomenologically and talk about a playful mindset rather than an externally observable category of action. Essentially, they state that a participant in a soccer game can be in a playful or serious mindset, depending on her goals, motivations, and attitudes.

18. A gold farmer is a person playing an online game in order to sell the goods earned for real money. At the time of writing, a stereotypical gold farmer operates from China or Russia, spending the majority of his waking hours killing monsters in *World of Warcraft* in order to sell the gold to players in Western Europe and America (see, e.g., Dibbell, 2007; Steinkuehler, 2006).

19. This is our sincere belief. There has been no court case.

20. The semiotic concepts of index, symbol, and icon come from Charles S. Peirce (1876, 1885) and discuss how signs convey meaning. Symbols, such as words, convey meaning through convention. Icons, such as pictures, convey meaning through similarity. Finally, indices convey meaning through a direct relationship: The mercury in a thermometer is an index of heat, for example. Peirce's index is sometimes interpreted narrowly as a causal or spatiotemporal relationship, but we use a broader view on the concept, based on direct connection and (relative) lack of arbitrariness. See Chandler (2006) for more on semiotics, Loponen and Montola (2004) for use of this trichotomy in representation of game worlds, and Bergman and Paavola (2003) for Peirce's collected definitions of index. See Grayson and Martinec (2004) for further analysis of indexicality and perceived authenticity.

21. As always, physical signs represent mental ideas and constructions. Just like the words printed in a novel represent a fictional diegesis, the indices of the physical world are used to construct the *Killer* game world.

22. Goffman (1974) sees fabrication as the "intentional effort of one or more participants to manage activity so that a party of one or more others will be induced to have a false belief about what it is that is going on." His view is modernist in the sense that he assumes that there is something true that is falsified in fabrication. In this book, we assume that fabrication is indeed asymmetrical: The fabricator's perspective indeed differs from the fabricated perspective. Whether one of the views is more "true" or even more complete than the other remains a (postmodern) philosophical issue.

Case B

The Beast

Markus Montola and Jaakko Stenros

Having heard of the Spielberg film A.I.: Artificial Intelligence, *you've checked out trailers on the Internet. Something strange catches your eye: Jeanine Salla is credited for being the sentient machine therapist in the production team. Even with this kind of theme, the therapy of sentient machines certainly warrants a Google search.*

Jeanine's homepage is there, with a blog and everything. It turns out that something weird has happened recently; a man called Evan Chan has died in a boating accident, even though his wife claims that he was an excellent swimmer and the boat sank close to land. And even more strangely, these Web pages seem to have been created in the year 2142. Following the subtle hints and solving the puzzles written into the texts and source codes of the Web site, you are able to find clues leading to dozens of Web sites relating to this fully fledged mystery, created by unknown people who obviously spent big bucks to do it. Probably sooner than later you will realize that you are playing a game associated with the movie, possibly giving out prizes in the end.

In order to succeed in solving the murder mystery, the players had to explore a large network of Web sites (see Figure B.1[1]), send emails, call answering machines, and read telefax messages. Finding the puzzle was often the hardest part; just like Jeanine Salla hid in plain sight in the trailer credits, the first part of solving a problem was often to recognize it. The players were also kept on their toes through changes in the unspoken modus operandi during the game: At some point the game introduced events that were staged in physical space. When the players had learned to call answering machines and listen to the tapes, they were made to chat with an actor pretending not to know anything about the game.

In order to hide the fact that it was a game, the puzzles were made under utmost secrecy. The project did not even have an official name but an assortment of nicknames; during play it was most often just called *The A.I. Web Game*. Only after the game had ended did the fan community end up calling it *The Beast*, based on an internal joke.

"The premise from Day One was that the entire Internet should be considered as a single player; that we could put an ad in a newspaper in Osaka in the morning and have some kid in Iowa using that information by supper time,"[2] the game designers explained after the game. The game spawned Internet communities with thousands of participants massing their intelligence to crack the puzzles.

Lead writer Sean Stewart (2008) explains that it turned out to be surprisingly difficult to create challenges for such an audience with a ferocious appetite for something to do. As the game was largely created on the run, the game master team could flexibly adapt to their

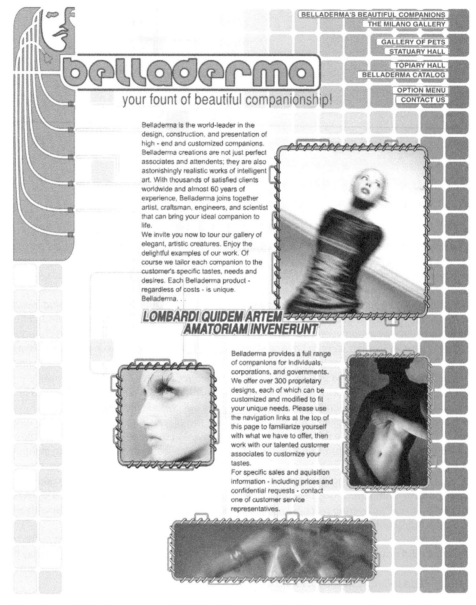

The theme of *The Beast* was artificial intelligence, with all its opportunities and threats. Belladerma was a fabricated company that sold artificial companions in all sizes and shapes on its Web site.

audience: Many of the puzzles were designed to be *extremely* hard in order to entertain large crowds for more than a few moments. Solving the game took 43,000 messages for the largest community, The Cloudmakers.[3]

At Microsoft, where the game was created, the designers of the game never confessed during the run of *The Beast* that a game existed or that they were behind it. In fact, the total denial of the gameness was the design principle. Everything had to look and feel as much as possible like it was real and believable. The only reference to the event as game was in a television advertisement, and there it was bluntly denied. One trailer of the movie *A.I.* hinted at the puzzles by quickly flashing a red sentence on the screen: *This Is Not a Game*.

When looking at the principle of not being a game, the reasons behind sentient machine therapy become obvious. *The Beast* had to invite players to participate in a covert way, one that does not reveal the gameness of the game (Figure B.2). The players labeled this mechanism with a metaphor originating from the book *Alice in Wonderland* (1865), calling it a *rabbit hole*.[4] A player stumbling into rabbit hole is plunged into an unreal world like Alice was taken into Wonderland.

Fundamentally, *The Beast* was an advertisement campaign for Spielberg's movie. It was supposed to promote the film but also to broaden the *A.I.* franchise beyond the apocalyptic movie in a fashion allowing the production of further movie-related products. Using Daniel Mackay's (2001) term, *The Beast* was supposed to flesh out an entire *imaginary entertainment*

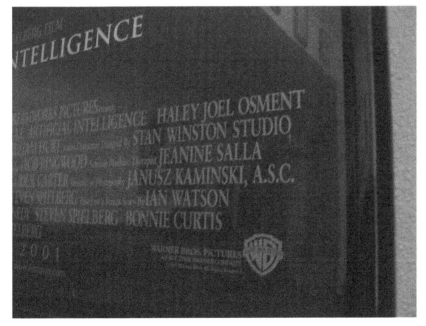

FIGURE
B.2

Artificial Intelligence posters featured at least two rabbit holes in addition to this Jeanine Salla credit. Counting small notches in letters gave you a number sequence; calling that number revealed a welcoming voice message. On the backs of at least some of the posters there were also small circles and squares, marking letters on the front side. Assembling the marked letters correctly revealed that "Evan Chan was murdered" and that "Jeanine was the key."

environment,[5] a whole world of intellectual property similar to the *Star Wars* universe or J.R.R. Tolkien's Middle-Earth. Sean Stewart elaborated on this in an interview:

> *"It's about understanding the zeitgeist. You don't make Schindler's List: The Game, you build a World War II basket for a game. An intense cultural moment the game lives in. And so that's what we decided to do for A.I. – to create the A.I. Zeitgeist." The mission of The Beast, as Stewart describes it, was to create a context for thinking about the coming, fictional extinction of the species homo sapiens as a highly playable scenario. (McGonigal, 2006a)*

Even though *A.I.* was not followed by such a basket of media products, *The Beast* has been considered a trailblazing success both as a game (Szulborski, 2005) and as a marketing campaign (Martin et al., 2006). According to the creators[6] of *The Beast*, over three million people "actively participated" in the game, and the campaign generated "over 300 million impressions for the film" through press.

The question of active participation in *The Beast* is complicated. In collaborative puzzle play, only one player can be the first to solve a puzzle, and the others can only use their smarts if they carefully refrain from reading community Web sites. Thus, the majority of participants can be considered *readers* instead of active players—people who keep up with game Web sites and player forums, but do not contribute to a group's progression in the game (Martin et al., 2006). It is easy to understand the readers' reluctance to actively participate when you know that some devoted puzzle-solvers spend more than 40 hours a week trying to crack the game.

This is perhaps the main weakness of *The Beast*: keeping up with devotees is tasking, and the idea of solving puzzles even they have not bested can overwhelm a casual player.[7] In fact, one could go as far as to claim that *The Beast* was a collaborative game, even though there was also fierce competition to solve the puzzles first. Only the winners of that competition transcended the group of readers, becoming contributing participants in the game.

There has been a lot of discussion on whether *The Beast* was a game and whether it managed to pretend not being a game. According to Jane McGonigal (2003b), *The Beast* was appealing because it allowed the players *to pretend to believe* that it was "real." While all participants must have known that it was an artificial puzzle, the way it was shrouded in mystery allowed players to engage in pretend play. Thousands of players pretending together can create powerful feelings. She also shows how the player communities worked toward upholding the pretence: Players exploiting design flaws were chastised on game forums, and the main group of players refrained from using illicitly acquired game information. Even though one design principle was to not establish any explicit rules, the player communities formed opinions on acceptable and unacceptable ways of proceeding in the game.[8] Pretence of belief was essential for both readers and active players (Figure B.3).

Still, it cannot be said that *The Beast* pretended to be real. The game was clearly set in the future, and widely propagated information marked it as fabrication. While it was obviously *a mystery,*[9] it was not fabricated reality as such.

The power of *The Beast* was combining the aesthetics of a cross-medial mystery with well-developed puzzles and a fascinating story. Indeed, the tagline *This Is Not a Game* was used as a design philosophy in this regard as well: The story and the fictional characters had to be written with the quality of a good novel or a film instead of the level usually expected of digital games (Stewart, 2008).

The pleasure of cross-medial expression is in the tangibility and concreteness of the experiences it can deliver. The ultimate cross-media experience had been compellingly illustrated

"Congress shall establish an agency within the United States Department of Justice to uniformly enforce the criminal laws pertaining to all sentient property. Said agency shall be designated as the Sentient Property Crime Bureau." The Web site of the SPCB is an obvious fabrication, but it supports pretence of belief.

a few years earlier in David Fincher's movie *The Game* (1997), where a filthy rich businessman purchases the experience of his life from a strange game company. In Fincher's movie, the protagonist is taken on a tailor-made trip anticipating his every move, creating as strong a reality fabrication experience as probably possible. The coolness factor of such cross-mediality derives from the way an all-encompassing and perfect fabrication can create the feeling of an

alternate reality. Sean Stewart, lead writer of *The Beast*, recalls[10] an early discussion with lead designer Elan Lee, who was also looking for an all-encompassing experience:

> "What's your idea of the game experience?" someone asked Elan.
>
> (Thoughtfully). "The instant you click on a link, your phone should start to ring, your car should only drive in reverse and none of your friends should remember your name."

The Beast gave birth to the whole genre of *alternate reality games* (Martin et al., 2006)[11] that use variations of its basic ideas—they tend to have puzzles, rabbit holes, aesthetics of mystery, Web-based narrative, and cross-medial playing styles. The more prominent titles include games such as *The Art of H3ist*, *Chasing the Wish*, *Project MU*, and *Ocular Effect*. Television broadcasters, in particular, have picked up alternate reality spin-offs, providing additional information to players of games such as *Alias Online Adventure*, *The LOST Experience*, and *Heroes Evolutions*.

Notes

1. Retrieved from www.cloudmakers.org.
2. According to Puppetmaster FAQ (http://familiasalla-es.cloudmakers.org/credits/note/faq.html, ref. May 28, 2007), a fan page with collected designer answers to frequently asked questions.
3. Figure from Sean Stewart (www.seanstewart.org/beast/intro, ref. May 28, 2007).
4. The metaphor probably migrated via the hit film *The Matrix* (1999), which also used it as a tunnel between the real world and a fabricated illusion. Lewis Carroll's *Alice's Adventures in Wonderland* is a common touchstone in the aesthetics of pervasive games. For example, David Fincher's *The Game* (1997) concludes with The Jefferson Airplane song *White Rabbit*, which is inspired by Carroll's book.
5. Another word for an imaginary entertainment environment is *hyperdiegesis*. Örnebring (2007) talks about how the various *Alias* ARGs have utilized the hyperdiegesis of the television series by adding content to the gaps left in the narrative space of the television series. Fan fiction is another typical example of utilizing a hyperdiegesis.
6. Figures from 42 Entertainment (www.42entertainment.com/beast.html, ref. May 28, 2007), which is run by the same people who designed and ran *The Beast*.
7. *Perplex City* featured an interesting solution to this design problem. By promising a reward of £100,000 to the first person to solve the last puzzle, the game company Mind Candy may have managed, to some extent, to slow down information transfer in Web communities.
8. This is similar to how social rules are generally established on the Internet. For example, on forums relating to a certain television series, there are rules on how future plot twists, spoilers, can be discussed.
9. We use *puzzle* to denote a problem with a solution. *Mystery* is an unconceivable and obscure event or occurrence, which leaves the observer wondering about its deeper meanings and implications. Some mysteries, such as the credits for a sentient machine therapist, are also puzzles.
10. www.seanstewart.org/beast/intro, ref. May 28, 2007.
11. Probably together with *The Majestic*, a pervasive online game for PC computers, with quite similar aesthetics. *The Majestic* was designed at the same time as *The Beast* but commercially released after it by Electronic Arts in July 2001 and shut down in April 2002. See Taylor and Kolko (2003) for further discussion.

TWO

Pervasive Game Genres

Jaakko Stenros and Markus Montola

In this book, pervasive games are seen both as a subcategory of games and as an expansion of what games are. However, as pervasive games take very different forms, it is useful to divide them into genres.

In this chapter we identify key characteristics, similarities, and perceived groupings and build certain genres of pervasive games. These genres are not discovered, but *constructed*; we classify existing games into groups according to their properties, historical developments, and the gameplay activity they create. These are not formal categories but loose descriptions based on features and properties aimed at providing information on the design and analysis of pervasive games. Neither are they all-encompassing; some games do not fit into any category and some fit into more than one. A single game does not make a genre.

Some of the individual genres that we propose have been discussed elsewhere previously, but rarely as a subset of pervasive games. Early prototypes of pervasive games have often been influenced by digital games, television, films, and other media, just like radio program genres influenced early television shows, and thus the understanding of these new types of activity has been tainted by the earlier types of media.[1] An emerging medium often borrows from earlier traditions before establishing conventions of its own, but at some point the borrowed clothes of other media must be shed.[2]

The eight genres of pervasive games presented here are an attempt to do just that. Some of these genres are already well-established ways of conducting play. Others are just emerging. We have attempted to identify them based on their features and properties.

Established Genres

Treasure hunts and *assassination games* are the oldest of the established genres. These activities originated as oral folklore and folk games, and through the decades they have spawned many well-known forms. Although they have been largely ignored by contemporary pervasive games research, these games are, in many ways, blueprints for the technology-enhanced games that started to emerge at the turn of the

millennium. *Pervasive larps* are a newer form of play, born in the 1990s. *Alternate reality games* (ARG) are very recent, as they were born soon after the turn of the millennium.

Treasure Hunts

Treasure hunts are games where players try to find certain objects in an unlimited game-space. The target of the hunt may be to uncover a planted prize (Figure 2.1), find a certain location, take a photograph of a hunter performing a task, or even locate a very specific everyday object. Often the prize or target is not valuable or worthwhile in itself; it could be just a logbook one gets to write one's name in. The discovery is a reward in itself. Treasure hunts can be either competitions between individuals or teams or solo missions where the hunter challenges herself. The challenges of a treasure hunt can be physical,[3] mental, or social.

Treasure hunts are the oldest genre of pervasive games and the one with the most well-established and well-known variants. Organized *Letterboxing*,[4] for example, can be traced back to Dartmoor, England, in the mid 19th century. It is a form of treasure hunt where the aim is to find a box with a logbook and an individual stamp based on hints heard from others or read from a book or online. It has recently spread around the globe and is especially popular in the United States. *Scavenger hunt* is a better known variation. Whereas in a straight *treasure hunt* you try to find something that you want, in a scavenger hunt you try to find something that nobody wants.[5] In practice, contemporary *scavenger hunts* are competitions between teams, which gather certain objects or photographs of themselves doing certain tasks during a set time. The team that collects the most objects, photos, or points wins the game.

The roots of treasure hunts are clearly in folk games. One example is the Polish tradition of *podchody*, where a group of children leaves instructions and clues for another group on how to find them (Clark & Glazer, 2004). Daniel Janton describes how it was played in Australia:

> [W]e'd divide into teams and one of the teams would head off, leaving clues for the other group to follow. [. . .] Clues not only told the team where to go next but provided a lot of the best fun of the evening. They were full of in-jokes referring to the other people in the game—the wittier the better and sometimes a little on the rude side! (Quoted in Clark & Glazer, 2004)

Later on these folk games became popular party games in the Anglo-American world. Socialite Elsa Maxwell recounts what she claims to be the first of these parties in *How To Do It*, an autobiographical manual on entertaining:

> There was a game that I staged in London one year in the twenties that began on an ominous note but resulted in a fad that was still going strong into the forties when the war apparently shelved it. Lady Diana Cooper, Blossom Forbes Robertson, and I hit on the idea of organizing a treasure hunt and sending invitations out in the form of an anagram. There was only one hitch. Not knowing how many people would be able to decipher the message, we had no idea how many would turn up. We needn't have worried. So many cars converged on Lady Juliet Duff's house in Belgrave Square, where the hunt was to start, that the police arrived wanting to know what was going on. We all had visions on being arrested as public nuisances,

FIGURE
2.1

Sunrise in Wakerley Great Wood, where Andy Darley[6] found the Receda Cube of *Perplex City* after a weekend of digging around. The picture on the right shows the first glimpse of the coveted treasure. He wrote "There isn't actually a textbook for what you do next when you've just dug £100,000-worth of highly sought-after metalwork out of the ground. Beloved Other Half's advice was short and to the point: 'don't waste time talking to me, get out of there NOW.' Not a bad idea."

> *but then, just as we were about resigned to being carried off to the nearest police station, out from a car stepped a fair-haired young man and the law disappeared like the mists at morning. It was the Prince of Wales. So we carried on, the party was the hit of the London season, and when I returned home in the fall I found that idea had gotten here ahead of me. Treasure hunts were all the rage. (Maxwell, 1957)*

Treasure hunts may not be "all the rage" today, but they are very much alive, having spawned a lot of variations. The Internet is commonly used to recruit players and spread rules or hints, as well as being a playground for net-based hunts.

Some treasure hunts, such as *Mystery on Fifth Avenue* (Case C) and *Shelby Logan's Run* (Case E), have retained this exclusive upper-class stint. Michael Finkel (2001) describes a treasure hunt game *vQuest* that was played in Seattle in the year 2000. The participation fee was $25,000 for a team of six players, but due to extensive sponsorship, a large part of the fees could still be donated to charity. The game could offer players over 24 hours of intensive puzzle hunt[7] action, driving around in their team-colored minivans, meeting numerous nonplayer characters, visiting places such as the roof of Seattle Space Needle and flying an Alaska Airlines flight-training simulator. The teams faced the challenge armed with equipment ranging from night vision goggles to cordless power saws and butane flamethrowers.

Other contemporary forms of treasure hunts are much more affordable and accessible. *Geocaching* is a variant of *letterboxing* that was born in 2000, when the jamming signal that prevented nonmilitary users from pinpointing a location accurately with global positioning system (GPS) was turned off. Two days later Dave Ulmer

posted a message on the Internet where he gave the GPS coordinates for the first stash (Cameron, 2004; Ulmer, 2004). The caches in *geocaching* are also different from the boxes in letterboxing: Geocachers often exchange trinkets instead of just stamping logbooks (Cameron, 2004; Peters, 2004).

Similarly, games such as *Insectopia* (collecting virtual insects generated from Bluetooth IDs, see Case I) and *Manhattan Story Mashup* (collecting photographs of words to illustrate stories created by other players) are further variants of pervasive hunts. Collecting photographs instead of items has become especially popular—and it tends to be both performative and socially expanding. In *The Great Scavenger Hunt* of 2007, for example, there were 501 possible tasks, descriptions of pictures, that the teams could take. Each task had a point value between 1 and 20. The tasks varied from easy and generic pictures such as "Stranger buying condoms with monopoly money" to difficult, embarrassing, and complex as in "Team mate dressed as mermaid in a fountain" and "Human banana split (whipped cream, cherry, chocolate syrup, nuts, and bananas)."[8]

Assassination Games

Assassination games (see Case A) emerged around the mid 1960s when students at universities in the United States started to play games inspired by the film *La decima vittima* (1965). The rules of the hunt were stated in the beginning of the film as:

> *Rule 1: Every member has to commit to carry out ten hunts. Five as a hunter and five as a victim, alternating, each time chosen by a computer in Geneva.*
>
> *Rule 2: The hunter knows everything about his victim: name, address, habits.*
>
> *Rule 3: The victim does not know who his hunter is. He must locate him . . . and crush him.*
>
> *Rule 4: The winner of every single hunt has the right to a prize. The person who comes out alive will be declared a decathlete. He will be praised and receive one million dollars!*

The rules of the contemporary variants are quite different from the rules stated in the film: There is no prize aside from the satisfaction of winning, the computer in Geneva is replaced by a referee, the player is both a hunter and a victim, and so forth. However, the game as an activity and the events portrayed in the film have a similar feeling.

Assassination gaming is a strongly established genre. It is especially vibrant in university settings, where countless assassination guilds exist, with numerous variations of rules and names (see Figure 2.2). The version detailed in *Killer: The Game of Assassination* is probably the most common version. Some versions are more theatrical (see Tan, 2003) and thus closer to pervasive larps, whereas others are fast-paced sweaty variants akin to smart street sports.

The German film *killer.berlin.doc* (1999) documents a game of *Killer* that ran in Berlin for 2 weeks. That version of the game was more about stalking than killing—and indeed used stalking and killing as a metaphor for love (as *La decima vittima* did 34 years earlier). A participant explains in the film:

> *By the second or third day I begun to like being observed . . . knowing that someone is always following me. And I had such a sense of my first murder that I thought*

he's interested in my person and he'll come up with something very thorough. And actually later the greatest fear that I came to have was that I would be eliminated in some totally unspectacular way.

Another recent game that took this approach is *Cruel 2 B Kind*. It used the basic rule structure of *Killer*, but in it assassinations were carried out through good deeds. In the current political climate in the United States, where assassination-centered *Killers* have been banned on campuses, variations with good deeds instead of bombs address a clear need.

Assassination games can also be staged with the help of technology. *BotFighters* (Case D), an early example of a pervasive game played on a mobile phone, has a game structure similar to *Killer* (see Sotamaa, 2002). In that game, victims' current locations can be learned based on the base station their phone is communicating with, and physical proximity is important in order to carry out an attack.

Pervasive Larps

Pervasive larp is a style of pervasive gaming that utilizes live-action role-playing techniques. The central requirement is physical acting with character-based make-believe and pretend play: Role-playing requires the players to pretend and perform being someone else (see, e.g., Fine, 1983; Pohjola, 2004). *Killer*, for instance, can be role-played if the players pretend to be, and act out, their assassin characters.

FIGURE
2.2

A variant of *Killer* is played in Sweden under the name *Deathgame*. Photos like this are given to assassins in order for them to recognize their targets. The carrots represent knives.

Live-action role-playing (*larp*, sometimes also called *theater style*) involves physically acting out as a character in an environment that has been propped to look like the diegetic setting. The exact history of larp is unclear (see, e.g., Mason, 2004; Tan, 2003), but it seems to have evolved from traditional "table-top" role-playing[9] in the early 1980s. Getting up from around the table, putting on a fantasy costume, and heading into the woods or a hotel room started happening in a number of different places around the world roughly at the same time. However, it bears a number of similarities with improvisational theatre and psychodrama—and it is not difficult to find other historical precedents (Morton, 2007).

Pervasive larps, like assassination games, are also an oral tradition that has been reinvented separately by many isolated player groups. Philip Tan (2003) describes how theatricality and larp-like elements made their way to assassin games played in MIT, while one of the most influential publications discussing the genre, White Wolf's popular *Vampire* larp book *The Masquerade*,[10] illustrates how larpers came up with pervasive larp through taking their game to the streets. Thus, even though their practices and styles vary greatly, pervasive larps are a culturally established genre, as they have been played around the world for years (see, e.g., Talvitie, 2004, 2007). In the case of assassin games, an established pervasive game genre took on elements of role-playing, while in the case of vampire games, a pervasive variant of a non-pervasive style of larp was invented. *The Masquerade* was originally published as a nonpervasive larp sourcebook,[11] but the second edition discusses the designers' observations:

> When we set out to create [The Masquerade], we envisioned people playing in small groups in their homes. [. . .] We were wrong. Many people are now playing in public spaces and at conventions, some of them in groups of over two hundred players. (The Masquerade Second Edition 1994)

Usually pervasive larps only use a city as a backdrop, featuring rules that forbid startling bypassers, and often the playful action is hidden through fiction. The vampires of *The Masquerade* hide from the mortal world, and revealing the existence of the supernatural is a crime that can be punished by death. Still, these urban larps played on the city streets are examples of early pervasive games (for further discussion, see Montola 2007; Salen & Zimmerman, 2004). One of the important factors in expanding larps into public urban areas was the proliferation of cell phones, which allow inexpensive and easy game mastering.

Larps with a vampire theme are still regularly played all over the globe. The longest running campaigns have had thousands of players and dozens of games (see Figure 2.3). At the same time, other community-created pervasive larps, often not based on any published sourcebooks, have become a mainstay in larp circles. Although the fantasy genre is dominant within traditional live action role-playing games, pervasive larps are inspired much more often by cyberpunk, crime, new weird, secret agent, or other contemporary settings.

Although widespread, pervasive larps are not very visible in the media, as the game masters seldom look for artistic credibility outside their peers, they are hard to grasp without participating, and, most importantly, there has not been any real money to be gained from them. Games are usually created by the community for the community, and the participation fees are used to cover the material costs of setting up a game. Individual games are usually run just once, and they are rarely documented well.

FIGURE
2.3

Larps based on *The Masquerade* that took to the streets almost accidentally gave birth to the pervasive larp genre. This picture is from a staged photoshoot of *Helsingin Camarilla,* a vampire chronicle that ran in Finland from 1994 to 2004.

Our example case of a pervasive larp, *Prosopopeia Bardo 2: Momentum* (Case F), shows how influences from urban exploration, political protest, and reality hacking can be combined with an ambitious artistic agenda.

Alternate Reality Games

Alternate reality games are currently one of the best known genres of pervasive games. The ARG interest group of the International Game Developers' Association describes them as follows:

> *Alternate Reality Games take the substance of everyday life and weave it into narratives that layer additional meaning, depth, and interaction upon the real world. The contents of these narratives constantly intersect with actuality, but play fast*

and loose with fact, sometimes departing entirely from the actual or grossly warp-ing it—yet remain inescapably interwoven. Twenty-four hours a day, seven days a week, everyone in the country can access these narratives through every available medium—at home, in the office, on the phones; in words, in images, in sound. Modern society contains many managed narratives relating to everything from celebrity marriages to brands to political parties, which are constantly disseminated through all media for our perusal, but ARGs turn these into interactive games. Generally, the enabling condition to [it] is technology, with the internet and modern cheap communication making such interactivity affordable for the game develop-ers. It's the kind of thing that societies have been doing for thousands of years, but more so. Much more so. (Martin, Thompson, & Chatfield, 2006)

Compared with the definition of pervasive games presented earlier, it can be seen that alternate reality games present a subcategory of pervasive games, typically featuring col-laboration rather than competition, large self-organized player communities, Internet-based gameplay, and secretive production styles.

Alternate reality games also feature sophisticated puzzle-based gameplay, basically giving the players extremely difficult tasks to complete. The first step is usually to take a look at something equipped with ludic glasses, to realize that it is a puzzle, and only then start solving the problem. This recognition of a task is often the most difficult part of the problem solving. A single player is usually not able to solve a puzzle, and hence alternate reality games harvest *collective intelligence*, bringing a large number of players together via the Internet to crack a mystery that would be almost impossible for any sin-gle player to crack on her own (McGonigal, 2003a).

The birth of alternate reality games is usually placed in the year 2001, as both *The Beast* (Case B) and *Majestic* were played then. Particularly *The Beast* has been hugely influential, and it has been credited as the defining piece of the genre (Martin et al., 2006). The first subscription-based alternate reality game, *Majestic*, was developed at the same time, but because of a delayed schedule was published after *The Beast*. It was a commercial failure, but it pioneered the tactic of announcing a game, gathering participants, and then publicly declaring that the game has been cancelled—only to start the game in a different manner.[12]

The Nokia Game series (played from 1999 to 2003 and again in 2005) predates both games. It is an example of an early pervasive game used to market new mobile phones and to encourage and teach people how to use them to their full potential. The sto-rylines, game mechanisms, and play styles, although varied from year to year, are quite similar to what would later be used in alternate reality games. In order to participate and follow the storyline, players would have to look for clues in advertisements on tel-evision and in the newspaper. They would also get weird phone calls and text messages and at times had to call each other. In addition, players had to solve smaller puzzles and minigames in order to progress.

After *The Beast*, a number of smaller scale alternate reality games were organized by the players. These nonprofit games were instrumental in solidifying the genre and main-taining a level of interest until the next big budget advergames came along. It is interesting to note that although these games were produced independently, some of them still pre-tended to be connected to a film (Szulborski, 2005); it is as if the aesthetic of alternate real-ity gaming in the beginning was perceived to include the production model. Commercial games made a comeback in 2004 and 2005, with *I Love Bees* and *The Art of H3ist* being the

most successful ones both in terms of player participation and in visibility created for the product being pushed. *I Love Bees* also followed in the footsteps of player-created *Chasing the Wish* in bringing the game strongly into the ordinary, physical world (see Figure 2.4). Previously, players might have interacted with actors via phones, but these games had performative missions that took place in the nonvirtual world. One of the most interesting recent experiments is *Eagle Eye: Free Fall*, the ARG-like interactive promotion for the *Eagle Eye* (2008) movie, which only runs for 10 minutes for each player.

Aside from games as advertisements and player-created community efforts, there is a third business model. *Push* was the first alternate reality game to offer cash prizes. According to Szulborski (2005), it failed because the integration of the show and the game was superficial and the cash prize hurt the community of ARG players. However, it pioneered the concept of tying an ARG to a television series, in this case *Push, Nevada*. Although *Push* failed, and the television series was also cancelled after seven episodes, the model lives on.

Alternate reality games can be developed in tandem with television series, as in *ReGenesis* and *Sanningen om Marika*, but lately it has become quite common to set up interactive online content to maintain interest in television shows, as has been done by *The Lost Experience* and *Heroes Evolutions*. These games are not so much advertisements for the series, but function as a loyalty program ensuring that people watch the shows.

Sometimes such games can take on a life of their own; after the television series *Alias* featured two Web puzzles (the first one in 2001–2002 and the second one in late 2002), *Alias* fans also created their own ARG *Omnifam* in 2005 (Örnebring, 2007).

FIGURE
2.4

Players of the alternate reality game *I Love Bees* have gathered at a set location at a set time—around a pay phone waiting for it to ring.

Indeed, it is often hard for a player to distinguish a commercially produced game from a fan creation. Other examples of a seemingly "genuine" games have been *Project MU*, an unofficial extension of *The Matrix* franchise, and *Exocog*, an ARG pretending to be an advertisement of *Minority Report* (2002). The latter one actually came out before the movie, which made it particularly difficult to recognize its origin.

Emerging Genres

The established genres discussed earlier are styles of play that come from long traditions and depend on established conventions. For example, many ludic media products are considered alternate reality games because they appear to be similar to other media products already recognized as alternate reality games. The emerging genres discussed here are not yet recognized, as they are even more distinctly constructions of the authors.

These genres are much more clear-cut, as there is less cultural variation, as well as being more feature dependent than the established genres. Indeed, a game combining many sorts of features may alternate between genres in a rapid and all-encompassing way. As an example, we discussed *vQuest* as a *treasure hunt* earlier. But actually, it composed of 25 somewhat separate challenges. Played individually, some of these challenges resembled *smart street sports*, others *playful public performances* or *urban adventure games*. And for outsiders, most of *vQuest* appeared as a *reality game*. In some sense, established genres are more about traditions, conventions, and forms of games, whereas emerging genres are built around properties and features of games.

Smart Street Sports

Competing in *smart street sports* requires both physical exercise and cold tactical thinking. They are usually played outside in urban areas or on university campuses. In some games, all players move in the physical space, supported by GPS devices, cellular phones, and other handheld computers, whereas others combine physical gameplay with a virtual one. Smart street sports tend to depend on technology.

Most games in this genre can be seen either as updated, technology-enhanced versions of the sporty neighborhood games of youth or as physical variants of popular digital games. The pervasive variants of *tag* styled after the arcade classic *Pac-Man* are common in this genre, including titles such as *PacManhattan* (Case G), *Human Pacman* (Cheok et al., 2003), and *Pac-Lan* (Rashid, Bamford, Coulton, Edwards, & Scheible, 2006). *PacManhattan*, for example, uses the grid-like cityscape of Manhattan to model a game world comparable to the arcade classic. Players run on the streets, playing both the parts of Pac-Man and the ghosts pursuing him. *Can You See Me Now?* (see Figure 2.5) is a mixed reality version of similar gameplay, where half of the players play a computer game while others run on the street. This structure creates an interesting interplay of advantages and disadvantages: While a sprinting street player is faster than a virtual player, virtual players do not get tired, and they can use traffic and slopes to gain an advantage.

Smart street sports are usually designed so that they are quick to take up; starting to play requires very little preparation, and the games have a high replayability. This lends itself to event-based playing. The strength of the smart street sports genre

is exemplified by the fact that these kinds of games have been dominant at the Come Out and Play festivals.[13]

Playful Public Performances

Culturally, city performance games are similar to smart street sports. Both contain an athletic component, are usually played in places where there are bystanders, contain a performative element, and are more popular in the United States than in Europe. The biggest difference is that while smart street sports focus on competition and exercise, city performance games are more geared to creating fun through performing, playing, and creating a spectacle. The games are often very visual. Clear predecessors and key influences of city performance games are scavenger hunts, street parties, busking, and some forms of political theater. Playful public performances usually drop the political content of confrontational theater and the money-making motive of busking; instead they are out to create fun for the participants and an enjoyable experience for the audience.

The spectacle was at the forefront of the *Big Urban Game*, played in the fall of 2003 in celebration of the Twin Cities of Minneapolis and St. Paul. In the game, three huge inflated game pieces were moved through the cities once a day (see Figure 2.6). The route for transporting was voted online by players and then the teams dragged the pieces at a certain time. The time it took to make a move influenced the score. The fastest team won. Although there was a game at the core of the *Big Urban Game*, the event was supposed to inspire citizens to see their living areas in a different way. The huge pieces were statuesque and clearly tried to inspire a playful atmosphere.

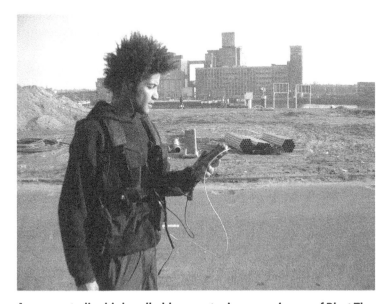

FIGURE
2.5

A runner studies his handheld computer in a press image of Blast Theory's *Can You See Me Now?*

FIGURE
2.6

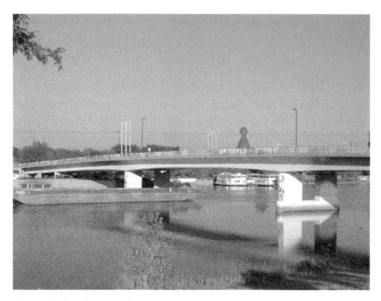

The red token in *Big Urban Game* is being moved over a bridge.

Games such as *Shelby Logan's Run* (Case C), *Momentum* (Case F), and *I Love Bees* also feature powerful public and semipublic performances, showing that the borders of the genres are not fixed and that single games can easily combine multiple genres.

Looked at as a pervasive game, the reality television game show *The Amazing Race* (Case M) is yet another interesting case, as the public performance is mostly shown retrospectively in the television series. Even though the racers can be sometimes seen by bystanders, they are forbidden to disclose the fact that they are participating in the race.

Urban Adventure Games

Urban adventure games combine stories and puzzles with city spaces. These games take the player to areas with some historical or cultural significance to solve puzzles and follow stories, but also to learn tidbits about the history of a place. Solving a puzzle typically provides further instructions on how to find other locations. These games are clear descendants of interactive fiction, even more than alternate reality games are, as their form of a forking path and their emphasis on putting together a story from fragments are very similar. One might even go so far as to describe these as hypertexts that are maneuvered in physical space, the descendants of digital adventure games set out on the town.

REXplorer (Case K) and *Visby Under* (see Figure 2.7) are examples of games that are targeted at tourists. The idea is that walking around a historical milieu is energized by adding ludic content and structure to the task. These games also often lead the player–tourist to locations not mentioned in the most superficial of guides and tell more intimate stories than one encounters in contemporary history books. Many cities have targeted advertisements and tourist information based on similar positioning technology, but game implementations are rare.

FIGURE
2.7

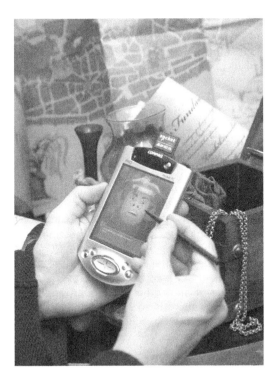

***Visby Under* was a research prototype of a location-based adventure game aimed at tourists. A handheld device was used to weave the physical architecture together with the local mythos in the Hanseatic town of Visby.**

Uncle Roy All Around You (Case L) takes a different approach. In this game a player, equipped with a PDA with a map, looks for Uncle Roy by following remote instructions from him. A virtual player helps the street player by navigating a virtual version of the city and communicating with him. The game explores many artistically motivated issues, with trust being a central theme.

Curiously, it is possible to make *generic* locative stories, ones depending on relative rather than absolute positions. *Backseat Gaming*[14] (Bichard, Brunnberg, Combetto, Gustafsson, & Juhlin, 2006) is designed for kids playing during a car ride. The application creates a game-like story based on very generic roadmaps by estimating which places the players will pass next: If the players are on a road passing a church, lake, and village, the game generates a storyline out of such elements. *The Journey*[15] is an even more relative system, as it uses cellular phone positioning just to decide that the player has moved sufficiently. It is a detective story, which progresses through a variety of fictitious places—but the game is happy when the player just moves enough to change a mobile phone base station. Even though the experience can be absurd and surreal, with the cellular phone claiming that you are in a bar when you are really at a metro station, the act of walking itself, preferably in a nocturnal film noir fog, can give the story additional flavor.

These games are different from city performance games because the players do not seek to attract attention to themselves, and from smart street sports due to the relaxed pace of playing. The city is used as a stage providing an important part of the aesthetics, and movement through the space is pivotal to playing. Puzzles provide the ludic content, and success is dependent on the skillful use of the cityscape to make them feel *real*.

Reality Games

Reality games are pervasive events that consciously play with the concepts of real and reality. They are often more paideic than ludic, seeking to encourage players to see and experience their living area in a new and different way and to have stronger agency over it. This often takes the form of spreading messages that question norms in the cityscape, aesthetic vandalism such as changing the colors of streetlamps, and generally making the urban setting more playful and anarchic, as was done in *Scen 3* in 2001–2004. Although reality games are played by conscious participants, often the emphasis is on affecting the urban environment in a way that is visible to bystanders. Usually the actions seek to make the bystander–audience question the expectations of the space they live in. Thus the games are played for the benefit of the unaware participants.[16]

It can be questioned if reality games are games at all, as they share as strong links to performance art and public space movements as they do to ludic traditions. From the point of view of bystanders, reality games merge ludic and ordinary content completely seamlessly. The most extreme reality games are played without players; they only have unaware participants. In a way, extreme reality games are the logical continuation of alternate reality games and pervasive larps; their content does not give away the fact that a game is being played (like the Web pages time-stamped in the future in *The Beast*), there is no winking-at-the-audience rabbit hole hidden in advertising material, and they do not have characters that the players pretend to believe that they are. They can thus be characterized as prerabbit hole alternate reality games, events that are staged in certain locations that people might stumble upon and that do not have players, but targets.

Lacking voluntary structures of artificial conflict, and having nothing contractual in participation, reality games could easily be excluded from this book as nongames. Yet there is one crucial reason for keeping them in: Most expanded games have unaware bystanders who are still somehow influenced by the games. Most pervasive games are reality games to some people. In addition, taking the stand that political protests that adopt ludic structures should be excluded from the realm of play and games would be as ideological as including them.

Reality games end up on a slippery slope of ethical dilemmas. The occult horror game *Vem gråter* (Case J) is an excellent example of this: Some of the unaware participants experienced actual fear instead of a mediated excitement.

Conclusions

William Huber (2003) has stated that "the game audience builds genre from interactive/syntactical, thematic/semantic, visual aesthetic, and technological/platform considerations." However, pervasive games are not established enough as a phenomenon to enable analysis of the genre descriptions used by audiences, marketing departments,

designers, and players. It seems that, with the exception of alternate reality and assassination games, most games today seem to insist on coming up with a new term, advertising themselves as the first incarnation of a new species. Conversely, pervasive larps are often not differentiated from contained larps. Thus, the genres presented earlier are constructs based on our analysis. We have taken the *activity* that games incorporate as the starting point.

This is similar to what Greg Costikyan (2005) argued when he stated that a "genre is defined by a shared collection of core mechanics." In his treatise on genre in games, Aki Järvinen (2007) is on similar ground. He sees genre as a technology-independent concept. He argues that "we should not stay blind to common aspects of game elements and systems that lie beyond their material difference." Although we are more focused on the activity and experience a game (or its core mechanism) creates than on the properties of the system, we share the view of not limiting genre thinking to the technology a game is based upon.

Rick Altman (1999) has divided the functions of genres in regard to films into four types[17]: genre as a production formula, genre as a marketing tool, genre as a contract between the viewer and the film, and genre as a common structure. Our four first established genres are divided similarly to these criteria. They are developed and marketed members of a certain genre, they share similar structures, and the players understand this. The four other genres, the emerging ones, understandably do not follow these functions, as they are still in the process of finding their feet and are, to a certain extent, predictions.

Even though we have refrained from constructing genres around singular technologies, the group of *pervasive mobile phone games* warrants a mention as a group that seems to be about to establish itself as a common denominator of all pervasive games playable with player-owned mobile phones. While few such commercial games exist at the time of writing, the design space of such games is almost as wide as our entire category of pervasive games. After all, an ideal handheld can be used as a platform for almost any pervasive games, ranging from alternate reality games to smart street sports and from urban adventure games to treasure hunts. We will discuss pervasive mobile phone games in detail in Chapter Nine.

Only time will tell if urban adventure games and reality games will ever become as established as treasure hunts, larps, and assassination games, just as it will show if smart street sports and playful public performance games will ever stick as well as terms as alternate reality game has.

This chapter mostly discussed the various forms of *ludus*, or formal play. *Paidia*, informal play, has always explored strange playgrounds, surprising times, and unbounded social relations. Pervasive paidia is not a genre of pervasive games—as these activities are not games—but they exist in a close relationship with pervasive games. In the next chapter, which discusses historical influences on pervasive games, we cover many such activities.

Notes

1. Examples of this adaptation-like conceptualization include the stationary play in *Epidemic Menace* (Case H), which is sort of a combination of the television series *C.S.I.* and the digital game *Command & Conquer*, just like *PacManhattan* (Case G) is pitched as *Pac-Man* on the streets of New York. The genres constructed here are an attempt to shed the borrowed clothes of other media. See also Murray (1997).

2. In her dissertation, Jane McGonigal (2006a) has presented the most substantial categorisation of pervasive games (or *ubiquitous play and performance*) thus far. She divides games by their underlying design philosophies (colonization of new technologies, creating a disruptive presence or activating users though gameplay). Although an interesting analysis, it is not a sufficient categorization as a design instrument. It also lacks practical value for the player in characterizing a game. Dakota Brown (2007) has also produced a genre division, based on the technology that a game uses (experimental and expensive technology, off-the-shelf technology, and no technology). As we have consciously moved away from technology-based definitions, we have to dismiss this definition as well.

3. *Orienteering* can be seen as a highly physical version of treasure hunt. The orienteers compete for the best time in running though diverse terrain, navigating through a set of control points with a map and a compass. The activity was established as a competitive sport and a military exercise in Scandinavia around the turn of the 20th century.

4. Also known as *questing* when used in place-based education (see Clark & Glazer, 2004).

5. As formulated in the movie *My Man Godfrey* (1939).

6. Darley's excellent report on finding the Receda Cube appeared first in www.unfiction.com in 2007, and later also on his own Web site www.andthenhesaid.com/cube (ref. October 31, 2008).

7. For some people, *puzzle hunt* denotes a *treasure hunt* where you solve puzzles to find more puzzles, generally around a town. Other people call these events *The Games*: for them, *puzzle hunt* is a day-long event of stationary puzzle solving.

8. For more details, see www.thegreatscavengerhunt.com (ref. August 3, 2007).

9. Tabletop role-playing has been described by Daniel Mackay (2001) as "an episodic and participatory story-creation system that includes a set of quantified rules that assist a group of players and a game master in determining how their fictional characters' spontaneous interactions are resolved. These performed interactions between the players' and the game master's characters take place during individual sessions that, together, form episodes or adventures in the lives of fictional characters." For a more formal definition, see Montola (2007b, 2008).

10. A larp version of White Wolf's *Vampire: The Masquerade* tabletop role-playing game, published in 1993 and 1994. The later editions of *The Mind's Eye Theatre* were published with another name, *Laws of the Night*.

11. For comparison of vampire larps, see Werkman (2001), who describes a game that is mostly played in a single space, and Salen and Zimmerman (2004), who describe a game played on the town.

12. This was featured in speculative fiction before *The Majestic*, for example, in Fincher's movie *The Game* (1997).

13. Annual Come Out and Play festivals have been held in New York (2006, 2008) and Amsterdam (2007).

14. See www.tii.se/mobility/Backseat/backseatgamesBSG.htm.

15. See http://journey.mopius.com.

16. Reality games are even more poorly documented than most pervasive games, as the organizers often do not want to, or cannot, take credit for the games, as they sometimes advocate illegal activities. Some documentation does, however, exist, for example, in the magazine *Interacting Arts* (see especially issue #5, *Verklighetsspel*, edited by Gabriel Widing [2007]).

17. Järvinen (2007) has shown how Altman's work on film can also be adapted to games.

Case C

Shelby Logan's Run

Joe Belfiore

It's four o'clock in the morning. Your van is parked alongside a desolate highway, less then a quar-ter-mile from the Southern Nevada Correctional Facility. You peer past the glow of laptop and GPS screens, but out in the darkness there is silence and the only light shines from dim streetlights above the massive prison yard. The audio quotes from the last clue, an 8-track tape, unambiguously describe this location, so you must be in the right place. "I've got the clue!" crackles your walkie-talkie. "It's a list of locations—and I'm sure they're inside the prison!"

How could that be? Could the game control really want us entering a prison to find another clue? After conferring with your five teammates, you conclude you must go in. After solving under-water puzzles while scuba diving in Lake Mead, doing drag at a gay bar, and scouring the roof of the Stratosphere Tower it doesn't seem particularly unlikely that the organizers would have a clue in a prison.

Eleven minutes later, the wail of sirens and a beacon of spotlights would send your team and four others sprinting wildly back to the parked vans in a panic, heading toward the next challenge.

This adventure took place in the 2002 edition of what is simply known as *The Game*, an elaborate combination of a treasure hunt, a road rally, and a puzzle-solving marathon. The Game is typically staged over a time period of 24–32 hours, and it usually involves 8–10 teams of four to six players per team. There are few rules and very little formal structure—the Game is based on tradition alone. There is no prize, there is no publicity or public invitation, and there is no company or club. It is simply a mostly consistent set of people who convene to compete by doing outlandish things with great intensity, only for the reward of bragging rights and the experience itself.

On a sunny afternoon in August 2002, the next edition of The Game was announced.[1] Ten individuals in the Seattle area, some with Game experience and some without, answered the ring of their doorbells to meet a panicked individual who asked to speak to "Shelby Logan . . . I know he's here. Don't tell me he's not, I'm absolutely sure this is the cor-rect address!" Puzzled, each future team captain would implore that they had no idea who Shelby Logan was.[2] But before any rational explanation could be found, the visitor was attacked and dragged into a nondescript van by tie-wearing, authoritative individuals. All that was left behind was a scrap of paper with a phone number.

Typical of The Game, *Shelby Logan's Run*[3] was announced via an invitation staged as just described, and the team players had months of interaction during which the backstory was

FIGURE
C.1

The vans, manned by the players, chase the helicopters. Silver plastic pumpkins, containing the first clue, are tossed out of the helicopters.

revealed. An elaborate, automated phone system[4] served to provide gradual information about the date and place of the game and enabled registration of players—each of whom somehow seemed to have information already entered into a national witness-protection computer system.

During this process, bonus clues, if solved correctly, gave teams hints about what to bring or how to be prepared. Teams successful in solving the bonus clues in the months leading up to *Shelby Logan's Run* knew to bring a player with scuba certification and their C-Card, an 8-track player, a tent, and a lot of other relevant equipment.

On Friday October 25, 2002, 10 teams arrived in Las Vegas and proceeded to a GPS location about 10 miles out of town, where they knew they would be spending the night. One at a time, they arrived and noticed that spread far around the perimeter of a dry lake bed in the desert all the other teams were present. A visitor from game control came to collect signed waivers and to place a GPS unit in each car, for the organizers to track each team's location, and the teams went to sleep.

At dawn, they were awakened by two helicopters buzzing the campsites. After a panicked packing of their tents, the vans raced across the dry lake bed chasing the helicopters, which began to drop clues out onto the sand (see Figure C.1). Over the course of the next 24 hours, the physical and logical challenges faced by the teams would be substantial.[5]

For example, at Valley of Fire State Park, teams had a long hike through the silent desert, eventually finding and catching a live rat with a clue inside, a chip they had to read with a RFID scanner. The Game had actually donated one scanner to ensure that Las Vegas had two 24/7 veterinary hospitals with equipment for scanning such tags. One team also tried out laxatives as a solution with no luck.

The puzzles in The Game present a wide range of intellectual challenge as well, and in a well-designed Game they are varied in necessary skill, expertise, format, and medium. In *Shelby Logan's Run* the players were faced with an audio recording of the song *One Week* by Barenaked Ladies, but with the vocal track removed and dual-tone multifrequency tones in the timing of some words/syllables.

Before the start of a Game, experienced teams go to great length to prepare themselves for any imaginable intellectual or physical demand. The equipment and resource list *usually* include the following.

A mobile workstation inside a van for puzzle solving: Most teams now rent a 15 passenger van and remove one of the seats, enabling them to build a table on the inside so mobile problem solving can happen. Adequate lighting and readily available materials (pencils, compass, scissors, etc.) are critical for success.

Electronic equipment mounted in the van and powered by large marine-cycle batteries: Laptops, GPS units, a printer/photocopier (for creating duplicates of clues so players can work simultaneously), charging stations for walkie-talkies and cellular phones, high-powered spotlights, and so forth.

Extensions of the body's capability for speed or performance: Rollerblades, a bike, snorkel gear, dress-up clothes, climbing rope, swimming equipment, and whatever you can come up with.

Puzzle-solving resources: Encyclopedias, almanacs, record books, and scientific and mathematical references. The Internet and mobile connectivity have changed the face of team preparations greatly in this dimension; many teams now employ a stationary base team that has access to a fast Internet connection. Phone calls can be made at any time, and these helpers can do research and work online independently.

One of the most difficult and unexpected challenges in The Game is the emotional tax. The organizers of *Shelby Logan's Run* held an explicit goal that players would feel the highest of highs and the lowest of lows during The Game. When it is late, when you are irritable and tired, your teammates are driving you crazy, and when a seemingly nonsensical series of numbers prevents you from moving on, the emotional strain is high. But when you break through and feel the adrenaline of great performance, the reward is equally high.

The Game originated as a small outing for a group of high school juniors in Clearwater, Florida, in 1985, inspired by the movie *Midnight Madness* (1980). The first Game was slated to begin at 21:13 on a Sunday night, as there are fewer police to deal with at night. The organizers expected that it would take four hours for each of the four teams to run its course. This first edition set the basic framework that would be followed for years—teams would be confined to a single vehicle of their choosing, and by solving a series of clues they would go from location to location until a winner finished first. Teams were designated a color, as the clues found at each location would be in a colored envelope or container, and teams could have as many players as the captain cared to invite—as long as they used only the one vehicle.

The first edition of The Game lasted *far* longer than anticipated. At 150 miles in length, the sun had risen before the victorious Black Team completed the game course. Hours later the other three teams finished, and the format and scope of The Game was born. The experience was so stimulating that everyone wanted to do it again: Already in the first Game the players had to enter a police station and find their own photos on wanted posters in the lobby. The Black Team volunteered to create the next game, and another tradition was born: The winner has first right of refusal to make The Game in the following year.

FIGURE
C.2

The Fremont Street Experience mall displayed the largest puzzle in The Game history, projected on an electronic ceiling that stretched the length of four city blocks. Picture from the beta test of the game.

The Game has increased its scope significantly as the resources and capabilities of its players and creators have increased (see Figure C.2); the current generation of The Game has been played in five different major U.S. cities. During the year before The Game, Team Silver made 10 weekend trips to Las Vegas to scout locations and arrange things, and also organized a beta test to ensure that the whole experience ran smoothly. During the actual play, the game control oversaw The Game from a hotel room.

The Game represents a period of a few days where humdrum life is left behind and where you prepare as optimally as possible, where you perform as best you can, and where you imagine—just for a little while—that maybe you know what it would feel like to be James Bond.

Notes

1. www.shelbylogansrun.com/plain.aspx_k=0-storyline.html.
2. The name of the game, *Shelby Logan's Run*, is a reference to two films: the classic science fiction *Logan's Run* (1976) and the film noir puzzle *Memento* (2000). The main character of *Memento* is called Shelby.
3. *Shelby Logan's Run* was organized by Team Silver, consisting of Joe Belfiore, Kristina Belfiore, Chee Chew, Scott Shell, Kevin Shields, and Walter Smith.
4. www.shelbylogansrun.com/plain.aspx_k=0-pregame1.html.
5. A complete list of the locations and challenges is available at www.shelbylogansrun.com, ref. September 24, 2008.
6. As reported by the organizers in www.shelbylogansrun.com/page.aspx_k=7-mousestank.html, ref. September 24, 2008.

THREE

Historical Influences on Pervasive Games

Jaakko Stenros and Markus Montola

The older games discussed in this book were not perceived as pervasive when they were designed and played; the players may have thought that they were doing something out of the ordinary, but they did not have a conceptual framework to describe it. It would be preposterous to claim that there is a long, historical list of pervasive games, but it would be equally preposterous to pretend that these new types of games just sprung into the world ready and without forebears.

It is impossible to say which event was the first one to fill the requirements of being a pervasive game. Swedish game designer Martin Ericsson (2004) has looked at an ancient Egyptian religious ritual[1] in terms of larp. The performance climaxes as the Pharaoh, playing the part of Osiris, slays a hippopotamus portraying Seth.[2]

> *The Games at Abydos were not the first participatory dramas and they were not the last. Through the ages and across the globe we find similar spectacles of serious role-taking creating phenomena ranging from intimate initiatory rites to sprawling carnivals. (Ericsson, 2004)*

Just as the *Games at Abydos* could be seen as a very early larp, it could be seen as a very early pervasive game. The paideic performance certainly broke the ritualistic boundaries of space, time, and participation, as it quite likely had a considerable sacral and secular influence on the society.

In the discussion that follows, we have limited our scope to ludic activities since the industrialization. The earlier distinctions of game and play were quite different from ours, as such concepts are intimately connected to the way a society understands itself and the world around it. The idea of temporal expansion is strongly connected to the dichotomy between work and leisure, and many pervasive games tap their power from this distinction. Likewise, spatially expanded games make sense mostly in an urban society based around public and private urban spaces.

Area/code, a New York-based company that specializes in pervasive games, lists roots of the games they organize in their manifesto:

> *[Pervasive games] have their roots in the neighborhood games of childhood; in the campus-wide games and stunts of college; in the nerd-culture of live-action*

> *role playing and Civil War re-enactments; in the art-culture of Happenings and*
> *Situationism; in urban skateparks, paintball fields and anywhere people gather*
> *together to play in large numbers and large spaces.*[3]

To this list we would add ubiquitous and pervasive computing, different forms of ludic literature, persistent virtual worlds, and games speculated about in fiction.

In addition, one important predecessor and source of ideas for pervasive games not yet mentioned is other games. Many pervasive games are adaptations of board games or digital games, using tested mechanisms from classic games and elaborating on old forms of play in new, sometimes technology-enhanced ways. Here we have chosen to mostly concentrate on influences that have somehow heralded the structures that blur and expand the magic circle, confusing the ordinary and the ludic.

Play in Public Space

Most pervasive games challenge notions of where games can and should be played. Many of them are played in the public sphere; some are carnivalistic spectacles (such as *Big Urban Game*), whereas others hide themselves in plain sight from prying eyes and are enjoyed in a covert manner (such as *The Masquerade* or *Insectopia* [see Case I]). These endeavors often challenge hegemonic notions of what can be done in public space and, hence, tie into a long tradition of "reclaiming the streets."

Similar relatively new phenomena include activities such as *urban exploration* (Ninjalicious, 2005), *buildering* (North, 1990), *flash mobs* (Ejbye-Ernst, 2007), and *geocaching* (Cameron, 2004; Peters, 2004), but play in public space obviously has longer roots. *Skateboarding* started in the 1950s (Borden, 2001), the *graffiti* movement emerged in the 1970s, and the 1990s brought us *street parties* (Klein, 2000; see Figure 3.1) and *parkour* (Feireiss, 2007). And, of course, the practice of playful street performance goes back to the ancient societies. The space that is appropriated can also be private. Some of these more confrontational appropriations include *urban explorers* trespassing on private property, *squatters* claiming obsolete private space for public use, and *skateboarders* using empty pools in private backyards[4] for their games.[5]

Child's play is another central phenomenon, as it takes place wherever children happen to be, and not just in places that are specifically reserved for play. Thus, children playing in the streets have probably been a common sight in all urban environments. Dakota Brown (2007) traces the history of pervasive games to child's play, seeing how they appropriate unplayful urban spaces for their play. A game of marbles, for instance, has to react to external stimuli ranging from changes in the weather to a policeman wanting to clear the street. Historically, streets have been a playground for children, although controlled by the adults. This space has been condoned and, even seen as a preferable choice for play in comparison to organized activity. Norman Douglas (1931) presents this argument in his *London Street Games*, pointing out that organized games, such as cricket, hinder imagination:

> *[I]f you want to see what children can do, you must stop giving them things.*
> *Because of course they only invent games when they have none ready-made for*
> *them, like richer folks have—when, in other words, they've nothing in their hands.*
> *(Douglas, 1931)*

FIGURE
3.1

Street parties are a visible, carnivalistic part of street reclamation. The picture is from a Reclaim the Streets event in Canberra, Australia.

Although Douglas discusses what we would call game equipment and rule systems, the argument regarding limiting imagination holds to space as well. Henry Jenkins (1998) has noted that uncontrolled, wild spaces are more important than playgrounds, as they give the child more opportunities to modify (or play with) the area. He draws parallels between boy cultures of the outdoorsy 19th century and the living room-bound 20th century, making the case that play has moved from nearby streets and forests to the digital spaces of video games. However, as the examples given earlier show, many still play in the alleys and parks of the physical world—even when those spaces are intended for some completely different activity.

Campus Culture

The permissive and tolerant atmosphere of cities and, in particular, campuses has been important in fostering emerging types of play. Pervasive games are but one such group of games benefiting both from the research conducted at universities and the player cultures of, for example, assassination games, numerous variations of treasure hunts, and role-playing games.

Many other examples exist. *The New Games Movement* of the 1960s and 1970s, spearheaded by Stewart Brand, is one. It was a reaction against the Vietnam War and the calculative cold war mentality (Pearce, Fullerton, Fron, & Morie, 2005; Turner, 2006). It went on for a decade, spawning numerous games that sought to replace "masculine" competition with togetherness and fun (see Figure 3.2). Few of these games were pervasive, aside from the weak social expansion of the fact that bystanders were welcome to join in. As the introduction to *The New Games Book* explains: "There are no spectators" (Fluegelman, 1976). Yet the way they sought consciously to appropriate new spaces for

FIGURE
3.2

Games designed by the New Games Movement focus on collaboration and fun. This photograph is reprinted from the *Illinois Parks and Recreation Magazine*, the July/ August issue from 1976, where it was subtitled "In the Lap Game, the record number of participants is 309. Can you beat it?"

playing, as well as the activities they produced, has fed directly to the way playful public performances and smart street sports.

The long tradition of student pranks, hoaxes, and April Fool's Day jokes also comes close to the pervasive games of today. The best of these activities are elaborate public performances with aims ranging from producing amusement to educating the general public and showing off to rival student clubs. Collecting stories and memorabilia is often an important part of these activities, which has given students in many places a reputation for stealing traffic signs.

Some student pranks fall clearly within our definition of pervasive games. One example is called *telephone bingo* (Holmila, Kovanen, & Saarenpää, 2007), where every team is allocated a dormitory building and given the campus phone book. The game is played in the night by calling the dormitory landline telephones, making people wake up (and turn on their lights as they wake up). The first team that manages to create a row of three or five simultaneously lit windows wins the game. Waking up people in the correct order requires both logical skills (to understand the order of the rooms) and quick use of a mobile phone. A more physical variant can be also played without phones: One team member runs inside the building ringing appropriate doorbells while another stays outside to check the windows and yells instructions to the stairwell.

Another example of ludic pranks is a game played at a tram stop: One player talks to the driver in order to distract her while the others run loops in the back of the tram entering from the back door and exiting from the middle door. The team that completes the most loops wins. The game usually lasts a few minutes, at which point the driver notices the play and kicks the freshmen out of the tram.[6]

Play in Everyday Life

While playing in everyday life has been less common than playing in public space, historically relevant influences exist for the development of pervasive games. The reason

why play in everyday life is less discernible than play in public spaces is that when people start to play, they usually create a special time and special place for their play. While the special place often conflicts with its environment, the special time is far more seldom selected to challenge its context. As computers and the Internet conquered offices, such conflict has perhaps become a bit more commonplace: Play is colonizing the segment of time that has been quite intentionally set aside for work. In this respect, playing *Solitaire* in the office is like staging a festival on a public square: Setting aside a magic circle for play, but doing that within a larger everyday context.

Some forms of pervasive play have blurred the distinction between play time and serious time more thoroughly: Secret societies are an example of pervasive play that takes both ludic and paideic forms. Participation ranges from events taking place in highly secluded areas to public events and everyday life. Initiatory rites of such clubs can pervade an applicant's whole earlier life, and playful and serious loyalty to the group can be expected to persist for decades. This mixture of playful, serious, ritualistic, and religious symbolism is prominent in most secret societies, ranging from Freemasons to Skull and Bones. The aesthetics of *Killer* (Case A) and those of a secret society are similar in many ways: They both feature shared secrets, double lives, and perception enhanced by secret knowledge.

This secret knowledge is something that, from the point of view of library and information science, can be seen to link pervasive games not only to children's play, but also to *cults* (see, for example, Galanter, 1989). A ludically motivated belief in an interpretation, imposed by the game organizers, momentarily replaces knowledge anchored in ordinary life (J. T. Harviainen and A. Lieberoth, forthcoming). This can be seen as a temporally limited version of the way the teachings of a charismatic leader can replace years of learning in a less zealous atmosphere. That said, cults are the opposite of playful.

Sadomasochistic 24/7 relationships are another form of pervasive paidia. A typical play session takes place within a carefully established magic circle with, for example, a dominatrix and a slave. It has a clear beginning, a clear end, and a safe word. If this consensual power exchange is extended into ordinary life, this kind of (sexual) play becomes pervasive play, moving beyond sexual encounters.[7] These kinds of relationships face challenges associated with social frames that also apply to pervasive games, as a study by Dancer, Kleinplatz, and Moser (2006) shows:

> Owner and slave who try to maintain the slave relationship based exclusively on the interactions within a discrete SM scene risk running into difficulties when they leave the dungeon to pay the bills, do chores, or decide in which restaurant to eat. The power exchange that is so clearly demarcated in the scene can lose its power outside of such a structured environment unless it is formally considered and applied to other daily situations. (Dancer et al., 2006)

The play is sustained through the use of various frames similar to those Gary Alan Fine (1983) used to describe role-playing, and the Apterian protective framework is upheld through the consensuality of the relationship (and sometimes made manifest through the use of a safe word). The participants also submit to a lusory attitude and restrict their actions according to a playful code: The master might have the right to punish the slave through (consensual) spanking, but not through (nonconsensual) beating. Continuous, long-term sadomasochistic play is similar to pervasive larps, as both assign new meanings to mundane tasks in public space through roles.

What all of these forms of play in everyday life have in common is that they take place in subcultures. The shared understanding of the proper way of conduct within the group is analogous to the rules of games—and the bleeding of such practices into mainstream culture is akin to the blurring of the magic circle in pervasive games.

Roots in Literature and Arts

Pervasive games are a textbook example of how life imitates art: Many pervasive games have been inspired by games in speculative fiction. In many cases it is not easy to show direct influences (such as in the case of *Killer*) but again and again games have been speculated about before they have been played. G. K. Chesterton's short story *The Tremendous Adventures of Major Brown* (1905), as well as John Fowles' novel *The Magus* (1965), describes activities similar to alternate reality gaming (Alexander, 2006). Jules Verne already depicted a ludic and pervasive activity in his classic *Le tour du monde en quatre-vingts jours* (1873). Here we attempt to present briefly the most influential and often-cited examples.

Technological advancements, such as ubiquitous computing and virtual realities, were speculated in works of science fiction (quite specifically in cyberpunk literature and, for example, in the form of Holodeck in the television series *Star Trek: The Next Generation* [1987]). Similarly, many of Philip K. Dick's bleak visions of the future predict the technology that we use, such as ubiquitous computing in *Ubik* (1969). An interesting case is also Stephen King's *The Running Man* (1982). This playful novel not only predicts the bloodthirsty games of reality television, but it was also written under the playful pseudonym "Richard Bachman" with hints to the author's real identity.

Works of fiction that play with the theme of blurring the real and the fictive or of a game becoming reality are common. For example, a number of Philip K. Dick's novels and short stories play with them, as does William Sleator's *House of Stairs* (1974) and *The Interstellar Pig* (1984), the films *WarGames* (1983) and *The Last Starfighter* (1984), and Orson Scott Card's novel *Ender's Game* (1985). However, it was not until the 1990s that these kinds of works started to resonate with the masses.

During the 1990s, a number of films have explored borderlands between the real and the fictive, the ordinary and the game. The most pivotal to pervasive games is David Fincher's *The Game* (1997), which tells the story of a businessman who gets to play a game as a birthday present. The game continues even as the company that runs it seemingly disappears and finally turns very real with the man fighting for his survival. Other films that use the theme of the real world versus an imaginary world include *The Truman Show* (1998), *eXistenZ* (1999), and *The Matrix* (1999). *The Blair Witch Project* (1999) is particularly notable from the perspective of alternate reality games, as the reality fabrication buzz of the film was largely created on its Web site and media coverage (see Lancaster, 2001). These films were all moderately successful, with the exception of *The Matrix,* which was a huge success, spawning a franchise.

The 1990s also saw a clear rise in the interest in conspiracy theories and secret histories of the world. Oliver Stone's film *JFK* (1992) is an important turning point in this development, as is its markedly less serious sci-fi counterpart, the popular paranormal television series *The X-Files* (1993–2002). Such interest has not waned in the following decade, as the record-breaking success of Dan Brown's *DaVinci Code* (2003) has shown (previously many of the same ideas were presented as facts in the book *Holy Blood Holy*

Grail [1982]). Again, the genre of conspiracy theories is not a new one (see, for example, *Principia Discordia* [first version in 1965], *The Illuminatus! Trilogy* [1975], *Capricorn One* [1978], and *Il pendolo di Foucault* [1988]), but prior to Brown's book it was a fringe phenomenon. The world-is-not-what-it-seems motif has become mainstream, almost a cliché, and it is used in fiction (numerous television shows testify), nonfiction (linguist and political activist Noam Chomsky writes about reality as a conspiracy theory), and everywhere in between.

There is also fiction in which conspiracies are portrayed as a form of participation and as a way toward societal change. Often these combine the motif of a hidden reality with freedom fighters (or terrorists) organizing themselves in cells. The comic book series *The Invisibles* (1994–2000) written by Grant Morrison and the book (1996) and film (1999) *Fight Club* both offer examples of a form that can be, and indeed has been, adapted into a pervasive game.

The ludic structures of conspiracy theories and the motif of a true world being hidden behind the curtain of ordinariness often surface in pervasive games. The same goes for the fantastic and speculative games. The static fictions of novels and films offer ideas, dramatic arcs, and story worlds, which are shared culturally and which work as a common reference point for an emerging type of games. It even seems that, instead of just reading about or watching them, game designers and players want to experience first hand the engaging concepts that they encounter in fiction.

Performing Arts

Pervasive games are rarely played for an audience, and they do not take place on stages. Although theater and performative art in general usually do, it is not always the case. Theater is at times performed in public without informing the "audience" that a play is in progress. Brazilian theater theorist and director Augusto Boal has been constructing his *Theater of the Oppressed* since the 1960s, and *invisible theater* in particular comes close to pervasive games. These are scripted plays performed in public spaces (such as metro cars or ferries) in order to raise awareness or stimulate public discourse on a political issue (Boal, 2002).

Other traditions and movements that have used similar expression as pervasive games are Happenings, Fluxus, Situationism, and 1980s performance arts. For example, *Funeral ceremony of the Anti-Proces* (see Figure 3.3), a Happening staged in Venice in 1960, started with a funeral and continued with the body (actually a sculpture) being carried on a street. Fiona Templeton's urban theater installation with a large cast for an audience of one in *YOU—The City* (Carr, 1993; Templeton, 1990) was like a pervasive game where the one player getting dragged around the city did not know the rules.

Although explicit connections between street theater and pervasive games are elusive, the forms they take are strikingly similar. The spaces they are performed in (streets, parks, and other public spaces) are the same. The step from busking to smart street sports is a short one. At the same time, games are increasingly framed as art and shown in galleries. *Rider Spoke*, a mobile phone-based pervasive game, was originally staged in the Barbican, one of the most important stages for performative art in London, and in the Nordic countries larps have been staged in or with the help of theaters and galleries, and at times they receive art-targeted grant money.

FIGURE
3.3

Funeral Ceremony of the Anti-Proces **was a Happening staged in Venice in 1960. "Outside, pedestrians take their hats off thinking it is a real funeral" (Kaprow, 1966). Although it was not branded a game, the Happening does bear more than a passing resemblance to a pervasive larp (on that connection, see Harviainen, 2008). Picture quoted from Kaprow (1966).**

Yet the most important similarity is in the discourses regarding audience engagement. The setting up and performing of invisible theater plays are clearly different from pervasive games, as plays are usually clearly scripted and have a very specific aim, but from the point of view of the audience (or unaware participants) the situation is similar to encountering a pervasive game that lacks clear demarcation. Traditionally, games have players and performing arts have an audience. In theater the division between actors and spectators has been important; Anthony Howell (2000) goes so far as to warn that even acknowledging the audience interferes with the "essential homeostasis of the artwork" and such interaction may reduce the spectator–participant to an automaton that passively performs the actions expected of her without reflecting on them. Yet many performances do interact with the audience, especially when they leave their traditional spaces. This can be seen as the ideological barrier that divides performances into works that are relevant for expression of pervasive games and works that are not. As Boal (2002) stages his invisible theater in public, he calls his audience *spect-actors*. They are

both spectators and actors taking part in the play. Even deciding to opt out and stay silent is seen as a conscious decision making nonparticipation active.

Of course, there is a long history of blurring the line between actors and spectators in theater. Breaking the "fourth wall," the invisible wall between the audience and the show, has become a subgenre of its own, meta-theater. Theater director and theorist Bertolt Brecht used the method in order to alienate the audience (to produce what he called the *Verfremdungseffekt*) and to force them to connect directly the action on stage with the world outside. Since then, the fourth wall has been broken in many ways, ranging from creating a comical effect to turning the audience into actors. These plays are not so much played for an audience as they play *with* the audience. In the context of role-playing in larps, where a group of people engages in embodied role-play, it has been discussed if the game can even be observed and enjoyed by an external audience. Christopher Sandberg (2004) denies this and calls for a different audience theory instead. He asserts that in order to fully understand and appreciate a larp, one must participate in it. This creates a sort of *first person audience*, which requires a personal connection to the game and a collective commitment (see also Lancaster, 1999).

Ludic Literature

The relation between story and game is an important one to pervasive games, as so many of them are based on fictitious story worlds. However, ludic elements have existed in literature long before story worlds began being significant parts of game experiences. The history of this ludic literature is long and contains various hoaxes, mysteries, interactive texts, and puzzles fabricating reality and merging the fictional with the ordinary. Bryan Alexander (2006) lists the use of pseudonyms, mixing real history with fictional characters, faking documentaries, and citing both real and fictitious sources as methods that have informed the design of alternate reality games. One of the most established forms of these texts are satires, such as Jonathan Swift's classic *A Modest Proposal: For Preventing the Children of Poor People from Ireland from Being a Burden to Their Parents, and for Making Them Beneficial to the Publick* (1729), which suggests that poverty in Ireland can be solved by eating children.

Alexander describes literary hoaxes as *bimodal*, as they create two castes of readers: Those who see through the text to expose the joke and those who take the text at face value. Any type or genre of text can be bimodal. Over time one reading may become dominant. For example, Swift's *Gulliver's Travels* (1726) is today often regarded as boys' adventure fiction, yet when it was first published it was also a pastiche of the kinds of travel books that were popular at the time. Naturally, bimodal readings are also necessary with mockumentaries, faked documentaries, reality TV shows, and other works that further confuse the division between fiction and nonfiction. However, the hidden messages can be quite subtle. For example, most listeners of the original *The Hitch-Hiker's Guide to the Galaxy* radio show (1977) did not realize that the author, Douglas Adams, had hidden his own phone number in the show:

> *In the entry in which [the Hitch-Hiker's Guide] talks about dying of asphyxiation thirty seconds after being thrown out of a spaceship it goes to say that what with space being the size it is, the chances of being picked up by another craft within*

those seconds are two to the power of two hundred and sixty seven thousand seven hundred and nine to one against which, by a staggering coincidence was also the telephone number of an Islington flat where Arthur once went to a very good party and met a very nice girl whom he entirely failed to get off with.[8]

Some books have also contained clues that led to physical world treasure hunts. Such armchair treasure hunts include *Masquerade* by Kit Williams (1979) and *Mysterious Stranger* by David Blaine (2002)(see Cameron, 2004; Szulborski, 2005). In order to find the mystery that turns into a puzzle, the reader needs to do a secret or alternative reading, which then explicitly turns into a pervasive hunt. Such hunts can also fly from the pages of the book to the Internet such as *Cathy's Book: If Found Call (650) 266-8233* by Sean Stewart and Jordan Weisman (2006) does.

Less clear is the case of *Publius Enigma.* This was a mystery that took place in the rock band Pink Floyd's Usenet news group. In the summer of 1994, a user by the name of Publius started posting messages outlining a puzzle: There was something hidden in the band's album *The Division Bell* and his hints would help uncover it. This launched a debate and a search for clues, turning the recording and the leaflet that accompanied it into a puzzle. Apparently, the band was in on it (the words "Enigma Publius" flashed on stage at a predicted time), but the enigma was never publicly solved or explained. Three years later, Publius declared the mystery solved. Szulborski (2005) considers *Publius Enigma* a proto-ARG, even though it still remains a complete mystery to the general public.

Alternate reality games are closely related to these forebearers. Alexander's two reader castes are not fine enough to explain these forms of participation since they do not completely reveal themselves as soon as one has identified the hidden layer in the text but require continued interaction. The readers of a text notice an alternative reading that turns into a *rabbit hole,* an invitation to play, and can choose to take a ludic stance to explore further. Experienced alternate reality gamers can become skilled in reading such hoaxes. They understand the ludic nature of the fake Web sites, know that they should call each and every phone number visible in a hit television show, and understand that sometimes a typographical design choice is actually a secret message. Today, the aforementioned quote from the *Hitch-Hiker's Guide* would very probably be an invitation to participate. But to participate in *what* would not be revealed—before dialing the number.

Gamer Cultures

Pervasive games are part of the long tradition of games. Although the arena is different, the core mechanics are mostly the same as in traditional, classical games. The influences of *chess, poker, marathon,* and the like are so ubiquitous that they are rendered invisible. These games define what games are. Pervasive games are only pervasive in comparison to these benchmarks.

The cultural and economic significance of games has been steadily growing throughout the last few decades. Digital games first appeared in arcades and then moved to living rooms as computer technology became more widespread and sophisticated. After living rooms, digital games went on to conquer workstations, digital networks, and mobile phones. Games have become ubiquitous, which paves the way for ubiquitous

games as well. This has shaped how games and playing are perceived and how they have found their place in the cultural sphere.

Handheld electronic games, popular in the 1980s, helped usher in the normalcy of gaming wherever one might be. An activity that once was practiced using dedicated devices is now commonplace on laptops and mobile phones as well. As *Solitaire* and social networking sites that offer games, such as Facebook, have conquered offices, attitudes toward everyday play have become more liberal. Even though mobile phones have entered the market of everyday gaming, dedicated devices are also doing better than ever.

Single-player computer games have rarely gone for pervasive aesthetics. The main exception is the compelling aesthetics of games where the player's computer seeks to represent the character's computer. *Uplink* from 2001 is an excellent example. The player is a hacker, working for an international criminal organization. The game pretends to be a terminal program, connecting the player's computer to a hacking server (see Figure 3.4). The fancy user interface even waits for connection times as the hacking software logs in on the nonexistent hacking server.

By making the player's computer into a representation of the character's computer, *Uplink* also transforms the body of the player into a representation of the body of the character. You never die in *Uplink*: If you get caught for tampering with bank accounts, the worst thing that can happen is the criminal organization renounces any connection

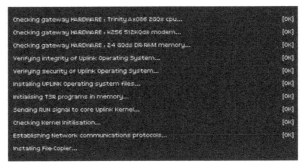

FIGURE
3.4

This Is Not a Game aesthetic in *Uplink*. The game pretends to be hacking portal software by making the player go through a detailed login sequence instead of just hitting a start new game button.

with the character, deletes her accounts, and destroys the server. The game is over as the connection is terminated, but the player can always create a new account and start from scratch with a new alias.

As people spend more time playing digital games, the content, logic, and structures of games have a growing influence on the players' imagination. Just as films and books have inspired games, digital games have inspired pervasive games. Games can contain challenges that players would like to try out in the physical world (like the adventure mystery of *Myst*), interesting themes, settings and story worlds (e.g., *Wing Commander, Final Fantasy*), or valid game mechanics (such as real-time strategy games and even *Pac-Man*). The spectrum of faithfulness of the pervasive adaptations of digital games is wide. *PacManhattan* (Case G) is fairly close to its source even if the experience of playing is very different in the pervasive and digital version. *Epidemic Menace* (Case H) uses game mechanics resembling real-time strategy games, but it is not an adaptation of any specific game. And paideic *cosplay* inspired by *Final Fantasy* is hardly even recognizable as gaming. Many of these adaptations are produced by fan communities and hobbyists, and the drive behind them is often to get to do the cool things in games *for real*.

Role-Playing Games

Role-playing games started evolving from *miniature war games* in the 1970s, when Gary Gygax and Dave Arneson published the first version of *Dungeons & Dragons*. In war games, players commanded armies that fought on a battlefield while a referee handled rules arbitration. *Dungeons & Dragons* brought in characters that the player could identify with or immerse into, and the referee evolved into a game master who functioned as an interface to the whole game world.

Role-playing games mostly take place in the imaginations of players. Pens, papers, dice, maps, and miniatures are often used to keep track of the game state, but the most important part of the gameplay unfolds in the discussion between players and the game master; make-believe, performance, pretense, and acting are central elements of play. This style of playing would later be called *tabletop role-playing* or *pen'n'paper role-playing*.

In the early 1980s, another form of role-playing evolved. Live-action role-playing games, *larps*, were born when table-bound players decided to stand up, put on character costumes, and start performing their characters physically (see Figure 3.5). As larps took to the streets, pervasive larps were born. Because both larps and pervasive larps evolved sporadically in gaming communities around the world, it is impossible to trace down the first games that were played. Phenomena that have influenced pervasive gaming though larps include theater, the scout movement, and historical reenactments such as The Society for Creative Anachronism (SCA). (For the history of role-playing games, see also Fine, 1983; Mackay, 2001; Mason, 2004; and Montola, 2007a.)

Although their influence is felt most clearly in pervasive larps, role-playing games have influenced pervasive games in general. The structure of role-playing games, a complete fictional world set up and administered by game masters and populated by characters played by players, is today common in many games. The *puppet masters* of alternate reality games are clear descendants of role-playing game masters (see McGonigal, 2006b). Role-playing as a gaming attitude, be it minimalist (see Chapter Seven) or full-blown immersion, has found its way to both digital and analog games.

FIGURE
3.5

***System Danmarc 2* is a great example of the ambitious live-action role-playing games that have proliferated in recent years. This nonpervasive cyberpunk game was played in the center of Copenhagen in a walled-off area, where a dystopian city was built out of freight containers.**

Persistent Virtual Worlds

The origins of persistent virtual worlds lie in textual adventure games pioneered by the early computer games *Colossal Cave Adventure* and *Zork*.[9] These games were predecessors to virtual worlds, as the action in those games took place in game worlds that were only accessible to a single player at a time and they were not persistent. The original *Multi-User Dungeon* (MUD) of 1978 featured a text-based world where player–users could embark on adventures through their avatar–characters, as well as chat with other players, effectively turning computer gaming into a social activity. Countless MUDs spawned during the following decade, making play in virtual worlds not only a social but also a communal activity (see Rheingold, 1993).

As increasingly appealing visual interfaces were added to MUDs, they evolved into huge massively multiplayer, online, role-playing games. Through milestones such as *Meridian 59, Ultima Online, Everquest, World of Warcraft*, and *Lineage II: The Chaotic Throne*, the genre has accumulated millions of players worldwide. The growth of MMORPGs has also spawned a number of paideic, noncompetitive virtual worlds, such as *Habbo Hotel* and *Second Life*.[10] Social networking sites also inhabit a kind of persistent virtual worlds and the influence of MMORPGs has been felt there as well.

Persistent worlds allow for the growth of long-lasting communities and accumulation of in-world wealth and power. As players advance slowly in *World of Warcraft* through gathering treasures and experience points, they also form social connections, join guilds, and build communities. In order for this to happen, the virtual world must be sustained at least for weeks or months.

Many pervasive games feature persistent virtual worlds. Even though *BotFighters* (Case D) is mainly played in the physical world, the bots, credits, and weapons only exist

in a computer environment. Even though the players did not have a three-dimensional spatial representation available, this can be seen as a persistent virtual world.

There have been attempts to stage games both in the physical world and in a fully virtual environment; Craig Lindley (2005) calls this format *trans-reality games.* A successful prototype is yet to be seen, even though some attempts have been made (such as *Takkar* combining online role-play with larp, see Christensen, Jørgensen, & Jørgensen, 2003). While *Can You See Me Now?* combined virtual and physical spaces, it did not seek persistency.

The influences of persistent worlds are not limited to virtual ones. The game world of *Killer* may persist for weeks, and *Momentum* (Case F) had one running for 5 weeks, even though neither was simulated technologically. Rather, it was the socially constructed game diegesis (see Loponen & Montola, 2004) that persisted for weeks, allowing the murder scheme or role-play to develop for an extended time.

The Migration of Influences

The phenomena covered in this chapter contain both implicit and explicit influences. In some cases, the migration of an idea can be traced through time, and it is possible to show clearly how a concept influenced the design of pervasive games. However, it is more likely that similar ideas have surfaced in a number of places at around the same time, and it is impossible to show how influences have traveled or if there has been any exchange of ideas. Sometimes ideas have also been forgotten only to be discovered or reinvented later.

For example, Robert Sheckley wrote a short story called *The Seventh Victim* in 1953. Twelve years later Elio Petri directed the film *La decima vittima* based on it. According to Johnson (1981), this film inspired the early assassination games at university campuses in the United States. Slightly over a year after the film premiered in the United States, the game was featured in an episode titled *The Death Game* of the television series *The Saint* (1962–1968). One of the characters explains:

> Six months ago, almost to the day, this Death Game craze broke out of universities all over the western world, here [UK], Canada, America, France, Germany. One minute nobody had heard of it and the next minute everyone was playing it.

If *La decimal vittima* indeed did inspire *Killer*, that time frame would have to be fairly accurate.[11] This is supported by the fact that the gameplay featured in the televisions series was closer to the kind that was depicted in the film than the more polished form *Killer* takes today. Steve Jackson Games published a rulebook for these games in 1981, which in turn inspired a lot of games of *Killer* worldwide. The films *Tag: The Assassination Game* (1982), *Gotcha!* (1985), and *killer.berlin.doc* (1999) were inspired by some of the above—and in turn introduced the game and its mechanisms to new audiences.

Another complicated trail of influences is offered by *The Game* treasure hunt tradition. The story starts with game aficionado and maestro of musicals Stephen Sondheim, who was throwing scavenger hunt parties back in the 1960s. It was later described in *The New Yorker*[12] as follows:

> Stephen Sondheim's most famous game took place in Manhattan on Halloween, 1968. It required twenty people (preferably young theatre Turks like Herbert Ross,

Nora Kaye, Lee Remick, Mary Rodgers, and Roddy McDowall), four limousines, complicated maps full of numbers and arrows, and a sack of perplexing props: scissors, bits of string, pins. Each team of five had to drive to a spot designated on the map, and there they would find a clue telling them where to go next; the trouble was, the clues were numbers, and there was no way of knowing how they might be revealed. One destination was a bustling bowling alley in which the last lane was curiously empty; there stood a single enigmatic pin, which you had to bowl over in such a way that you glimpsed the number written on the side. Another site proved to be nothing but a nondescript door with a mail slot. But if you stuck your ear near the slot, you could hear the faint voice of Frank Sinatra singing "One for My Baby"—which might still have stumped you unless you recognized that the lyric begins, "It's a quarter to three." A quarter to three: the number was 245. Then there was the vestibule of a brownstone, where a small elderly woman (actually, the mother of Anthony Perkins, Sondheim's fellow game designer) would beckon you upstairs for some coffee and a slice of cake. Those who actually ate the cake stood no chance of winning: the clue was drawn in the icing.

Sondheim and his friends were operating in an established tradition, descendants of the high society treasure hunts popularized by Elsa Maxwell in the 1920s mentioned in the previous chapter. Yet the New York tradition would soon come to a close. According to Sondheim, the game organized on Halloween 1968 was one of the last of the big game parties. "Towards the end of the sixties, beginning of the seventies, I don't know—it just stopped. Everyone outgrew them except me," he said in *The New Yorker* interview.

Sondheim and Perkin's murder-game parties inspired the film director Herbert Ross to hire them to write the film *The Last of Sheila* (1973). In the movie, a wealthy film kingpin hosts a puzzle hunt on a yacht on the Mediterranean. His guests—the players— may or may not have information about the death of his wife in a hit-an-run accident a year earlier. The film is tightly plotted, but it also features a throw-away moment of insight into game mastering.

Don Luskin and his friends saw the movie in 1973. It stimulated their imaginations and they organized a series of four games in the following years (with Patrick Carlyle and Cherie Chung): *The Game* (1973), *Game 2* (1975), *Game 3:7878* (1978), and *Game 4* (1979), all in Los Angeles. Luskin's games used none of the locations, clue mechanisms, or other details of *The Last of Sheila*, but he credits the film as the inspiration for his games (Luskin, 2008). The game tradition moved from one coast to the other. The invitation to the first game read:

You are invited to play The Game. The Game is a treasure hunt through Los Angeles. [. . .] Entry fee is $4.00. The object of The Game is to win everybody's entry fees by being the first to find them. [. . .] Feel free to bring friends.

Luskin's games were covered in the *Los Angeles Times* and in turn inspired movie makers at The Walt Disney Company, who produced *Midnight Madness* (1980) based on the games. In the film, several student groups race around the city in a nocturnal puzzle-solving race. According to Luskin (2008), the game portrayed in the movie was extremely close to the original, including terminology and even locations and mechanisms of several clues. Indeed, they threatened to sue Disney over the similarities, and settled out of court for a cash payment and a mention in the movie credits.

Midnight Madness, again, inspired Joe Belfiore and his Stanford friends to create another fast-paced and increasingly difficult treasure hunt initially called *Midnight Madness*, then *Bay Area Race Fantastique*, and, finally, *The Game*.[13] These games are still organized in many cities, with increasing elaborateness and strong obfuscation of the magic circle. *Shelby Logan's Run* (Case C) and *vQuest* are recent games in this tradition. It is interesting to see how the treasure hunts slowly evolve into a tradition where a team is expected to show up with a van full of equipment that helps solve the upcoming challenges. The invitation to the second Luskin, Carlyle, and Chung *Game* asked players to bring a map, a flashlight, dimes, a dictionary, and a thesaurus. Twenty-seven years later in *vQuest* the players showed up with pimped out vans equipped with everything from copying machines to kayaks.

The interplay between games and film does not end here. David Fincher's film *The Game* (1997) was allegedly[14] inspired by the game series initiated by Belfiore. Fincher's film is a common point of reference for pervasive games.

Much of the aesthetic of both Fincher's film and the game series initiated by Belfiore is present in the entire genres of pervasive larps and alternate reality games. The inspirations can clearly be seen in *The Beast*, which in addition to using many of the mechanisms of the games inspired by *Midnight Madness*, was created by Microsoft. Coincidentally, most participants of *The Game* treasure hunts were Microsoft employees (Finkel, 2001).

Even though such clear histories can sometimes be distinguished, influences rarely migrate this visibly. Thus, this chapter should be read more as a catalogue of neighboring phenomena of pervasive games and as a list of other examples of how the distinction between game and the ordinary is becoming blurred. Some of the sources, especially when it comes to older examples, used in this chapter are unreliable, based on hearsay or subject to self-serving agendas. Unfortunately, this is a general problem in research on transient art: Early pieces in particular are poorly documented. Still, when the migration of an idea has been explicit, it has been pointed out. However, we have mostly taken the stand that when similarities between specific phenomena and pervasive games are sufficiently great, it is not a big conceptual leap to see how cross-pollination between the phenomena has occurred.

As we edge closer to the present day, the more muddled the list of influences becomes, even if they are better documented. It is as if pervasive games are part of a larger cultural shift, questioning the concepts such as "real" and "fiction." This is the approach adopted in Chapter Thirteen, where we elaborate on some of the connections mentioned here and look at pervasive games in the context of changing media culture in general.

Conclusion

In order to understand the origins and implications of pervasive games, we need to move away from the technological origins of the form and look at it in cultural contexts. In this chapter, we have discussed influences as we have identified them. The "history" thus created should be approached as an after-the-fact construct, a tool to understand the currents that have helped shape the forms in which pervasive games were born. It is our wish that this chapter could also function as a source of inspiration for game designers, mapping different phenomena to steal and adapt from.

Still, this cultural approach to the development of pervasive games must stay conscious of the significance of technological developments. While pervasive gaming, as we see it, does not require any hardware or software support, various technologies considerably broaden the design space of possible games. While *Killer* can be played with Stone Age equipment, *The Beast*, *BotFighters*, and *Epidemic Menace* depend on recent technologies. Furthermore, while information technology is not a requirement for each and every pervasive game, it seems to act as a *catalyst* for the pervasive gaming culture.

The most important developments for pervasive gaming in information technology have been the research fields of ubiquitous and pervasive computing,[15] sparked by technological innovation regarding miniaturized computers and wireless communication. *BotFighters*, launched in 2001, was labeled as a pervasive game from the start, and in a Guardian article dated May 2001,[16] both *BotFighters* and *Majestic* are mentioned as examples of pervasive games.

Another early example of a technology-based pervasive game, *Pervasive Clue* was presented the same year by Jay Schneider and Gerd Kortuem (2001) in a workshop on ubiquitous computing games. "We define a Pervasive Game as a LARP game that is augmented with computing and communication technology in a way that combines the physical and digital space together," they wrote. These references illustrate how the very concept of pervasive games, right from the beginning, featured many of the influences discussed in this chapter.

Notes

1. It can be argued that while games are open-ended, rituals tend to have a predictable end. Ericsson's own work, such as the larp *Hamlet* (see Koljonen, 2004), has problematized this approach, as the larp based on Shakespeare's play invariably ended in tragedy. Still, *Hamlet* was an interesting play experience, just like *Tetris* can be an interesting play experience, even though the player starting the game is doomed to lose eventually. While rituals mostly have predictable outcomes, games mostly do not, but this rule is far from universal.
2. Originally described by Herodotus (2001).
3. Quoted from www.playareacode.com/manifesto.html (ref. June 2007).
4. See the documentary film *Dogtown and Z-Boys* (2001), directed by Stacy Peralta.
5. One way to view all these activities is to group them under three overlapping headers: *urban exploration*, *infiltration*, and *urban adventure*. *Urban exploration* consists of "seeking out, visiting and documenting interesting human-made spaces, most typically abandoned buildings, construction sites, active buildings, storm water drains, utility tunnels and transit tunnels." In *infiltration* the pleasure comes from beating the human element (sneaking into a concert or a movie theater), and in *urban adventure* the joy is in doing something cool (*elevator surfing, parkour*, etc.) rather than visiting someplace cool (Ninjalicious, 2005).
6. Markus Montola still occasionally boasts about the fact that he talked his freshman team to victory at a University of Helsinki Department of Communication freshman party back in 1999.
7. Popular works featuring this kind of lifestyle include the movie *Secretary* (2002) by Steven Shainberg and the scandalous French classic *Histoire d'O* (1954) by Pauline Réage.
8. Quoted from the original radio scripts of *The Hitch-Hiker's Guide to the Galaxy* by Douglas Adams (1985).
9. Espen Aarseth (1997) traces the history of these games back to the religious fortune-telling device *I Ching* and *Dungeons & Dragons*. Like *Zork* and *Multi-User Dungeon*, these cultural artifacts are *ergodic texts*: They are texts that require work (erg) from the reader. The work can consist of solving puzzles, choosing from alternatives, or even moving around in a textual world. The work done

by the reader changes the text he/she is presented with and, subsequently, interpretations made of the text.

10. For the history of MMORPGs, see, for example, Koster (2002) and Bartle (2003).

11. It is possible that the television series introduced the game to a larger public audience than the Italian film. Still, the game did already exist at that point, and the fact that the winner of *Death Game* is called a "decathlon winner," resembling the "decathlete" of *La decima vittima*, further strengthens the argument that the film was the starting point. *The Saint* episode offers an interesting time capsule from the early days of *Killer*. "It's a bit kinky, but it's very in," declares one character.

12. "Deconstructing Sondheim," *The New Yorker*, March 8, 1993, by Stephen Schiff.

13. Based on the community site www.gamecontrol.com.

14. While we failed to find definitive proof on this inspiration, the allegations are common. For example, the trivia section of *The Game* in the Internet Movie Database (www.imdb.com) links the film to both the Belfiore and the Luskin traditions.

15. Although these fields have different origins and subtle differences exist, they are nowadays often treated as synonyms (see Nieuwdorp, 2007).

16. "Games without frontiers" by Sean Dodson, for the Guardian, May 31, 2001. www.guardian.co.uk/technology/2001/may/31/internetnews.onlinesupplement.

DESIGN

Case D

BotFighters

Olli Sotamaa

You're hanging out in a café, and all of a sudden your mobile phone beeps. You have received an SMS message. This time it is not one of your friends letting you know that she's late: Instead, you have been attacked! Another player, Motorhead88, has you on target, and an aggressive counterattack is your only choice. Your fingers tap the buttons vigorously, but despite all your efforts the superior enemy downs your bot within a minute. As you are left behind charging your empty batteries, a message hits your mobile: "Gotcha lamer! The easiest points of the day!"

The next morning you are still annoyed about what happened. Something has to be done to Motorhead88. You log onto the Web site to update your armor and shields and to check out the location of your new enemy. A few phone calls later you have a bunch of friends in the car, and the suburb is about to witness the cruelest drive-by-shooting ever. You drive within the range and start firing missiles. The poor guy has no chance. "Gotcha lamer!"

In *BotFighters,* the player adopts the role of a battle robot with the objective of killing as many other bots as possible. Success in battles earns the player play money that can be used to update armor and other features of the bot. The game world is draped on top of the real world so that the location of a bot is determined by the location of the player's mobile phone.

To play the game, the player sends simple commands via SMS.[1] These messages allow the player to scan the surrounding area, to select particular opponents, and to fire her weapons. Information about the play states and the consequences of players' actions are also delivered via SMS (see Figure D.1). In addition, players immediately receive warning messages when opponents nearby either make a scan or start an attack. A typical fight involves two or more bots firing at each other until at least one of them has lost all its energy. Both the type of weapons and shields and the distance between the players affect the result.

BotFighters is arguably one of the first commercial location-based games. It was produced by It's Alive! and was first launched in Sweden in 2001. Later on, the game was also launched in Finland, Ireland, Russia, and China. The game uses GSM network cell identification to determine the location of a player. In the original game, the mobile dimension was based solely on SMS messages. In a later version, the messages were replaced with a Java-based application. While the battles out on the streets are coordinated with the mobile phone, the Web site allows players to repair and upgrade their robots. Furthermore, the Web site provides a status report documenting the recent events in the game world and shows the locations of bots on a visual map. Hence, if the mobile phone becomes both a weapon and a radar, the Web site represents a home base with a bot repair workshop.

Screen captures from *BotFighters 2*, which was never launched. The original *BotFighters* was played with plain text messages without a graphical user interface. For example, sending a message "SCAN" promted the server to respond with the approximate directions and distances of nearby bots. The targets were notified with SMS as well: "Warning! Scanning signal detected from South-East."

The rules of the game do not recognize any breaks or safe locations. In other words, the game is on everywhere and all the time. If necessary, a player can log out of the game, but this is not encouraged, as the player cannot gain points during the break. Some of the design decisions directly encourage players to remain unpaused and active. An example is a powerful weapon called *Long Distance Missile*. This weapon, which can be used only once every 24 hours, is earned only by players who have not paused the game during this time.

Because of the straightforward objectives of the game, the focus of gameplay is mostly on the interactions between players, not so much in the interplay between the player and the game world. As a result, the game events often develop into a chase with players simultaneously locating their enemies and hiding from their assailants (Struppek and Willis, 2007). A few elegant tactics that exploited the technical infrastructure were introduced by the players. The way the games rely on mobile phone base stations allows active players to learn the exact boundaries between cells, and this knowledge can be used to one's advantage in gaming situations. One example is the hit-and-run style in which players start out of range and quickly move to a position where they get their phones to change the radio base station. After the switch, the weapons are fired, and then players quickly retreat out of distance to avoid any retaliation (Bjerver, 2006).

As a game, *BotFighters* shares traits with a variety of other games. Just like *Killer*, *BotFighters* turns the everyday environment into a playground. It is a shared secret, mostly invisible to people outside the game. For a devoted player it, however, has the power to turn any ordinary situation from grocery shopping to a business meeting into a breathless chase. *BotFighters* also bears similarity to games such as *paintball*, which can produce an adrenaline-pumping experience of real-life combat without putting the players into real danger. The fictional level of the game refers to the tradition of *mecha*, armored fighting vehicles that are familiar from certain science fiction universes and especially popular in Japanese manga and anime series. In the case of *BotFighters,* the cyborgian relation between the immense mech robot and the pilot in the cockpit is replaced with an equally complex relation between players' physical movement from one place to another and the virtual armor controlled with the mobile

phone. Finally, because the game can force players to change positions and, in some cases, move relatively long distances, it can be argued that *BotFighters* belongs to the group of *exer-games*. These games, ranging from early virtual reality experiments to recent successes such as dance games (*Dance Dance Revolution*, *In The Groove*) or various *Nintendo Wii* games, are characterized by their ability to provide players with physical exercise.

The fact that players are constantly moving in and through physical spaces raises the larger issue of the social construction of space. In the case of *BotFighters,* the playground is particularly urban. In urban areas, cell identification is surely accurate enough, and, even more importantly, the critical mass of players is guaranteed more easily. It is widely agreed that certain subcultures such as skateboarders or *parkour* practitioners can have the ability to subvert and resist the production of public urban space. Skateboarders, for example, create alternative uses for modern urban environments and attach meanings to locations and objects (benches, rails, ramps, etc.) that may have no special significance to anyone else in the city. In the case of *BotFighters*, players may choose to avoid certain areas of the city for personal reasons. In this case, real-life meanings and memories attached to locations can have a significant influence on the way the game is played. At the same time, playing *BotFighters* has, at least at the very personal level, the potential to produce entirely new understandings of familiar city locations (Sotamaa, 2002).

Note

1. SMS stands for Short Message Service.

FOUR

Designing Spatial Expansion

Markus Montola, Jaakko Stenros, and Annika Waern

Spatially expanded games are not limited to certain, controlled physical areas. Nor are they restricted to a set playground, game board, or online service. Instead, they venture into undefined and unlimited areas, sometimes incidentally or on the spontaneous initiative of the players. By doing so, they *appropriate* space, architecture, and objects to the game, making them parts of the experience.

A game that is not limited to a dedicated physical region or set of props is different from a classic game in a fundamental way: It offers infinite affordances (see Chapter One, McGonigal 2007). One of the most important tasks for the players is to figure out what places, objects, and pieces of information are relevant. There is no certain way of deciding whether a building, vehicle, or item will turn out to be significant for the game, as every physical object appropriated in the game holds at least potential game relevance.

Although not all spatially expanded games make use of technology, modern mobile and Internet technology is a great tool in creating spatially expanded games. Some spatially expanded games use technology in order to trace player locations and movements or to create a virtual overlay infusing a magical interpretation of the real world. In this chapter, we first go through features that are useful in all sorts of spatially expanded games and conclude with features that rely on some kind of technology support.

The cases presented in this book feature various forms of spatial expansion. In some cases, this means just playing in the streets (Cases D and G), whereas others also give meaning to various properties of physical space, including architecture (Case E), history (Case K), and purpose (Cases A and F).

Playing in Public

All cities have public places where citizens are free to roam. However, most of these spaces are socially reserved for certain activities. Sidewalks are for walking, parks are for lounging, and roads are for driving. These restrictions are only partially regulated by law; their details are determined by implicit social norms that are well understood by

most of us. You might be legally prohibited from bicycling on a sidewalk, but dancing on the street is only prevented by social convention.

Spatially expanded games *transform* the way we understand space. When Laura Ruggeri drew random geometrical shapes onto maps of Berlin in 1997 and told people to walk along the lines, her *Abstract Tours* changed the perception of driveways into walking paths, fences into difficult obstacles, and railroads into danger zones. She describes the piece as follows:

> There was a choice of ten forms, from a triangle corresponding to about three hours on foot, to a square of about two days. The length of time varied according to how much the route was adhered to; sometimes to climb over a fence needed less time than to go on a long deviation around the block. [. . .] All participants were encouraged to follow their itinerary as closely as possible and to the best of their physical abilities: in order to 'stick to the line' some jumped over fences, cut through private properties, climbed over walls and crossed rail tracks, while others chose to swerve from their route in order to dodge obstacles. (Ruggeri, 2001)

According to Ruggeri, *Abstract Tours* (see Figure 4.1) parodied the idea of a sightseeing tour and challenged the canon of tourism, what is worth seeing, by sending people on a random trip. Instead of leading travelers to the remains of the Berlin Wall, it revealed

FIGURE 4.1

The random pattern marks the abstract tour. Ruggeri (2001) writes that "one group performing the tour with a crowbar, ropes and other climbers' gear had been intercepted by the police and questioned for hours; two people had wandered on to a private golf course (that did not feature on any map!) stealing the balls that were later exhibited as trophies; members of Stalker had marked their route by leaving a white trail of flour behind them; a Czech tourist had persuaded an old German lady to let him into her house on the grounds that it was on his route; and a Berlin resident spent hours inside the headquarters of Schering, a pharmaceutical company, successfully dodging their security guards."

"countless walls, fences, obstacles hindering public access on both sides of the city" (Ruggeri, 2001).

When American photographer Spencer Tunick had 18,000 people pose nude in the main plaza of Mexico City,[1] he completely transformed the social norms of that special time and place. While no sensible person would strip naked at the Zócalo on a usual day, a crowd of nude people changes and suspends social conventions. This kind of collective playfulness can be powerfully utilized in game design. When games transform the city into a playground, this can result in friction with regular users of the space. A game staged in a public space will have spectators and witnesses. The game designers must take this into account and make a conscious decision about to what extent the game will also be a performance. This is discussed in detail in Chapter Six.

Although public space is by definition public, it does not mean that anything goes. Some organizers use games to question, carnivalize, or subvert public space. Street parties and guerrilla dance festivals staged without permission on heavily trafficked streets are part of the countercultural *Reclaim the Streets* movement. Large-scale games that do not seek to subvert space (commercial games in particular), but may have an effect on bystanders, often require permissions from authorities. Informing the public about the gameness of the event is often wise as well.

Playing in public always requires a good understanding of the local cultural and political environment. In Chapter Ten on ethics, we discuss several cases of problematic misunderstandings, including a joyful art installation that was interpreted as a terrorist attack by officials.

Sightseeing and Local History

Spatially expanded games are a natural way of enabling people to see the city in a new way, heightening the character of the city. Servicing tourists is the obvious application for such games (see Case K). However, it can be equally interesting to create such games for long-term residents. A spatially expanded game could lead a local player to a place two blocks from her home that she has never seen before.

The most powerful tool for telling a location-based story is through the *authentic* physical space and physical game content. The best pervasive experiences do not take place on the screen, even if it shows an augmented image of the surrounding world. Instead, spatially expanded games become most interesting when they make intense use of the city *as it is*, including its history and ambience, and use the game content to twist it, just slightly, into a diegetic game world.

A way to use spatial expansion is to direct players toward particularly interesting places at interesting times. A mall might offer to sponsor the game if it encourages players to see the grand opening on a set day. Conversely, a designer who wants to raise awareness about homelessness can lead players to a place where homeless people line up for food handed out by charity organizations. A game can (automatically or through human organizers) collect information on a player's physical and social environment and use it to lead her to the best place to observe a sunset or a street concert.

If a game could be moved to another city without changing it noticeably, it is *location free* (Flanagan, 2007). Location-free games can appropriate space through requesting players to visit places that are described in a generic rather than a specific manner. Players might, for example, be asked to dance on a bench in a park or spy from a high

place with a view. This approach is particularly effective if the players create content that other players must experience in the same place. Alternatively, the game can disregard place entirely and center on players seeking each other out (as in *Killer*) or running into each other randomly. These games become spatially expanded through the fact that these meetings can occur in places that have a distinct out-of-game meaning. Playing *Killer*, it is a very powerful game experience to discover that your meal was poisoned at your usual university cafeteria.

Site-specific games must be localized and adapted to each new setting. This can potentially be very costly. The cost can still be justified if the game is able to tap into the historical and ambient meaning of a specific place as well as its construction, architecture, or geography, thus offering very rich game experiences. Rather than just randomly adding content on top of an arbitrary place, site-specific games are able to enhance a player's understanding of a place and foster a deeper spatial experience of its geography. By choosing the sites carefully so that they reflect the history and feel of a place, a game designer can encourage players to look into local history. While these structures can be used to encourage education, place-based learning and community building (Clark & Glazer, 2004), games such as *Uncle Roy All Around You* (Case L) also used them to convey artistic and political messages (see Chapter Twelve).

Site-adaptable games occupy a middle ground between these forms (Reid, 2008). These are games that can be adapted easily to a novel place by relying on types of places that can be found in most cities. A site-adaptable game can, for example, require content to be placed at a church, a bank, and a railway station. *Backseat Playground* (Bichard et al., 2006; Gustafsson, Bichard, Brunnberg, Juhlin, & Combetto, 2006) is an interesting example of this approach, as it allows the game to adapt automatically to the players' location and travel path. It is played in a moving car and designed specifically for long trips—usually through the countryside. As the game combines position information with map data, it can lay out an interactive story in the visible landscape for the backseat travelers in a car.

Playing in Prepared Locations

Even if the game area is unlimited, play tends to be concentrated in certain locations. These locations can be chosen by the designer, and the game can lead players to them. If there are no preset hot spots, players may still gravitate toward areas that have a critical mass of participants or are otherwise good for the intended play activity. Designer-chosen locations help control the thematic and aesthetic totality of the game, but they can be perceived as constraints to players' freedom of movement.

The *Prosopopeia* games used an interesting mixture of prepared and unprepared gaming areas. In the first game, *Där vi föll*, the players expected the game to be played only in public spaces and areas accessible to everyone. Instead, the players were supplied with a fully scenographed boat, *Vattnadal*, where they could stay, cook dinner, and sleep. Comfortable headquarters are a great asset for long duration street games, as no one really wants to wander the streets and pubs for 16 hours a day.

In the second game, *Momentum* (Case F), a larger base of operations was needed to accommodate the 30 players for more than a month (see Figure 4.2). The game designers rented a retired nuclear reactor hall beneath the city of Stockholm and turned the dismantled reactor hall into an underground headquarters for a group of revolutionaries.

FIGURE
4.2

Although *Momentum* was played around the city of Stockholm, the locations that the game would lead the player to were carefully selected to support the aesthetic vision of the game masters. The urban decay of the old dock area and the decommissioned nuclear reactor contributed to the feeling of the game.

The headquarters featured a war room, relaxation areas, meeting rooms, a control room, and even a gym. The ritual hall was fitted with paranormal technology, while other areas provided players with computers, libraries, and office equipment that could be used during the game.

If prepared locations are created with a sufficient level of detail, players really enjoy exploring them, whether this means ransacking Uncle Roy's office or hunting for clues from a hard drive full of nonsensical files. Designated play areas also allow for some control over the interactions of the game. As *Momentum* featured a war room with a big map on the table, players felt it natural to have discussions over the map and mark down locations of importance, strengthening the feeling of spatial expansion even while players were hiding in a bunker.

Finally, set locations allow for special technical installations. In *Uncle Roy All Around You*, the office contained a surveillance camera relaying video from the room to the online players. In both *Där vi föll* and *Momentum*, the players' headquarters were staffed with various pieces of surveillance and communication equipment that allowed the game masters to monitor player activities and discussions in some detail.

Urban, Suburban, and Rural

Most pervasive games are played in urban areas. Cities offer the kind of playground that is densely populated by interesting architecture, diverse people, and a plethora of meanings, yet it also offers a kind of anonymity created by the large number of inhabitants and passersby. It is, however, also possible to play outside the city center.

Skateboarding was first conceived as a land-based equivalent of *surfing* in the 1950s. It was mostly conducted in suburban settings until the urban street style emerged in the 1980s. During the 1970s, the popular thing was to find an empty pool in a suburban area and—without permission—co-opt it for the activity (Borden, 2001). Although the play was constricted to the pool area, the search for it was akin to a pervasive game:

> *Journeys by bicycle, car and skateboard were used to survey local neighbourhoods and more distant areas systematically, keeping eyes, ears and noses tuned for such telling signs as 'pump houses, high pool fencing, pool sweeps, slides, the smell of chlorine, inflatable pool toys, solar-power panels, big hoses gushing for days or chlorine deposits (white salt marks) on the gutter of a street', plus pool cleaning trucks and the hum of pump motors. 'It's an art form of sorts, hunting pools.' Very occasionally, a small aeroplane would be deployed to overfly a likely neighbourhood, looking for the tell-tale gleam of a white pool. (Borden, 2001, quotes from articles published in Thrasher magazine)*

A suburban setting can have just as many interesting and enticing locales for play as a city center. As they are less obvious, the challenge is to find them—and to find the courage to play in an area where the limits of expected behavior are stricter. Players get away with more outrageous activities in urban areas as they are already populated by diverse street cultures.

Likewise, play in rural areas is challenging as attitudes toward the environment are even more solid. Yet even in such areas pervasive games have been staged successfully. Aside from *orienteering*, most pervasive games played in rural areas are situated on roads. An example of this is the pervasive larp *The White Road* (Pedersen & Munck, 2008). The players dressed up as "road knights" (a specific kind of drifter culture in Demark) and walked the roads for 3 days, never breaking character immersion. A more mainstream possibility is demonstrated by the rural adventure game *Backseat Playground*.

Playing on the Move

Having a large or unlimited area for gaming means that players have to move and are sometimes even required to travel long distances. This is the exact opposite of the classic idea of portable games, which is to fill idle moments of daily life with interesting game content.[2] Spatially expanded pervasive games can use the opposite philosophy: Instead of making travel less bothersome and waiting less boring, many pervasive games require players to do *additional* traveling or waiting in order to succeed.

The choice between *move to play* or *play while moving* is central in spatially expanded games, as only very few activities adapt to both ways of playing. If the goal of the game is to fill an idle moment, the game should offer some payoff for playing for just 30 seconds. However, if the players are going to visit a local castle to access game content, they might be prepared to spend hours on the trip. Many good designs combine

the two approaches by providing different activities for different situations. In the mobile phone game *Songs of North*, players could scan their surroundings and interact with random encounters while on the move, whereas they had to actively travel to different places to perform more challenging quests.

Moving is not interesting as such, but adding challenges, content, or aesthetic pleasure to a trip can be done in various ways. Move to play is a philosophy that can be found in a number of subcultures from *skateboarding* and *parkour* to *roller-skating* and *train surfing*.[3] Indeed, an urban journey can be an exhilarating experience.

Traffic and Transportation

Players usually consider finding the best (fastest, cheapest, most efficient) methods for transportation to be a game challenge even if this is not explicit in the game rules.[4] To make the best use of this, a traveling game needs to be designed in a fashion that accommodates diverse methods of moving, ranging from walking and bicycling to hitchhiking and taking taxis. From the design point of view, these methods are radically different when it comes to aesthetics and travel time. If the game design works best with a certain mode of transportation, this has to be either explicated in the rules or motivated in the backstory of the game.

All physical movement takes time. While Larry can fetch a new leisure suit from the store with a few strokes of the keyboard, it can take a player hours to do the same thing in the real world. Estimating how much time a trip will take is very difficult. Mobilizing large groups of players takes longer than mobilizing small groups, traffic congestion and problems with public transport affect the journey time, and, as pervasive games often take players to unknown parts of town, players tend to get lost now and then.

These factors make it important to design large-area games so that it does not really matter how long a trip takes. In particular, it is dangerous to assume that players should ride a taxi, as this could impact the cost of the game significantly. Then again, relying on buses might leave players stranded if the game takes them to desolate places in the dead of night.

Playing in traffic can be hazardous. Players caught up in the thrill of the moment take more risks than they would in their ordinary lives. In *BotFighters* (Case D), players were willing to push the gas pedal a little harder just to score some extra points while driving (Bjerver, 2006), whereas people testing the *parkour*-inspired GPS game *Wanderer* were willing to risk being bumped by a car in order to perform better (Hielscher & Heitlager, 2006). Designs that divert player attention are even more risky, whether the diversion is caused by staring at a mobile phone screen (see Ballagas, Kuntze, & Walz, 2008) or an obstructive head-mounted display (see Herbst, Braun, McCall, & Broll, 2008).

In general, driving a car while playing a game is a bad combination, unless the game has been designed specifically for drivers. At the very least, games for drivers should never require the driver to manipulate small buttons or look at a small screen (which, incidentally, is the usual setup for car navigation systems).

Global Gaming

Many alternate reality games exploit spatial distance in order to foster global player groups. It is fun to participate in a game, knowing that people all around the globe have

to combine their efforts in order to succeed. An interesting example is *I Love Bees*, where a major component of the game was answering pay phones at certain times and completing tasks on the site. Although the game was based in the United States, the phones were located in several countries across the world, forcing players to collaborate across borders. The experience of participating in something large is inherently pleasurable; part of the attraction of waiting in line for days in order to get tickets for the premiere of a new *Lord of the Rings* movie is that countless people around the world are doing the same thing.

Requiring players to travel considerable distances is also an interesting option for a pervasive game designer. If a player has to travel to another city, the game structure emphasizes the strength of the spatial expansion: As the player has first-hand evidence that both London and New York are relevant for the game, she has all reason to expect that Paris and Los Angeles are included as well.

The Amazing Race (Case M) is an extreme example of a game where finding the fastest possible transportation is a considerable challenge in itself. Games with smaller budgets can perhaps pay the trips as prizes to well-performing players or require players to fund their travels themselves. *Perplex City* combined the puzzles of *alternate reality gaming* with a *treasure hunt* mechanism, hiding the "Receda Cube" in Wakerley Great Wood, north of London. The first person to solve the puzzles of the game, find the hidden treasure in Wakerley, and bring it back to the game company was awarded the grand prize of £100,000.[5]

Many players of a global game will feel excluded if it is only the local and the lucky few who get to travel who are able to participate. This might not be a problem for a game using hundreds of pay phones, but it can be a real issue if the game offers only few major events. One way to approach this issue is to foster an online community where participants are encouraged to post detailed descriptions of the real-world events. Still, this creates two tiers of players: Those who are actually able to participate and those who are only able to watch. *Vanishing Point*, the puzzle game advertising Microsoft Vista, used expensive events to convey game clues; their techniques included sky typing and projecting videos onto dancing fountains and digital wallpapers onto central buildings all around the world. To provide all players with the same clues, the game organizers also posted photographs and videos of the events on their Web site. While this solution waters down the pleasure of finding clues for the players who are able to be on site, it still maintains some of the astonishment elicited by the game manifesting itself in the ordinary world.

Physical Play

Because spatial expansion requires a player to move, a player's body becomes a de facto game token, the flesh avatar of the player. This brings an important *physicality* to playing. Doing things physically, for real, can be pleasurable and fun. It can also be dangerous, thrilling, or scary.

Indexical Environment

One way of building highly physical games is through *indexicality* (see Chapter One), using an indexical environment where every physical object in the game represents

itself. A mobile phone can only portray a mobile phone, and a plastic sword can only portray a plastic sword. Indexicality is accomplished most easily through using authentic locations for game areas and authentic objects for game props.

The strong point of indexicality is that it allows players the embodied and tactile pleasure of treating each prop and set as real. Overcoming real obstacles is highly rewarding. Uses of indexical environments can range from shooting rapids with a rubber raft to searching a library for puzzle clues. The indexical approach needs to be maintained at a consistent level throughout the game. Many players find it incredibly cool to be able to literally cut their way through a metal blast door, but the activity will also prime them to expect that they can use a fire axe to chop down any wooden doors in the game area.[6] Games that rely on indexicality face problems with restricting players to certain areas or activities, which might be necessary for legal or safety reasons. Players who are let loose in the world are incredibly good at inventing routes and means to complete a game quest. Even when explicitly instructed on what to do, they might still make mistakes. If players are told to break and enter a particular house, there is a considerable risk that they will accidentally go to a neighboring house instead.

The use of indexical challenges emphasizes players' (indexical) skills: The players have to be actually able to climb over a wall or carry out accurate triangulation. This means that tuning the difficulty level is quite challenging. Indexicality can sometimes unbalance the game or give unintended or even unfair advantage to some players.

Urban Exploration

Seeing the backside of the city, from run-down industrial areas to shady alleys, is a physically immersive experience that conveys a strong feeling of *being there*. Service tunnels, sewers, abandoned factories, and other off-limit locations are fascinating and atmospheric environments for any urban adventure. Strange places evoke feelings of being outside the ordinary sphere of life, and the forbidden nature of exploring them makes it feel immediate, unprocessed, and, hence, more real. A player sneaking into an abandoned house experiences a very immediate feeling of being outside of her ordinary environment, and this feeling can be transformed into a feeling of being inside the game. The activities offered by such strange places, such as searching for a parcel in a dark cellar or climbing a wall to reach another cave, are exciting in themselves.

When playing in authentic physical environments, certain considerations have to be made. First, many of the areas are not entirely safe; ruined buildings may have weak structures and abandoned buildings usually have broken glass lying around. The game operator needs to ensure that the players are aware of the possible dangers and that they do not need to run, climb, or jump in places that pose a clear risk of an accident. As a general rule of thumb, your urban exploration scenario should probably not be more dangerous than your average sport. Second, players must be equipped with the right gear: Two separate flashlights, a pair of gloves, and a set of clothes that can get wet, dirty, and torn are a good start. If you surprise your players with an unexpected crawl in a maintenance tunnel, they will not have any of that gear with them.

Third, there are many legal issues concerning the use of urban exploration in pervasive games, as some forms of it fall under trespassing or even breaking and entering. This varies from country to country: In some countries you are allowed to go almost anywhere, whereas in others you really need to take care of renting all the locations

in advance.[7] Whenever using urban exploration in games, it is a good idea to remind all participants of the Sierra Club[8] motto: "Take nothing but pictures, leave nothing but footprints." Game organizers who ensure that their players follow this rule can save themselves a lot of trouble, both when it comes to cleaning up afterward and upholding a good reputation.

Urban exploration strongly supports exploration and discovery, which are highly appealing game experiences. An abandoned dockyard may seem frightening and alien at first, but finding game elements there turns the whole area into a playground. Be aware that once the players have found game elements in an unexpected place, they start to expect finding them anywhere and everywhere. The way a player perceives her surroundings changes, and soon every cracked backdoor and dislodged manhole cover is a pathway to the secret underworld of the city.

Exergames

Stimulating the whole body in a game leads to a more immersive experience and a stronger feeling of presence. Adding physical strain to a game can make it more enjoyable as the body pumps out endorphins.

Spatial expansion is a natural way of creating exercise games. Many people consider exercise a boring activity, with goals set in the distant future. By enhancing the exercise with the continuous microgoals and rewards that are typical of gaming, the activity can be made immediately rewarding. One way of looking at this is through ends and means. Exergames, just like sports, use physical activity as a means, whereas in exercising the activity is an end in itself. Indeed, many sports can be seen as spatially expanded games, including *orienteering*, *sailboat racing*, and even *rallying*. Such sports can be used as an inspiration for all exergame designs.

PacManhattan (Case G) can be seen as an exergame, where the exercise of running in New York is given a new theme from *Pac-Man*. For many people, playing a live-action version of an old arcade classic makes much more sense than just jogging. *PacManhattan* also increases the attractiveness of running by including tactical thinking from the digital game.

Manhattan MegaPUTT is another example of pervasive exergaming: While *PacManhattan* is about fast-paced running, *Manhattan MegaPUTT* is a much more slow-paced form of aerobic exercise, where players minigolf their way through the busy streets of the metropolis. The healthy hike is complemented with the challenges of miniature golf and entertainment derived from social expansion.

Expanding to Virtual Spaces

Mixing physical play with all kinds on cyberspaces, virtual worlds, and mixed realities creates games that not only can take place anywhere in the real world, but that allow their players to travel to fantastic worlds that can only be created in virtual space. However, regarding pervasiveness, the same rules apply to virtual spaces as to physical space: In order for a game to be pervasive, these virtual spaces need to be unlimited and essentially appropriated from other uses.

FIGURE
4.3

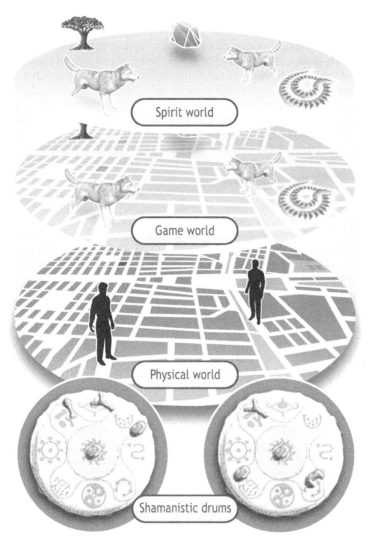

The mapping of three worlds in *Songs of North* (see Lankoski et al., 2004), showing the
physical world, technological game world, and the fictional spirit world portrayed by the
game. The spirit world was not shown visually, as exact mapping is impractical when using
cell positioning. The lack of precision was obfuscated with a shaman drum metaphor:
Players could hear the sounds made by totem animals and perform magic by "drumming"
the keyboard. The lots cast on the drum were the only visual indication of what was
happening in the spirit world.

Cyberspace

Adding Web content and expanding the game online is the easiest step toward cyber-spatial expansion. The Web is part of our everyday world, and it is one where authentic and fake, fact and fiction, already blend seamlessly (this is discussed further in Chapter Thirteen). Creating game-related Web sites that pose as real and that link to ordinary Web sites is one of the easiest ways of creating an ambiguous borderline between the game and reality, and many alternate reality games have used this approach to create a kind of spatial expansion on the Internet.

Expanding into online virtual worlds is also possible. The game can appropriate cyberspaces that are already available in an analogous way to using the Web. The game *Sanningen om Marika*, which was played primarily in Web forums and Internet chats, included game activities that led the players to *Entropia Universe*, a massively multi-player online world (Denward & Waern, 2008). This way, the players of *Sanningen om Marika* appropriated the playgrounds of *another* game, which led to a form of virtual social expansion as well. It is also possible to stage a spatially expanded game in a vir-tual world, such as playing a *scavenger hunt* or some kind of a race within *World of Warcraft*. Such play is often organized by players spontaneously and casually. Winners are sometimes awarded different game benefits, such as good weapons or gold, or they get to do something interesting in the game such as participate in a raid.

Mixed Reality Games

Perhaps the best-known approach to spatial expansion is to use positioning technology to place virtual content at specific locations in the real world. By infusing virtual content in the physical world, the game re-appropriates space in a very direct way.

This is but one of a range of design options for games that combine play in physical and virtual space. The straightforward use of a virtual overlay over physical space does not generate a separate virtual world; rather, the physical world is augmented with vir-tual content for a mobile player. Due to the difficulties of three-dimensional positioning, such overlays also tend to be flat so that physical altitude is of no consequence in the mapping, furthering the experience that the overlay is not that of a parallel world.

It is a bit trickier to create mixed reality game experiences, where some play-ers play in physical space and some in virtual space. To offer something to players playing in the virtual world, the virtual space must be sufficiently interesting on its own. Some activities that can be interesting and self-rewarding in the real world, such as traveling long distance, may become boring in a virtual world, particularly if the dis-tance is equally long and the travel speed is the same.

One game that explores this issue is *Uncle Roy All Around You*, where online play-ers at one point in the game have to move through a virtual space that is modeled after a real area in London. To make this activity interesting, they are tasked with finding their route through a sequence of virtual rings, each appearing only when the previ-ous one has been passed. This very simple game challenge, combined with moving at a speed that is slightly faster than that of walking through a real city, makes the experi-ence enjoyable.

The game *Epidemic Menace* (Case H) addressed the same issue by providing online players with an overview of the physical game space, overlaid with full information about virtual game viruses and the position of the real-world players. In addition, they

had access to views from a set of surveillance cameras in the area. The video streams were also overlaid with images of the virtual viruses. This way, the online players could act as team managers and guide the real-world players through mobile phones. The very same overview was also provided publicly on a Web site, effectively generating a spectator interface.

The online world in *Uncle Roy All Around You* is also an example of how the virtual world can represent something other than just the real world; the virtual copy of London is not quite London itself. Such virtual copies of the real world can be given very strong in-game meanings such as being a dream world (*Songs of North*) or the spirit world (*Momentum*).

Our example games all use one-to-one mapping between real and virtual space (see Figure 4.3). Theoretically, there are numerous possibilities in layering the physical and the virtual together, playing with isomorphism, scale, dimensionality, translation, and orientation (see Lindley, 2005).

Finally, mixed reality games need not necessarily rely on location mapping at all. Another way for the virtual and the physical to interact is by being *adaptronic*, allowing virtual game objects to be influenced by changes in the physical environment (Walther, 2005). In *Epidemic Menace*, weather conditions in the physical world influenced how the virtual viruses spread, with warmth speeding up reproduction and the direction of the wind determining the vector of spreading (Lindt, Prinz, Ohlenburg, Ghellal, & Pankoke-Babatz, 2006).

Conclusions

Spatially expanded games are inherently about *discovery* and *changing perception*. These games are played in appropriated spaces—places that are not designed for gaming and which change their meaning for the players (and sometimes for spectators) through the gaming activity. Approaching a decidedly nonludic space with a playful mindset exposes the unseen and makes the familiar strange.

Spatially expanded games can never be fully play tested with paper prototypes. The difference is self-evident if we consider prototyping *PacManhattan* with a board game. Board game players have no idea how long it would take to run across a few streets, how exhausted they would be after half an hour, or how traffic and weather would influence the gameplay. Thus, some play testing and prototyping should always be done in real environments. Early play testing can be done in the real environment by players using mobile phones to role-play their use of technology.

New technology will probably soon increase the ways in which a game can infuse virtual content into the real world. Even though current technology prototypes have been rather clumsy and slow (Case H; Bichard & Waern, 2008; Herbst et al., 2008), augmented reality technology will eventually offer very interesting possibilities for spatial expansion by allowing players to literally see things that are invisible to others. Imagine adding barcodes to newspapers, which turn into interactive magical photographs in the style of Harry Potter when watched through an augmented reality (AR) device. When mobile AR technology moves from barcodes to optical character recognition, it can change the content of news articles: Where an outsider sees a story about a school reform, players of an agent game could use their device to find a story about an imaginary terrorist attack.

Notes

1. See, for example, "Thousands strip for photo shoot," by Thomas Sarmiento for Reuters, May 7, 2007. www.reuters.com/article/topNews/idUSN0626494920070507. See also photos at www .spencertunick.com. Both ref. September 24, 2008.
2. As game developer Lasse Seppänen (2001) has put it, "mobile gaming remedies moments of boredom when there's no access to better gaming devices."
3. *Train surfing* is the dangerous and usually illegal practice of riding on top of trains.
4. *The Amazing Race* often solves this problem by bluntly forbidding certain methods of transportation.
5. If a treasure hunt game requires players to travel in order to find physical clues, it should be ensured that there is something for everyone to find. In the case of *Perplex City*, players who reached the goal too late were disappointed to have to search for hours with no hope of finding the Receda Cube (see Figure 2.1). Letterboxers and geocachers usually leave a guest book at the cache for explorers to sign.
6. The example is from *Pelageya: Clarissie*, a science fiction larp played in Finland in 2005.
7. The people granting permissions to play in these places often also know about their dangers. Consult them thoroughly in order to minimize the risks.
8. Quoted from Ninjalicious (2005), whose *Access All Areas* is an excellent guide to urban exploration. In fact, we recommend this book to anyone planning to design a game featuring urban exploration.

Case E

Mystery on
Fifth Avenue

Eric Clough

A family of six settled into their newly renovated apartment on the Upper East Side of New York. After a 2-year renovation, the family began getting back into the groove of their old life: long nights of homework, sharing time at the piano, and exchanging stories of their busy lives with each other. During the next 18 months, the family notices odd bits of architectural details throughout the apartment—radiator covers with encrypted lettering, inoperable cabinet doors, and tiny models of rooms within niches behind picture frames. But life continues and unanswered questions linger—until a letter with vintage stamps arrives in the mail marked "Lost Post."

Upon opening the envelope, the family follows a six-part poem that describes the location of a hidden panel, containing a leather-bound book. From there, the family spends 6 months "unlocking" their apartment and enjoying a journey filled with wonder derived from all things that inspire: music, history, storytelling, mystery, and the very craft of making things.

The story of the *Mystery on Fifth Avenue* begins in 2004 with the purchase of a 4200-square-foot apartment overlooking the Reservoir in Central Park on Manhattan's Upper East Side. The new owners chose to renovate the entire apartment, but did not want to go for a traditional plan so they contacted 212box,[1] a design firm that specializes in innovative ideas and who were able to deliver a plan for an architectural gut renovation and a full-interiors package. But in addition to creating a functional and beautiful apartment, 212box strove to provide something else for the four kids and, as a result, they hid—both inside the walls and in plain sight—numerous puzzles and treasures that together form a story of inspiration. While the renovation took just over 2 years, creating the mystery took a total of 4 years and included the talents of over 40 artists and artisan friends who were enthralled by the project.

Architecturally speaking, the residence is strategically split into two territories—kids' land and then the rest of the apartment—by a threshold that features a stone family crest. With its stunning view of Central Park, the once misdirected foyer is now a large library room that serves as an intersection to the living room, dining room, kitchen, and master suite. Similarly, a homework den and a pajama room in the children's wing provide circulation to two large two-room suites, each split between the boys and the girls. Space between rooms serves as functional bridges rather than a void of hallways—thresholds house storage, butler's pantries,

wet bars, linen rooms, bathrooms, and dressing rooms. Additional features include a sleeping den and a home office with a terrace.

There was also the apartment's unique history of once being the 32 servant's rooms for a triplex penthouse belonging to Marjorie Merriweather Post and E. F. Hutton.

Marjorie Merriweather Post and E. F. Hutton spurred one of the first cooperative apartment buildings in New York after they met with a construction company and a real estate firm in 1923. Having complained about the traffic noise and gasoline fumes, Mrs. Hutton said that she wanted to have her home rebuilt at the top of an apartment house. Tearing their existing mansion down and capitalizing on the significantly appreciated value of their property, a new thirteen-story (plus penthouse) building was planned. The top three levels and a portion of the ground floor were devoted to the Huttons' "relocated" mansion. The public entrance was placed on Fifth Avenue to permit a private driveway and lobby to be constructed on (the side street) for the exclusive use of the Huttons and their guests. Upstairs, a grand fifty-four-room residence was created that holds the record as the largest apartment ever constructed. The apartment included a silver room, a wine room and cold storage rooms for flowers and for furs, along with a self-contained suite of rooms for closer family members. (Alpern, 1993)

Unbeknown to the family at the time of moving into the apartment, they lived within the details of the clues and puzzles. It was not until the letter arrived that they would understand the full extent of their entire project. The letter contained a six-part riddle poem that described the location of a hidden panel containing a 222-paged, fully illustrated book describing a story that recounts a tale of inspiration. The book, entitled *In These Rooms of Wood and Stone*,[2] invited them to explore their newly renovated apartment by supplying them with clues (see Figure E.1) about hidden architectural details and codes, ciphers, and tips about secret passages, sculptures, and original products created for and from the story. In addition to originally scored music and songs, the book also included fictional letters from the original owner of the apartment, Marjorie Merriweather Post, and an educational story that taught the kids about the history and genesis of inspiration through politics, art, science, and much more.

In These Rooms of Wood and Stone, inspired by the four kids and created in turn to inspire them, is a story that fictionally traces "inspiration" through 40 historical figures, beginning with Francois I and ending with Marjorie Merriweather Post. The book is segmented into five parts with two chapters per section. The odd chapters contain the story of two young friends, Ricky and Elynn, who discover long-lost clues and who embark on a wonder-filled adventure; each of their episodes is followed by a series of clues, which lead the family through their own apartment of discoveries. The even chapters feature segments about fictionalized historical figures, who at young ages undertake their own personal paths of inspiration and talent; these sections are followed by biographies and contextual information. Throughout the book, illustrations, diagrams, definitions, and factoids make the journey both educational and fun.

In addition to the letter that led the family to the hidden book, the 18 clues that follow every chapter within the book begin simply enough, but grow in complexity and interconnectivity. For example, counting the number of salamanders in the apartment will help solve a finale book cipher poem about inspiration. Radiator covers are encrypted with poems for each child alongside astrological charts and descriptions. A rose stone reveals the location of a series of secret compartments opened only by solving wooden puzzles that fit together to form keys that open two contrasting millwork cabinets: da Vinci's *Vitruvian Man* and Le Corbusier's *Modular Man*. Riddles in the book lead to hidden niches behind pictures in the pajama room, which lead to a model of the kitchen, which leads to the stove elevation, which

Journey of Inspiration

Clue #1
Salamander, Salamander, Where Are You?

Clue #2
For Cherubs

Clue #3
Chamber Cipher Mathematics

Clue #4
Astro Heat

Clue #5
Rose Stone

Clue #6
Modular Vitruvian Treasure Chest

Clue #7
Galileo Galilei

Clue #8
Salamandre

Clue #9
Scytale

Clue #10
Loud Cranks

Clue #11
In Regards to its Use

Clue #12
Drawer a droit

Clue #13
Drawer a guache

Clue #14
Inspiration NRG

Clue #15
Magnet Poem

Clue #16
LightBox

Clue #17
Letter Puzzle

Clue #18
Salamander Cipher

The architectural plan of the residence showing the path and sequential order of the hidden clues.

leads to color-coded drawers containing a compact disc of original music by Chris Brown and Kate Fenner—produced for the family and the story.

A longer intertwined clue involves, in part, removing a leather strap embossed with lettering from the crown moulding of the pajama room and wrapping it around an octagonal-sectioned rail detail on the 212box custom-made master bed (see Figure E.2).

Clue #9
Scytale

There are eight leather straps that can only be read
When they're wrapped 'round the length of a pole
To find where that is, check one of the beds
Where to sleep all four children once stole.

One form of transposition is embodied in the first ever military cryptographic device, the Spartan scytale, dating back to the fifth century BC. The scytale is a wooden staff around which a strip of leather or parchment is wound. The sender writes the message along the length of the scytale, and then unwinds the strip, which now appears to carry a list of meaningless letters. The message has been scrambled. The messenger would take the leather strip, and, as a steganographic twist, he would sometimes disguise it as a belt with the letters hidden on the inside. To recover the message, the receiver simply wraps the leather strip around a scytale of the same diameter as the one used by the sender. The 404 BC Lysander of Sparta was confronted by a messenger, bloody and battered, one of only five to have survived the arduous journey from Persia. The messenger handed his belt to Lysander, who wound it around his scytale to learn that Pharnabazus of Persia was planning to attack him. Thanks to the scytale, Lysander was prepared for the attack and repulsed it.
–Code Book, Simon Singh

Before you proceed, please read on...

Clue #9 "Scytale" in the book leads to a leather strap installed on the crown moulding over the transom in the pajama room. The progression of the removal of the scytale wood detail from the master bed footboard and the rewrapping of the leather strap to reveal the next riddle.

DESIGN

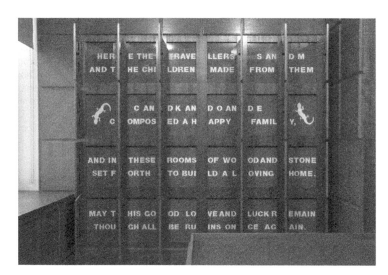

Twenty-four panels in the study open after a magnetic catch is released using a magnet key. Once opened, a unified illustration and poem is revealed.

Decrypting the riddle on the strap leads one to the rose stone and two decorative door knockers from two hallway doors, which fit together to make a crank, which in turn opens hidden panels in a credenza in the dining room. The panel of the credenza then reveals multiple keys and keyholes (see Figure 5.2) and, when the correct ones are used, yields a hidden magnetic sculpture and two hidden drawers containing acrylic letters and a table-size cloth inspiration map. The map is imprinted with a diagram of 40 historical figures and their association of inspiring one another. The map also holds the beginnings of a crossword puzzle—the answers to which describe an anagram poem that reveals another answer to a riddle of a location, which leads to one of the rectangular panels lining the tiny den, which conceals a chamfered magnetic cube, which can be used to open the 24 remaining panels, revealing, in large type, the poem written by the father of the family (see Figure E.3).

For the makers of the project, inspiration was drawn from many sources. In the case of renovating the apartment, there was inspiration in the multistorey view of the Central Park Reservoir and the city's skyline that acted as a backdrop to the palatial space. And there was the rich context of an inspiring historical figure, Marjorie Merriweather Post. While all of these aspects of the project certainly stirred the 212box team creatively, the true inspiration was looking into the eyes of four brilliant children and realizing that this apartment could make a lasting impression on their imaginations.

Notes

1. 212box LLC is a New York City collaborative office lead by Eric Clough and Eun Sun Chun. Encompassing a large breadth of subject matter, 212box's work includes design research in residential and commercial architecture, product design, graphic design, advertising, and film. Believing that design is a comprehensive endeavor, 212box focuses on all its aspects, including the business strategy, office team, design process, advertising, and its design potential in alternative media. 212box creates new partnerships with financial institutions, nonprofit arts organizations, individual clients, and private businesses to expand research beyond the design of architecture. The goal is to foreground design opportunities often traditionally overlooked, maximizing a design project through multiple and varied incarnations. 212box popularizes their design through the integration of high and low art forms, modern materials and construction technologies, business strategies, and architecture, advocating their practice through buildings, films, print, and products.
2. *In These Rooms of Wood and Stone* (212box LLC 2007) is a one-off publication specifically created for the family. *The Residence and "In These Rooms of Wood and Stone" Answer Book* (212box LLC 2008) documents and explains the project quite extensively. This case description is largely based on the answer book.

FIVE

Designing Temporal Expansion

Jaakko Stenros, Markus Montola, and Staffan Björk

Just as spatial expansion appropriates everyday environments and turns them into content and context for a game, temporal expansion does the same for the ordinary lives of players. This is done through making the game available for play at all times while decreasing players' ability to control *when* they are playing. In classic games, players decide when the game commences, pauses, or finishes. Removing the clear boundaries of playtime so that players can choose when to play and reducing player control over them, making it difficult to choose *not* to play, can enhance the game experience.

In many pervasive games, there is no binary dichotomy between playing and not playing; the distinction between the two is obfuscated. In *BotFighters*, a player must choose what and where he eats and what mode of transportation he uses, even if he is not actively playing. The awareness of the game running in the background influences such everyday decisions, even when gaming is not the player's main activity.

The cases discussed in this book utilize temporal expansion differently. Some games are on constantly, leaving players exposed to play at all times (Cases A, F, and M) or allowing them to initiate play at any time (Cases B and I). Some games even lack a clear beginning, pulling players in gradually through unaware participation (Cases E and J). The fun of these games is often created by the friction between game and life, in being forced to choose between playing and carrying out everyday chores. While spatially and socially expanded games use the tangible realness of ordinary life to spice up the game experience, temporally expanded games add the pleasure of gaming to ordinary life.

Styles of Temporal Expansion

Ordinary life and temporally expanded gameplay bleed into and influence each other constantly. A player shifts her attention between the two in a rapid and complicated manner, alternately focusing on the game world and the ordinary world. Sometimes the ordinary world takes over; sometimes it is the game that takes the player's full attention.

The concept of play session is not well suited for analyzing temporally expanded games. We would rather use a rough scale of *active play*, *peripheral play*, and *passive play* to discuss different play modes. Active play means focusing on playing, passive play means focusing on the ordinary world, and peripheral play is a mixed state with heightened awareness of them both. The three modes are all shades of gray, reminding us that the extremes of playing and not playing are hardly explanatory of the games discussed here. *Not playing* is a relevant state only when the game is not running at all, whereas *full play* is relevant only for games and play modes that are not interlaced with ordinary life.

Dormant Games

The most straightforward way of designing temporally expanded games is to rely on *dormancy*. Dormant games are played passively and peripherally for long periods of time until some event in the game forces the player to step into active play. The most widespread dormant play phenomena is probably the *Tamagotchi* toy—a virtual pet living in a small plastic box that needs to be fed and pampered at arbitrary occasions. The strong antropomorphication that the *Tamagotchi* inspires has been a source of controversy, to the extent that parents have sometimes had to babysit their child's *Tamagotchi* at work when they have been banned from school. Both *BotFighters* and *Killer* use dormancy in a similar way: The player is a potential target for other players, and if she is attacked, she has to defend herself. Martin Bjerver (2006) has captured an illustrative quote in his interviews of devoted players of *BotFighters*:

> [Silver] was getting ready for the night with his girlfriend, and had prepared with snacks and a movie. He had put the telephone in quiet mode and placed it on the TV. Suddenly his girl[friend] saw that the phone was vibrating. 'Someone is shooting at you' she had said. And that was true—he was already dead at that point. So he got mad, told the girl 'let's go!' and the girl had driven the car while he was operating the phone. (Bjerver, 2006)

Dormant games are interesting because players need to stay peripherally aware of the games while carrying on with their daily life, work, studies, and taking care of social obligations. Instead of spending quality time with his girlfriend watching a film, Silver ended up chasing another player on a motorway. Similarly, a player of campus *Killer* risks assassination every time she attends a lecture. A casual player can relax and go into passive play, but a hardcore player constantly watching her back and scanning for fights has to stay in peripheral play.

In many dormant games, a single player can make the choice of starting active play at any time: In *BotFighters*, a player who has found an enemy can initiate play by shooting at her. This action of initiation is one-sided; the shooter can force the target to play actively or the target will lose. There is no negotiation. The idea of forcing another player to start playing at the most inconvenient time, as well as the risk of being forced into play at any time, is a central source of fun in temporally expanded games. In games such as *The Beast* or *Momentum*, the game organizers also have the possibility to force players to play.

Ambient Games

The opposite of dormant games is when a background game becomes activated only when a player wants to play. In *Insectopia* (Case I), for example, the peripheral player is on the lookout for environments and moments when she is surrounded by active Bluetooth devices, but active play only commences if she so chooses. Games that run in the background and that a player can tap into at her own leisure have been called *ambient games*. The term is analogous to that of ambient music, a term coined by the musician Brian Eno to denote music that accommodates various levels of engagement (Eyles & Eglin, 2007).

> *An ambient game is coincident with real life; elements are superimposed on the real world. In an ambient game, the gameplay is in the background, available for the players to focus their attention on it. In other types of games, the player has information pushed at them, they are required to interact. In an ambient game, the players pull information from the game when they want it. Ambient games feature pull, not push, technology. Compare this to ambient music which is composed to be in the background, though the listener can bring it to the foreground and focus their attention on it if they wish. (Eyles & Eglin, 2008)*

Fantasy sports, an elaborate form of *sports betting*, is an interesting example of ambient games. In these games, the player takes on the role of a manager of a sport team and builds her team out of real-life players in the national league of that sport. This team is then pitted against other fantasy teams, and statistics generated by the official league determine the results (see, e.g., Crawford, 2006). Not all fantasy sports are pervasive, but the ones that use the latest results from the official leagues in an adaptronic fashion are (see Turtiainen, 2007). These games can be played so that the player only creates a team and then never tampers with it. However, it is also possible to revisit the game constantly, checking results in the fantasy game as well as in the official league, to calculate the worth of single players and buy and sell players in one's team. It is interesting to note that often these kinds of games are a way for fans of the sport to deepen their engagement and make the sport more participatory (see Figure 5.1). *Hollywood Stock Exchange* is a similar game for film buffs.

In their discussion on ambient games, Mark Eyles and Roger Eglin (2007, 2008) highlight the fact that the actions of a player in her ordinary life influence the game. This could be called adaptronic personal interaction or a hidden interface. For example, a pedometer could count the number of steps a player takes during a day, which can influence the game.

Extreme versions of ambient games are time capsule games, that is, games or mysteries created and left around to be found and solved some day. Instead of being triggered by a player or a program, time capsule games, like reality games (see Chapter Two), just wait for someone to find the message in the bottle, decipher the treasure map, and find the wooden box of goods from a small island. *Mystery on Fifth Avenue* (Case E) is an excellent example of this. The game hibernated in the falls and furniture of the apartment while the family carried on with their everyday life (see Figure 5.2). While this kind of play is difficult to monetize, setting up the mystery is a great source of enjoyment for the creator.

FIGURE
5.1

MLSN Sports Picks is a sports betting game for mobile phones. Even though the user interface is confined to the small screen of a mobile phone, the real game interaction takes place outside the magic circle, as the players follow sports news, watch games, and talk about odds.

Asynchronous Games

Games that use dormancy force the unsuspecting player to react immediately. A much softer version of this is *asynchronous play*. This is a style of playing where players do not take actions simultaneously but can take their turns or moves as they see fit. The game does not force players to make a game action instantly but gives them time to react. In *Day of the Figurines* (Crabtree et al., 2007), an SMS-based story-driven game situated in a fictional town, players are sent text messages, but they do not need to reply to them right away.

Gaming in the context of multiplayer pervasive games can only be relatively asynchronous, as after a certain period the game usually needs to move on. Thus, these games can also be seen as turn-based games where turns are temporally limited; the player needs to react within, for example, 10 minutes, an hour, or a day.

Setting an exact deadline for reacting to stimuli is easy when the game is technology based, but it may not be a good idea. In many pervasive games, reaction times are blurry, as they are negotiated in a social situation—just like in nontimed *chess*, where the reaction time of a player is negotiated socially.

Asynchronous multiplayer games face the problem of accommodating different play paces for different players, while still providing them with opportunities for collaboration and dialogue. The problem is aggravated if there is a global story progression in the game. Benford and Giannachi (2008) discuss ways to accommodate variable time progression for players in multiplayer narrative games. Their central example is *Day of the*

FIGURE
5.2

A clue led the players to combine two door knockers to create a crank. Applying this crank to a small pinhole at the base of the credenza, which had been there innocuously for months, expanded the credenza, revealing secret compartments and more puzzles.

Figurine, which effectively implements a catching-up mechanism, as a returning player can read all recent SMS from the game to understand what has happened since she left off. Benford and Giannachi also discuss other potential strategies, such as dividing the player community based on their play pace, running separate player communities depending on when they entered the game, and using traces of previous activity to populate later game sessions.

Temporally Seamless Games

Some pervasive games try to be *temporally seamless* through completely integrating ordinary life with game participation. One way to accomplish this is through hiding the game from the players: If you do not know which of your actions are significant to the game, you end up constantly acting like you would in the game. The difference to ambient games is that everyday life is not simply a source of adaptronic input, but that a player's active gaming also actively influences her everyday life to the point where separating the two becomes difficult.

Momentum (Case F) was a pervasive larp where the players were instructed to play the game *as if it was real*. By running continuously for 36 days and taking the this-is-not-a-game aesthetic used in alternate reality games to its logical extreme (McGonigal, 2003a; Szulborski, 2005), it pushed the life/game merger to the maximum. From the point of view of a participant, it was only the knowledge that the game was a game that differentiated it from reality. Participants pretended that they had forgotten that they were participating in a game.

Producing a temporally seamless game is expensive, cumbersome, and taxing. In order for the game and life to merge seamlessly, the (game) world has to always respond to player actions in a timely and diegetic manner. This requires huge investments from the people who create and run the game, as they need to stay up to date on what all the players are doing around the clock and then ensure that the correct reaction occurs.

Surprising players by having the game pop up at unexpected times and in unexpected ways is a powerful tool in strengthening the life/game merger. Just as breaking something physically brings a feeling of tactile immediacy, interlacing the game in unexpected temporal areas (lunch break, happy hour, last call, sunset, eclipse, Easter) gives players a feeling of freedom regarding their environment and of realness in relation to ludic activities.

Persistent Worlds

Having a persistent game world does not automatically make a game temporally expanded. In most online role-playing games, the game world is persistent and other players can play even when you are not playing. However, a player can decide her own playing times, and the way other players play affects her status in the game only marginally.

In mainstream online games, such as *World of Warcraft* or *Everquest*, the only thing you can really lose by staying offline is social standing among other players. Still, some persistent worlds *do* have stronger features of temporal expansion. In the fantasy online game *Shadowbane*, other players can declare war on your settlement, which you then have to defend for a set period. In the science fiction world of *EVE Online* you have to fuel your space stations periodically or they will fall out of order and eventually be destroyed. In order to optimize defense and maintenance, most large *EVE* corporations recruit officers from various time zones around the world.

Games that have a persistent world contain the seed of temporal expansion. Although it may not be the aim of the designers, players may start playing the game even when they are not playing officially. Especially role-playing games tend to do this. Series of live-action role-playing games that are set in the same diegetic continuum, such as

Vampire the Masquerade larp chronicles, have sometimes prompted players to start playing between games. This playing can even jump from one medium to another. A face-to-face larp may be continued over email, phone, or as a tabletop role-playing game or when two players meet randomly on a street.

Games that have a persistent world can effectively become *dormant games* if the players choose to play them in that fashion. This is usually initiated by the most active and committed players, who start to set up obligatory play sessions or call on their inactive playmates to get online when they are needed. If a dormant game is not something that the designers want—as all players are hardly prepared to play whenever someone else prompts it—it might make sense to discourage this kind of activity.

Structuring the Game Duration

The designer of a temporally expanded pervasive game can divide the game into phases, each requiring a different play style. Although using different phases does not expand the game per se, they are important tools in structuring and pacing a game that runs over a long period of time. Long, time-consuming games set in persistent worlds tend to be pervasive, as the required effort forces players to juggle ordinary life and the game. Game phases can be explicitly communicated to the players or kept hidden. Figuring out the best style of gameplay of a particular game part can be a challenge in itself.

The most useful way of temporal structuring is using *high-* and *low-intensity phases*. In a continuous game, it often makes sense to schedule major events for certain weekends to ensure that a maximum number of players are able to participate. In *Momentum*, the most important events took place during three intensive weekends, and players were given an advance warning of them before the game started. In the interims, the game masters introduced fewer plots, which were usually personal or less important, tied only loosely to the major plotlines. In addition to allowing players to attend the most important game events, this design allowed them to play passively and to relax in the meantime.

In *The Beast*, new content was always added to the game on Tuesdays. There was no diegetic explanation for this, and the majority of players were not available at those times. According to Dave Szulborski (2004), the day was seemingly chosen at random, which damaged the plausibility of the game. However, players who learned about the update day could relax on other days and focus their active play on certain times. According to *The Beast's* lead writer Sean Stewart (2008), although a lack of an artificial rhythm is theoretically more satisfying, it is more advantageous to have a time when players are allowed to not have to respond to an experience that lasts weeks or months. A lack of rhythm in a game makes it hard to parse noise from signal.

Starting the Game

The very start of a pervasive game often makes or breaks the whole game experience and, hence, should be crafted very carefully. The following example from *vQuest*, documented by Michael Finkel (2001), illustrates a powerful way of starting a game:

> *The Game started with a phone call. Actually, it started about ten minutes earlier, when I signed up for it on the Internet. The application seemed innocuous. I typed in name, address, telephone number, e-mail address. Only the final request was a*

bit curious: I was asked my favorite coffee drink. "Latte with a shot of vanilla," I wrote and hit SEND. Then the phone rang. A woman with a thick Southern accent informed me that she represented a company called Clark Lewis United Enterprises. She said she was conducting a telephone survey and asked if I could spare a minute. I was about to hang up when she said, "at the end of this survey, you could be eligible to receive a free latte with a shot of vanilla." I grabbed a pen and paper. The woman repeated the name of her company, and I jotted it down. I saw what the first letter of each word spelled out and realized that the Game had already begun. (Finkel, 2001)

A common way of luring players into alternate reality games has been through *rabbit holes*, which are ludic entrances to the fictitious world of a game hidden in ordinary environments that people can find accidentally and then enter the game (McGonigal, 2003b). Basically this means that puzzles or mysteries that lead to the game are hidden in plain sight. *The Beast* was entered through the advertising campaign of the film *A.I.*, whereas *Urban Hunt* drafted players through a fabricated advertisement for a television series placed on a Web site that follows reality TV shows.

Believability is the most important feature of a rabbit hole, as it should not betray its ludic nature before the player has entered the game. However, as rabbit holes have become a typical way of starting an alternate reality game, regular players have become quite apt to recognizing them. Today, rabbit holes that wink at a knowing audience have also become quite common (see Figure 5.3).

Another tried-and-true trick utilizes the fake cancellation technique, as depicted in the film *The Game* and later on in games such as *Majestic* and *Momentum*: The game operator fabricates a cancellation of the game even before it starts but makes that cancellation a part of the game. Thus, the player gets to volunteer to partici-pate, but the game still gets to surprise her. An extreme way of staging this would be to include a "broken" participation form presented on a game Web site, returning a 404 broken link page while still collecting the information for the game organizers. A player would consider her registration unsuccessful and, thus, volunteer to enter the game in an unaware manner. (See Chapter Ten for ethics discussion.)

Prosopopeia Bardo 1: Där vi föll was another game paying attention to details already in the sign-up phase in order to create a seamless experience. While the sign-up page was entirely recognizable as one, everyone entered the page with a personal invitation code. After the sign up was completed, the codes became useless, and players could not find the pages again. "See you on the other side" was the message after the final click, after which the player was irreversibly considered to be in the game.

Tutorial Mode

Participating in a long, complex pervasive game is not only time-consuming, but it often also requires the player to learn how to play the game. One solution is to borrow a method from digital games, which use a tutorial mode to familiarize players with the interface, teach the use of the controls, and introduce the backstory.

Momentum had an introduction period to the game world and play mechanisms. The first weekend of the game was heavily controlled: The player characters were led by a character played by one of the game designers, who passed on background information,

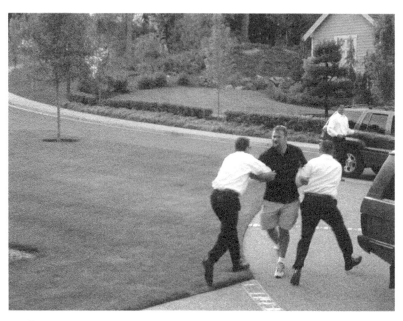

FIGURE
5.3

***Shelby Logan's Run* started when the doorbells of the future team captains were rung individually. Each encountered a frantic man demanding to speak to "Shelby Logan" before being dragged away to a van. Only a small clue in the form of a phone number was left behind.**

taught how rituals (the core game mechanics of *Momentum*) worked, and introduced the central gaming locations. This ensured that all players were on the same page regarding the theme, tone, and style of play, as well as the mechanisms and practicalities of playing. However, this period was not denoted to the players in any way, but implemented in a diegetic fashion.

The tutorial mode can also be designed in an opposite way. In *Shelby Logan's Run* and *Där vi föll*, players had to crack puzzles in order to find out the exact starting time and place of the game. This kind of preparatory phase can function as a warm-up or can simply be used as a competitive way of cutting down the number of participants.

Change over Time

The rules of the game can change over time. Places and objects that were not relevant in the beginning of the game can become important, scoring systems can change, and games can have different modes.

A simple way of implementing change over time is to change the scoring system. If in the beginning players were supposed to spot blue cars or Bluetooth beacons, in the end this could be changed to red motorcycles or radio frequency identification (RFID) tags. Even though very little has changed from the game design point of view, players have to change the way they perceive the world ("what is relevant") and adapt their behavior.

Another common way of doing this is to raise the stakes as the game progresses. In *The Beast*, players were first calling answering machines, but later they had to talk with actors. The first part of *Momentum* guided players through missions, the second left them to complete missions alone, and the third part only gave them aims, leaving them to come up with the missions by themselves. In *I Love Bees*, players were supposed to answer pay phones around the world. In the beginning, the phones rang at times when they were easy to reach. Later on, the phones started ringing in closed restaurants. Finally, the game masters would call all the pay phones at Washington, DC's, Union Station simultaneously (McGonigal, 2008). This kind of escalation is normal for games, but in pervasive games it often also leads to a qualitative change in the challenges presented.

Late Arrivals and Early Leavers

In games that last a long time and have numerous players, there are always those who want to quit playing before the end and those who wish to join in during the game. Early leavers risk a feeling of frustration over leaving the game with unfinished tasks. They may also jeopardize the game for players who stick with the game. Latecomers to persistent games may feel disadvantaged if players who have entered the game earlier have been able to establish better positions.

A long-running game needs to be designed to cater for both these situations. Obviously, players need to know whether it is possible to arrive late or leave early. However, even if players are committed, unforeseeable events may force them to change their plans, sometimes breaking the rules of the game in the process. The goals of *Insectopia* are either easy to complete instantaneously (e.g., catching the insect) or they naturally require periods of dormancy in between (e.g., making sure that you catch the same insect every week). This makes it easy to fade in and out while still providing an incentive for long-term play. Latecomers may be initially disadvantaged, but the incidental find of a rare insect can allow them to climb fast in the high score list.

Managing Stress

Temporally expanded games can be highly stressful. Michael J. Apter (1991) discusses pleasure and arousal in the context of playful and serious mindsets, claiming that people in a playful mindset seek pleasurable, aroused *excitement* and avoid *boredom*, whereas people in a serious mindset seek pleasurable, nonaroused *relaxation* and avoid unpleasant, aroused *anxiety*.[1] Basically, this means that being worked up while working in a serious mindset leads to anxiety, whereas being worked up while playing a game in a playful mindset is experienced as exciting (see Figure 5.4).

The problem of temporally expanded games is that players are, to some extent, always in both a playful and a serious mindset, whether they are playing actively, peripherally, or passively. Thus, tension can produce both excitement and anxiety, just as a lack of it can lead to relaxation and boredom.

Numerous accounts agree that games such as *BotFighters* (Bjerver, 2006), *The Beast* (McGonigal, 2006a), and *Momentum* (Stenros, J., Montola, M., Waern, A. & Jonsson, S. 2007a) can be highly stressful. While *Killer* and *BotFighters* require players to watch their

FIGURE
5.4

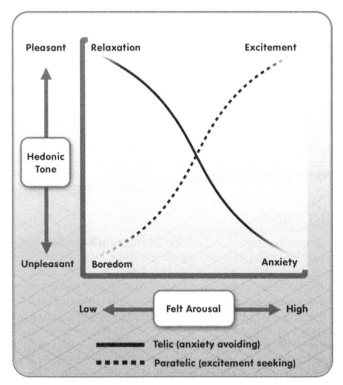

Michael J. Apter's (1991) visualization of how telic (serious) and paratelic (playful) mindsets operate differently.

backs constantly, finding and solving problems in *The Beast* and *Momentum* simply require a huge amount of active play. There are many things to be considered in stress management.

Contextual Adaptability

All temporally expanded game design should give consideration to *contextual adaptability*: "The ability of a game to adjust, either actively or passively, to changes in the social environment so that negative effects on gameplay or activities overlapping play sessions are minimized" (Björk, Eriksson, Holopainen, & Peitz, 2004).[2] The gameplay should be reasonably compatible with other player activities. The player of a contextually adaptable game is not expected to look at a mobile phone while driving a car or yell out loud in a business meeting.

One of the easiest methods for increasing contextual adaptability is allowing interruptability, as discussed later. Another key to contextual adaptability is to allow players to play the game without changing their outward behavior. Thus, the design of ludic interactions is key: It is much easier to play a game in places not meant for playing if the interaction is invisible or indistinguishable from ordinary activity. From a distance,

playing *Insectopia* is indistinguishable from SMS chatting, which makes the game playable wherever it is acceptable to send text messages. The social weight of the technology is minimized through disguising it as another technology. Pervasive and ubiquitous computing technologies make even more unobtrusive interaction possible by integrating technology into everyday objects and clothes.

One problem is that designing for contextual adaptability can lead to a game that is not engaging or interesting as the challenge and engagement level needs to be controlled. A player of a boring game can put it down more easily than someone who is emotionally committed to succeeding in the game. Indeed, a *BotFighters* player may enjoy the thrill of surviving an attack while driving a car, whereas flash mob participants enjoy breaking social conventions. A good temporally expanded game strikes a balance between sufficient contextual adaptability and thrilling pervasivity.

High Stakes and Social Obligations

As a game becomes longer and more engaging, the emotional stakes that players invest in it become higher. If a player is in danger of losing significant game resources or even losing the game when failing to address the game as needed, it requires more attention and becomes emotionally straining: A player cannot afford to relapse into passive play. This means that balancing the rising stakes of the game and social obligations, basically dealing with the overlap of game and work, becomes a central issue.

This strain is not necessarily a bad thing; a game (such as *Killer*) can even be based on it. High stakes lead to intensive, stressful playing and hardcore culture (although not all hardcore players prefer high stakes); correspondingly, games with low stakes are less intensive and inspire carefree, casual playing. Many persistent world games have experimented with allowing player characters to die permanently, forcing players to lose all the resources they have gathered. However, because of the stress and irritation of such a feature, it is a rare design feature in contemporary online worlds (see Mulligan & Patrovsky, 2003). In *Killer,* the penalty of a surprising and often unavoidable permanent death is mitigated by the fact that the games are relatively short, and getting out of the game through dying is a central part of the gameplay.

Interruptability

If a game is not built around the concept of dormancy, then some way of stepping out of the game should be offered to the player. A central method of balancing high stakes and social obligations is designing *interruptability*—giving the player a metaphorical pause button. However, in order to discourage players from interrupting the game, this sometimes comes at a price or is socially frowned upon. In *BotFighters*, exiting the game means that the player loses the usage of the most powerful weapon until she has been in the game again for 24 hours.[3] In *Killer*, restrooms are usually defined as safe zones outside of the game. However, fleeing to a restroom while being chased by another assassin would be seen as bad sportsmanship—or in this case the rule regarding safety zones might be ignored.

Role-playing poses a particular problem when played over a long period of time and on the street: Players who abandon their character roles must frequently to be able to interact with outsiders or carry on with their normal lives. However, unless this is done

in a clever way, temporal expansion becomes impossible, as the player will be in full control over when she is playing and when she is not. *Momentum*, with its month-long running time, used the *possession model of role taking* as a means to overcome this dilemma. The players played themselves in a fictional world where they were possessed by spirits of dead people. This meant that both the players and their characters had a role within the game diegesis and that they could at any time choose to actively *play* as themselves or as their character. Through this mechanism, the game was not suspended when a player stepped out of character, and a player could, for example, pick up the phone to talk to her mother. In general, dual roles are one way of navigating the problem of interruptability.

Pace and Stress

The stress caused by dormant games depends on how fast the game requires a player to react to ludic stimuli. If the reaction time is very short, players need to be constantly prepared to react, and the elements of surprise and tension dominate the game. The paranoid atmosphere of *Killer*, in which the surprising assassin often leaves you with no reaction time at all, is an excellent example of this. This is one reason why *Killer* games are limited in length, typically lasting no longer than a few weeks.

Allowing a longer reaction time leads to a more leisured pace, a more casual game, and more flexibility for the player. One way to facilitate this is by supporting asynchronous playing.

Stress can be a positive force, creating a flow-like state for a player. However, upholding this for long periods of time is taxing.

Information Overload

Most pervasive games use information technology to allow players to participate in the game. This ranges from sending emails and text messages to calling and sending faxes. In a long duration game, it is often central to adapt this messaging to individual playing styles in order to both allow devoted players to access content more rapidly and let casual players play the game at their own pace.

In this sense, SMS messages are one of the most delicate media. Receiving as few as 5 or 10 messages every day can turn into a serious irritation, while still conveying very little information. To deal with this problem, *Day of the Figurines* constantly tracked the number of messages sent into the system and adapted the activity level of the system accordingly: The faster and more active you are, the faster you will get more messages (see Crabtree et al., 2007). This also means that the game has high *contextual adaptability*— it adapts well to any situation.

Conclusion

Temporally expanded games invade a player's ordinary life and spice it up. They mix playful and serious activities and situations, producing a refreshing element of surprise that feels as though it is just out of the player's control. The games add color to mundane, boring moments with the ever-present possibility of playing. However, as players

can never control the games completely (without exiting the game), this does produce anxiety that needs to be taken into account in the design.

The ultimate temporally expanded game would completely erase the distinction between the ordinary and the ludic. This has been attempted by numerous alternate reality games and pervasive larps, but they all still require a leap of faith and a conscious act of pretence. As discussed further in Chapter Ten, conscious play is a central ingredient of games. The complete removal of the magic circle causes feelings of unease, anxiety, and even dread.

Playtesting games with temporal expansion can be very difficult. As players take the game with them everywhere they go, it is impossible to predict all situations that may emerge. Only long-running playtests in real contexts can shred light on how the game fits in with the rhythm of ordinary life: Try sending SMS messages to your friends at random times, asking whether they could *right now* run two blocks to dodge an incoming missile—and how they would feel about it. Gathering data from playtesters is not trivial either, as retrospective player reports tend to be inaccurate, and updating a game diary in real time requires a lot of work.

Notes

1. We have simplified Apter's terminology a little: He discusses playful as *paratelic* and serious as *telic* frames of mind. As we restrict our discussion to gameplay, we can make do with playful and serious. We do not penetrate deeper into Apter's model regarding stress but use this conceptualization as a tool for the design of pervasive games. Stress should be understood in its everyday meaning here, not as a precise psychological concept.
2. Contextual adaptability has been earlier discussed as social adaptability, for example, in Björk et al. (2004).
3. The reason for this was sustaining the critical mass: The designers wanted to enable 24/7 gameplay by sustaining a sufficient number of players at all times.

Momentum

Jaakko Stenros and Markus Montola

You've been playing a larp nonstop for weeks now. It's not an ordinary larp; you're supposed to play two characters. One of them is your ordinary self, the guy that your mother and friends think they know. But the other is different; she's a dead revolutionary from another age, who possessed your body early in the game. She's a pacifist and a vegetarian, disliking many of your regular habits. For over a month you live a double life, trying to keep up appearances while slipping away at every possible moment to fight the fight. You learn mythology and conduct rituals in places of importance, sometimes slipping behind the scenes of the city in order to visit abandoned tunnels and dismantled industrial areas.

As the game concludes you, along with the other dead revolutionaries, stage a demonstration, marching through the city with torches and banners. During the 5 weeks you have learned countless secrets and assigned new meanings to places, actions, and things. It is weird to participate in such a direct confrontation with the consensus of reality: Outsiders can't see the function of the parade, not understanding it is All Hallows' Eve and the dead rebels are heading home.

Prosopopeia Bardo 2: Momentum[1] was a pervasive larp staged in, around, and under the city of Stockholm for 36 days in the fall of 2006. The game was designed and played around the central idea of *play it as if it is real.* This was reflected in the game world, characters, playing style, character selection, game areas, runtime game mastering, and the general mood of the game. Everything was to be as realistic and seemingly unmediated as possible: If you wanted to dance, climb, drink, or punch in this game, you had to do it for real (see Figure F.1).

The backstory of the game was woven from real history, with just certain interpretations and fabricated facts added: For example, the game used historical people, places, and mythologies. This enabled the players to research the game world endlessly, as there was a huge amount of real world books, videos, Web sites, and such to engage with. For the players, it was impossible to determine where the fabricated content ended and real history began.

The players could never tell who was playing and who was not. Some game masters pretended to be players, whereas others pretended to be outsiders. Sometimes outsiders were presented in a way suggesting that they might be players, and sometimes such outsiders had actually been instructed to act in some way when encountered by players. As the players did not know where the ordinary ended and the game began, the protection offered by the magic circle waned. The lack of game mechanisms meant that the players were responsible for all of their acts both in the game and in the ordinary world. This meant, for example, that

Momentum **pushed the boundaries of social expansion through unaware participation. During the final day of the game the players staged a public demonstration in the center of Stockholm, demanding that dead revolutionaries not be forgotten. The police who observed the demonstration were unaware of the ludic origin of the event.**

there was little actual violence in the game: A player mugging someone would also be punished for real.

The player characters were all dead revolutionaries, people of renown, including figures such as Ken Saro-Wiwa, the Nigerian Ogoni environmentalist, and Sylvia Rivera, the New York transgender activist. The players constructed interpretations of these people based on material they could find from libraries and the Internet.

The possession model of role taking is a double life strategy (see Chapter Seven), where players seek to get *immersed* into the characters and pretend to be actually possessed by the ghosts, enabling the players to play as their ordinary selves (the hosts) as well as the characters (the spirits). This is actually how many occult traditions believe possession works; you learn about your possessor, you engage in a ritual with or without mind-altering substances, and you pretend (or engage in self-hypnosis) really hard to be the possessor, possibly even believing it yourself. Thus, the immersion into character could be interpreted as "playing it for real." The model also allowed players to play without interruptions; if you got a phone call from dead rebels while sitting at the dinner table, you could easily merge the two realities with no conflict.

Although the game mostly took place in Stockholm, the game area was borderless, as activities took place around the country and even across borders. The specific locations were chosen to resonate with the urban and political decay aesthetic of the game. While

The players used supposedly "techno-occult" devices to play the game. The lack of GPS coverage was explained to be caused by the fickle nature of magic. The *Omax* phone channelled voices from the afterlife when in the correct location (actually it communicated with the other devices in the picture and played sound files from the game server when certain variables were aligned). The *Thumin* glove was used to find fissures in reality (it would vibrate when close to the hidden RFID tags). The *Steele* pyramid was an occult artifact that had to "see the stars" (and GPS satellites).

scenography was built into a few select places, such as the rebel headquarters, most of the city was used as it was.

The aim of the design was to construct a game where the seams between the ordinary and the ludic disappear, using all three expansions. There was no spatial limit to the game, and the players did not know who was involved in the game and had to approach each person on the street as if they were part of the game. The game had a set ending, but until then the game ran constantly, infiltrating the players' everyday activities.

The seamless design philosophy also extended to the technology used in the game. The game used *indexicality* as a design strategy in its propping and set building (see Chapter Four); everything had to look, feel, and work exactly as if it was real. If the game technology broke down, it had to be fixed in a diegetically sensible manner (see Figure F.2).

The main method of game mastering was the use of innumerable nonplayer characters. These researchers, ghosts, shamans, angels, and warriors stayed in constant contact with the players, creating an illusion of a fully populated underworld. Different characters used various media to communicate, some sending emails, with others using MSN messenger or phone calls. In addition to everyday communication channels, the players were able to contact dead people through custom-built supernatural communication equipment inspired by electronic

voice phenomena—a paranormal field of study supposedly dating back to Thomas Edison. Creating an illusion of seamlessness required the game world to function flawlessly. The game masters had to work in shifts in order to know player plans and improvise appropriate and timely responses. They used video and audio surveillance, spies infiltrating the player group, network monitoring, and GPS tracking. Almost a hundred people worked behind the scenes on the game mastering, technology, nonplayer characters, scenography, research, and so on.

All this contributed to an experience that merged ordinary life and game as totally as possible, taking the players to literally live in the magical world of *Momentum*. The only way players could step outside the game was through the use of a safeword, which was only done for the total of half a dozen times.

A huge amount of game content was needed to allow unlimited play for a long duration. Most players played actively for a few hours every day during the week and then uninterruptedly from Friday to Sunday evening. A few played actively only during the weekends, but the most dedicated fifth played actively much more, literally living in the rebel headquarters.

In order to meet the demand, *Momentum* tapped on many sources: Many mission structures came from MMORPGs such as *World of Warcraft*. Searching for ritual sites used the location-specific play of *geocaching* and the riddles of *letterboxing*. Much of the playtime was spent on the immersionist character interaction typical to Nordic larp (see Figure F.3). Physical action was brought in from *urban exploration*, and the public political performances borrowed a lot from the *Reclaim the Streets* movement and the *adbusting* community. Finally, the rituals

The players have gathered in the war room to plan their next ritual and to solve the puzzles they have run into. They do this while immersed in their characters, while role-playing the ghostly possession.

were constructed in a way that is in apparent debt to both performance art and historical occultism.

The tight connection to the ordinary world and to ordinary history was a never-ending source of game content. As all the information in libraries and on the Internet also existed in the game world, the players could do actual research on game issues in the ordinary world. As some Web sites were fabricated, the players had to run google searches in order to solve problems.

Playing a game intricately tied to the ordinary world is difficult. The threshold was mitigated using a game structure based on an escalating difficulty level. In the first phase of *Momentum*, the players received missions, objectives, and instructions on how to carry out these assignments. The plots were straightforward and predetermined. In the second phase, the players received fewer instructions on how they were supposed to act, and only missions and goals were provided. In the final phase, the game masters took a step back; the players had to both decide what they wanted to do and come up with the means to do it. In practice, this meant that in the beginning a nonplayer character instructed the players on rituals, pointed them toward books and sites relevant to the mythology, and then led the players out on the town to perform the ritual they had constructed. Near the end of the game, the players were given the mission of staging and performing a demonstration. It was up to the players to decide what the demonstration was for, how it would be conducted, what would be its mythological significance, and how to recruit people for it. The players were first enabled to learn the ropes of the game and then allowed to toy with them.

The pedagogic structure also supported the left-leaning political message of the game: The argument made by *Momentum* was that we live in the world we perceive, and changing that perception changes the world. The game introduced, taught, and helped test methods of resistance and alternative viewpoints to the players.

The way the game was played out was left to the players, and improvised game mastering supported an open-ended plot. To structure the free play, the game adopted the form of an archetypical rebellion, where disparate factions are united by a common enemy. After the climax of the conflict, the factions enter a struggle for the spoils or, if they lose, survival in a hopeless fight. As *Momentum* rebels won their fight in the third week, the game had a relatively happy ending. A failure scenario would have ended in the two last weeks, turning into a tragedy seasoned with bitter infighting.

To a certain extent, *Momentum* can be seen as an exercise showing whether role-players can get "stuck in character," as has sometimes been claimed in the popular press. In retrospect, we can see that this game used almost all the tricks in the book to make players forget the border of the ordinary and the artificial, but still it failed. Although the players were exhausted, moved, and exhilarated when the game ended, they had no problem leaving their characters in the realm of fiction. The game had given them food for thought and possibly even changed their perspectives on some issues, but it had not made them permanently believe that they were possessed.

Many of the methods used in *Momentum* were tested in *Prosopopeia Bardo 1: Där vi föll*,[2] a smaller, shorter prototype game that had run a year earlier. The central lesson from *Där vi föll* was that a pervasive larp needs a way to deal with conflicts caused by overlapping influences of ordinary life and game world. This problem was solved efficiently through using the possession model with three roles: the revolutionary, the possessed player, and the player outside the magic circle. Even though the third one was rarely invoked, clear differentiation of the second and the third role made *Momentum* a much clearer and emotionally safer game to play than *Där vi föll* was.

Notes

1. We have previously discussed *Momentum* in a number of publications. For design, see Jonsson, Montola, Stenros, and Boss (2007a); for social play modes, see Stenros et al. (2007); for game mastering, see Jonsson et al. (2007b), for seamless life/game merger see Stenros et al. (2007b); and for a full report, see Stenros et al. (2007a). Additionally, for designing pervasive larps, see Montola, Stenros, and Waern (2007).
2. Eng. "Where We Fell." For evaluations of that game, see Jonsson, Montola, and Waern (2006) and Montola and Jonsson (2006).

SIX

Designing Social Expansion

Markus Montola, Jaakko Stenros, and Annika Waern

Games that expand the magic circle of play spatially or temporally also have the tendency to expand it socially. When the spatial and temporal boundaries of games are broken, outsiders get involved in the play, whether or not they are aware of it. Social expansion can be a desired property or a by-product of other design choices, but it is also something that needs to be examined and assessed in each pervasive game. There are two basic questions to ask: "How is my game going to affect outsiders?" and "How are outsiders going to affect my game?".

As we have seen, temporal expansion is about blurring the dichotomy of playing and not playing, as all the mixes of activities blur the boundary. Social expansion adds to these various shades of gray, as different roles of participation and various levels of awareness become relevant. In this chapter, it is essential to pay attention to the difference between a *participant* and a *player*. The former denotes anyone who comes into contact with the game, whereas the latter denotes a person who plays the game *consciously*. If a spatially expanded game takes the players to a bar, the waitresses and even the pianist participate in the event, even though they clearly are not players. In *Killer*, your target's girlfriend is a participant even if she never meets you: She has a part in the game, even though that part may never be actualized.

Social expansion is also dependent on temporal and spatial expansion; games that do not blur the borders of game area and play session are unlikely to produce social expansion. This dependency is exceptionally clear in *Mystery on Fifth Avenue* (Case E). Although the game features temporal expansion and has a potential for strong social expansion, it can only be played by the people who are allowed to spend time in the private apartment it is staged in. In practice, the lack of spatial expansion limits the opportunities for social expansion.

All the case examples presented in this book feature interesting forms of social expansion. Even the ones that do not seem to have obvious interaction with outsiders are often interesting in the ways they hide from their environments. The outsiders can be obstacles (Cases A and D), witnesses (Cases C, F, and J), an audience (Cases G and M), or tokens to be collected (Case I) and they can be invited to become fully fledged

player–participants (Cases B, E, and J). Players can also introduce socially expanded activities to many of these games: While most assassins try to avoid outsider attention, a *Killer* player could learn the whereabouts of her target by asking outsiders.

Game Awareness

When designing pervasive games, it is central to understand how the *game awareness* of participants fluctuates during the game. A person who is completely aware of the game, who knows what is going on, and who is aware that some elements are artificial and fabricated will react very differently from a person who is completely unaware of the game.

There are three[1] rough levels of game awareness. Participants in the *unaware state* do not notice anything strange going on, even though they are witnessing play or unknowingly even have a role in a game. Participants in the *ambiguous state* notice that something is going on but fail to realize that the weird occurrences constitute a game. Finally, participants in the *aware state* understand that there is a game going on and can usually tell who are playing and who are not. However, these three levels are grades on a sliding scale; a person who just wonders why everyone entering the bar is wearing a black suit and sunglasses and a person who suspects that the men in black are playing some sort of game are both in the ambiguous state.

Unaware participants treat everything they encounter as ordinary and real (see Figure 6.1). As discussed in Chapter One, they lack the protective framework of play shielding

**FIGURE
6.1**

In *The White Road* the players dressed up as a specific type of Danish vagrant and wandered around the countryside for days. The people they encountered did not know that a game was in progress. Passing trucks honked at the hobos and, when buying beer, the locals would give coins to them. (see Pedersen & Munck, 2008)

DESIGN

them from scary experiences, as well as the lusory attitude restricting their choice of options for action. These people are still *somehow* involved in most expanded games; in *Killer* they are witnesses to be avoided by the assassins, in *Insectopia* they carry Bluetooth insects around, and in *The Beast* they watch the movie trailer, potentially paying enough attention to the credits to notice the sentient machine therapist reference.

Ambiguous participants realize that there is something out of the ordinary going on. They are concerned enough to pay attention to detail and try to find an explanation for the encounter. They might treat the game as a performance, an art installation, an act of vandalism, a carnival, or something else. These people may google "sentient machine therapist" to satisfy their curiosity, confront players to ask why so many people are running amok in the park, or call the police when they encounter something suspicious and frightening. The challenge with unaware and ambiguous participants is that their behavior is more difficult to predict than that of aware players. Playing with people who are not aware of the game also poses a number of ethical questions, which are discussed in Chapter Ten.

Aware participants constitute the easiest group. They know there is a game going on and how to deal with it. Aware participants include players, informed spectators, and game organizers. Simply telling a bystander that a game is in progress will move her to this category (or at least to the ambiguous state if she has reason to doubt the statement). Because of the way pervasive games are structured, aware participants still often lack a holistic bird's eye view of the game; they may not know everyone who is involved or all the elements that have been incorporated. Yet the knowledge that a game is running allows them to explain the weird and unexpected events that they may encounter. However, even informed and experienced players might sometimes wonder what is and what is not a part of the game. Often this ambiguity is fun.

Game Invitations

The game awareness level of a person may change during the game. Often this journey from unaware to aware participation can be a great experience. Changes in game awareness take place through *invitations*: As the games are played in social environments, they constantly propagate implicit and explicit invitations to bystanders, offering them a chance to change their mode of participation. It is possible to invite bystanders to participate in the unaware state as well as in the ambiguous or even the aware state (see Case B). Performative play invites bystanders to spectate; rabbit holes invite curious explorers to play the game. The full range of invitations is extremely broad: Treasure hunts may require players to enlist help from bystanders, whereas games such as *Killer* challenge bystanders to realize what is going on as they seek to hide themselves from the witnesses.

Invitation to refuse is an important form of invitation. As unaware game participation is obviously problematic at times, it is extremely important to provide bystanders with exits. Inviting aware participants to refuse the game is usually trivial; it is easy to refuse an invitation from people dressed up as superheroes performing and photographing wacky actions on the street. The tricky part is making refusal a valid option for unaware participants as well. Staging a reality game scenario around the idea of a "broken" elevator would be an extreme example of an event with literally no exits for participants.

Interaction between aware and unaware participants is especially exciting for the aware players if there are no ludic markers of who is a player and who is not (Benford et al., 2006; McGonigal, 2003a; Montola & Jonsson, 2006). The ambivalence regarding playership can produce an intricate dance, where the aware player is simultaneously testing the other person to find out whether she is playing, and trying to carry out the right game move in case she is, while still keeping the encounter grounded in reality to achieve plausible deniability if she is not.

In the best-case scenario, both outsiders and aware players find the interaction rewarding. *Momentum* (Case F) took the players to an art gallery where they were supposed to obtain a painting that the game masters had put on display. However, the gallery workers had not been informed about the game in any way, and the rules of the game forbid players to tell that a game was in progress. For one day, the gallery was frequented by weird people who were all interested in the same painting. After a while, the gallery workers started to suspect that something weird was happening (slipping from an unaware state to an ambiguous one), started to write down the names of the people coming in, and then googled them; they basically started to play a game of their own. One of them later recalled the day:

> *I tried to look up Ingela [the person credited for creating the painting], and I couldn't find anything except she was mentioned in like a blog. They [the players] were [also] talking about a journalist that was killed, [. . .] they mentioned her name there. And it seemed to be like about all these conspiracy theories and all of these UFO's and all that, so I was like, it was intriguing that these were the people that they were doing. [. . .] It was definitely something to do that day, yeah. (Stenros, Montola, & Waern, 2007b)*

The gallery workers were interviewed a few days after the encounter, which was when the ludic nature of the encounter was disclosed for the first time. They felt that their exposure to the game had been a positive one and that the fact that they did not know what was going on was a central reason why it was fun. When they were asked if they would like to continue participating in the game, they declined:

> *I don't know if that would work, because it's funnier when you don't know. 'Cos if you know, then. . . That wouldn't be fun. (Stenros et al., 2007b)*

Creating fun experiences for unaware participants is tricky, and a little dangerous. In this case, it would have been very difficult for the gallery workers to refuse the invitation to play, as the game invaded their work space. Although the case exemplifies that ambiguous encounters can be a lot of fun, it is not a model example for how to invite unaware participation.

Modes of Participation

In addition to the various levels of awareness, pervasive games often offer various modes of participation. The cross-medial alternate reality puzzle game *Sanningen om Marika* (see Denward & Waern, 2008), which revolved around a television series, serves as an example: Some participants were happy to watch the television series, whereas

others also played the alternate reality game complementing the series. Some events were staged physically and attended by some players, and there was also a subgame that players could play on their mobile phones. Even though all these modes of participation were linked and contributed to each other, players could decide on their engagement in the different forms of play. As Christy Dena (2008a, see also 2008b) writes, such tiers "provide separate content to different audiences and in doing so facilitate a different experience of a work or a world."

One way of structuring tiered playership is using a layered *onion model* with outer and inner modes of participation. An outsider could first be invited to spectate, then to participate in an alternate reality game, then a treasure hunt in the physical world, and, finally, a reality television show. Each layer of participation is more engaging, demanding, and exclusive than the previous one: Players have to struggle to move through the layers, which also provides them with the invitation to refuse the inner layers.

This structure is particularly useful in three cases: in pervasive larp, in reality television, and in games with high monetary prizes. The outer layers serve as qualifying rounds, limiting participation in inner layers in a fair way. The inner layers reward the most involved players with new forms of play and possible prizes. The outer layer of *Perplex City* was an alternate reality puzzle game, but in order to win a considerable sum of money, players had to use puzzle clues to find their way to England and to dig up a physical artifact from the ground.

As Dena (2008a) writes, some participation modes are products of the player communities—especially alternate reality game *readers* (see Case B) are enabled by player communities:

> Over 7,000 Cloudmakers made the experience of The Beast *possible for over 3 million people, and around 10,000 players answered payphones so that nearly two-and-a-half million people could casually track* I Love Bees. *It is because of the cultural production of grassroots communities that people are able to watch.* (Dena, 2008a)

It is important to ensure that the various play modes contribute to each other and support an experience that is larger than its parts. A television show can be used to provide clues to the outer layers or alternate reality gamers can end up tracking pervasive larpers in the process of their problem solving.

Playing with Outsiders

Encouraging social expansion in a game usually requires that players feel that interactions with bystanders—or players they think are bystanders—will give them some benefit in the game.

This can be achieved by giving the players missions where they need to engage with bystanders. In *The Great Scavenger Hunt*, players needed to pose for photographs with bystanders. One task in *vQuest* required the players to convince a baseball audience to shout a chant with the words "artificial" and "intelligence" in it. Another approach is to objectify bystanders into game tokens. *Insectopia* is a great example of this, as the Bluetooth devices that bystanders carry become collectible insects. Bystanders can also be knowledgeable experts from whom players need to get information (e.g., to solve a

puzzle in an alternate reality game), an audience for a performance put on by the players, or the target audience for a fun activity that the players invite bystanders to join in.

Another way of encouraging interaction is to create random player-to-player encounters so that players never know when interacting with someone is relevant for the game. The problem with this is that often, if the game area is not limited, there are simply not enough players to achieve a critical mass for relevant encounters. Nevertheless, people complimenting randomly encountered bystanders in *Cruel 2 B Kind* demonstrate how this can work.

A useful way of creating the illusion of a live and densely populated game world is to make use of *instructed nonplayer participants*. These actors, plants, and nonplayer characters are central tools for game designers and game masters. They are used to provide game content and props to players so as to stop them from doing things that are not advisable or would break the game and to guide them to the right place at the right time. If players cannot discern who is an instructed character and who is a bystander, the mere existence of nonplayer characters encourages players to engage in meaningful interaction with bystanders. If even more subtlety is needed, the designers can employ *informed outsiders*. These are people who do not know much about the game but have agreed to perform a certain task. For instance, a bartender could give a locker key to people who ask her to play a Metallica CD, just because a game master kindly asked her to do so.

Fostering Pronoia

One result of taking the game into the real world and blurring the line between life and game is that players may not be able to discern between deliberately planned parts of the game and coincidental events in the real world. When play is not limited temporally, socially, or spatially, players cannot discern a real nurse from a planted one, a fabricated Web site from a real one, or see the difference between an authentic and a staged demonstration.

Early on in *Momentum*, the players had to contact a cell of revolutionaries. They knew that these people called themselves "The Others." Through googling they found a page on the Swedish Wikipedia, which explained that they had to go to one of the most central city squares in Stockholm and shout: "We want to meet The Others!" When the players did this, at first nothing happened. Then they received a flyer from a person handing out advertisements for a party to everyone in the area, except that the particular flyer that the players got had a handwritten note on the back side, which directed them to a certain floor in the biggest hospital in Sweden. There they were to contact a nurse. The nurse, who was a specially instructed participant planted by the game masters, was just hanging around in the corridor waiting for the players to arrive. From the point of view of the players, she was no different from the other nurses, except that she finally mentioned The Others and, thus, confirmed that the players were actually on the right track.

The *Momentum* game masters staged several similar missions in order to obfuscate the boundaries of the game. The way that the players viewed the world gradually shifted: They started to see everything in the world as game related. This is similar to the way seasoned alternate reality gamers constantly scan the real world searching for rabbit holes. These games encourage players to interpret *everything* as a possible clue or an opportunity to play.

In a way, players become paranoid, suspecting that everything relates to a game. However, this is positive paranoia, *pronoia*, a "sneaking feeling one has that others are conspiring behind your back to help you."[2] Jane McGonigal (2006c) discusses pronoia in pervasive games as a consequence of a *benevolent conspiracy*, as there is indeed a group of game organizers conspiring behind the backs of the players to ensure them as good a game as possible.

In *Prosopopeia Bardo 1: Där vi föll*, the players had a number of ambivalent encounters with people they could not pin down either as players or as bystanders. After the game, the players considered an encounter with a complete outsider as one of the highlights of the game:

> *A guy came by when we were [playing] at Skogskyrkogården. We talked to him for a while, but couldn't figure out if he was involved in the game or not. This I think is the best part, where you have no way of knowing if a person or experience is created with intent or not. (Montola & Jonsson, 2006)*

This feeling that everything is part of the game and that everybody is trying to improve the game experience is a central source of fun in pervasive games.

Emergent Interaction

Playing pronoia-inducing games in public spaces tends to create emergent interaction with outsiders. If the game design succeeds in instilling players with a feeling that it is safe to talk to anyone to try to enlist their help, the game world comes alive socially. The most fun game experiences often emerge when players are willing to extend the invitation to play to everyone (see Benford et al., 2006; McGonigal, 2003b; Montola & Jonsson, 2006; Stenros et al., 2007).

Jane McGonigal (2003b) documents an event from the scavenger hunt *Go Game*, where the players had been given the task of hanging a large cloth banner from the restricted overpass at the Hilton Hotel in San Francisco. The players promptly assumed that a hotel worker they encountered was a plant:

> *The team had already encountered two plants that day, one of whom had welcomed them into the backseat of his car to help navigate them more quickly through the city. So the team explained its mission to this "hotel worker"—the players knew, of course, that he was not really an employee, but rather an actor hired by the Go Game. When he initially declined their request for assistance in getting to the overpass, the [players] persisted. They wouldn't give up, because they knew plants were sometimes directed to be coy and to play hard-to-get. Finally, after much persistence, the "hotel worker" secreted the four players away to an employees-only hotel exit that landed them exactly where they needed to be to finish the mission. (McGonigal, 2003b)*

The players loved the experience, both during play and after having learned the truth about the matter, that is, that the hotel worker was authentic. McGonigal (2007) argues that when players are provided with specific instructions that require them to take an adventurous attitude toward public places, this allows them to surprise themselves with

their own daring and ingenuity. Also, they will learn that strangers are surprisingly receptive to such interaction.

Neil Dansey (2008) has discussed the concept of *apophenia*, seeing a connection between two unrelated things, as a source of emergent content in a game. The strength of apophenic emergence is that the game becomes richer when players assign ludic meaning to ordinary instances. The flip side of apophenic (mis)interpretation is that players may miss or dismiss designed ludic elements.

> *For apophenia in games, ambiguity can be created, but an interpretation must not be suggested, nor can progress in the game depend on the ambiguity being resolved. Game designers should provide nothing more than the potential for apophenia to occur. Luckily, pervasive games by nature have ambiguous elements which already do this. This ambiguity gives plenty of opportunities for players to see order in chaos. (Dansey, 2008)*

From the point of view of the players, it is not relevant if a game event was truly apophenic or if it was intended and designed by the game organizers. Apophenia can be a cornucopic source of meaningful game content and fostering it can result in a game much thicker with meaning than could be designed economically. Similar effects can be achieved by consciously using ambiguity as a design resource (see Gaver et al., 2003). Design strategies that cater for apophenia include giving players goals but not telling how to achieve them, providing too much information for no apparent reason, encouraging extrovert character role-play (see Chapter Seven), forcing players to ask for help from bystanders, and pushing players to speculate, question, and tolerate uncertainty.

Empowerment on the Brink

The act of playing, the magic circle, provides players with an excuse and an alibi to do things that break social norms. Cindy Poremba (2007) has discussed this with the term *brink games*, games that recognize and expose the conflict between ordinary life and game.

> *The popularity of* Twister *lies in its forbidden play or brink status: the framing of the game allowing the temporary reinscribing of rules of intimate social distance. In real life, only intimate partners get this close. But in* Twister, *we are only playing the game. Wink. (Poremba, 2007)*

The activity these games create might not be tolerated outside the magic circle, yet that transgressive element is the central appeal of these games. Players might play them in order to get to question societal norms, to push their own boundaries, or just to get a kick out of nibbling on the forbidden fruit.

Brink games need not be socially expanded, but precisely because social expansion—obfuscating the division between players and nonplayers—is a bit of a taboo, as there is almost always a brink element in social expansion. For example, *Cruel 2 B Kind* fosters "random acts of kindness" toward bystanders, *Momentum* pushed its players to stage a public demonstration, and *photo scavenger hunts* often encourage weird behavior among or with bystanders. That these kinds of activities are unexpected, uncommon, and at times even barely tolerated is the exact reason why they are thrilling and fun.

In essence, players are *empowered* by the game challenges, and they may leave the game with *insight* into what drives people in various social situations.[3]

Double Life

Popular culture often features heroes with double lives—secret agents, superheroes, and magical monsters that keep up the appearances of living ordinary lives, while in secret they will turn into werewolves and occult investigators at the first suitable occasion. The double life structure is a very useful and functional way of accommodating flashy fiction in boring everyday life and bland everyday places. The role of a secret agent or superhero enables a player to switch easily between the ordinary and the ludic, and the requirement of secrecy ensures that this does not disrupt bystanders.

Killer, in which a student also becomes an assassin, is probably the first game featuring a double life. In *Momentum*, the double life was created through possession: The players were dabbling with the occult and became possessed by their characters. This enabled them to alternate between their ordinary lives and their game personas while staying within the fiction. As intangible and invisible possession is a flexible double life strategy, players can juggle their two personalities as they see best, and their characters' bodies are indexical representations of themselves, which is rare in larp. *Masquerade* also utilizes double lives to some extent, as all players portray vampires trying to avoid the attention of living humans. Yet traditional vampire mythology poses some challenges to sustaining the illusion: While it is relatively easy to play in a way that avoids consecrated ground, wooden stakes, and garlic, it is difficult to engage in a longer game if one must shun sunlight.

The enjoyment related to leading a double life stems from secrecy, both from hiding one's true nature from others and from sharing a secret with other players. By utilizing these mechanisms, pervasive games can tap into the privileged feeling of belonging to a secret society and create a similar powerful sense of togetherness.

Power Structures

Typically, there is an imbalance in the available information among different participants. The game organizers know more about the content and boundaries of the game than the players, who in turn know more than the unaware participants. This leads to an imbalance in power over the game experience: Power brings responsibility; one should not deliberately fool people in order to control them.

Avoiding this imbalance limits the design space needlessly; instead, the players and unaware participants should be empowered by other means. This is the core reason why it is so important that the game can be refused. By refusing to play, a participant makes the strongest statement available; she rejects the experience altogether. A game that is not played by a sufficient number of players is a failure in all respects—artistically, politically, and commercially.[4]

An invitation to spectatorship is a good way to strike a balance between players and nonplayers. Being a spectator is an easier role to bear than that of being a player and can be empowered by giving spectators access to information that players do not have (e.g., overviews, the location of a hidden stash) or by giving spectators the role of a referee. It might also be possible to offer multiple frames of reference—a ludic flash mob, for example, could do this by presenting itself as a game to participants and as a reclaim the streets event to bystanders.

Players can be empowered in comparison to the game organizers by providing them with a vast collection of choices. It is possible to weave many leads for the players and

then sit back and see which ones they like. Another good way for game masters to empower the players is to pick up on their ideas, story threads, and activities and give them a larger role in the game. This is particularly important in activities that players might perceive as ethically or socially challenging. For example, if players need to find out what a certain location, such as a house, looks like on the inside, they could either break into the house or surf the net for pictures of the house interior. The game masters should not punish the players for choosing the less challenging option.

Social Play

A pervasive game does not need to blur the line between player and bystander to be socially expanded. Another way to expand the game is by blurring the line between player–performer and *spectator* (or *witness*). These games are obvious to bystanders: Spectators may be perplexed as to whether what they are witnessing is a game or a play or some other performance, but they do not mistake it for ordinary life.

The easiest and most common way to encourage social expansion is by designing a game that is fun and, more importantly, looks like it is fun. If the game is attractive to bystanders, they may stop to take a look—and if participating in the game has been made sufficiently easy, they might even join in.

Performative Play

Players are, to a certain extent, always performing for the benefit of other players. However, adding spectators to a game changes the dynamic. Players do not only try to succeed and enjoy themselves, but they also seek to impress and entertain an audience. Audiences can range from 10 million television viewers (*The Amazing Race*) to a bunch of random bystanders. Players of *Killer* aim to have an external audience of zero people but may still end up creating a surprising performance for individual murder witnesses. Simply adding spectators to a game does not make it pervasive. Rather, offering spectatorship is a strategy that can be employed to deal with ambiguous participation in socially expanded games.

Inside the magic bubble of gameplay, people are prone to go a bit further than in ordinary life—they are willing to do weird, wacky, strange, and fun things. This makes them a bit more vulnerable than normal. The transgressiveness of these activities is a big part of the fun; the possibility of embarrassment can give you a rush. Still, setting up a game in a public space means that players may be embarrassed when they carry out these visible, out-of-the-ordinary activities, whether they are dancing in the streets, carrying giant inflatable bananas, or wearing strange hi-tech gear. There are a number of ways to get rid of this uneasiness.

There is safety in numbers: One person doing a robot dance may be embarrassing herself, 5 people doing the robot are clearly performing for an audience, and 150 people doing the same are already a subculture. Players are less likely to be bashful if they are part of a larger group that carries out the task. This is one of the reasons why scavenger hunts are done in teams and why people feel comfortable in flash mobs.[5]

It is often more embarrassing to do something slightly out of the ordinary than to go completely over the top. Just as there is a critical mass in the number of people one

needs to combat embarrassment, it is possible to battle it by ridicule. Dressing up as Pac-Man in *PacManhattan*; doing the robot dance with music, makeup, and a backdrop; and donning far-out costumes for a bachelor party are all examples of this. The two strategies can also be combined in the form of a visible uniform: Matching shirts are used in *Epidemic Menace*, *Shelby Logan's Run*, and *The Amazing Race*. *Human Blackjack* went far out, dressing the players as playing cards (see Figure 6.2).

Many players feel comfortable with the fact that they are not really *doing* a weird thing, but *performing* it. Doing wacky things together in a game is not only fun, but also liberating. Players experienced in improvisational theater can get into the stage mindset readily, but a casual participant gets considerable help from a physically represented stage. This can take the form of a game board, a playing field, or a traditional stage.

Embarrassment is created to a large degree by the fear that spectators will perceive the player as strange. The player prefers that spectators understand that she is playing, as they then realize that her behavior is sensible. Sometimes the easiest way is to state explicitly that a game is in progress, using signposts, player T-shirts, or by announcing the game in the local press. A more subtle way is to provide players with business cards, which can be handed out to inform perplexed spectators and bystanders about what is going on (see McGonigal, 2006a; Stenros et al., 2007a).

Having Fun Together

Games that seek to engage willing spectators can be designed either so that encouraging audience participation is a challenge for the players or so that the design makes it both

FIGURE
6.2

***Alice in Wonderland* goes Vegas. A fast-paced performative game of *Human Blackjack* was played in Tompkins Square Park, New York, as a part of the Come Out & Play 2008 festival.**

natural and easy for spectators to join in. It is not easy to enter into a game that you run into as a part of your everyday activities. A spectator has to overcome any possible embarrassment, just as a player must. However, in addition, she has not had the possibility to prepare for the game beforehand and she might not have the time to do so. She might not know the rules of the game or implications of the expected game actions, and so forth.

These obstacles can be used as a challenge for players. For example, in scavenger hunts where players are supposed to take specific photographs, there is often a category for photos that involve outsiders. Persuading nonplayers to play along is part of the puzzle.

The game must still be designed in a way that makes joining it without preparation possible. What is expected of a new participant must be either obvious or easily explainable, and she cannot be required to have any specific equipment. Refusing or leaving the game must also be relatively easy.

Collective Play

When the number of players rises, the nature of the game changes. However, when these players also organize themselves and start to play together toward a common goal, the nature of the game—and the challenge of designing such a game—changes dramatically.

Collective group play is common especially in Internet-based games such as alternate reality games. These games are not so much played by multiple individuals in parallel as by a *hive mind* acting in unison. As a result, these games often feature puzzles that are insanely difficult. A single player would rarely be able to solve any of these puzzles, let alone complete a whole game. Players share the work and the result of it through the Internet.

The way these games are played underlines the difference between what one player is able to do alone and what players are capable of together when they are a part of a social network. Collective group play *amplifies* what players are able to achieve. The amplified intelligence created in this manner has the characteristics of being highly social (sharing, tagging, and ordering massive amounts of data together but individually), highly collective (contributing what you are best at), highly improvisational (selecting tools and workspaces on the fly), and highly augmented (employing visual tools and dynamic overlays) (McGonigal, 2007).

Conclusions

Socially expanded games engage in a dialogue with people and society outside the magic circle. This makes spatial expansion the most difficult, dangerous, and powerful way of creating pervasive games. *Candid camera, reality television*, and *invisible theater* have already proved the potential; the challenge is to make the potential fit together with the uncontrollable powers of open-ended gaming.

Prototyping and evaluating games with social expansion are challenging. As these games emerge from the friction between game and nongame, they keep surprising the designer. A performance that is well received by one audience might go wrong the

next day. As laboratory experiments and even beta testing can be impossible, the game designer must be constantly aware of the political climate and cultural context of the work. The designer should stay on top of her work at all times, which often requires a lot of work and runtime game mastering.

Ultimately, socially expanded games can entirely demolish the boundary between the playful and the ordinary. When a big enough group of people gathers on a city square and decides to change the rules of their lives, social reality changes for real. Sometimes that can mean 18,000 people posing naked for Spencer Tunick's camera; sometimes it can mean a revolution.

Notes

1. The original version of the division was presented in Montola & Waern (2006b).
2. This definition is borrowed from Jules Marshall's story from *Wired* magazine, May 1994. www .wired.com/wired/archive/2.05/zippies.html, ref. September 24, 2008.
3. This latter argument is indeed the one that was used to defend and market *Candid Camera* in its early years and that resurfaced at the turn of the millennium during the boom of reality television. Nevertheless, the authors believe that it is again valid in regard to pervasive games.
4. The majority of the Swedish population completely rejected the experience of *Sanningen om Marika*. In an online survey carried out by *Aftonbladet* newspaper, a vast majority voted that they did not understand the production, and the undertone of the comments was also that they did not care to understand it. The reaction shows that, in this case, there was a true possibility to reject the game experience altogether (wwwc.aftonbladet.se/vss/special/storfragan/visa/0,1937,30304,00. html, ref. November 11, 2007).
5. Hakim Bey (1985) discusses the idea of *temporary autonomous zones*, sociogeographical areas where groups of people liberate themselves through temporarily suspending the consensus society. The zone is created by a festive, anarchic *insurrection*: Hakim Bey argues that while *revolutions* are followed by a reaction where the consensus society reestablishes itself, *insurrection* can last for a while without provoking such a reaction. Flash mobs and pervasive games can be festive insurrections that suspend conventional norms and practices, momentarily changing the local social world. Obviously, the temporary autonomous zone belongs to the same conceptual family as the magic circle, the interaction membrane, and the liminal state.

Case G

PacManhattan

Frank Lantz

On a busy street in New York City a showdown is brewing. Clyde has Pac-Man in his sights and is moving in for the kill. Pac-Man paces back and forth, careful to keep a parked car between himself and his opponent as he looks for an opportunity to break away. The ghost cautiously closes the distance between them. Pac-Man ducks under the crossbar of some nearby scaffolding and then nervously glances backwards. One option is to take off back down the street the way he came, but he has already collected the points from this block and needs to keep moving forward if he's going to stand a chance of clearing the board. Meanwhile, Clyde is happy to let the clock tick, knowing that reinforcements are on the way.

Suddenly Pac-Man makes a decision and starts running back down the street, looking like he's ready to cut his losses. Clyde runs after him in close pursuit but is caught by surprise as Pac-Man immediately spins around, doubles back, and shoots past him, dashing across 5th Avenue. It becomes clear that this was his plan all along, and that this dodge and roll was timed perfectly to coincide with the traffic light behind Clyde's back.

This dramatic slice of street-level video gaming comes from a game called *PacManhattan*. *PacManhattan* was created by a group of students from New York University. In 2004, I taught a class in New York University's Interactive Telecommunications program called Big Games. The subject of Big Games was large-scale, real-world gaming, and *PacManhattan* was designed and produced by the students as their final project.

On one level *PacManhattan* is a form of street spectacle, a life-size enactment of the classic arcade game that starts from a visual pun—the similarity between the game's digital maze and New York's urban grid—and procedurally generates a form of surreal improvisational theater (see Figure G.1). But if that were the whole story, then *PacManhattan* would be little more than a clever stunt—and the students' goal was far more ambitious than that. Their goal was to make a real game, a multiplayer reinterpretation that remained true to the essential qualities of the original but was a fun, playable, challenging, well-balanced game experience in its own right.

In order to accomplish this goal, they had to solve some interesting technical and creative problems. The original vision for the game included building custom location-aware devices that would track a player's position in real-time using GPS technology. After a couple of weeks, it became clear that building this hardware would absorb the entire semester, leaving no time for solving the game design problems that were the focus of the class, so instead the team headed down to Washington Square park to figure out how to create a playable version of the game using existing technology.

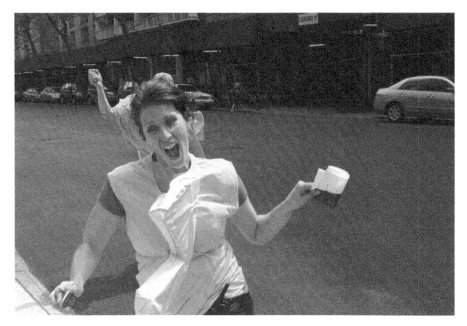

Pac-Man running from a ghost. She holds a map and a cellular phone.

The final version of the game uses networked communication to fill the location awareness gap. Each of the five players on the street (four ghosts and Pac-Man) has a corresponding "controller" player in a central location called HQ with whom they are in constant communication via mobile phone. The game is played on a 5 × 6 grid of streets, where each intersection is marked by a unique number. Whenever a street player reaches a new intersection, they inform their controller, who then updates that player's location on a shared online map. The result is a crude but effective real-time location engine with city block-level granularity.

Once this platform was in place, the real work of game design could begin. The students began by analyzing the game's core dynamic. *Pac-Man* is a game of constant pressure and narrow escapes, a game of voracious consumption and geometric precision, and above all a game about a clever quarry who is outnumbered but nonetheless outwits his bumbling pursuers.

In order to capture these qualities, the game uses a form of information asymmetry— Pac-Man (and his controller in HQ) has access to all game data at all times. He can see the entire map, including the location of every ghost. The ghosts, however, are not shown Pac-Man's location, but can see each other's locations. The ghosts have one additional piece of information—they can see whether the street they are on still contains "dots," the virtual objects that Pac-Man automatically consumes for points as he travels. From this information, the ghosts must work together to deduce Pac-Man's route and sweep the grid in search of their prey. Once a ghost catches sight of Pac-Man, she can raise the alarm and announce his position to the others, who are hopefully close enough to corner him.

As in the original game, Power Pills add an element of dramatic reversal to the action. Each of the map's four corners contains a Pill—marked by a ribbon tied to a lamppost. When

Controllers playing at the *PacManhattan* HQ.

Pac-Man touches the lamppost, he announces this to his controller and the game flips into power mode. For 60 seconds the hunter becomes the hunted, and any ghost Pac-Man touches must head back to the starting area.

The final result works surprisingly well as a game experience. *PacManhattan*, which could easily have devolved into a mere stunt, is instead an intense, suspenseful, and highly playable game. At the heart of the game is the strangely intimate relationship between each street player and their corresponding controller in HQ (see Figure G.2). *PacManhattan* takes a supremely solitary pastime and renders it hypersocial by splitting each game role right down the mind/body divide. Neither the controller nor the street player is completely in control, but instead they must work together to combine top-down and street-level perspectives into a cohesive whole. All gameplay decisions are made as a two-person team.

In addition to making *Pac-Man* extremely social, *PacManhattan* also brings an extreme physicality to the game. Not just in terms of the athletic skill and nontrivial endurance required, but also in the way that the physical details of the urban environment affect the gameplay. Traffic, pedestrians, lines of sight, and points of access—all the complicated and arbitrary concreteness of the world—these things that are abstracted out of the platonic geometry of the Pac-Man maze become the endlessly surprising contours of *PacManhattan*'s unpredictable terrain. This public setting contributes a palpable sense of risk to the player experience, created not only by the physical danger of dodging cars and people in a crowded, busy urban environment, but also by the social buzz of behaving in a highly unconventional manner that cuts across the normal rules of civic life.

Ultimately, these elements help explain the fascination and delight with which millions of people greeted the spectacle of *PacManhattan* and which caused the game to be recreated by players in Seoul, Korea; Lyon, France (see Figure G.3); and other cities around the globe. Beyond the surreality and geek nostalgia, there is a sense of promise—the promise that gaming can continue to evolve, utilizing technology to create experiences that are both fantastic and real, that feature social interaction, physical activity, and an intense engagement with the world around us.

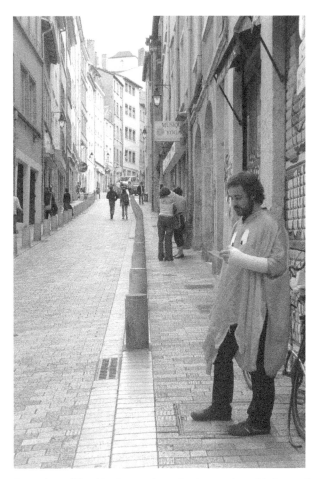

A version of *PacManhattan* has also been played in Lyon, France. A *Pacman@Lyon* ghost studies his map.

PacManhattan can be seen in the context of other large-scale gaming projects, both those with a more technical augmented reality focus and those with more of a game-centric street sports approach. Around the same time that *PacManhattan* was being developed, and unbeknownst to the students who created it, the Mixed Reality Lab of the University of Singapore was developing its own version of a life-size *Pac-Man*. The *Human Pac-Man* project is a full-on "gloves and goggles"-style virtual reality simulation overlaid onto physical space. On one level, the games are obviously quite similar, but closer examination reveals some striking differences. The questions that *Human Pac-Man* asks are primarily engineering questions—how can we build technology that will allow us to project virtual objects and spaces onto our real-world environments? The questions that *PacManhattan* asks are primarily design questions—what are the new types of game experiences enabled by pervasive/ubiquitous computing? In *PacManhattan*, technology is seen as just one of the ingredients needed to assemble a compelling experience, and the focus is on how these ingredients are put together.

PacManhattan is perhaps more at home within the emergent street gaming scene that it helped to spur. The annual Come Out & Play festival, which claims some *PacManhattan* alumni among its founders, takes a similar design-centric approach. The games of Come Out & Play tend to have roots in "organic" street games such as *kickball* and *tag* and seek to evolve these real-world play patterns in new directions, whether that means appropriating the archaic technology of public payphones as in *Payphone Warriors* or turning a subway ride into a team-based game of tactical control as in *Metrophile*. Like *PacManhattan*, these games are less interested in the novelty of emerging technology and more interested in exploring the creative possibilities of sculpting new experiences within the urban environment.

SEVEN

Pervasive Game Design Strategies

Jaakko Stenros, Markus Montola, and Annika Waern

Previous chapters looked at design strategies that help foster particular aspects of pervasivity. In this chapter, we aim to put it together by describing design strategies that create coherent and attractive overall game experiences. In a way, this chapter is about pervasive game aesthetics; it describes ways in which pervasive games can be constructed to form pleasingly coherent experiences.

This means that the design strategies are mostly *holistic*: They influence every single decision made in the game design. This also means that some of the strategies conflict with each other, and thus not all of them can be applied in a single game. Indeed, contradicting strategies open up interesting design spaces and might be the root of novel pervasive game genres.

This chapter is much more normative than the earlier design chapters. It is much simpler to provide clear guidelines in the context of a particular holistic design strategy. We do not say that all pervasive games should feature, for example, runtime game mastering, but all games that do should consider the issues and approaches discussed under that heading.

Tangible Experience Design

Pervasive games can be visceral and tangible experiences. As discussed in earlier chapters, climbing an actual wall or persuading a hotel worker is a thrillingly real experience. In many pervasive games, the design of tangible experiences is central. The goal should be to provide players with the feeling that they are, right at that moment, experiencing something unforgettable. Good, creative design gives players great stories to tell after the game and rewards them with a feeling of achievement—that they managed to do something incredible through their own efforts.

Surpassing Expectations

In regular games, players have a limited set of options at any given moment, but in pervasive games, *any action* may be a *game action* (see Chapter One for infinite affordances). This property goes two ways: Just as players may apply any solution to a given game challenge, game designers can use any and all methods to create a challenge. Exceeding player expectations is a holistic strategy to shake and surprise the players. It consists of two phases: first establishing the expectations and then squashing them with an impressive maneuver. Rinse and repeat until players are ready for anything.

Escalate previous experiences. Surpassing expectations becomes more difficult as players become more experienced. There are many examples of escalation in high-end treasure hunts (Case C). In *BARF V: Mission Impossible*, players had to get to an island with no means provided: They could swim or find a way to obtain a boat. Some years later, a team of players showed up to *vQuest* prepared for similar challenges by bringing their own kayak (Finkel, 2001), and, indeed, in *Shelby Logan's Run* 2 years later such foresight was rewarded, as the game required the players to get off the Hoover Dam to a boat in the middle of the lake (see Figure 7.1). Even when players expect and prepare for anything, escalation is still possible. In *Mission Impossible*, the players had to catch a pig, read a text written on its side, and use it to open a combination lock. In *Shelby Logan's Run*, a similar puzzle was used, but now the clue was on a microchip *inside* a living rat.

Tune down player expectations and then exceed them. In *Där vi föll*, the players were expected to look for a boat in a run-down harbor area. The whole area looked repulsive,

FIGURE
7.1

Turning up on the brink of the Hoover Dam, the *Shelby Logan's Run* players found out that they needed to reach a boat in the middle of the reservoir. Picture from the beta test of the game.

DESIGN

and the players squirmed when the clues directed them to a barely floating shipwreck with a Tolkien-inspired name[1] (see Chapter Four). But once the players entered the vessel, they found a comfortable hippie hideout affording various play activities. Players who had expected to go home for the night were instantly given a new modus operandi in the form of sleeping quarters, a stocked-up kitchen, a library, and a computer full of relevant documents. Suddenly they could live in the boat for the entire weekend and research the rich game content accessible through computer files and books.

Use unexpected twists in gameplay. Players can be very impressed by changes in the fundaments of their gameplay. In *The Beast* (Case B), the players had learned to call phone numbers where they would reach an answering phone. At one point in the game, they instead got to talk to a live actor. McGonigal (2003b) reports that several players were confused about this and believed they might have called the wrong number. Retroactively, when they had understood that this event was part of the game, many reported it to be their favorite game moment.

Use far-out gameplay. Unexpected gameplay can push player expectations really far. *Där vi föll* encouraged involving outsiders, something that larp participants were primed to avoid based on previous larp experiences. The players were given tasks to talk with unaware outsiders, such as priests and hobos, delivering messages and asking for clues. In *vQuest*, the players encountered the game in a situation that they were convinced was not part of the game—when stopped by a police officer and charged with speeding they ended up with a clue instead of a fine.[2] In both *Shelby Logan's Run* and one leg of *The Amazing Race*, you gained an advantage from getting piercings or tattoos in a tattoo parlor. The British *Kidnap* art piece captured volunteer victims in broad daylight and held them prisoner for 48 hours. *Tre grader av uskyld*, a Danish pervasive larp, used over 20 extras and supporting players to create Tarantino-esque gameplay for a handful of payers. *Tre grader* included scenes where players had to clean up a bloody car and trash it with hammers. In another, they had to meet up with a drug courier and even fish his powder-filled condoms out of a toilet bowl—just like real smugglers have to do. Possibilities are infinite, and even very unpleasant activities and experiences can, in some cases, be appreciated.

Players may return the favor. If challenges are created in an open and engaging way, players will sometimes exceed designer expectations as well. *Sanningen om Marika* had players shadow a suspicious-looking outsider and document where they were going through photographs and video. One player submitted a long video in which he followed a person from Stockholm, Sweden, to Riga, Latvia, and into the local Russian Consulate. The elaborate documentation shows how he first followed a car on the highway, parked at the airport, bought a ticket for the same plane, and ended up in Riga. After the game, he revealed that the dazzling document was a fake; he had been on a trip and created the film by shooting several cars and persons from a distance.

Linked Tasks

One method of creating tangibility is linked task structures. In chained tasks, success in one challenge directly influences the chances of success in another one. In the extreme version, this means that players have to succeed in challenge A before they can even access challenge B, but more flexible task structures are often preferable.

Chaining tasks make the individual tasks more meaningful. In *Momentum*, one group of players had to locate a package using a set of mathematical clues. This task required

the successful completion of two steps: First, the players had to triangulate geometrically the location on a map and then they needed to scout out the area by foot to find the stash. On their own, these tasks would have been rather boring exercises, but combining them gave them meaning and value. The triangulation had to succeed or the players would end up in the wrong area. Similarly, once the players were on the right track, finding the stash meant that they were able to locate an envelope from a complete city, not from a small neighborhood. Finally, since the envelope contained story elements that fit into a rich story context, the menial exercises turned into diegetically meaningful activities.

Linked tasks as game structure. In puzzle hunts, for example, in The Game (see Case C) tradition, the answer to a clue typically reveals the game location of the next clue. This strict sequentialization of clues means that a team that fails to solve one puzzle is out of the game. The Game series circumvent the problem by allowing players to contact the game masters for extra clues when stuck too badly. While this solution emphasizes the ludic nature of the game, it serves as a way to balance the game by allowing slower teams to stay in the race and still have a chance to compete for victory.

Force collaboration through interdependence. Players love to know that other players are working on different parts of the same puzzle elsewhere. The sense of tangibility is enhanced as players realize that other players are depending on them to succeed. In the *Momentum* example given earlier, the search for the dead drop was part of an intricate web of missions carried out by different player teams. To synchronize their activities, players had to phone and tell each other about their findings. This way they would also get to hear stories about what other players had experienced and found out, creating the feeling that every tiny, menial task was part of a bigger picture.

Real Challenges

A third strategy for tangible experiences is making players do things for real. Both mental and physical authentic challenges can be exciting, and overcoming them gives a stronger sense of achievement than overcoming an obviously constructed puzzle. Cracking the original Enigma encryption from World War II (even with clues and contemporary computer technology) can be much more pleasurable than cracking a code devised by a game designer. Scaling a real wall can be more fun than scaling one with artificial grips, and shooting rapids can be more fun than riding a roller coaster. You want to offer your players the feeling of *I can do it: I outsmarted the German cryptologists, I am able to climb over a 10-foot wall.* Fine-tuning the difficulty of such challenges can be a tricky job.

Know your players well. Professional athletes need higher walls to scale and would probably not do very well with hieroglyphs. While bookwormy players might enjoy shooting rapids immensely, they require higher safety measures than seasoned veterans.

Provide hints. Most people cannot read hieroglyphs even with the Rosetta Stone provided as a decryption key, but giving a player an actual guidebook for reading hieroglyphs from that particular age might do the trick. Even with help, players will still enjoy facing a real challenge, as success will show them that they actually could learn to master something new. Through cracking a hieroglyph puzzle, players realize they could learn to read hieroglyphs if they set their mind to it.

Foster teamwork. Many of these tasks cannot be overcome by every participant of your game. Thus, you might want to create teams of players with different skills. The athletic

person can catch the pig while the mathematical one can decipher the code written on it. Teamwork also opens up possibilities for collective solutions, whether it means cornering a pig or lifting a teammate over a fence.

Foster networking. Alternate reality games have shown that incredibly difficult mental challenges can be solved by Internet communities consisting of thousands of enthusiasts. Not only do large networks of players require much more difficult puzzles, but taking the network approach changes the very nature of the difficulty level. With one person, the question is whether she can solve the puzzle or not; with 1000 people, the question is how long will it take for them to solve it.

Real challenges do not need to be difficult. The tasks that players encounter can be simple, even menial, if they make sense in a larger context. In *Momentum*, the players were entertained by fixing an old matrix printer that was delivering them important game information. Even though the act of clearing a paper jam was not thrilling or extremely challenging, it made the game feel immediate and visceral: It created tension and gave players something physical to do while playing a social game. At the same time, it provided them with a nostalgic return of information technology from past decades.

The 360° Illusion

A design ideal of a physical *360° illusion* emerged in the Nordic larp community during the nineties. Johanna Koljonen has described it as

> [. . .] *a complete universe available to interact with, a situational, emotional and physical realism in character immersion, and a what-you-see-is-what-you-get attitude to the physical environment of the game. I call this style the 360° illusion, in reference to the totality of both the physical game environment and the space for immersion it strives to create. (Koljonen, 2007)*

The idea of a complete, fully immersive physical environment has been seen as the holy grail of virtual reality technology (see Murray, 1997). In Nordic larp, the 360° illusion is composed of three requirements: Having an *indexical environment* means that players inhabit a perfect representation of the game world (this will be discussed later under *the magician's curtain*). The ideal of *indexical activity* stipulates that actions, be they fighting, debating, sleeping, or hacking, are carried out for real; all activities are what they seem and do not represent something else. The indexicality is required of the player as well; she inhabits the area as a character engaged in emotionally and physically *immersive role-play* (see Waern, Montola, & Stenros, 2009,[3] for further discussion).

All three are required to create and populate a complete game realm. Simply having an indexical environment would be akin to a museum diorama or an immersive amusement park ride (see Lancaster, 1999). Combining an indexical environment and activity leads to a situation similar to reenactment camps: Without an element of role-play, the participant is alienated from the perfect environment; she does not fit in. In fact, overcoming this alienation can be especially difficult in a flawless setting.

Integrate into the environment. Achieving a 360° illusion in a game with strict boundaries—a fantasy village or a bomb shelter—is easy in comparison to achieving the

same illusion in a pervasive game. Pervasive games can aim for a 360° illusion, but this almost certainly requires the game story to be set in the present day.

Establish a clear level of indexicality. There are different levels of indexicality. Having a what-you-see-is-what-you-get aesthetic is different from an aesthetic where the illusion is supposed to hold even if you peek behind the curtain. For example, some game devices can be built so that the indexicality does not stop at the surface of the gizmo: It is possible to open it, repair it, or tune it. The level of indexicality should be consistent (see Chapter Four).

Choose your thematics wisely. Indexical action is just as dangerous as ordinary action. When defining the theme of the game, discourage risks. For example, do not encourage car chases or hacking.

Don't make compromises. Watered-down photorealism is not photorealism. A rubber sword is not a medieval sword, and an email that clearly originates from the local university is not from the CEO of a megacorp. A 360° illusion requires a lot of work, and going halfway may leave players second-guessing each encounter.

Compromise if necessary. Implementing a full 360° illusion can be very expensive: One group spent 3 years and hundreds of thousands of Euros building a fantasy village with a fire-breathing, life-sized dragon (Figure 7.2).[4] Even if you make compromises, a bit of 360° aesthetic can be used to spice up the game.

Encourage collective make-believe. When a full 360° illusion is not possible, encouraging make-believe might help. If the players collectively agree to ignore elements that break the illusion, it becomes strengthened. This approach will not create the wow effect that a full illusion can do, but it can still become very effective. As Koljonen (2006) notes, "The imagination is a strong muscle, and as long as that muscle is willing to work, a total and present 360° environment is not strictly necessary." Children are much better at make-believe than adults, because most adults are out of practice. A particularly useful mechanism is *blue cloth*,[5] that is, when players collectively agree to disregard elements that are distinctly marked to not be part of the game. Once used to this convention, participants stop noticing such objects.

The Magician's Curtain

The concept of a *magician's curtain* means that game organizers attempt to create an illusion of a coherent game world for players, doing their best to hide the strings and wires that keep the game together. However, the magician's curtain cannot be upheld by the organizers alone, as it is far too easy for players to expose (incidentally or intentionally) the fabricated nature of game content. It requires a conscious act on the part of the players as well; they must understand that they are not supposed to try to hack the game, discuss the nuts and bolts of its construction, or let this knowledge influence their play. Upholding the magician's curtain is a necessity for a game that attempts to merge game and ordinary life seamlessly, but different games require different levels of *suspension of disbelief*—the effort of disregarding the man behind the curtain.

This Is Not a Game

The *This Is Not a Game* (TINAG) principle is an aesthetic design choice, mostly used in alternate reality games, where the event explicitly denies and obscures its nature as a

FIGURE
7.2

A whole 360° fantasy village was built for the *Dragonbane* larp. Pictured here are a computer model and a physical model that were used to design the temple, as well as the finished building in the game. Note the magical pyrotechnics illuminating the scene and the dragon that was built on top of a forestry machine. The production team used the models for communicating the vision of the game (see Koljonen, Kuustie, & Multamäki, 2008).

game. The principle governs both how a game is designed and implemented (it should deny its gameness but at the same time be unmistakably fictional) and how it is played. Jane McGonigal writes about the double consciousness of players:

> [The Players] must believe "this is not a game" in order to enjoy the immersive pleasures of its realistic aesthetic. They must disbelieve "this is not a game" in order to maintain the ludic mindset that makes realistic murders, apocalyptic science, cyberterrorism, and other dark plots pleasurably playable. (McGonigal, 2006a)

The TINAG aesthetic is based on the magician's curtain. Although players are able to find seams between the game and ordinary life, they ignore them to their best ability. *The Beast* is an obvious example of using TINAG; the players pretend to believe in the alternate reality while still being perfectly able to distinguish between the ordinary and the ludic (McGonigal, 2003b).

Seamless Life/Game Merger

The magician's curtain is taken to the extreme in games that try to merge life and game seamlessly. This approach relies on obfuscating the difference between fabricated game content and events and the world outside the game. The ideal stage is one where it is impossible for players to recognize the boundary of the magic circle. This can create an intriguing setup, where players are forced to interact with the ordinary world in interesting ways. The experience of seamlessness can be created using a variety of techniques, combining elements of ordinary life with those that are fabricated purposefully.

Using ordinary reality as a sourcebook. If solving game problems requires information from the ordinary world, players will have to explore libraries and search Internet sites in order to succeed in the game. If some books or Web sites are carefully forged or fabricated for the game, players are not able to discern where the game ends. Sometimes information can also be fed to real sources. For example, some ARGs place adverts in daily papers and magazines.

Interact with outsiders. One of the most effective strategies for merging game and life is social expansion. Game content and clues can be made accessible through a mix of carefully instructed actors, temporally recruited outsiders, and random encounters. If players are supposed to find a lost girl, the game organizers can send out an actor impersonating her on the streets prior to the game. If the players decide to ask around, they may find people who have actually seen or met her. Through mixing all of these in the same game, players will eventually feel that everyone and anyone around them could be part of the game.

Don't let players leave the game. One way to create a strong life/game merger in long-duration games is to let players carry on with their ordinary lives, only to run constantly into game-related events and information. Utilizing temporal expansion in this way leads to a state of mind where the players are constantly in game and will start to connect anything they experience to the game. Eerie coincidences are often reported as one of the most enjoyable experiences in pervasive games.

Careful use of ludic markers. Ludic markers are signs that explicitly tell players that something is related to the game. For example, the players of *The Beast* learned that any mention of Jeanine Salla was related to the game. Games that aim for seamlessness have to use such markers very carefully, and sometimes omit them entirely. Sometimes it should be impossible to tell apart a player from a bystander, while at other times players will need discreet clues that they are talking to the right person. The same applies to game locations; mixing authentic locations and scenographed game areas will create a feeling that the whole world is part of the game. It is often a good idea to hide prepared locations within unmarked areas—it is quite fun to find a mad scientist's laboratory in an underground tunnel complex featuring no ludic markers at all. At the

same time, players might need a careful hint that this particular tunnel complex is safe to enter.

Full seamlessness is a very demanding strategy that can lead to both ethical and practical problems (see Case J). Still, games that show their seams for the most part can use seamless design in parts to enhance a particular experience.

Runtime Game Mastering

Although some pervasive games are fully automated, like computer games, most are not. One reason for this is that technology is simply too constrained to recognize and keep track of all relevant in-game activities, another is the tendency for new content to emerge during the course of the game. But most importantly, many pervasive games generate their main attraction through striking a difficult balance between player improvisations and fixed predetermined rules. When a game is not fully automatic, it becomes less predictable and often feels more realistic (Jonsson & Waern, 2008).

The job of a *game master*[6] is to strike that balance, to make the game respond to player improvisations and real-world interventions while allowing the game to run smoothly. In order to fulfill the task, she must be able to *monitor* the game, *influence* the state of the game, and be able to make *decisions* about how the game should progress. In tabletop role-playing games, all these functions are embodied in one person, but because pervasive games are spread out over time and space, they require some kind of a support system. One person simply cannot be everywhere all of the time. Distributing the task requires a powerful *communication* system.

There are a host of options for how a game master can obtain information about an ongoing game. Players might wear GPS devices, video cameras can be staged in strategic locations, selected players may act as informants, and players might use gaming devices to interact with the game masters. Actions that influence the state of the game can range from switching on a smoke machine to sending emails to players. Because the manpower required for game mastering is immense, some of the tasks might need to be partially automated.

Gods and Power Users

Game mastering can be done in two different modes. A *god mode* game master has no role in the fictional universe but exists outside it and can control and modify it as she wishes. A *power user mode* game master has a role within the game world, as a character with special abilities. Typically, game masters will switch between these roles quite frequently: For example, they will first go online and chat as game characters and later upgrade some of the teams to a new game level.

While puppet masters running alternate reality games often try to stay entirely invisible to the players, this is not necessary in all pervasive games. One possibility is to create diegetic power user roles that allow game masters to go in and fix the game technology. This role allows them to appear in the game world, but does not hide the fact that they are game masters. In less immersive games, such as *Epidemic Menace* (Case H), game masters can also appear in the god mode.

FIGURE
7.3

Active game management often requires a nerve center where the game mastering takes place. White boards, phones, Internet access, and duct tape are usually minimum requirements, but all kinds of gadgets from data projectors and copying machines to different kinds of authoring tools and surveillance monitors can be helpful as well. Pictured here are the game mastering headquarters in *Shelby Logan's Run (left)* and *Där vi föll (right)*.

Active Game Management

Having active game control allows a game to incorporate numerous design elements that would be challenging to implement in a completely automated game. New content can be created as a reaction to what players have done, and, in general, the game can be fine-tuned during the play (see Figure 7.3). This is often a specific aspect of sustaining the illusion of a credible game world, but many simpler games also benefit from active authoring. If authoring is required, the process must be as fast and easy as possible.

Sustain a responsive game world. With the infinite affordances provided by pervasive games, it is extremely hard to prepare systems that automatically provide a sensible reaction to every player action. If players send emails to nonplayer characters, the game can either provide automated responses or the game masters can actually engage in correspondence with the players—if you email Bree of *lonelygirl15*, she will email you back. In the physical world missions of *Sanningen om Marika*, you could even meet the main character Adrijanna in person. The former method is less expensive and faster, but the latter sustains the illusion of a complete game world with living people.

Dynamic difficulty level. Creating challenges and material while the game is running allows the game masters to tailor the difficulty level to suit the audience. In *The Beast*, the puppet masters had to crank up the difficulty level when they realized that the combined intelligence of thousand-player communities exceeded their wildest expectations. In *vQuest*, the game masters instead had to provide hints and guidance to help the slower

DESIGN

teams. In *Sanningen om Marika*, the game masters flagged one task complete for all teams, as only a few teams had even attempted to complete it.

Steer the game. Games striving for a predetermined yet interactive plot often require game masters to control the pace of the game or to subtly steer players in the right direction. Even in games that offer multiple paths, the game masters may need to interpret player actions to decide which path has been taken or ensure that players do not try to wander off the beaten path. If players see this steering too clearly, there is a risk that they will lose their sense of agency.[7] There is a risk that they will no longer try to follow the plot on their own: They can start milking for clues, asking the game master characters for help and tips. This reduced agency usually leads to a worse game experience.

Human backup system. Finally, game masters function as a backup for any experimental technology that the game might use. If there are problems with the equipment, game masters may either fix it or attempt to substitute it with manual work. Indeed, often the easiest, fastest, and less expensive way to come up with a game engine is to scrap all technology, populate the game with spies, and hire a referee to oversee the game.

Keeping Track of the Game

In order to be able to oversee a game, the game masters must monitor player activities and stay up to date on what they are doing. There are a number of ways to do this—and most games require more than one approach.

Controllers. One of the best ways to keep on top of the game and subtly help steer it in the right direction is to have eyes, ears, and hands in the player group. These double agents can be (or pretend to be) players, but they report back to the game masters from time to time on what is going on. Controllers run the gamut from simple informants to a full-blown undisclosed game master presence. A human spy can tell you not only what has been happening, but also what it means and what the players are planning to do next. If controllers get caught, the game can lose its appeal as the players no longer feel that they are masters of their own game.

Surveillance. Cameras, microphones, and other sensors can be useful in maintaining an overview of the player situation or to determine specific changes. However, the information provided by surveillance is of limited use; understanding a social situation through a webcam feed is often impossible, and monitoring the streams requires constant manpower (see Figure 7.4). In highly mobile games, surveillance is very difficult, unless the surveillance equipment is somehow worn by the players. In addition, installing surveillance in public places is often illegal. An alternative option for fully mobile games is to use human observers outside the player group, as has been done in *Interference* and *Uncle Roy All Around You* (see Benford et al., 2006).

Log files. Similar to surveillance, log files from the technology used by players are handy in finding out specific things, such as who a player has communicated with, when did they perform specific actions, and so forth. Interpreting the logs always requires powerful and usable tools.

Self-reporting. Informing the game masters can be a task for the players. This can be woven into the fabric of the game in various ways: Players can be tasked to press a button that reports their location due to diegetic reasons, they can be tasked with writing diaries or reports as part of their role in the fiction or with calling the game masters for clues at relevant intervals, or they can be required to document their quests through

FIGURE
7.4

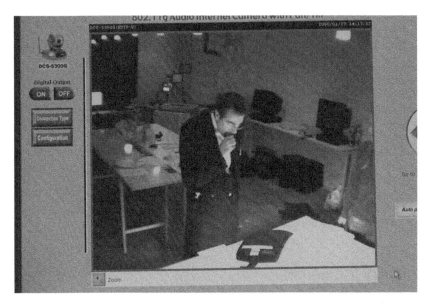

Footage from a surveillance camera helps determine who is present and, to some degree, what they are doing. However, contextual understanding of the meaning of the events can be challenging. Picture from *Momentum*.

photos and films that they upload to the game server. There is also the option of asking players to report outside of the game. This needs to be used with care as it shifts players' focus away from the game tasks to the game experience itself. Reflecting on the play while the game is still in progress could harm—but also deepen—the experience.

Monitoring player forums. Players tend to discuss the games they play. In longer games, online discussions are a great source of information not only on what the players are doing, but also on what they are having difficulties with and how they perceive the game. In most alternate reality games, the game masters continuously monitor (and influence) game-related Web forums, and thus stay well informed about what the players are doing and whether they need to steer player activities.

Dealing with Large Scale and Long Duration

Small games can be run by putting Post-it notes on a wall, but as games become more complex, they require better game mastering systems for collecting player reports, deciphering log files, accessing surveillance tools, and organizing game master notes. The game master system should provide a quick overview of the current state of the game and allow the user to easily zoom in on details based on the overview.

Support hand-over processes. Allowing game masters to work in shifts is necessary in any game that runs for a long time. Logging and sharing information are at the core of a hand-over system; it is essential to mark down what players have done, what they

know, and what is expected to happen next. This makes it possible for one game master to pick up a plot that another initiated.

Encourage optimal play patterns. Teaching players to play in a way that demands less direct game mastering reduces the workload. In shorter games, the fact that players can do absolutely anything is a fun way of building a believable game world, but in longer games players will settle into a rhythm or a routine. This can simplify game mastering immensely. For example, encouraging players to report their activities on a public Web forum makes surveillance considerably easier. Similarly, rewarding senior players for tutoring newcomers may shift the task from the game masters to expert players.

Maintenance. Even if games are not technology mediated, they often need to be tuned based on player feedback, requests, and general playability issues. Maintenance is a holistic task that aims to improve the game for all participants, and thus it is different from runtime game mastering, which micromanages individual game instances. In long-term games, it can be advisable to introduce a regular maintenance pattern, for example, a weekly or daily maintenance downtime.

Games Telling Stories

Some games are based on narratives whereas others are not. Stories are particularly relevant for pervasive larps, alternate reality games, and urban adventure games, whereas assassination games, treasure hunts, and smart street sports do not typically feature them. A compelling game narrative provides players with a frame for the play experience: Solving the puzzles of *The Beast* was motivated by the need of discovering the narrative. The narrative was both a reward for discovery and an excuse for spending endless hours looking for clues.

In Jesper Juul's (2003) terminology, games with strong stories are usually *games of progression* instead of *games of emergence.* Games of progression feature a series of particular challenges presented in sequence, and a player progresses through the game by overcoming them. Games of emergence feature relatively few rules, but complex and changing gameplay emerges from those rules. *Leisure Suit Larry in the Land of Lounge Lizards* is a classic example of progression, whereas *chess* is a classic example of emergence.

This distinction critically influences the replayability of the game. A game of progression is only completed once: It may take countless hours of gameplay, but once the game is finished, playing it becomes more or less pointless. Games of emergence tend to be much shorter, but they are played over and over again.

Some hybrid games offer a story world that is more of a sandbox to play in. Exploring the story world is not only common in digital games such as the *Grand Theft Auto* series, but also in sequential pervasive larp campaigns, reality games, and urban adventure games. The completeness and coherence of the diegetic world are extremely important in these games. Coherence is also important for the story elements in any pervasive game, especially if the story is distributed. All the tidbits the players run into do not need to fit together snugly, but they should not contradict each other so that players are able to construct a coherent whole out of a story. In contrast, games of emergence can introduce story elements that are neither complete nor coherent, as long as they allow for interesting gameplay (Juul, 2005).

Designing competitive games of progression has become problematic in the age of networked communication. Not only are walkthroughs and guides easy to access, but players also collaborate efficiently in solving the problems. Producing collective puzzle play in the style of alternate reality games is not a free choice for a designer, as it is almost impossible to prevent such play styles.[8]

Distributed Narrative

Especially since the success of *The Beast*, distributed narrative has been a popular way of presenting a story in a game.[9] The distributed narrative is told in small fragments, which are hidden in different locations and in various media. Players try to uncover and assemble the complete story. The story may be fixed or the actions of the players may alter it, but the end result is a complete narrative (or at least a sequence of events the players themselves narrativize) from start to finish (see Dena, 2008a). While traditional digital games provide cut scenes after the completion of various game tasks, distributed narrative takes this approach one step further: Story snippets are still presented as rewards for success, but they are placed all around the world in small fragments. The game task is to find the reward, whether this means discovering a Web site, finding a physical letterbox, or calling an answering machine.[10]

Make the story significant. Digital game cut scenes are often criticized for their lack of relevance in the game. It does not really matter what happens in a cut scene; the player can skip the flavor and just continue to play. But if the story contains further puzzles and clues, players will find it much more relevant. For instance, players who are familiar with the story might be able to utilize their knowledge of the main characters to progress in the game.

Connect with traditional media. Story content related to established movies and television shows is often found particularly valuable. *The LOST Experience*, for instance, rewarded players with extra video clips that also contributed to the TV experience.

Clues are not obligatory. In a basic setup, every piece of game narrative can be found by following a clue found somewhere else in the game, but such a setup is not necessary. For example, the main characters can have a Facebook presence showing additional content, which can only be accessed by players who (accidentally or methodically) look for them in the service. Googling around is a rudimentary puzzle-solving method, and the gratification of an unexpected discovery is occasionally much greater than the gratification of cracking an obvious puzzle. Especially if there is a large player base, one can expect players to stumble upon hidden story snippets. In the ARG community it is customary to share discoveries with other players.

Think outside the box. Story content can be deployed everywhere, a typical Web site being the simplest possible option. Anything from crop circles to classified ads can be a medium for a pervasive game.

Collective Story

The story that emerges through a game played by a group of people is collective by nature. The story that the players remember and retell is not the one that the designer wrote, but a combination of all the discovered clues and experienced events, and the

stories about how these events happened and how clues were discovered. It evolves both during and after the game, as players reflect on their experiences. In ARGs, players produce both a description of the diegetic story, a *trail* (Dena, 2008a), and a story of how all the puzzles were solved. The first consists of a (re)assembled distributed narrative, the latter is the collective story.[11] In larps, treasure hunts, and assassination games, the collective story is often produced through some kind of a debrief, where players narrativize game experiences together.

Understanding and harnessing the process can help in creating truly communal experiences. *The Beast* fostered collective stories in a manner that turned out to be highly successful; the success of the game depended on whether a community emerged and whether that community began to tell its own story. Jordan Weisman wondered about this while the game was being planned: "Would there be a way to form what we called The Hive Mind, and focus [the players] on the telling of the story . . . rather than us telling the story to them?"[12]

Foster arenas where the story can emerge. Collective stories are created when players share their experiences. In games that have an online component, it is useful to provide a Web forum for discussion, a resource that can also be invaluable to game masters. In smaller games, it is advisable to organize a debrief or an after party. Note that if the game has a prize, then the players may be less willing to share during play, emphasizing the need for a debrief.

Instruct through example. Planting a fabricated account of play can provide a template for players. If they end up using the same template to report their experiences, this will have a clear effect on how they narrativize the game.

First Person Story

First person stories are not so much stories per se as sequences of events that players experience and later turn into stories when reminiscing the events. Although similar first person stories can be created for several players, they are experienced as private, as certain particular events happen only to a certain particular player. First person stories are especially common in pervasive larps, assassination games, treasure hunts, and urban adventure games, as these games feature incidental coincidences with outside events, making each experience unique.

Appeal to the narcissism of the player. The point of a first person story is that the things are happening to you, that it is only you who is at the center of things experiencing the events. Narcissistic play is at its height when something singular happens as a part of a larger story world, for example, when the Gold Magnate was destroyed in *EVE Online* in 2004. The Gold Magnate was a unique one-time-only vessel given out in a competition, sold for a large sum of money, and destroyed in a fight. As no replacement will ever enter *EVE Online*, the unique story can be recounted over and over again, not just by the people who experienced it. Each individual's experiences enrich the play of others as well (see also Dena, 2008a).

Support minimalist role-play. A first person story is something that happens to someone. The story needs to be experienced from a clear point of view. This someone can be either the player or a character. In minimalist role-play, the player assumes a role that is akin to a function or a job description (such as a doctor or a femme fatale). As players enter the game world, this encourages a minimal level of role-play. To support minimalist

role-play, the game should be designed in the way that acting as one's role is playing the game. This can be supported by using titles, call-signs, a functional hierarchy, role-specific clothing, or role-specific equipment (see Figure 7.5). Without a functional role, the player can easily feel like an outsider to the game. Of course, that can sometimes be the point of the game, as in the performance piece *YOU–The City*.

Personalize. Tailoring a role, character, avatar, or point of view for an individual player helps her make a personal connection to it. In a larp, this can be a prewritten character that a player completes by adding her personal touch. It can also take the form of avatar creation software. Sometimes even getting to name the character is enough.

Enable character-centric role-play. The traditional way to deal with roles in role-playing games is that the player assumes the role of a complete person, someone with a history and a personality, with her own motivations, quirks, dreams, and aspirations. The difference of minimalist role-play is that the character becomes the players' interface to the game; she can only do things the character can do or wants to do. Even if the player knows Spanish, the player is not allowed to use this skill if her character cannot. The character nails down the point of view for the player. Thus, it is important to empower the characters; an introvert character without contacts, resources, or skills is very difficult and ultimately boring to play. The danger in character-centric role-play in a story-driven game is that some players may spend their time immersing into the character persona rather than actually attending to the story.

FIGURE
7.5

Interference **players were dressed in overalls to look like engineers working in the streets and to support minimalist role-play. They were also equipped with numerous gadgets that supported functional roles.**

DESIGN

Replayable Progression

Some games seek to combine elements of games of progression with features of games of emergence, mixing together a compelling story with emergent gameplay. This is done to increase replayability. For example, digital games such as *Fallout 2* progress differently depending on player choices, assembling new dramatic arcs for every player. Whereas pure games of progression can be played once or twice, these hybrids can manage to sustain interest for several game instances.

Create multiple dissimilar points of view. A player should have more than one possible approach to events of the game. The *Star Wars* game *Knights of the Old Republic* can be played on the light side or the dark side, but the alternatives are not limited to a choice between playing good or evil. MMORPGs and role-playing games offer various character classes and factions to choose from. An extreme example is the classic role-playing game approach, where each character is unique—albeit that in practice characters in the same group or faction are often fairly similar. The downside of adding dissimilar points of view is that the game becomes more complex, and players who only play the game once miss much of the content.

Foster the social play of collective storytelling. In some games, the story is the same every time a game is played, yet it remains important. In these games, players collectively recount the same story over and over again, and the fun is in the reenactment. Ritualistic social play is the meat of games such as the card game *The Great Dalmuti* and the campfire game *Werewolf*. The trick is to make social interaction between players a major element in playing the game. The game mechanics and the story are just a background used to structure the fun conversation with fellow players.

Include way too much content. One way to increase replayability is to simply include so much content in the game that it is impossible to go through it in one go. Playing the same game again deepens the story as the player pays attention to clues in a different manner once she knows how the game plays out. Alternatively, the player can be made to encounter a different sort of flavor text regarding the story—basically keeping the skeleton of the story the same but dressing it up in different ways. This approach requires extremely high-quality content as the experience is similar to reading the same book over and over again.

General Issues of Game Design

Certain general game design issues need special consideration in pervasive games. These include designing the pace of the game, sustaining the critical mass of players, creating engaging experiences, and designing pervasive games for casual audiences.

Sustaining the Critical Mass

Most multiplayer games require a certain number of players in order to function properly; features such as an elaborate economic structure and emergent social play cannot be achieved with a small number of participants. Supporting the critical mass is a function of both the spatial and the temporal scope of the game: Players need to be close

enough in both dimensions to play together. If critical mass is not reached, disheartened players will quit playing, and reaching critical mass becomes harder: Indeed, a short-time failure to reach a sufficient number of players can destroy the entire launch of the game.

Limit the time and space of play. If the game is playable only during the evenings and downtown, the player concentration is increased. As the player base grows, these times and areas can be extended. The limitations need not be absolute: If players are encouraged to play mainly in certain areas, they know where to meet, but they are still free to play anywhere they like.

Reward extensive play. Come up with game mechanisms that encourage players to stay online. In *BotFighters*, for example, you get to use the coveted long-range missile only after having played for an uninterrupted 24 hours. If most players keep their game running all the time, it is more likely for an active player to find someone else to play with. An implication of this is that a game needs to support both peripheral and passive play.

Provide single-player content. A typical solution for online role-playing games is to keep players occupied with single-player content until critical mass is reached. The content can range from full gameplay to maintenance functions (shopping, optimizing skills).

Provide two-player content. The design possibilities for two players are markedly wider than for a single player. Use this as a stepping stone while gathering critical mass for a multiplayer or even massively multiplayer game. Two players can engage in all kinds of activities from dueling to social role-play.

Conceal the lack of critical mass. If players are unaware that there are too few players participating at a given moment, they are likely to stay with the game for longer, which can prevent a downward spiral in player numbers.

Pacing the Game

Designing the pace for a pervasive game is one of the most difficult parts of the design, and easy guidelines are hard to provide. The appropriate pace for a pervasive game depends on many factors: Hardcore players want to be pestered by the game constantly, whereas a slower pace allows casual play. If the game takes place in one event, it probably has to be much more intense than a temporally expanded game that stays in the background for weeks.

Test and iterate. Whatever you think works on paper will work differently in the real world. All three expansions change the player perception of the tempo, and paper prototyping is an insufficient testing method. Simulating a digital game in the real world can lead to similar difficulties, which underlines the need to test the game in a fairly complete form in order to adjust the pace of the game.

Allow for variable pacing. Especially when players play along with their ordinary lives, their preferences vary wildly. This is obvious if we look at how players play online role-playing games: Some players spend more than 60 hours a week online, whereas others do not care to play for even 10 hours.

Make it foolproof. Some players leave the game without notice, others only play on weekends, and some just play erratically. Thus, an asynchronous game should not get stuck if one player never makes her move, and a pervasive larp should never count on one player to efficiently convey her secret information to other players.

Prepare for dedicated players. People who become enthusiastic about a game consume content extremely fast. A variety of strategies can be used to mitigate this problem: *The Beast*, for example, used extremely hard stopgap puzzles to stall the players' progress. The low-level gameplay in *World of Warcraft* is made gradually easier over time in order to keep dedicated players occupied while allowing casual players to access most of the content at a slightly slower pace.

Immersion and Flow

The concept of immersion pops up almost regardless of what kind of a game one is designing. The problem is that the term is used very differently in digital games, alternate reality games, and live-action role-playing games. The most often cited definition of immersion is this:

> *The experience of being transported to an elaborate simulated place is pleasurable in itself, regardless of the fantasy content. We refer to this experience as immersion. Immersion is a metaphorical term derived from the physical experience of being submerged in water. (Murray, 1997)*

This allegorical definition given by Janet H. Murray offers a good intuitive understanding of the term, but it does not help comprehend how to design games that encourage and support it. It does not help that experiences similar to immersion have been discussed with a number of different terms.[13]

Laura Ermi and Frans Mäyrä (2005) have developed a gameplay experience model that features three types of immersion. When designing immersive games, it is important to realize what kind of immersion is sought.

Sensory immersion, usually understood in the context of digital games, means "audiovisually impressive, three-dimensional, and stereophonic worlds that surround their players in a very comprehensive manner." In pervasive games, the physical world is the best source of sensory immersion as virtual content is typically sparse and made available on a small cellular phone with a tiny screen. In practice, digital worlds are denser in game-related content than most pervasive games. In order to truly use sensory immersion without screens and stereos, the gaming location must be spectacular.

The feeling of *challenge-based immersion* is created when "one is able to achieve a satisfying balance of challenges and abilities" (Ermi & Mäyrä, 2005). The challenge can be either physical or mental, although preferably a combination of both. The concept of *flow* is a close relative. It was coined by the psychologist Mihaly Csikszentmihalyi (1975), who uses it to describe the mental state where one is fully immersed in an activity such as dancing or playing a game. The concept of flow has become a dominant paradigm in digital game design; many design guides include chapters devoted to describing the balance between a player's ability and the challenge provided by the game (e.g., Bateman & Boon, 2006; Fullerton, Swain, & Hoffman, 2004; Rabin, 2005).

Finally, Ermi and Mäyrä (2005) categorize experiences where "one becomes absorbed with the stories and the world, or begins to feel for, or identify with a game character" in *imaginative immersion*. The phenomena described here best fit the understanding of immersion in the context of ARGs (see McGonigal, 2005) and larp (see Harviainen, 2003). The following tips are geared toward imaginative immersion.

Create a dynamic immersive story. Games that contain a good story are better at creating imaginative immersion than those that rely purely on challenges and quests. To avoid a sense of railroading, the story needs to be dynamic or at the very least create an illusion of player agency.

Employ role-playable characters or avatars. There is a sliding scale of involvement that different character manifestations can have: A cursor encourages no character immersion (there is no character and no immersion), an avatar is a puppet controlled by the player, and a character is a persona or an identity the player identifies with or even pretends to be. Greater involvement with the avatar character leads to greater imaginative immersion.

Craft a coherent and engaging game world. Players long for coherent worlds (Ermi, Heliö, & Mäyrä, 2004).[14] They want the diegetic world, no matter how fantastic, to adhere to an inner logic. Uncovering the logics and laws of a world can be fun, but in order to facilitate immersion into a game world the ludic reality must be internally consistent.

Casual Pervasive Games

Many of the games discussed in this book require quite a devoted playing style in order to be rewarding. *Momentum* required the player to be ready for the game for 5 weeks, whereas *The Beast* featured dozens of incredibly difficult puzzles that only the most diligent and brilliant members of the player community could solve. Martin Bjerver (2006) differentiates casual and devoted players of *BotFighters* based on the method of their spatially expanded gameplay: Devoted players travel a good while in order to attack someone, whereas casual players basically fight the players they find in their everyday life.

Casual pervasive play is not easy to create because the cultural conventions and frameworks to enable it do not exist. It took decades before *Spacewar!* became a casual game: The 1962 version could only be played by computer scientists using an extremely expensive PDP-1 computer. The arcade version *Space Wars* was released in 1977, but even though that version was an easily usable slot machine, the game was still far from casual compared to playing *Solitaire* on Windows[15]: Office workers could simply not use an arcade game for a brief moment of relaxation between their work tasks. Today, you can get a free version of the game with a few clicks and play for 2 minutes on your coffee break. Back in the 1970s, playing an arcade game could be considered geeky, but today's casual games have largely lost that stigma.

There are many factors involved in deciding whether a game is "casual" (see Kuittinen, Kultima, Niemelä, & Paavilainen, 2007). They include the nature of gameplay, the technology needed, the difficulty of acquisition, and several cultural conventions surrounding the play. In particular, the cultural conventions for pervasive games are demanding as the play styles often break out of established conventions of gameplay. Some factors can, however, help in creating casual pervasive games.

Choose a simple platform. The game has to be inexpensive and you have to distribute it widely. Everything must run on players' own phones and computers, preferably even without installation, or, in the case of game events, you can lend players devices needed for play.

Keep the social threshold low. Many casual gamers do not want to wear capes and sword props in public, at least not if the game is not a carnivalistic performance of a

crowd of people. Many *BotFighters* players appreciated the fact that playing the game is indistinguishable from SMS chatting.

Enable tiered participation. Where some players might enjoy dwelling deep into the game puzzles and devoting long hours to a game, others might be content with just surfing the Web to find out what has happened in the game recently. Participation tiers allow players to choose their own level of engagement and it also offers opportunities for casual players to become gradually more and more involved with the game. *Cathy's Book* is a good example, where a casual player gets a payoff from just reading the book. The experience deepens when she starts to check Web sites and call the phone numbers. Depending on her level of devotion, she can delve deeper into the game and crack more of the mysteries.

Conclusions

This chapter presented a repertoire of holistic design strategies. Although we have tried to cover the major strategies found in the pervasive games of today, we are convinced that many more will emerge as a result of pervasive games maturing. Indeed, various more established genres, such as alternate reality games and treasure hunts, have already given birth to their own more detailed design repertoires.

While the strategies presented here originate primarily from the gameplay design, other factors influencing the design of pervasive games also deserve consideration. For instance, the technological decisions may prompt the use of appropriate design strategies that will be discussed in Chapters Eight and Nine. Likewise, the business model of the game may determine whether the game is designed as a *leisure event*, as a *customer product*, or as an *ongoing service*. The key to successful development is in mutually supportive strategical decisions, where the technology, the business model and the gameplay work well together.

Notes

1. *Vattnadal* or Rivendell in English.
2. Based on both Michael Finkel's (2001) account and *vQuest* documentation on the game Web site. Neither source specifies whether the woman was an actor or police collaborating with the game operators. At least the group in which Finkel was playing was speeding at the time—the game was a race against time, after all. Documentation on the *vQuest* site says: "Teams are pulled over by SPD officers for various traffic infractions. After making the teams sweat for a while, the officer returns to their van with a "ticket"—the next clue!" (www.tipover.com/features/vqnews.htm).
3. Proceedings of CH1'2009 conference.
4. See Koljonen (2008) and Koljonen et al. (2008) for the ambitions and outcomes of the *Dragonbane* larp project.
5. The term comes from a fantasy reenactment group that uses blue cloth to cover anything in a game locale that is not part of the game. Another common convention is that game masters who are not part of the game dress in single color (e.g., black) clothes.
6. A variety of facilitator roles exist in games. Role-players call them game masters or dungeon masters, alternate reality gamers call them puppet masters, puzzle hunters call them game controllers, and people running military exercises call them referees. Their powers, responsibilities, and modus operandi vary from game to game.

7. *Railroading* is a derogatory term that is often used for games where no matter what the players do, the game always follows the sequence of events that the game master intended from the start. Many narrative-based games are actually railroaded; the trick is to not make it apparent to the players.

8. The MMORPG industry demonstrates how difficult this can be. For example, all the details and secrets of *World of Warcraft* are available on a number of sites, neatly assembled and organized. Players harvest this information manually by playing the game (www.wowwiki.com), by aggregating automatically collected data (www.thottbot.com), and by reverse engineering the game client. Even though this can be seen as detrimental to the genre (the developers would definitely not have provided players with all such information), they are an integral part of the way MMORPGs are played, and the game development must conform to this fact. Massively multiplayer pervasive games must take this into heavy consideration as well.

9. Distributed narratives are finding their way into television and films as well. When popular works set up customer loyalty programs or advertisement campaigns in the form of (alternate reality) games, the reward for players is often additional information regarding the story world (cf. Örnebring, 2007).

10. Aarseth (1997) presents a detailed theoretical take on all sorts of *ergodic* texts.

11. The terms *narrative* and *story* have distinct meanings in narrative theory.

12. Interview by Shannon Drake in *The Escapist*, November 2006. www.escapistmagazine.com/articles/view/issues/issue_73/421-Number-of-the-Beast, ref. September 24, 2008.

13. For example, Gary Alan Fine (1983) discusses *engrossment*, whereas Gordon Calleja (2007) considers *immersion*, *presence*, and *identification*, settling on *incorporation*. The term *immersion* also holds different denotations and connotations (compare, e.g., Murray, 1997, Harviainen, 2003, and McGonigal, 2003a).

14. According to Marie-Laure Ryan (1994), virtual reality developers refer to this as *semiotic transparency*. She writes: "The predictability of the response demonstrates the intelligence of the system. The user must be able to foresee to some extent the result of his gestures, otherwise they would be pure movements and not intent-driven actions." As the Wiimote shows, it is not just the world that needs to be coherent, but also the interface.

15. According to a recent study, *Solitaire* on Windows is by far the most popular computer game played in Finland (Kallio, Kaipainen, & Mäyrä, 2007). Indeed, it is a perfect match of gameplay, technology, distribution, and cultural conventions. After a certain point, the sheer popularity of a game turns playing into a casual activity.

Case H

Epidemic Menace

Jaakko Stenros and Markus Montola

You are an agent of the European Epidemic Prevention Agency (EEPA). Your job is to track down a lethal virus that has escaped from a research laboratory. You and your team must track down all the escaped specimens before they spread and multiply, affecting the general population. You are also competing with another EEPA team for the glory of a job well done. To carry out the mission you have a plethora of different gadgets and gizmos: Augmented reality goggles allow you to see invisible viruses and a backpack full of electronics used with an enhanced smart phone are used to capture them. But you can't stay outdoors too long, as exposure to the pathogen must be minimized, and thus members of your team rotate between the mobile virus hunt and stationary command central in a nearby building.

In mission headquarters you need to coordinate the agents on the field with a real-time map that tracks the agents and the airborne viruses. You can monitor changing weather conditions, observe how they affect the spread of the pathogen, and try to piece together the reason why the virus escaped in the first place. Someone unleashed it on purpose. But who was it?

Epidemic Menace[1] was a research prototype game created in order to experiment with crossmedia gaming (see Figure H.1). The idea was to combine numerous gaming devices and input systems to a complete whole. The game used cellular phones, augmented reality devices, video feeds, live actors, and so on to transform the campus area to a fictitious world where an invisible virus was spreading.

The basic gameplay revolved around two modes of play: Some players controlled the EEPA work from the command centers, whereas others ventured out doing fieldwork. The headquarter staff were provided with an overall impression of the epidemic, with "satellite information" on where the viruses were spreading. The fieldworkers had to use tactical and practical information from the command center players to locate viruses; they played with location-aware portable devices that could disinfect areas and capture viruses for deeper analysis.

In order to create a credible and thorough experience, *Epidemic Menace* used *minimalist role-playing* techniques. The players were costumed by providing them with EEPA shirts and technological gadgets, and the game was instructed by an actor playing "Professor Mathiessen." The interesting thing was that the devices and costumes given to players also provided them with functional roles within the game. The command center staff naturally assumed a coordinating role. The field workers had to rely on instructions provided by the command center.

After the setup, the first agents went outside and were equipped with virus-capturing devices—a customized smart phone that was able to detect and capture viruses in the player's immediate vicinity. The agents in the command center could see on a map where the agent was and guide her toward the viruses. All the while the two teams competed over points. Once they had caught enough viruses, they received another film that gave more information on the events leading up to the release of the virus. A high point total also enabled the team to upgrade to a better disinfection device, augmented reality goggles that enabled the virus hunter to see the viruses, and a different virus-capturing device.

Finally, the team would have to make a decision on whom to arrest for releasing the virus. If they chose the right person, then that would stop new viruses from popping up on the campus. At the end of the game, there was still a race to capture the remaining viruses and, thus, more points.[2]

Epidemic Menace is interesting as an example of *crossmedia games*, which have been characterized by Irma Lindt (2007) as "games where the game content of a single game instance is made available across different gaming interfaces." To elaborate on this, crossmedia games are

played across different devices and media channels and that employ a wide variety of gaming devices and media channels in the game play, including state-of-the-art mobile and stationary computing devices as well as more traditional communication and information channels such as television broadcast or print media. (Lindt et al., 2005)

The difference compared to multiplatform games, such as games that are available on different platforms (*Tetris*, *Grand Theft Auto 3*) even if they can be played together (*World of Warcraft*), is that the various interfaces are designed to be different. Different tasks are performed on different interfaces. This is supposed to generate and support interesting game-play across different media (Lindt, 2007).

FIGURE
H.1

Promotional picture for the second iteration of *Epidemic Menace* shows augmented reality devices, mobile phones, and a virus as it would appear to the player.

Epidemic Menace was a game that was played on and through numerous interfaces. The technology was very much in the center of the game, but the plot and the common aesthetics tied the different operations performed on dissimilar devices together. The field players were tracked with GPS positioning, and their positions were transmitted via Wi-Fi so that the players in the command center knew where they were (see Figure H.2). The viruses could be seen on real-time camera footage, on maps of the area, and on the various gadgets used to track, observe, and capture them. If the players got too close to the viruses, they would infect the players and make the mobile gaming interface less stable. The backstory film provided a context and information that enabled the players to make an informed decision on who was behind the spread of the viruses. Part of the fun of the game was in fooling around with expensive prototype technology. However, the minigames offered by individual devices would never have been as fun or as engaging as the whole that emerged from the sum of its parts.

In a way, this is an elaboration of some forms of sport where certain pieces of game equipment are used for certain tasks (e.g., a bat for hitting and a glove for catching in *baseball*). Each device in *Epidemic Menace* carried with it a way of seeing the game world and interacting with it. This moved the actual, experienced game one step away from the various screens and buttons toward the physical world. The game was situated in tangible reality, taking place not just on the various interfaces, but also between them.

Epidemic Menace also used the strategy of exceeding player expectations in an interesting way. At first, the game was presented as a tactical puzzle-solving game where game interaction took place via technological devices. However, near the end of the game the players were led to highly contaminated areas; instead of entering physically, they had to remote control an AIBO robot dog in order to scout the laboratory areas, eventually finding an actor who could relate more of the backstory to the players.

In terms of spatial, temporal, and social expansions, *Epidemic Menace* is not a very pervasive game.[3] It was played during a few hours within the campus area, where outsiders strolled around, but the game did not encourage interaction with them. Spatially speaking, the game was *adaptronic* (Walther, 2005), meaning that events in the physical world influenced what happened in the virtual one.

The weather patterns had a twofold influence on how viruses spread. First, some airborne viruses spread according to wind speed and direction. This was done in order to add

The players of *Epidemic Menace* played in two locations: indoors in the control center or outdoors hunting the viruses. It was possible to switch play modes. The indoor picture is from the first iteration of *Epidemic Menace*; the outdoor picture is from the second iteration of *Epidemic Menace*.

tangibility to the experience, solidifying the connection of the virtual and the physical in the mixed reality of the game. Second, the growth of some viruses was dependent on warmth and humidity measured at the site. The reason for this adaptronic solution was mostly playability: If the game was played in bad weather, the players could succeed with less time outdoors than on a sunny day. Even though the adaptation is invisible to the players, it is very relevant for pervasive game design: Player preferences regarding outdoor play are highly dependent on weather conditions, and, unless the game can calibrate itself accordingly, it is bound to become unpleasant in some weather conditions. Additionally, the adaptronic design aimed at creating an interesting interaction with the physical world. Players could, for example, look at the wind direction and then conclude in which direction the virus was moving.

Notes

1. *Epidemic Menace* was organized in cooperation by Fraunhofer FIT, Sony NetServices, and Blast Theory as part of the IPerG research program. The first iteration of the game was staged near Bonn, Germany, in August 2005 and the second in July 2006. For more thorough descriptions of the game, see Lindt, Prinz, Ohlenburg, Ghellal, and Pankoke-Babatz (2006), Lindt, Ohlenburg, Pankoke-Babatz, and Ghellal (2007b), Fischer, Lindt, and Stenros (2006), and Fischer et al. (2007). Also, for designing crossmedia games, see Lindt, Fischer, Wetzel, Montola, and Stenros (2007a).
2. The *Epidemic Menace* project was executed in two slightly different iterations. These iterations had some differences, as their function was to stage a comparative study. Overall, the first version was a longer game with more tasks (it included, for example, a part where the virus was analyzed) and a greater number of devices (AIBO) in play, whereas the second one changed some of the equipment and aimed for a more condensed experience. In this description, we present a synthesis of the two iterations: No installment of the game included all the features presented here together.
3. *Epidemic Menace* is an excellent example of a game based on pervasive and ubiquitous computing technologies. Even though we have moved away from a technological definition of pervasive gaming (in Chapter One), those technologies do show great promise for games expanding the magic circle.

EIGHT

Information Technology in Pervasive Games

Annika Waern

A game does not need to use pervasive technology to be pervasive. However, most of our example games use information technology in one way or another, and some of them can be classified as pure computer or mobile phone games.

Pervasive games benefit from technology in many different ways. It can help players stay in touch when playing in different places, a game engine can aid game masters or replace them, and positioning technologies enable games that hide virtual content in the physical world. An important aspect of information technology is that it can store, communicate, and maintain pervasive games. A sufficiently complex pervasive game becomes nearly impossible to sustain for long periods unless it is at least partially automated. Another advantage of partially automated games is that they are typically easier to restage at a different time or place.

A host of technologies exist, that can be used in pervasive games. In this chapter, we will not go into details on any particular technology; there are too many and the description would date very quickly. Instead, we aim to provide strategies on how to *design the use of information technology* in a pervasive game.

Supporting Play with Technology

While using technology in pervasive games has obvious benefits, it comes at a cost. Even off-the-shelf technology can be expensive, not to mention the price of developing, testing, and deploying new hardware and software. The game would become dependent on the technology and suffer from every glitch—remember that inaccurate positioning, lags in data traffic, and disconnections in wireless communications are the rule rather than the exception! Information technology remains a brittle medium particularly in pervasive settings, and any game design that relies on it needs a backup plan for malfunctions.

Technology-Sustained Games

Many pervasive games, particularly those developed in the research community, are *technology-sustained*. They rely on computerized simulation: The computer maintains the game state through monitoring and reacting to player activities. The game content and rules are defined based on what this simulation can trace. These games are very similar to traditional computer and mobile games and can be understood as computer games interfacing with the physical world. To battle another "bot" in *BotFighters* (Case D), the player's mobile phone must send its position to a game server, which provides information about other bots that are close by. The result of the fight is then calculated by the system and registered at the online game server. In *REXplorer* (Case K), all game content is controlled through interacting with a magic wand (Figure 8.1).

In *technology-supported* pervasive games, information technology is used to support some but not all game activities, and the system might not contain a complete rules engine. *The Beast* (Case B) and *Momentum* (Case F) are examples of technology-supported games. Although both games rely heavily on technology to relay information between players and game masters, the primary player activities were not dependent on the technology. Even though *The Beast* was largely an online game based on modern information technology, there was no rules engine running—the Internet was simply used as a medium for communicating and staging the game. Solving many of the game puzzles required no technology at all, and some activities took place in the physical world. *Momentum* is an even better example; the core activity was role-play in both the physical world and online. The technological installations supported some automatic game play, but the diegetic role of technology was constructed so that even if it broke, the breakdown had a role in the story.

Technology-supported games have an advantage over technology-sustained games in that the technology is a part of the game, but it is not the whole game. They offer richer opportunities for immediate experiences: Visiting places physically, meeting people face to face, and surfing the ordinary Internet are all activities that are central to the pleasure of pervasive gaming but very difficult to trace by a game engine. Even if technology-sustained games can encourage players to indulge in such activities, they have difficulties in valuing them within the game engine. Taking a technology-supported approach opens up a richer design space.

Some games fall between these two categories. These are games where a computer (or several computers) controls the game state and the games cannot be run, won, or lost without technology, but at the same time the games include important real-world activities that are not known to a game engine. The chief example in this book is *Epidemic Menace* (Case H), where players sometimes interact with an actor and watch films. Although these activities are crucial to the advancement of the game story, they are independent of the automated game system.

There are some particularly useful ways to use technology in technology-supported games. These include supporting communication, keeping traces and scores, sequencing information and quests, and supporting game mastering.

Support communication between players or between players and game masters. Many pervasive games use information technology primarily for this purpose. The phone communication between mobile and stationary players in both *Uncle Roy All Around You* (Case L) and *Epidemic Menace* (Fischer, Lindt, & Stenros, 2007), the ghost communication between players and game masters in *Momentum*, and the player-to-player text

FIGURE
8.1

**Technology-sustained games tend to make players focus on the device during the game.
Pictures from *Epidemic Menace (top)* and *REXplorer (bottom)*.**

messaging in *Day of the Figurines* (Benford, 2007) all show how a game can be built around communication. It can happen via a custom-built, diegetic communication chan-nel, as in *Momentum*, or by using existing everyday technology, such as mobile phones, as in *Epidemic Menace* and *Day of the Figurines*. The choice depends on the type of game. If communication plays a minor role in the game, the natural choice is the mobile

phones, as the players already own them and know how to use them. However, if communication is a major theme of the game—as in *Momentum*—the game can benefit from using specially built in-game artifacts that the players are required to learn to use, build, or repair as part of the game.

Staying connected and keeping in touch constantly is the rule rather than the exception today. If a game requires that players spread out over a distance, they will communicate by mobile phones or via the Internet even if the game forbids it.[1] One reason to introduce game technology can simply be to keep tabs on the game communication and to direct it in beneficial ways.[2]

Establishing, obstructing, and listening in on game communication are all interesting game activities. One game that made use of these was the student project *SpyGame* (see Björk, Holopainen, Ljungstrand, & Åkesson, 2002) in which several teams competed in bringing a physical briefcase back to their home base. Each team was split into a group of runners and an online team. The runners were directed by the online team, who were able to trace the current position of the briefcase and who were also the only ones to know the team's home base. When a runner caught up with another runner, he or she would take over the briefcase and start to carry it to his or her own home base. The runners and the online team communicated through SMS, but all messages were relayed through a game server. This server would, at random times, display the messages also to the other teams. This meant that the teams needed to be very careful with what and how they communicated. A good strategy was to split messages up into several message or to develop some kind of a code.

Track player activities and keep scores. Although not all player activities can be traced by technology, many can. Technology can count keystrokes on a keyboard or the number of steps walked, recognize gestures, monitor player activities on particular Web sites, track player positions in the real world, and so on. Modern sensor technology is continuously increasing the way player activities and environmental conditions can be traced.

This information can rarely be used in its raw form. It needs to be aggregated and presented in a useful way. A system that traces the positions of participants might, for example, plot their routes on a map or calculate a score based on how many of the game locations the players have found.

Hiding information and sequencing quests. Information technology can be used to unlock new game content automatically once the players have achieved something that can be traced by technology. Games that use this technique become partially (or fully) automated. The hidden game content can be in-game information such as pieces of the background story. A very common use of positioning technology is to place virtual content in specific places in the real world. To retrieve this information, players have to travel to the physical place to pick it up. A more advanced use of this technique is to sequence player activities; players might have to solve one puzzle before they are allowed to try another. Score keeping, hidden information, and quest sequencing should all be used with some care, as they introduce automatic functionalities into the game. It is typically easier to cheat in a pervasive game than it is in a computer game; it is easy to hide from network access, go to places where positioning does not work, or just shut off a device. In general, pervasive games work better if they give *rewards* rather than penalties for using technology properly. In *Treasure* (Barkhuus et al., 2005), players can only pick up virtual gold coins (placed in physical

locations) if they are located in the right place by GPS positioning. This game design encourages players to actively seek out better GPS coverage.

Game-mastered games. As illustrated by *The Beast* and *Momentum*, pervasive games often benefit from being game mastered. As pervasive games tend to be spread over large spaces or long time periods, they can become very hard to game master without the use of information technology. Game mastering is a great way to answer the challenge of varying playing conditions, broken technology, and player improvisations, as game masters can simply *change* the rules as they see fit.[3] Game-mastered games can use all of the aforementioned techniques.

Seamful Design

Matthew Chalmers has coined the term *seamful design* (Chalmers & MacColl, 2003), a design approach where the inner workings of a technology are made visible to its users and used as a design resource rather than as a problem to overcome. Seamful design is particularly useful as a design approach for pervasive games and can be applied to both technology-supported and technology-sustained games.

All technology has its limitations. GPS does not work indoors or in thick forests, establishing a Bluetooth connection takes some time, most gesture sensors cannot distinguish direction, and so forth. In computer and video games, these limitations can usually be anticipated and dealt with, as the game rules are entirely defined within the scope and limits of the technology. But as pervasive games provide players with infinite affordances, they are different: Players will use the game devices in unexpected ways, the world is subject to constant change, and just about any aspect of the outside world can interfere with the game or the technology. This makes it hazardous to set up the game in a way that hides the inner workings of the technology. What Chalmers instead suggests is to make the inner workings of the technology not only visible, but also an integral part of the gameplay. By designing a game that makes use of the limitations in an interesting way, the real-world interference with the game offers interesting play options rather than just obstacles toward optimal game play.

Turn limitations into assets. In Chalmers' *Treasure* (Barkhuus et al., 2005), players use both GPS and WLAN to play the game. Players have to be within GPS coverage to be able to pick up coins. But in order to upload them to the game server and get points for them, they have to get back into WLAN coverage. However, when they are in both GPS and WLAN coverage, they run the risk of other players sneaking up on them to steal their coins. This means that players have to start to understand the invisible landscape of GPS and WLAN coverage and develop strategies to balance these risks and rewards. A player might hide in a GPS shadow in an area with WLAN coverage and jump out to capture the coins from another player right when he comes in to upload them.

Incorporate maintenance in a positive way. Design technology that clearly displays any malfunctions, and allows players to fix it, as part of the game. An old 1980s matrix printer was used in the *Momentum* production to receive particularly important messages. It made quite a racket and frequently jammed, but the players loved it. Whenever the printer started to make a noise, they knew that an important message was coming and had to run there to save it from being eaten by the machine. As well as creating

tension in the game, the task was solvable: They knew exactly how a matrix printer worked and what to do to prevent a jam (Stenros et al., 2007c).

Show the environmental influence on the technology. Design feedback from real-world interactions so that it is clear how reality has affected technology and, by doing that, empower players to find their own way to achieve the game goals. As a simple example, consider a game that relies on a sunlight sensor worn by players. A seamless game might use the sensors to determine whether the players were indoors or outdoors, but this would fail during rainy days or if a player decided to cheat by covering the sensor. However, if the players were given the task of finding light sources that emit daylight, the sensor would be used in a seamful way, and the players could address the need of a daylight light source as a puzzle.

Giving Technology a Role

A core difference between technology-supported and technology-sustained games is that in the former, the technology appears within the game world. In the latter, the technology frames the game completely—it does not exist outside or without the technology. In technology-supported games, the technology must somehow be made available to players in a form that does not conflict with the game context.

We can identify four main strategies for giving technology a role in a game. As all these ways have their different consequences, the decision is central to the game design. The most obvious strategy is to just give the players *gaming devices*—means to play with. Just like a physical book is usually[4] not supposed to be a part of the story written on its pages, gaming devices are just means to an end. This is the natural approach for technology-sustained games (see, e.g., *Treasure*) and is also a viable solution for technology-sustained games that focus on a gamistic experience with little story content (such as the *Go Game*)(McGonigal, 2006b). A more interesting strategy for technology-supported games is to give technology a role as *diegetic artifacts*. These are items that exist physically within the game world: Players are welcome to fight over them, steal them, and, in some cases, even break them. This is a method typical to pervasive larps. A similar strategy is to embed the technology in a person, providing players with *body extensions* made possible by wearable technology. By strapping sensors to a player's body for the full duration of the game, it is possible to create the illusion that the player has superhuman abilities: A wireless earphone can simulate extended hearing by relaying sound from a remote location.

The fourth strategy is to *embed the technology in the environment*, making it partially or completely invisible to players. Embedded technology is powerful because it tends to keep players guessing about where it is located and how it functions: If it is used for surveillance, you never know whether the game masters are listening to you. Embedded technology can also enhance a place: A magic room, for example, can play different music depending on which players are inside. By hiding the technology, however, it becomes more difficult to use a seamful design approach. It can also create problems if the players happen to discover the installations, as they can become confused about whether it is intended to be discovered or not or indeed at all part of the game installations. A player in a mafia game who stumbles on a surveillance camera can become uncertain about whether it was installed by the diegetic FBI, the game masters, or a real world security company.

Giving Information a Role

In addition to designing the role of a technology, game designers must also consider which role they construct for the *information* conveyed by a device. It can be interpreted either as part of the game diegesis or as nondiegetic information about the status of the game. The augmented reality displays of *Epidemic Menace* allow players to see diegetic viruses, and the ghost communication devices of the *Prosopopeia* games allowed players to hear diegetic ghost voices. If such an illusion is created with sufficient fidelity, the diegetic world comes alive: Instead of perceiving a 3D model or receiving a call from a game master, the players can directly experience a game world that is different from the ordinary world. The illusion becomes even more believable if the physical artifact itself is designed to fit the game context. The nondiegetic alternative is also perfectly viable; games such as *vQuest* and *Go Game* do not use technology in a way that superimposes a fictional layer on top of the ordinary world, but simply conveys the game tasks and objectives to the players.

An interesting alternative is to communicate nondiegetic information to players in order to support them in creating a fictional layer. The game master might send an SMS to a player with information that their character should know. This strategy is particularly useful when technology needs to stay hidden. It was used in the fantasy larp *Kejsartemplet* (Åkesson & Waern, 2006), where for obvious reasons technology could not appear in its modern form but was disguised as magic artifacts. One of the functions implemented was a system of informing the wizards whether they could use magic. The system utilized wireless communication in conjunction with hidden vibrators sewn into a garment worn by the wizards. When the vibrators signaled, the wizard players knew that magic had stopped working in the kingdom. The wizards could act out their characters based on this meta-game information, while allowing the rest of the players to maintain a seamless illusion of fantasy. All of sudden, and with no visible cause, all the wizards just seemed anxious and terrified: To the other participants, this appeared as if their connection to magic had been severed.

Technological Performatives

To conclude the discussion of the roles of technology, we should consider the role that technology takes in shaping the experience of spectators and bystanders of socially expanded pervasive games. Reeves, Benford, O'Malley, and Fraser (2005) mapped technological interfaces in terms of how the manipulation of the technology and the visible effect of this manipulation were made visible to an audience. Manipulation can be hidden (pushing a button in secret) or revealed (making overt and large gestures), and, likewise, its effects can be hidden (sound effects conveyed through earphones) or revealed (displayed on huge screens). Depending on how these are combined, the resulting interactions can seem *secretive*, *expressive*, *magical*, or *suspenseful* to an outsider. This strongly influences what kind of invitations the game offers.

Secretive interfaces support hidden manipulations and they also hide the effects of those manipulations. These interfaces are useful for games that are intended to stay hidden. In *BotFighters* and *Insectopia* (Case I), both the manipulations and their consequences take place mostly on cellular phone screens; the outsider witnessing the game being played would probably think the player is sending SMS messages or simply running to catch a bus while holding her phone.

Expressive interfaces are the complete opposite of secretive interfaces: They require large-scale interaction (large gestures, running, screaming) and have large effects. Expressive interfaces in public spaces can be a good option for games that strive to invite spectators. *Laser tag*[5] is quite expressive; the manipulation (ducking, aiming, shooting) is visible, as are the effects: The targeting lasers are visible (especially in smoke, fog, or rain), and the audiovisual effects tell who is shooting and who gets hit. Expressive interfaces are useful in games that want to invite spectatorship.

Magical interfaces hide the manipulation of a device but reveal the effects. They may hide or reveal the performer. Magical interfaces are useful tools for game masters in particular, but may cause undesirable interpretations for bystanders who are unaware of the *gameness* of the effect. The wizards of *Kejsartemplet* were magical: The wireless signals were hidden, but the performance acted out by the magicians was clearly visible to the bystanding audience (which, in this case, were other larp participants).

Suspenseful interfaces show the manipulations but hide the effects. Suspenseful interfaces can be just confusing, but if players clearly show that they enjoy the effects they can also serve as a strong invitation to play or to spectate. *Momentum* and *Epidemic Menace* are suspenseful; an outsider could witness players performing rituals and strange activities, but as their effects manifest as sound messages from the ghost world and virus populations, seen and heard only on players' devices, spectators cannot understand the entirety of gameplay.

Generally speaking, different player types consider different sorts of interactions attractive. Players of a suspenseful game may have to face considerable social pressure, as they are about to publicly perform something strange with no discernible reason or alibi. Secretive is probably the most common choice for mainstream games, as the minimized social expansion makes the games the easiest to play.

Designing Interactive Artifacts

Modern sensor and actuator technology opens up the opportunity to build interactive artifacts that are specially built to fit a specific game. Sensors can be bought for a few dollars on the Internet, and there are development platforms that make it straightforward for a skilled technician to wield these into a game object and program their functionality in the game. The use of sensor and actuator technology opens up the possibility to enhance the real world not only with invisible information and quests, but also with physical objects, body extensions, and environments that contribute to realizing the magic of the magic circle.

The design of in-game artifacts faces a number of issues that require special attention. The interaction model for a physical device is much less flexible than that of a computer game interface or a generic device. In addition, while a nondiegetic device can focus its interaction model entirely on ease of access, an in-game artifact can be designed deliberately as a puzzle. Finally, to work as an integral part of the game diegesis, an in-game artifact must be designed carefully to fit the theme and mood of the game, and this design must cover all aspects of its look and feel.

Design interaction to fit all play modes in your game. An in-game artifact is often used in a varied range of game situations, and it can be very hard to find a single interaction model that fits them all. A case example of this is the "EVP recorder"[6] built for

FIGURE
8.2

In *Prosopopeia Bardo 1: Där vi föll*, a reel-to-reel tape recorder was rebuilt into a magical artifact. The players used it to communicate with the dead. This machine was designed so that players could even take it apart without discovering the phone hidden inside it.

Där vi föll (Montola & Jonsson 2006), which was actually a reel-to-reel tape recorder from the 1970s that had been modified to include a mobile phone (Figure 8.2). The players could record messages for the ghosts on the tape recorder and then let the tape run empty for a while. When they rewound the tape afterward, they would find ghost voices answering the recorded messages on the same tape. This device was rather difficult to use; the old recorder was cumbersome on its own, and one of the first game challenges was to learn to operate it. However, later on in the game the device was used as a tool in other game tasks, and the intentionally challenging interaction model became a source of frustration.

One solution strategy is to provide players with configuration options for the device interaction model. When the players of *Där vi föll* found the EVP recorder, it was supplied with a single pair of earphones. It was up to the players to understand that they could plug in a loudspeaker and listen to messages together. When doing so, the ghost messages were also played out in real time instead of being just recorded on the tape. Thus, by plugging in the loudspeaker the device was turned into a real-time device and a multiplayer device, as all players present could hear the messages.

Create consistent aesthetics. The aesthetics of interactive artifacts, just as the aesthetics of all game objects and environments, are an important factor in pervasive games.

Apart from contributing to players' immersion in the game world or making a game more pleasurable, engaging, or thought-provoking, the aesthetics inform players about how they are expected to engage in the game. An example of this is the elaborate display created for the game *Day of the Figurines* (Benford, 2007). This game, which is actually a rather simple SMS-based phone game, was given a physical presence through a virtual game city display table placed in an arts exhibition. The table had several design features to invite spectators to enter into the game. First, it was *large* and placed where bypassers would notice it without yet knowing anything about the game. The table was concave so that when people stepped close to it they actually stepped *into* the city. The height of the table invited spectators to have both a bird's eye view over the whole city and, by bending down, a close first person view. In order to aid the game operators in moving the figurines, the board was also augmented with projected lines. This highly graphical display invited bypassers to step up and become interested in the display as well as understand something about how it worked. To enter into the game, players chose a figurine to represent them. The tiny doll was placed at the edge of the virtual city. Players would leave the exhibition with a memory of the physical city, a phone number to send an SMS to, and a Web address. During 24 days, the figurine would be moved around the city by game operators according to the player's instructions. Players would be informed about the state of the city and the experiences of the figurine by text messages; they could also at any time go back to see the actual display (Figure 8.3).

Another important function of aesthetics is to set the style and mood of the game, as this will influence what the players expect to do and experience within the game. *Momentum*, which was created as an intense and hard-core experience, used urban exploration and cyberpunk as its design themes in props and installations as well as in the choice of environments and locations where the game was staged. When standard technology that does not fit the overall aesthetics of a game is used, it is possible to cover or hide it in ways that are more in line with the general look and feel. In *Momentum*, a lot of technology was cased in this way to look more like magical artifacts in a cyberpunk setting.

Aesthetics are not limited just to the visual or aural media. With custom-built technology, it is possible to maintain a consistent aesthetics also in the interaction model for the device. In *Momentum* the players used technomagical gloves to search for hidden fractures in reality. The technical effect was that the players were searching for a radio frequency identification tag with a reader hidden in the glove. When the RFID tag was found, the glove would vibrate. This slow and very sensual movement, almost like they were caressing the object, both added to the game mood and had an in-game interpretation. By stroking the surface, the players awakened the hibernating magical spot, which responded to their touch by vibrating.

Provide instantaneous feedback. A very common problem in pervasive technology is that it takes time for the device to react to player activities. Snags in communication over distance and bandwidth problems are typical causes of this, but the source of the delay can also be human game masters who need time to respond. Unless the interaction model is designed to provide instant feedback, this can become a huge problem. In technology-supported games with unclear boundaries in time and space, players are likely to spend time and effort looking for "hot spots"; places and activities that can have any effect at all. In such situations, players must be given *instant* feedback when they find a place or an activity that is able to trigger an effect. Otherwise, they are likely to keep on searching and miss the exact spot or activity that triggered the effect. Typically, this feedback needs to be generated locally by the device the players are using. If the reaction

FIGURE
8.3

The game board of Blast Theory's *Day of the Figurines* was designed to provide a public and performative interface to an otherwise fairly invisible game activity. Each player would have a personal figurine placed on the table as their physical avatar.

comes from a remote game server, the response is affected by lag. The RFID gloves in *Momentum* reacted automatically by buzzing over any RFID tag. A remote game server—or a game master—might still be in charge of determining the *game meaning* of the action. The role of local feedback is just to tell the players they triggered *something*, not necessarily what it is or what they have achieved by triggering it.

Note that unless they have some other reason to continue, players tend to stop searching when they encounter an effect. This can also create boundary problems if the technology reacts quickly. An example of this was the technical problems encountered in *Savannah* (Benford et al., 2004), which is a GPS-based game where game content is placed in particular physical locations. This game ran into problems, as players would stop walking when they first received some game content, which would happen right at the borderline of the GPS area. Players would sometimes stop receiving content while standing still, and other teams might not receive anything in the same place.

Conclusions

Technology is used in pervasive games for both practical and aesthetical reasons. It makes games easier to maintain over time or vast spaces, it enables players to communicate with each other and with game masters, and it can automate game play in ways that are impossible without technological support. To players, it can appear as magic, implementing functions that superimpose the diegetic game world on top of our everyday reality.

However, the dream of technology as magic will remain a dangerous fiction. Technology is a brittle medium with quirks and deficiencies that the game designer must understand in order to design a good game experience. The real world will always intervene with technology-based games. In general, it is not such a good idea to hide technology or disguise it as something that it is not. Instead, technology-supported games work best when players understand the inner workings of the technology they use and can use this understanding to their advantage in the game.

Technology is best seen as a handy tool that can be used in pervasive games when it fits. It is not the only way to create pervasive games, and large pervasive games are seldom implemented using one single technology solution throughout the game.

Notes

1. Communication devices are forbidden in *The Amazing Race*. Only reality television game shows can fully expect the participants to fully obey all game rules: The constant surveillance combined with the risk of disqualification from a competition worth a million dollars. Hobby groups can also trust the sportsmanship of the players to some extent.
2. Diegetic communication could, in theory, go through a game engine, influence the game state, or be modified by it. However, this would require advanced real-time language and image recognition. In practice, game engines can only tackle connection information (caller, receiver, time, length of call). Understanding the content requires human game masters.
3. Runtime game mastering is covered in Chapter Seven. See also Jonsson, Waern, Montola, and Stenros (2007b) and McGonigal (2006b).
4. *Cathy's Book* (2006) being an interesting exception to the rule.
5. Players of *laser tag* shoot each other with laser guns. All players wear sensor vests, which determine whether a hit is scored, possibly disabling the player for a while and also keeping track of the points. Despite the name, most *laser tag* systems use infrared light for shooting and lasers only for targeting.
6. EVP stands for *electronic voice phenomena*, human-like voices that can be occasionally distinguished from radio static. Researchers such as Friedrich Jürgenson and Konstantin Raudive spent decades trying to comprehend the messages they believed to be voices of the dead. The *Prosopopeia* games were set in a reality where this hypothesis was correct.

Case I

Insectopia

Johan Peitz

You suddenly realize that you are starting to recognize the people around you. There is that woman who always takes the same bus as you on Tuesdays; she's the one that walks down the slippery slope instead of taking the stairs. And later you bump into that guy from the office below; you know all about where he likes to have lunch but have no idea what his name is. No matter. It is only important whether they brought their insects, as you need to see them again. If you don't, your collection is likely to shrink and you'll maybe have to start searching again for other valuable collectibles. Maintaining your entire bug collection is not easy, even though you have spent quite some time finding out what kind of insects are associated with your colleagues, neighbors, and bus companions.

Today something is different; searching through the bus you find a Divine Swallowtail, one of the most precious insects of all! Who might it belong to? Is the owner that smart-looking businessman with the ridiculous tie, that woman in the green coat and mittens talking loudly with her friend, or perhaps that suspicious-looking kid in the back? In the days to come you will simply have to find out.

Bluetooth devices are everywhere in the contemporary urban environment. They are in mobile phones, photo booths, printers, and photocopying machines. *Insectopia*[1] is a simple casual mobile phone game that exploits this property of our environment: Every device with an active Bluetooth connection carries a bug or a butterfly, which can be discovered by the player. The unique identification of each Bluetooth chip is translated by the game into an insect. Thus, every Bluetooth beacon is a potential resource, whether it is another player or not. A random person on the street could be carrying a valuable insect inside her cellular phone.

The player of *Insectopia* looks for Bluetooth-rich environments and then enables the insect search on her phone (see Figure I.1). She finds out what invertebrates there are in the vicinity and chooses which one to add to her collection. Only one insect can be added at a time, and the player has to wait for a few minutes before another search can be conducted. By collecting rare and valuable bugs, the player increases the worth and size of her collection, eventually competing against other players on high score lists. *Insectopia* is a global, open-ended game that can be joined at any point by players all over the world. Because of its environmentally generated content, the game is playable wherever the players go. A player who has explored her neighborhood can always make excursions in order to search for new insects to add to her collection: A player living in a sleepy suburb can visit the local mall, while a hard-core player could maximize her chances by hanging around business centers and airports.

FIGURE
I.1

The screen capture on the left shows an insect collection and the point values of each insect. The other shows the selection between single-player and double-player modes. The minimalist user interface requires very little attention from the player.

The game is fully playable as a single-player game but also allows players to team up in pairs. Taking a more active stance toward the game allows players to enhance their insect-catching abilities to the benefit of them both. Encouraging social play, the game allows players with a partner in the same location to catch insects without having to endure a time penalty before catching again, which would be the case in single-player mode. By leveraging social gameplay even further, it is also possible to trade insects with other players in order to build the perfect collection. A functionality for this kind of matchmaking is not available in the game by design, forcing players to seek each other out actively or to recruit new players.

In order to succeed in the game, players need to figure out the associations of the various insects, persons, and devices. A collected insect will only stay alive for 8 days, making it necessary for the player to investigate which insects belong to which persons. By making repeated and selective searches, players can take note of changes in their surroundings and map it to the changes in their insect search result, eventually making educated guesses about which insect belongs to whom. These theories can then be confirmed or discarded in future searches. The game mechanics of *Insectopia* do not encourage the player to play as much as possible. However, it tries to adapt to players' real lives by encouraging play during idle moments of everyday life when people are likely to be carrying mobile phones around. This works especially well while commuting or when in similar situations. By recognizing fellow travelers, players can start to associate insects with persons and build their own library of familiar strangers.

Although the possibility of intense play sessions exists, the game is supposed to be played in a very casual way. There are no roles to play, no expensive technology is needed, no eye–hand coordination is required, and there is no need to gather many players. Players can choose to play whenever it suits them, be it alone or together with others. All in all, the commitment needed from the players is very low, as the game tries to fit into their ordinary lives

and is available when they need it. For a quick game, little to no commitment is required by the players. If there is no interest in maintaining a collection, the game can be used as a toy to see how many Bluetooth devices are around and which insects they represent. However, finding a valuable insect is likely to trigger a desire to keep it and engage in the game more actively. As a player gets more into the game, she can choose to play in different game modes depending on the current social context. The single-player mode allows players to search leisurely for insects at their own pace. The insectoid world is created on a player's mobile phone based on active Bluetooth IDs, which means that the environment is rich and limitless without being repetitive. In addition, the game does not disrupt bystanders in any way—the game does not even establish an active connection to the devices used as building blocks for the insects.

The gameplay in *Insectopia* can be deepened by adding layers to the collecting mechanism. First, every insect in *Insectopia* has a value associated with it that is proportional to its rarity. As a player searches for insects with her mobile phone, mostly common insects such as ants and flies appear. These insects are worth very little in comparison to rarer invertebrates such as butterflies and beetles. It is possible for players to compete in online high score lists, not only for the most valuable collection, but also for the biggest one. With insects that have not been nurtured properly dying every 8 days, these lists are quite dynamic. It is easy for new players to get in and hard for experienced players to stay on top. Second, *Insectopia* challenges players to nurture their caught insects over time. If a player does not visit the spawn device of the insect at least once every 8 days, the bug will wither and die. This allows players to keep insects of people who they share their daily life with quite easy, while it makes it harder to keep a big collection up and running.

An item-collecting game called *Mogi* is similar to *Insectopia*. The main difference between them is that where the insects in *Insectopia* are generated by Bluetooth devices around the player, *Mogi* requires administrators to place items using GPS coordinates. While this makes it possible for the game operators to create and place items in interesting places for the players to find, it lacks the social emergence displayed by *Insectopia*. *Mogi* has to be localized for each city where it is played, whereas *Insectopia* can be played right out of the box. However, players of *Mogi* can go look for items in the wilderness, at least as long as the game operator has placed items there, whereas *Insectopia* players have to look for environments that have a high density of Bluetooth devices in order to get a satisfactory game experience.

Pervasive games generally tend to require a lot of content to function properly. *Insectopia* circumvents this by using the existing infrastructure around a player to generate resources for a game. Using nothing but their own mobile phones, players can explore the hidden world of *Insectopia* that lies superimposed on their real world and, thus, rediscover their real world.

Note

1. The *Insectopia* prototype was developed and tested publicly. At the time of writing, it is going through a viability investigation and possible commercial release. For a more in-depth look at the design, development, and evaluation, see Peitz, Saarenpää, and Björk (2007).

NINE

Designing Pervasive Games for Mobile Phones

Jussi Holopainen and Annika Waern

Mobile phones are rapidly becoming the most common gaming device for pervasive games. There are multiple reasons for this; the most obvious one is that modern mobile phones are actually tiny computers that we carry with us at all times. Mobile phones are the *most widespread pervasive game platform* available: In 2008 there were over three billion mobile phone users in the world.

Mobile phone games have been around for a while. Early phones came with preinstalled games, and nowadays high-end phones can download games wirelessly. Preinstalled games in particular have been highly successful; almost everybody who has owned such a phone has also played the games. It has even been claimed that *Snake*, preinstalled on older Nokia handsets, is one of the most popular digital games ever.[1] These games are typically small casual games that fit the tiny screen and small buttons of the mobile phone.

When phones are used to support pervasive gaming, there are other aspects of the device that come into focus. Pervasive mobile phone games can be roughly divided into two categories: Pervasive games played with mobile phones and mobile phone games with pervasive features. Games belonging to the former category have core gameplay features similar to other kinds of pervasive games, such as pervasive larps and treasure hunts (see Chapter Two). They also tend to be technology-supported rather than technology-sustained (see Chapter Eight). This chapter focuses on the second category, looking at the challenge of creating mobile phone games that also have pervasive features. *BotFighters*, *Insectopia*, and *REXplorer* (Cases D, I, and K) are examples of games designed specifically to use mobile phones as the game platform.

Personal and Mobile Communication and Computing

The main reason for using mobile phones in pervasive games is that phones are used very differently from computers. The main use for a mobile phone is communication—to make phone calls and send text messages. Furthermore, the mobile phone is a very

personal device. Although children sometimes share phones, most people are reluctant to lend their phone to anyone else. The mobile contains a lot of intimate information: Pictures we have taken, the phone book, and a log of SMS[2] messages that many people keep as memorabilia. Based on this, the sharing of content between mobile phones has developed into a practice of negotiating intimacy. Both young adults and children will often share music and sometimes pictures from one person to the other in ways that strengthen and emphasize their social relations.

We carry a mobile phone with us at all times; many people would feel naked and vulnerable without their phone. There is no other device that has become this much an extension of us. Taking the phone away from a player is a powerful way to strip and incapacitate them (as was done in *Uncle Roy All Around You*, Case L). If a game makes phone calls to the players or sends them text messages, it permeates their lives in a very forceful way. An in-game chat client is just a part of a game, but sending an SMS or answering a call is part of your life.

Mobile phones are trusted; they are always on, always with their users, and can always communicate globally. People can almost always be reached on their mobiles. This makes the location and context of the participants of the conversation central to the conversation. People will choose different modes of reachability depending on the context (e.g., putting their phone in silent mode or preferring SMS to talking). When speaking on the phone, it is common that people disclose their location and usage context. The location and context of usage have also been used for playful purposes. Jarkiewicz, Frankhammar, and Fernaeus (2008) describe how children use their phones in a game of hide and seek. In their study, the seekers would sometimes call the person who was hiding, to hear the phone ringing and seek them out.

Pocket Computing

Mobile phones are rapidly turning into tiny computers. The emphasis here is on *tiny*: Their computing and communication capabilities are constantly increasing, but what does not change is the limited size of screens and keyboards. This, if nothing else, makes it a mistake to indiscriminately bring any random computer game to mobile phones.

In addition, the usage pattern of mobile phones is very different from that of computers. Although more and more people use the phone as a device to browse the Internet or play games, we tend to use it in short bursts, sometimes 5 to 10 minutes at a time, sometimes even just for a few seconds to check an incoming message. We use the phone while waiting for the bus or riding the subway, in secret at a dinner party or in class, or while doing something else such as watching TV. The intermittent usage of the mobile makes it unsuited for many computer games, even when they would otherwise fit the screen and the buttons. Mobile phone games need to be interruptable, but they can go on for long periods of time as people have their phones with them at all times.

Mobile phones are not only computers, but they feature cameras, have various ways of connecting to other devices, and are equipped with different sorts of sensors. Phones are constantly getting smarter at understanding their context, combining a variety of tools for sensing their location and surroundings. Positioning, as used in *BotFighters*, is just part of this. Some phones make Bluetooth available as a way of sensing when other devices are close by; some offer temperature sensors, others accelerometers that make it possible to trace how the player moves the device. Mobile games can also make use of online

contextual information in an adaptronic fashion; for example, the game can utilize the local weather conditions, traffic data, or even the cultural calendar of events from rock concerts to national holidays. A particularly interesting feature of the modern mobile phone is the camera. By taking a photo, players can prove that they were at a particular place. There are techniques to overlay virtual content onto photographs and video streams to create an impression that the players have uncovered something invisible by pointing a camera phone at it. Many phone cameras can take photos outside the visible spectrum, increasing the opportunities for using the camera as a way to uncover hidden information.

Taken together, these properties make the mobile phone an ideal platform for pervasive games.

Pervasive Presence in Mobile Phone Games

Most of the pervasive games discussed in this book take place in the real world or are cross-medial experiences. This chapter focuses on pervasive games that run on the mobile phone, with the interaction bound to the device. Most of the design suggestions and challenges presented in earlier chapters largely apply also to pervasive games played on mobile devices. However, it can be more difficult to make the player feel that the game actually is pervasive. The problems can be boiled down to the experience of *presence*: How players connect to the game and negotiate their place in it.[3] In a pervasive game, we desire to make players feel that the game extends *beyond* the tiny screen, creating a world that is integrated with the ordinary world, and that the players are able to act in this world through their device interaction. Player and game world identification, player-to-player interaction, especially when the game supports the formation of communities, and many of the design strategies described later in the chapter enhance this sense of presence.

Player Identification

Player identification refers to how the player grasps the role offered by the game to the player. This has many facets. The most basic thing that players have to understand is what they are supposed to achieve and how they can act within the game. This identification can range all the way from a full character role assumed in a role-playing game to the simple affordances of moving and rotating blocks to get rid of rows in *Tetris*.

Strong player identification can be difficult to accomplish in mobile phone games. For example, an anthropomorphic avatar, especially with player-preferred qualities (audiovisual and behavioral), is a well-known technique for increasing player identification and empathy for the game character (Cohen, 2005; Morrison & Ziemke, 2006). This approach is difficult to achieve with the tiny interface offered by a mobile. For pervasive mobile games, there is, however, the option of making the *player* a game character. An example game that uses this approach is the game *Mythical: The Mobile Awakening* (see Holopainen, 2008). According to the storyline of *Mythical* (see Figure 9.1), our world is full of magical creatures that we can contact technologically through mobile phones. In this game, the interface did not offer the player a representational focus in the game world, but rather the game implied that the physical players themselves were inserted into a magic environment made visible on the mobile screen. In *Insectopia*, the mobile screen presents a collection of insects that the player collects by strolling around in the

FIGURE
9.1

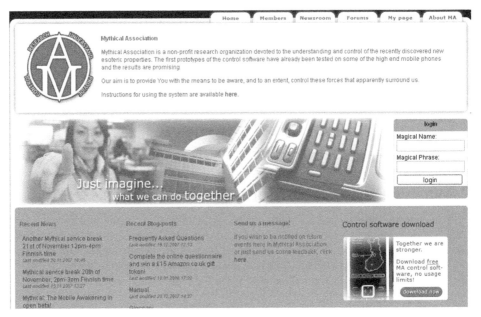

The original Web site for *Mythical: The Mobile Awakening*. The Web site utilized this-is-not-a-game aesthetic situating the player in a magical version of our own world. According to the background story, the mobile phone client was really just a technical interface providing the users a diagrammatic representation of the surrounding magical environment.

real world. Even *BotFighters* used a similar tactic; here the players carried around a bot that could battle against other bots in the real world. By making the player a game character, these games are able to create a strong relationship between the surrounding environment and what is shown on the screen of the phone. Note that this is possible even if there is no real relationship; in *Mythical*, most content was generated randomly and not tied to the physical location of the player.

Game World Identification

Not all games come with a game world, but those that do have it for a good reason. Through the process of *game world identification*, the player gains knowledge and forms her assumptions on how the game world behaves. Understanding the game world is what makes players aware of what kinds of events and actions are possible, what behavior is expected from the players, and roughly what the consequences of their actions will be. Game world identification is an understanding of the diegetic world and its norms and mythos, and it provides the background knowledge for allowing deeper player identification.

The *Mythical* game world is supposed to be a transfiguration of the real, mundane world, where the fantasy of the game world is merged with ordinary reality. *Mythical* faced problems with explaining the rich mythos of the game through the tiny mobile interface and the short usage sessions typical for mobiles. The often touted importance of the first

FIGURE
9.1

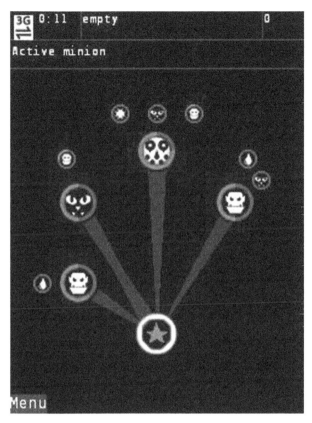

Continued

5 minutes for computer and console games (Partridge, 2007) is changed to the importance of *the first 30 seconds* for mobile games. This can prove to be a crippling obstacle for a pervasive mobile game that relies on a complex gameplay and a rich game world.

Another approach is to make reality the background and thematic context of a game. There is a wealth of such real-world information from local geography to local folklore. This strategy was used effectively in *Mythical*, where the background story contained references to local myths. Even simple tricks, such as describing otherwise location-independent game events as happening in or near the players' hometown, can be effective in creating a sense of an active game world overlapping with the real world.

Player-to-Player Interaction

As pervasive games are typically multiplayer games, an important factor in creating a feeling of presence is to facilitate *player-to-player interaction*. Interacting with other players is one thing that makes the game bigger than just a casual on-screen experience, whether it means a simple comparison of high scores or elaborate synchronous collaboration

mechanisms. In general, player-to-player interaction can happen through game mechanics (combat and trading), communication with other players and through the game itself (chat and emotes), and communication with other players outside the game (Web forums and TeamSpeak). In pervasive mobile phone games, the ordinary communication capabilities of the phone are a natural choice for extra-game activity, and there are also examples of SMS-based games that use text messaging for in-game communication.

It is important to encourage players to communicate both inside and outside the game. This way the players get a feeling that the game world is alive and that there are other players there. Also, any form of player-to-player interaction gives the interacting players a stronger feeling of player identification. Through interaction with other players they are shaping and sharpening their identities within the game.

Communities

An online game *community* can be defined as a group of people (players, spectators, and other kinds of participants) doing something together with a shared purpose. Even though player communities are often discussed in the context of persistent virtual worlds only, they tend to emerge in any game that is sufficiently successful for a longer period of time.

The main problem is in attracting and maintaining that critical mass of players. Persistent multiplayer worlds benefit from features that support community and group formation, as this helps players create a lasting commitment to the game world (Bartle, 2005; Friedl, 2003; Mulligan & Patrovsky, 2004; see also Arrasvuori, Lehikoinen, Ollila, & Uusitalo, 2008). Once a player feels part of a community, she is likely to continue to play. Community members will even frequently coax each other into playing at a certain occasion, for example, to participate in collaborative raids of *World of Warcraft*. Being part of a game community extends the presence of the game outside play sessions.

A player does not have to interact actively with a community for the community to be meaningful. For some players it is important simply to feel that other players are playing the game *actively*. A simple method is to provide indicators of overall current player activity, such as the number of players currently online, and ways to communicate with other players. Even simple indicators can make the difference. Some studies suggest that just indicating that there are other, real people playing with or against you will change the player experience (Gallagher et al., 2002; Ravaja et al., 2006).

In pervasive mobile phone games, an additional opportunity is to show traces of other players' activities in the real world. Based on information about location or proximity to other phones, players may, for example, pick up content that other players have left at particular locations or team up with players on the street (or even with nonplayers that other players have met). Giving players information about other players and their actions will make the game world livelier. This way the players get the feeling that there are other active players, increasing their commitment to the game.

Design Strategies

When designing pervasive games for mobile phones, it is important to consider the use situations and the natural affordances of the device. This section focuses on design strategies that address issues that are particular for pervasive games for mobile phones.

Mobile Phones as Context Sensor Platforms

Mobile phone games can be aware of the players' context and adapt the game experience to it. This is often a core element in making a mobile phone game pervasive.

The first and often simplest approach is to make the players themselves supply contextual information. Players can locate themselves on a map. They can seek out and enter other information that is available in the physical world, such as arrival times of local trains or the name of the driver of a particular bus. Physical items with bar codes or RFID tags can be read directly by some phones. Adventure games and treasure hunts can easily be built on such game activities. Real-world information is, in this case, used as codes that unlock hidden game content. The design challenge is to use information that is interesting enough for the players to uncover and, at the same time, potentially available to all players who need it. A good strategy can be to distribute different challenges to different groups, as is fairly common in ARG (Dena, 2008a,b).

A second approach is to use sensor and online information as a resource in creating a game world that adapts automatically to the players' context. Automatic adaptations can be based on sensors integrated with the phone (e.g., a positioning service or GPS tracker) or on information available online (e.g., the local weather conditions in the players' hometown). In such a game, the sensor information is often used to create a challenge or an opportunity for the player, who must act on it. The results are then transformed into the game context. A particularly interesting subtype of these games is games that rely on information about the communication infrastructure of the game. In Chapter Eight, we discussed the mobile game *Treasure* (Barkhuus et al., 2005), which used information about the availability of GPS positioning and WLAN connectivity to create different game experiences when players are in or out of reach. Other examples include *Insectopia* (Case I), which uses the unique Bluetooth identifiers of passing phones. The advantage of using infrastructure information as the context is that a phone always needs to be aware of its infrastructure status and this information is often available for application programs.

When using contextual information in a game, it is important to remember the infinite affordances offered by pervasive games. If players seek out contextual information in order to benefit in the game, they will use whatever means they have available to obtain it. If players need to locate a code hidden in a secret place, one player will uncover it and post it on the Internet. If you make information available only in daylight conditions, players will put their phones under daylight lamps or adjust their clocks to get benefits.[4] The variations are endless, and as a designer it can be very hard to foresee what players will do. As this is a central part of the fun in pervasive games, it is usually better to allow this to happen than to create excessive technical limitations or rules. It is often beneficial to use a seamful design approach, as this allows players to become aware of the inherent properties of the context information used in the game and use it to invent gaming strategies.

Games of Casual Exploration

One type of pervasive games that is particularly well suited for mobile phones are games that rely on casual exploration of the real world. These games rely on technology to create a physical/virtual overlay where virtual content is hidden in the physical world, where it can be picked up, examined, manipulated, or moved by the mobile phone players.

The game *Insectopia* is a good example of a game of casual exploration that enables players to investigate the environment at their own leisure. The Japanese game *Mogi* (Joffe, 2005) also belongs to this category; in this game, players collect virtual treasures that can be obtained at certain times from certain places: The first player to arrive at the location of a virtual treasure can actually win money for collecting the prize. Since this last example is a game played for money, players will invest more effort in it than in the other examples. Still, the game is played in short bursts of activity and can be picked up and left off at any time.

The design challenge for games of casual exploration is to make the virtual content and the interaction meaningful *both* in the real world and in the game world. All of the example games are based primarily on location information, where the players' location is the central resource for creating a physical as well as virtual experience. An opportunity for such games that hitherto has been little explored is to also use sensors embedded in mobile phones to provide means for local interaction such as gesture recognition. Gesture interaction gives the players a sense of physical, tangible interaction that takes place in the physical world and not just on the small screen. An example of a game that uses locations and gesture-based interaction is *REXplorer* (Case K).

Mirror World Games

Mirror world games are another promising class of games. Mirror worlds are virtual models of the physical world enhanced with information (Smart, Cascio, & Paffendorf, 2008); a mirror world is a persistent virtual space that reflects or models aspects of physical space. Where games of casual exploration tend to put virtual content into the real world, mirror world games represent some aspects of the physical world in a virtual context; these aspects can be highlighted or enhanced by the game activities. From an interactional perspective, these worlds appear to the player much more to exist on the device than in the physical world. *BotFighters* (Case D) is an example of a mirror world game in which the players carry around persistent virtual robots that they train to fight each other.

An interesting option for mirror world games is to let adaptronic input (see Chapter Four) affect the game world. This is often possible to do without using sensors on the actual phone, as the phone can also access online information about the players' context. Many mirror world games have two main modes of play: One for the mobile phone, where access to the mirror world can be limited, and the second one through a Web browser or PC game client, which provides both overview functionalities and more detailed information on the mirror world and sometimes also additional interaction possibilities. This creates a cross-platform experience.

In the future, we can expect many mirror world games to be built on *existing* mirror worlds. Excellent examples of mirror worlds with huge potential for all kinds of games are Google Maps and Google Earth. These services provide detailed geospatial information, which can be used as an input and background for various games, especially when also using locationing with the mobile phone.

Communication Outside the Game World

A particular challenge for pervasive mobile phone world games is to create an awareness of what is going on in the game world when players are not active in the game. As mobile

phone gaming tends to be done in short bursts, many players want to be aware of the events in a persistent game even when they are not playing the game actively (Korhonen & Saarenpää, 2008). This poses a challenge to interaction design, as the game needs to expand outside its own interface, communicating with players who are not logged in.

The benefit of pushing information to players through the phone is immediate delivery, allowing players to react quickly. Pushed notification is also an excellent way to create temporal expansion at surprising times. The flip side is that sometimes pushed messages feel like spam, they can be stressful when urging the player to go online when they cannot, and it can also incur high costs for the player or organizer.

It is also possible to inform players through a pull medium. A pull medium is one where players have to check up on their messages actively, for example, through checking emails or reading blogs. Many games also offer news and mail services that become available as soon as the player logs into the game, and such media are becoming increasingly available also on mobiles. On some mobile phones, the game client can be turned into a push medium. Such game clients run continuously in the background monitoring servers and can alert the player when something interesting happens in the game.[5]

An important issue is deciding what game events are communicated to the player. The basic rule is that the player should be notified about anything that would have caused her to act if she had been playing. However, the amount of messages should not be overwhelming because this can disturb the player or cause her to start ignoring messages. The best approach is to let the player set the notification pattern manually or make the game adapt to players' playing patterns (see Crabtree et al., 2007). Players should be able to disable all notifications using the same communication channel. For example, if notifications are sent by email, players should be able to disable them by responding to a notification email.

Some notifications might concern less urgent information. For example, player-created stories can be used to give the players stronger focal points for player and game world identification (Sorens, 2008). Such background information should typically be offered through pull channels.

Viral Invitations

Mobile phone games of today offer few advertisement and sales channels. They are typically bought online from Web stores that offer minimal information about each game. They are seldom reviewed in game magazines and cannot be bought by mothers in the supermarket. At the same time, reaching and maintaining a critical mass of players are crucial for the success of pervasive games and are often also very important for more casual multiplayer mobile phone games. It is good practice to estimate the required number of players and their required overall activity already in the early design phases. In games splitting players into factions, it is important to estimate the required number of players for each faction and to figure out balancing mechanisms for keeping the faction dynamics interesting.

By viral marketing, games are marketed by word of mouth rather than public announcements or newspaper reviews. Viral invitation should rarely be used as the only marketing method for a game,[6] but it serves as a useful complement to other marketing methods. In games, viral marketing can be built into the game structure directly by providing in-game incentives for players to recruit new players actively. *Coup*, a mobile phone game mimicking a feudal society, allowed players to recruit new players from the

game client (see Saarenpää et al., 2007). The recruitment notification was sent as an SMS, and the newly invited players became vassals of the inviting player. Thus the pyramid scheme of recruiting new players to the game was rewarded by the game mechanics. Games that rely on viral recruitment are common on Internet sites such as Facebook, so it can also be useful to let viral marketing for mobile games expand to other media.

As the mobile phone is considered such a personal device, there is also an opportunity for local strategies for viral marketing. Although we have no examples of a game that used this strategy, it is likely that a game (or a game asset) could benefit from being offered only to players who are able to meet in person with another player who already has it. This strategy would build on the youth segment's interest in *sharing* mobile content with each other.

For viral marketing to work, new players must be able to get a feeling for the game quickly. Potential players should be able to get an adequate overview of the game before registration or payment. This phase of getting acquainted with the game should require as little investment as possible from the potential player. Having a free trial period for new players is a good start, especially if the trial guides the player to get in touch with other players, providing implicit social commitment. Early collaboration with other players needs to be rewarding for both parties, both new and old players. Giving new players concrete in-game rewards consistently during the trial period will increase the likelihood of further engagement (Kaptelin & Cole, 2002) and joining the game properly.

Creating Critical Mass with Short Play Sessions

As discussed previously, the normal use pattern of mobile phones is that short periods of activity are scattered over the day. Some, but not all, mobile phone activities are triggered by outside influence, such as an incoming call or SMS.

A particular problem with the short playtimes of pervasive mobile phone games is that it increases the risk of players who know each other never being online at the same time. Players might be very lonely even in a game that has a high number of players as very few of them tend to be online at the same time. This creates problems for generating critical mass. There might be few possibilities for social contact, which reduces the potential for social interaction and motivation for collaboration.

A good strategy for overcoming this particular issue is to offer ways to make user activities present asynchronously. For example, turn-based gaming works well as the game will pause until all players have made their moves. In games with persistent worlds, it becomes important to leave traces of player activity as well as make players aware of current activity. Finally, in pervasive mobile games the outside world can provide sources of activity, in particular through the activities of people who are *not* playing the game. If these can be made to populate the game world, it will rarely be empty.

The main objectives of all of these approaches are that the player should never feel alone in the game and that meaningful social interaction and collaboration with other players are made possible, even if players might rarely be online at the same time.

Activity Blending

Another issue that arises from short usage sessions with mobile phones is that the usage situation seldom allows full attention on the game. This makes *activity blending* an

attractive design strategy for pervasive mobile games. A game that allows for activity blending allows players to engage in other activities during gameplay (answer a phone, drive a car). By supporting activity blending, the player can come back to the game easily after an interruption, increasing the likelihood that she will do so.

One way to support activity blending is to use a slow update mechanism, where the effects of player actions are determined within certain intervals or after a certain time has passed. The optimal update pace depends on the intended usage situation and can vary from minutes to days. To support activity blending, the interval needs to be long enough but also fixed so that the player can fully concentrate on other tasks in between. In slow-paced games, it is recommendable that players are able to check the current status of the game quickly and in a manner that does not disturb other activities. Especially designers of slow update games should consider using communication methods outside the game itself.

Dormant games can also support activity blending. These are long duration games that run semiautomatically in the background of players' daily lives. Players make semiregular updates to the game, for example, by moving their game assets or buying and selling in-game assets in an in-game market. To support activity blending, such updates are usually restricted to a slow update pace. The game then runs continuously in the background as other players are active in the game; if something sufficiently interesting happens the player is notified. Many casual online games are dormant games, only alerting players when they require attention. To enable activity blending, players should not need to react to the notification immediately, even if many prefer to react quickly when possible.

An example of a dormant game is an online strategy game where players can move troops and buy equipment once a day, but where they can be attacked by another player at any time. When attacked, the player still has some time to respond; if the player does not respond in time, the attack can still be handled automatically. Game event notifications can be nonintrusive, such as just updating the overall status in the game interface, or intrusive, such as when the game sends an SMS notification to the players. Considering and carefully designing for contextual adaptability (see Chapter Five) can also help activity blending, particularly in dormant games.

Finally, asynchronous gameplay can also support activity blending, but this requires that the player is in control of the pace of the game. The amount of time that players are willing to invest in a game can vary greatly. The challenge is to create a game that entices both those who prefer to play the game almost in real time and those who prefer activity blending and play the game in parallel with other activities. Some games will even benefit from a design that allows players to *leave* the game at any time without destroying their chance of succeeding in the game. One way to accomplish this is to allow the game to take control over the player's game character and make fairly reasonable choices.

Conclusions

Mobile phones are a powerful platform for making and staging all kinds of pervasive games. The phone can be used as an additional device providing computation and communication capabilities, or the design of the game can focus on the specific affordances provided by the phone with the associated sensors and services. This also means that a

pervasive game developed for the mobile phone should consider the overall pervasive game design strategies described in Chapter Seven.

The main challenge for pervasive mobile games is well known by every mobile game developer already. There are currently thousands of phone models available for the potential player, which creates a fragmentation nightmare for the developers.[7] This is especially difficult for games that require more sophisticated technologies, such as GPS and gesture recognition, or operator-based services, such as cell positioning. One way to overcome this problem is to provide different play modes for different phones. For example, players could participate in the game by just sending and receiving text messages, but there could also be play modes that use more sophisticated technologies.

Mobile phones are devices for social interaction, and sometimes they even have sophisticated online capabilities. Also, pervasive games can use the real world as a part of the game, and real world is, as we all know, a shared world. These facts make mobile phones suitable for multiplayer games. A thorny design challenge is to provide players with an adequate sense of an active game world with active players even though they may never be playing the game at the exact same time.

Pervasive mobile phone games can blend the real world and the game world in a compelling manner and, at the same time, offer natural multiplayer features. Keeping these things in mind, it is possible to develop mobile phone games that are something totally different from existing computer games.

Notes

1. www.gamezone.com/news/06_17_05_10_57AM.htm
2. Usually referred to as text messages.
3. Our concept of presence is similar to Friedl's (2003) discussion of knowledge of partners and knowledge of the game environment.
4. As an example, *NetHack* and *Animal Crossing* utilize the internal clocks of PC and Nintendo GameCube to trigger events and assign seasonal modifiers to the game, and players often cheat these games by changing the date or time before play. While the contemporary games can double-check the time over the Internet, the lesson is that players will cheat the sensors if they can.
5. At the time of writing, this is possible only on a small number phone models and not even on all high-end models.
6. While the average viral reproduction rate can grow above 1:1, such cases are very rare. While it is easy to name several success stories that have spread like wildfire (Hotmail, Facebook, *The Beast*, countless small memes), that tip of the iceberg is visible exactly because of the high reproduction rate; countless failed examples of viral-only marketing have not been visible to us. In almost all cases the reproduction rate stays below one, but even the declining growth it is still very valuable. If an average player recruits 0.5 players successfully, the viral mechanism still doubles the player base over time. (see Watts, Peretti, & Frumin, 2007.)
7. Publication platforms, such as the Nokia N-Gage, attempt to tackle this problem.

SOCIETY

Case J

Vem Gråter

Markus Montola and Annika Waern

It is a typical day at the faculty: A lecture in the morning, followed by a supervision meeting, and perhaps a visit to the university gym afterward. But something is out of place; in the morning you notice that someone's piled a bunch of chairs into a weird tower. At noon you find weird scribbling on the wall, as if someone has written some weird text with charcoal; a sight made very strange by a small puddle of something red on the floor.

When you're leaving the campus, a stranger stops you and asks whether you've noticed any-thing strange during the day. Some people are rumoring that something really weird is happening at the university.

These strange events were part of the reality game *Vem gråter*,[1] installed in a Swedish uni-versity in the spring of 2005. *Vem gråter* was created by a group of students attending a course on game design, run by artist and pervasive game designer Martin Ericsson. Their plan was to create a reality game, a set of events constituting an interesting experience for a group of par-ticipants unaware of the fabrication. Unfortunately, the event did not go exactly as planned, and a number of factors contributed to *Vem gråter* playing out in entirely unintended ways.

The first factor was a mistake made by the group of student designers: They reached the wrong audience. While a crossmedial poltergeist mystery may have appealed to their fellow students and even to some of the lecturers, those people did not encounter it in the school corridors. In our postgame interviews, it became apparent that nobody had actually played the game for real, even though a few students had started to realize that it was a fabricated ludic event and made efforts to participate in it.

Instead of the students, the maintenance staff of the school became the primary audience of the events. *Vem gråter* did not attract a bunch of entertained puzzle solvers, but people respon-sible for the cleanliness and order of the university premises. In their eyes, *Vem gråter* was not a game or a puzzle—they solved the mystery by interpreting the events as acts of vandalism.

The second factor was playing with a scary theme. As Michael J. Apter (1991) points out, a tiger in a cage is exciting because it is both dangerous and safe; a tiger without a cage is really scary in a highly unpleasant way. A reality game toying with a believable horror theme is not fun—it is scary.

The third factor was the lack of understanding of how stories grow from being told and retold. Even though an accurate observer might notice that an installation is a fabricated part of a puzzle, the subtle details are lost when that observer passes the story on to others. The story of *Vem gråter* was passed on to the principal of the school, a local newspaper, a crisis hotline for frightened women, and the police.

The fourth factor was creating a game in an area where people could not choose to avoid it. The people who worked in the school still had to go to work every morning and stay there late at night.

A central person in the event was an actor playing "Spiricom Thomas," a ghost hunter wandering the campus, who kept asking students and personnel whether they had encountered ghosts or heard stories about others encountering ghosts. The first-hand impression of this person seems to have been that he was slightly strange and obnoxious. However, as the installations started to appear, the university staff connected the events to this person and drew the conclusion that he might be involved in the events—maybe he was a potentially dangerous madman. Some women with a background of being subject to rape or other abuse were reported to have been particularly scared of him. When scared people framed their talk about Spiricom Thomas in this way, there was nobody there to correct the story or its interpretations.

What actually *happened* is a less interesting story. The university staff first got irritated, then scared, and, finally, angry. They informed the police and the principal, who started to investigate the events in a rather nonplayful manner. When the creators of the installations decided to step out and reveal that *Vem gråter* was supposed to be a game, a time of accusations and apologies followed.[2] The local newspapers covered the matter repeatedly, as seen in Figure J.1.

In theory, the installations of *Vem gråter* could be interpreted in four different ways. The intended, playful interpretation was that someone had created a cool mystery— a mysterious puzzle–game—to be solved. However, this interpretation was only available to someone who had experienced and really studied several of the installations. As far as we know, no one really made this interpretation. Some suspected a rabbit hole but did not actually find it.

The second interpretation acknowledges that these installations were the work of students but does not recognize their "fabricated" or playful nature. The people who adopted this interpretation saw the installations as pranks and vandalism. This interpretation was dominant among the staff.

The third interpretation did not connect the events with the students but acknowledges them as independent phenomena. Here Spiricom Thomas became the target suspect, as a dangerous madman staging the installations. This interpretation turned *Vem gråter* into a very scary event. This dangerous interpretation was also held by many members of staff.

The fourth interpretation was the one proposed by the game: The ghosts are real and the university is haunted. We did not find anyone who ever made this interpretation. It also was not really intended by the designers.

Even though *Vem gråter* managed to create a powerful illusion of being a part of ordinary reality, it failed to convey the intended messages. To most spectators, the playful interpretations were entirely lost: There were neither ghosts nor a game, only pranks or mysterious occurrences.

The challenge of any reality game can be formulated through Apter's (1991) thinking of excitement and anxiety (see Chapter Five): In order to be an exciting experience for someone in a playful mindset, a reality game places someone in a serious mindset at risk of unpleasant anxiety. A successful design should ensure either that all unaware participants approach it playfully or that people approaching it in a serious mindset are not subjected to excessive anxiety.

The lesson of *Vem gråter* is valuable to any designer creating a pervasive game, as all expanded games tend to appear as fabricated reality to some of its spectators. Games such as *Momentum* and *Uncle Roy All Around You* are in constant interaction with their surroundings,

Vem gråter was covered in the local newspapers quite extensively. The headlines shouted: "Spook Project at the University Degenerated" and "Spooking at the University Was a Reality Game." The media was not understanding of the activity, casting it as vandalism. Those responsible were called out to explain the event. The pictured articles were published in 2005 in *Gotlands Allehanda* and *Gotlandstidningen*; they are quoted from *Interacting Arts* #4 (Widing, 2007).

and for an organizer these interactions are difficult to control. Basic rules are simple and easy to learn: *Killer* groups learned fast to forbid authentic-looking guns. But risky games can spin fast out of control unless careful precautions are made.

Notes

1. Swedish for "Who is Crying."
2. We found out about the project as the dust was settling and decided to visit the university and interview people involved in the event. The results of this visit have been reported previously in Montola and Waern (2006) and in Montola et al. (2006a).

The Ethics of Pervasive Gaming

Jaakko Stenros, Markus Montola, and Annika Waern

Designing, organizing, and playing pervasive games often force participants to confront ethical questions.[1] In general, games distinguish themselves from everyday life in that they delimit activity differently. Things that are acceptable within the magic circle of a game might not be so in ordinary life, and vice versa. As discussed in Chapter One, participating in a *boxing* match changes the acceptability of violence: Punching the opponent in the face becomes more acceptable, while removing one's gloves becomes forbidden.

As Greg Lastowka (2007) writes

When the sumo wrestler enters the "magic circle" or the dohyo or the professional boxer enters the space and time of the bout, the rules of what social behaviors are desirable and forbidden are suddenly, radically changed. Violent and powerful physical attacks against another person, which are normally forbidden by law and social norms, become the obligatory mode of conduct. At the same time, polite and acceptable behavior may become inappropriate. For a boxer in the midst of a bout to attempt polite conversation with an opponent would be a gross breach of decorum. As one court noted: "subjecting another to unreasonable risk of harm, the essence of negligence, is inherent in the game of football . . ." (Hackbart v. Cincinnati Bengals, 1979)

Games liberate the activities of those who participate in them through offering a context where the outcomes of their actions do not influence their daily life. This is a central feature of the magic circle: The restrictions set down by the game are needed for the game to be free and liberating. Boxers can be allowed to exert violence, since the violence is limited by rules requiring them to wear boxing gloves and forbidding kicks to the groin. Expanding the magic circle takes pervasive games into a hazardous area, where a situation is ludic for some and ordinary for others.

Games are not the only human activity that has this property: Art, politics, and sacred ceremonies are all social systems that are demarked with differently framed ethics. However, social systems must be upheld socially; their limits are constantly renegotiated

by those involved. In secretive pervasive games, ludic and ordinary activities become blurred, and social negotiation becomes impossible, or at least fraudulent, as some participants are not as well equipped to participate. This is a feature that pervasive games share with transgressive activities in other social systems.

This chapter takes a look at the ethics of pervasive gaming from a rather practical perspective: Although the discussion is grounded in some theoretical discussions, our objective is not to build a generic theoretical framework for the ethics of pervasive play. We do not provide easy answers or strict guidelines; instead, we point out gray areas and pose questions that designers must address when creating a game. The purpose of this discussion is to provide the reader with tools to inform her own moral evaluation of pervasive game design.

We look at the ethics of pervasive gaming from three angles. First, we look at players: What are the ethical issues related to individual players, ranging from rights to responsibilities? Second, we look at unaware participants: How does the game influence, and how it is perceived, by bystanders? Third, we look at society: What are the ethical issues of pervasive games in a larger context?

It is important to note that this chapter, or indeed this book, must not be used as legal advice. Law and ethics do not always coincide, and there are great differences both between various legal systems and between cultural norms across the world.

Player Ethics

Many transgressive hobby communities stress ethicality and self-regulation: Even if the letter of a law is broken, it is important to be respectful of other people and the spirit of the law. As Alan S. North (1990) writes about *buildering* in his *Urban Adventure Handbook*: "When climbing past windows it is not polite to look in. This is especially true if there is something interesting to see." Similarly, *urban exploration* guides remind that when running into residents in "abandoned" locations, it is important to treat them with respect. Although they may be fellow trespassers, they actually live there (Ninjalicious, 2005; North, 1990). As Canadian urban explorer Ninjalicious writes, the liberty found in crossing boundaries has to be tempered with personal ethics:

> *Beyond the "do not enter" signs and outside the protected zone, you and your friends are free to behave as you really are [. . .] [A] lot of people who usually behave well do so because they're mindlessly obeying rules and laws, not because they're carefully considering which actions are helpful and right and which are harmful and wrong. People who think laws are more important than ethics are exactly the sorts who will wander into an abandoned area and be so confused by their sudden freedom and lack of supervision that they'll start breaking windows and urinating on the floor. [. . .] [I]t's important to seek out people with positive ethics, who will show respect for the sites by not breaking anything, taking anything, defacing anything or even littering while exploring. (Ninjalicious, 2005)*

The player who decides to participate in a pervasive game must understand what she is taking part in. Many pervasive games break societal norms and some even encourage the player to break laws. If the player still chooses to participate, she must do so of her own free will and with full comprehension as to what it is that she is doing. Unfortunately, providing such an understanding is rarely an easy task.

The player needs to know what she is prepared to do, have a clear sense of right and wrong, and set her own limits. Most importantly, she needs to stick to her chosen self-regulation even in the heat of the moment of playing. Limits vary from player to player: Some find it difficult to be rude to strangers but are willing to trespass at a junkyard, whereas the opposite is true for others.

Obfuscation of Consequences

Due to design strategies such as indexical representation, temporal seamlessness, differing levels of game awareness, and reality fabrication, players often find it hard to fully understand all the consequences of their actions. This *obfuscation of consequences* is a major ethical issue both generally and for individual players.

Pervasive games often require a double consciousness: Players need to be aware of both the game world and ordinary life. It is difficult to make the right choice if one does not comprehend the consequences of one's actions. Indeed, willingly allowing one's understanding to be blurred in such a way may be considered irresponsible in itself—a case perhaps comparable to lowering one's mental capabilities through the use of inebriating substances.

A clear example of how this can fail occurred in *Momentum* when players mistook a random person for an actor with awkward consequences. The players were given the task of obtaining a game artifact from an actor playing a homeless person, who was supposed to be found in a public square. The plan was to draw a circle of magic symbols around the bum in order to help players recognize their contact.

Unfortunately, the players were stalled for hours, and the actor left the scene, deciding that the players had missed their meeting. The players arrived hours later, finding a woman sitting in the circle, inebriated to the point of almost passing out. The players read this as a game puzzle featuring excellent costuming and acting, and attempted to solve it accordingly. It took them half an hour to realize she had nothing to do with the game: Until then they tried all sorts of possible solutions, including improvised cleansing rituals and going through her belongings. Before leaving the scene, the players assisted her in getting help.

The problem in this case was the backfired use of ludic markers (see Chapter Seven): The players who saw the magic symbols had every reason to believe that the woman was a part of the game. As *Momentum* had established a boundary-breaking mindset and extraordinary attention to detail, going through her belongings was understandable in the context of the game. In ordinary life, however, it was quite unacceptable.

Division of Accountability

Playing a game is exciting, and in order to progress in a game players are willing to bend the rules; not necessarily the rules of the game, but the rules of ordinary life. This raises issues regarding the *division of accountability*. As game organizers work toward obfuscation, which players accept willingly, it is hard to place the blame if an accident happens—and even harder to sort out the responsibilities in advance. Examples include speeding while playing and trespassing at the wrong location.

In a pervasive larp *The End Is Nigh*, played on the streets of Tel-Aviv, Israel, a character was shot and killed in the middle of a busy intersection. The body was taken and placed in a dumpster. The scene was carefully orchestrated by the game masters, who managed even the exact dumpster the body was placed in. Game master Itamar Parann recalls:

> When the "murder" took place we had a nearby GM (myself) ready—we could see that people inside a nearby Internet cafe were very worried (they were gesturing towards the people carrying the body, and when I entered they were going to call the police), so I walked inside, explained that this was not a terrorist attack and that we were gaming and that all was well. I then went and explained the same thing to a few teenagers who were rather nervous about what they had just seen. This is part of what I consider an important part of pervasive gaming—creating a safe environment for the players and for the game itself: I see it as the GM's responsibility to arrange this safe environment, since if a GM creates a game where murderers or violent people might "find expression," it is the responsibility of the GM to provide a gaming space in which such expression can actually take place. (Parann, 2008)

The players trusted the game masters that they would not get into trouble by playing the game the way the game masters intended. This trust should not be misused. The problem is that game masters cannot predict what players will do. Parann continues:

> [A]s a [game master] I am responsible for the safety and well-being of the players— but up to a point: As long as characters behave in a manner that is consistent with their character backgrounds, demeanor and reasonably expanded goals—I am responsible. But if a player/character just goes off the bend (decides to run naked in the middle of a street filled with cars), that is no longer my problem as that is not a part of the game in any way. If I think such a thing would be part of the game, I would have to arrange a place where such behavior is possible with safety. (Parann, 2008)

Wanderer is a *parkour*-inspired GPS game, where the player's goal is to travel at a constant speed to directions determined randomly by the game. When the game tells you to turn left, the only way to score points is to go left, whether that means jumping over a fence or turning at the crossroads. When the game was tested, it turned out that players were quite willing to take risks in order to succeed in the game:

> During the tests the players where highly motivated to follow the commands given by the game even when the environment was not allowing the player to perform the instructed movements. For example, players crossed streets, even with cars approaching that were forced to stop in order not to hit the player. During this example the players made it clear that they were not unaware of the environment, but were willing to force the environment in order to keep playing the game. (Hielscher & Heitlager, 2006)

The *Wanderer* example is similar to the speeding incidents connected with *BotFighters* (see Case D). The excitement of play may obfuscate the real risks one is subjected to. Although this also applies to all team sports, some pervasive games run larger risks, as their play arenas are not designed for play. Ultimately, players cannot expect to be kept

safe by organizers. But at the same time, organizers must still create a game experience that does not lure players into taking unnecessary risks.

In *Rider Spoke*, a participatory art experience carried out while riding a bicycle in London, players were required to stop cycling before they were allowed to carry out their tasks, recording voice messages. Both *Wanderer* and *Rider Spoke* specifically tried not to distract players who had to navigate in traffic. Still, the designer cannot predict what players will do, and a player can be temporarily too excited or distracted to realize the risks involved.

In games that employ run-time game mastering there is the additional danger that players may be under the illusion of safeness created by active surveillance. As a result, players may be willing to do whatever is within reason to follow instructions or solve puzzles. In a playful state of mind, "within reason" means something different from what it means in a serious context. Jane McGonigal (2006b) has noted that pervasive games have a tendency to shift the focus from free play within the illusory constraints toward becoming actors playing their part in a vision dictated by the game designer. She cites *Go Game* as an example; in it the players interpreted the spiced-up language of a task they received literally. "Howdy superheroes—hold onto your hats, it's time to drop your pants and dance! Press GO when you're ready to start the game." The players promptly dropped their pants and started to dance in their underwear in the middle of the city.

Social pressure, monetary rewards, and the urge to stay in the game can also drive participants to do things that they might not otherwise do.[2] Reality television shows such as *Fear Factor* provide a wealth of examples that also apply to pervasive games.

As mentioned in Chapter Seven, both *Shelby Logan's Run* and *The Amazing Race* required some players to get piercings or tattoos to gain game advantage. *Shelby Logan's Run* also required players to explore an abandoned Argentena mine complex in the Nevada desert. While scenes at the tattoo parlors may have caused slight regrets the following week, the scene at the abandoned mine actually led to a serious accident (see Figure 10.1).[3] Assigning the blame for such incidents is both a morally and a legally problematic issue.

Player Consent

Many pervasive games require players to give up some of their privacy: This is part of the very nature of expanded games and the technology used to orchestrate them. As we have learned, these games utilize positioning technology, monitor communications, employ spies, or even require players to carry biometric sensors to make the game function properly. These functions of course require establishing explicit player consent in advance.

However, pervasive game designers often want to hide the intricacies of the game: If the player does not know that her heart rate is being monitored, it seems magical that relaxation and meditation can open a door. When players are not aware of being monitored, the surprise appearance of a stranger at the exact right moment becomes a much stronger experience. As discussed in Chapter Seven, pervasive games are much more fun if they manage to constantly exceed player expectations. The unfortunate problem is that it is almost impossible to establish informed consent in hidden and unpredictable game structures. The same applies if player agreement forms are used for legal reasons to shift responsibility from the game organizers to the players. A binding legal agreement

FIGURE
10.1

This clue, printed on a CD cover, led the players of *Shelby Logan's Run* to Argentena mines in the Nevada desert. The warning in the corner did not stop one player from entering mine number 1296 instead. Maybe he interpreted it as a game clue, maybe he was excited by the game, or maybe he did not understand its context. In any case, he fell 10 meters down a mine shaft. The accident left him permanently paralyzed and almost completely blind. Sued for damages, five of the six game organizers settled out of court for a $10.6 million dollar compensation (paid by their insurance companies).

usually needs to be specific, whereas the game suffers if all the surprises are spoiled in advance.

Momentum players, for example, agreed that the game organizers could "collect technical surveillance data about your gameplay during the game and store it as long as it is needed for the purposes of game orchestration, research, and documentation." In a highly expanded game that is also long and continuous, the boundaries of accepted surveillance are very vague. Even though accepting a carte blanche agreement may indicate consent, it does not necessarily indicate *informed* consent.[4]

Prior agreements aid in setting the ethical boundaries for a pervasive game, but given the shifting boundaries of a pervasive game they are not always a sufficient strategy: Sometimes players have to be provided with ways to renegotiate boundaries during play.

Many assassination games, pervasive larps, and treasure hunts do this by providing players with access to a game master hotline, which they can call to consult game masters at any time. The use of safe words is another working practice that has been used in *Killer* and larps as well. One solution is to restrict some physical or virtual areas as clearly outside the game: An alternate reality game could utilize a Web site discussing the game as a game, whereas pervasive larp game masters could designate their office as a place to enter when wishing to exit the game completely. Such places, sites, and hotlines can also serve journalists and officials interested in the game.

Ethics and Unaware Participation

Unaware participation is perhaps the most problematic area of pervasive game ethics. Nonparticipants can encounter a game in a number of different ways: They can run into game props and markings, witness the game being played (or the game being actively hidden), or can come into direct contact with the players.

The easiest way to avoid problems is to hide the game completely. Using double life strategies (see Chapter Six) discourages breaking societal norms. The typical way to achieve this is to have a diegetic system of sanctions for exposure. *Killer* rules usually state that murders must be conducted without witnesses, and in *The Masquerade* the human population must never find out about vampires. Making the player group a secret society that wants to avoid attention is an elegant way of discouraging players from alarming unaware participants. Secrecy is also fun in itself; however, it limits the design space. For games that aim at artistic, political, or even marketing effects, secrecy is seldom a useful design alternative.

In alternate reality games, random encounters with the game are often seen as rabbit holes that may introduce new players to the game. If they find the encounters sufficiently intriguing, they can start to investigate and, by doing so, discover the game. Pervasive larps can also have rabbit holes, but more often unaware participants witness a game event—something unexpected, surprising, or frightening. Even if the bystanders are later told that what they saw was a game, such as in the shooting and dumping of a body in *The End Is Nigh*, they might not believe the explanation. They may refuse to view the events in a ludic context.

However, if the game can be identified easily as play, then it should be easy enough for bystanders to accept or refuse an invitation to play. The adoption of ludic markers is the easiest way to sidestep some ethical questions: If bystanders are never *unaware* participants, the question regarding what is allowed in public space is a matter of public policy.

Ludic markers for nonparticipants do not need to be explicit. Instead, a ludic marker can focus on communicating the playful or fictional aspects of the game. Humans are apt at recognizing play (Bateson, 1955), and thus pervasive games that employ silly costumes, use gaming equipment clearly identified as such (e.g., basketballs, huge inflatable game tokens), or incorporate playful movements (e.g., dance, hopping) are clearly play even if they do not take place on a playfield. In the same way, *The Beast* included realistic Web pages with dates set in the future, a clear indicator of the fictional nature of

FIGURE
10.2

Before being able to enter Conspirare, one of the central Web sites of *Sanningen om Marika*, the player was faced with a pop-up window: "Warning! Conspirare is part of a fictitious work. The opinions expressed do not always reflect the values of Company P or SVT. Possible correspondences with real people are at times coincidental. Taking part happens on one's own risk. Conspirare has only one rule—pretend that it is real. You take part by following the blog, watching video clips, and reading and discussing on the forum. The search will lead you out to the Internet and out onto the streets of your city. Click on OK to show that you have understood this."

the content. For games that deal with serious contemporary subjects, it becomes much harder to create adequate ludic markers for nonparticipants.

The Swedish alternate reality game *Sanningen om Marika* faced this problem. The game centered on quite a serious and contemporary subject: People that disappear. The game consisted of two separate parts: A TV series about a fictional disappearance, which nobody claimed to be real, and a debate program and online game in which the TV series was claimed to be based on a real story. All Web pages were provided with a pop-up window with nondiegetic information, which stated that they were part of a fictional production (see Figure 10.2). Still, many people ended up believing in the debate program and game part of the production. The illusion was not limited to people who just participated peripherally, but some of the active gamers actually believed the story to be real.

The reaction to *Sanningen om Marika* was surprisingly similar to the reaction to the classic 1938 Orson Welles's *War of the Worlds* radio show. Despite the clear message that the production was fictional, the fact that it was sent out on public television and based on a serious subject made people believe it to be real. The production gave rise to a brief mass media debate where several people voiced the opinion that

"trusted public service TV" should never blur reality and fiction in this way, as is already too common in other media.

Offenses, Harms, and Nuisances

Pervasive games sometimes contain offensive elements. The mere presence of Spiricom-Thomas in *Vem gråter* offended some people who interacted with him, while the thematic choices of *Sanningen om Marika* offended many members of the audience.

As Anthony Ellis (1984) discusses, offenses can come in many forms. Sensory irritation, excessively bad manners, expressing contempt against people's values, and indecency can all offend people. Indeed, as Donald VanDeVeer (1979) points out, offensive actions are often considered offensive only by a certain group, based on its traditions and cultural identity.

A society subscribing to the principle of freedom of expression cannot provide people with protection against being offended, as decency and manners are always matters of personal taste. Instead of considering whether a pervasive game is offensive, the relevant question is whether it is *harmful* or merely a *nuisance* to someone.

Joel Feinberg (1984, 1988) discusses harm as a "lasting setback to one's assets." While encountering a skulking ghost hunter may have been unpleasant and scary, harm was only done if the setback was lasting: Suffering from nightmares or being afraid to go out after dark might constitute such psychological harm. Nuisances are an intrinsic part of urban life, covered better by politics than ethics: Rock concerts may disturb people, frighten pets, and cause traffic jams, but these nuisances hardly make them unethical.

Harm should not be discussed without also referring to the concept of *risk*: Even when harm is not actualized, subjecting others to the possibility of harm is often found immoral. If you want to drive a car, society requires you to obtain a driving license in order to reduce the chance of harming bystanders. Heightening the risk by driving under the influence of alcohol is severely punished, even in cases where the driver has not actually harmed anyone.

Invitations and Invasions

Socially expanded pervasive games invite nonplayers to participate in the game in some role. The least invasive way of invitation is to invite nonplayers to watch. A spectator role is safer than a player role, as spectators do not need to adhere to the full set of game rules. Invitations can also be for other roles, for example, to participate as a helper, as a referee, or as a player.

In alternate reality games, it is common to include several levels of invitations, bringing a person further and further toward full-fledged playership, using the onion model of participation. As the full rules of a pervasive game are not always exposed at the time of entering the game, repeated levels of invitations can provide a good mechanism to ensure that players have a good picture of what they are agreeing to each time they decide to participate more deeply.

It is important that nonparticipants can refuse an invitation and that such a refusal is meaningful. Once you have refused, you should not be asked to join repeatedly.

However, some bystanders do not have the option to refuse. Professionals whose job it is to oversee certain areas, who must respond to suspect behavior, or who take care of people who are mentally or physically ill are not allowed to ignore events that can be interpreted as possibly real or ludic. In *Vem gråter*, the janitors of the university had to wash the walls that had been covered with scribbling. They viewed the events as mischief and vandalism. In *Momentum*, the players had to retrieve a painting from an art gallery where it was not known that one of the paintings was a prop in a game. The gallery workers enjoyed the game. Yet none of them had the option to refuse participation.

It should be noted that this is not a question of private or public space. The same situation can arise whether the game takes place in a library, on the street, or even in a private residence; someone is always responsible for maintaining order. Even if the local police department has been informed that a game is taking place, they still have to respond if a frightened neighbor calls in and reports suspicious trespassers or an alarming scene between players that she has witnessed.

A basic piece of advice is therefore to always notify the relevant authorities, be it the police department or park rangers, that one is about to run a game in their jurisdiction. If something unexpected were to happen and they need to get involved, forewarning can be instrumental in helping to defuse a situation. If players are supposed to act suspiciously, forewarning might even save them were the authorities to mistake them for the real thing. According to the organizers, *Shelby Logan's Run* informed 13 different organizations about their game, many of which also helped them produce a better experience for the players.

Invasion is the flip side of appropriation: The space is being claimed from someone. Regarding public space, the question from whom the space is being appropriated from is murky, but in semipublic spaces the subject is known. To the one being invaded, an invasion can feel like a positive, cherished diversion (surprise birthday party in one's own apartment, the gallery in *Momentum*) or disruptive and abominable (paparazzi, *Vem gråter*); it is not always possible to predict the reaction.

Pervasive Games and Society

The societal context in which a game is situated has a huge impact on how it is perceived. There are local differences in what is acceptable, and these norms also change over time. The social standing of player participants outside of the game also makes a difference. Similarly, the way a gaming event is framed has an impact as well.

To a certain extent, questions regarding pervasive gaming and society are all located on the axis between an individual and the community. Is a single player allowed to break societal norms? Is it acceptable for a minority to use games as political or artistic tools if they claim that they are working for the common good? How does context affect what is acceptable? What are the implications of pervasive games for the larger community? Who is allowed to play?

Societal Context of Play

McGonigal (2006a) reports an incident from Ravenna, Ohio, where 17 yellow bricks inspired by *Super Mario Bros* were distributed in urban areas as a part of an art project

FIGURE
10.3

Mario Question Blocks **installation in Toronto, Canada. Unlike many other blocks, this one was installed by Posterchild. Similar cardboard cubes caused a terrorist alert in Ravenna, Ohio.**

Mario Question Blocks (see Figure 10.3). This public art piece, initiated by a Web site by Canadian street artist Posterchild,[5] prompted city officials to call in the bomb squad on April Fool's Day. "Five teenage girls from Portage County face potential criminal charges after attempting to play a real-life version of *Super Mario Brothers*," McGonigal quotes the local news.

The blocks had been distributed previously in public spaces around the United States and Europe without intervention from the law enforcement. The charges in Ravenna were finally dropped, but the event still underlines that context is important. Posterchild, who has posted the instruction on how to build a Mario block on his Web site, has added a warning on his site after the Ravenna incident: "Warning: Not everyone has the same cultural context and not everyone is relaxed about public spaces," says the Web page in

capital letters.[6] In the United States you can be easily charged for causing a false terrorism alarm, while in Sweden that would be unlikely.

An example from the other end of the scale comes from Sweden. The players of *Momentum* staged a technomagical demonstration across the street from the embassy of the United States. They formed a ritual circle, chanted incantations, and wielded strange equipment. This caught the attention of the embassy guards who called the local police, who showed up with a riot vehicle. The players explained that they were performing a perfectly legal ritual of symbolic resistance in a public space as part of a game, and the police could do nothing about it. A player recalls:

> *[The police] came with, you know, a whole strike force, you know, these buses, it was a full bus, but only the two people in the front came out, because the others, they were suddenly in there prepared with submachine guns and everything, in the car. [. . .] And, and they came out with, you know, their hands on the guns and walked up to us [. . .] [T]hey were really jumpy, and [the players] started to explain that this is a game, and, of course, that was the easiest explanation. [. . .] And [the police] were like, you can be shot for having one of these things. In Israel you would've been dead by now. (Stenros et al., 2007c)*

Attitudes also change over time. The hi-tech treasure hunt game *NIT 2000* contained a scene staged at the WTC Marriott Hotel in New York, which was supposedly a terrorist headquarters. When custodial workers cleaning up the suite found vials labeled as radioactive waste, they contacted the police and port authorities. The liquid turned out to be dish detergent, and no charges were filed.[7] The game was run in the summer of 1999; it is likely that 3 years later the repercussions would have been much more severe.

Framing the exact same event as a nonprofit fun pastime, political protest, profit-seeking venture, piece of art, advertisement, or charity drive also has an impact on what is deemed appropriate. Usually, events that are organized for "the common good" have more leeway. Organizations, be they department stores or museums, are more willing to cooperate with game organizers if the game collects money for charity or seeks to liven up a neighborhood in a joyous and egalitarian way. Similarly, unaware participants are more likely to forgive transgressions for good causes, but if money is made out of the venture, they may feel that the profit has been made at their expense. But where monetary motivation tends to have a limiting effect on the permissiveness of pervasive games, framing games as politics or art can have the opposite effect. In the case of *Sanningen om Marika*, the organizer's (state broadcast company) high status made the game less accepted than if it had been staged by a commercial company.

It can also be argued that people with higher social standing get away with more even in games. The quote from Elsa Maxwell's (1957) scavenger hunt presented in Chapter Two is an extreme example: The police become interested in a public nuisance created by a traffic jam, which is then avoided as the Prince of Wales is involved.[8]

Laura Ruggeri, the creator of *Abstract Tours*, had a similar experience half a century later, when woken up on a Sunday morning by a police officer, who asked if she had authorized two Italian men to drop rubbish on the streets:

> *Well, my German wasn't good enough to equip me with a better understanding of the situation, but yes, I could make out that two Italian men had soiled the streets of a Berlin neighbourhood with a white, powdery substance, which was being tested at the*

time of the call. I asked to speak to the guys, who turned out to be two guys with an Abstract Tours map, and a bag full of flour. Their performance consisted in leaving a vanishing trace of their dérive. Apparently some old lady had complained to the police about the activity of these 'suspicious foreigners,' they had been taken to a police station, and as a justification had told the police that their action had been authorized by . . . me! Not knowing what to do, I told the police officer that they were exchange artists invited by the Berlin Senat, and should be released immediately. A complete lie, but it worked. (Ruggeri, 2008)

While small lies can save an individual pervasive gamer, we cannot recommend using such strategies in the long run—for both ethical and legal reasons.[9] Gaining a genuine societal acceptance is the best long-term strategy: Conversing with officials in advance and paying rent for the play areas are good ways to get started.

Games as Political Action

Games that have a clear political agenda should be judged as political actions. In liberal democracies, the freedom to express political views is usually seen as a human right. Breaking social norms and even some laws is often tolerated to a certain extent. Donald VanDeVeer (1979) has pointed out that it is in the interests of the third parties to have both sides of a conflict brought into public—offensive provocation is often the only or the best way to do so. Still, he limits this to offenses that do not cause bodily harm. He has formulated a *standard of permissiveness toward conscientious offense*: "Individuals engaged in conscientiously motivated dissent aimed at securing what dissenters judge to be more desirable social arrangements have a claim to restraint from coercive interference even if their dissent is seriously offensive."

Following this logic, if a pervasive game is aimed at improving the social system, it should be tolerated even if it might be offensive, as long as it is motivated by the organizers' conscience and steers away from causing bodily harm. In the spirit of free speech, the benefit of society demands tolerance of such expressions.

In fact, the examples of *Vem gråter* and *Mario Question Blocks* even call out for such protests. A society where a nightly wanderer is assumed to be a dangerous rapist or where cheery *Mario Question Blocks* are received as an act of terrorism may need more boundary-breaking games in public places, as we may find that we are no longer allowed to play in public spaces, meet the most unlikely of people randomly, or give out candy to strangers. While VanDeVeer's standard might have not applied to *Mario Question Blocks* at Ravenna, it perhaps did when more blocks were placed at Oberlin College, Ohio, after the incident.

One might be tempted to ask when a game is political enough to excuse its serious offensiveness. To a certain extent, all street parties and flash mobs are about reclaiming public space, but some participants are there simply to have a good time. Political protests have a long history of incorporating parody and satire and are usually fun at least on some level, but are political actions in the form of games too much fun to remain political? *Momentum*, however, staged a fabricated demonstration: not fun, but not serious either.

Another unanswered question is should the organizer inform all participants of a game about its political content in advance so that no one finds out too late that they are

protesting for a cause they do not believe in? In games that have unaware participants, this would not even be possible.

Games as Art

Judged in the framework of art, games again may be allowed more liberties. Although art has a long history of bending and breaking norms, the ethics are hardly clear cut. Anthony Julius has summed up the opposing views:

> This leads, from the perspective of the artists, to a certain disrespect of the law, a qualified antinomianism: law has no place in art, there should be no constraints on the imagination. It is the sheer clumsiness of legal investigations in the art world that most exasperate art's champions. From the perspective of moralists, by contrast, an artist deserves no greater licence than any other citizen. Art—or rather, artistic status—excuses nothing. Moralists need not be Platonists. They do not mistrust art; they merely hold that it should not have any special privileges. (Julius, 2003)

If artistic status excuses nothing, then the debate ends here. However, if art and artists are allowed to operate with less regard to societal norms, then the question becomes *how much* more room to maneuver they should be given. Art that breaks laws or offends sensibilities is *transgressive*. Julius sees four ways to transgress:

> the denying of doctrinal truths; rule-breaking, including the violating of principles, conventions, pieties or taboos; the giving of serious offence; and the exceeding, erasing or disordering of physical or conceptual boundaries. (Julius, 2003)

Julius has also identified five different defense strategies for transgressive art. The first two, *aesthetic alibi* (although some forms of expression, such as hate speech and blasphemy, can be legislated and circumscribed, these restrictions do not apply to art) and *art speech* (artistic expression is on par with political and commercial speech, and thus, for example, government funding must be allocated to all kinds of artists or else the state is not living up to constitutional requirements) are easy to counter. If the artist is no different from any other citizen, then art excuses nothing.

The three further defenses are much more sophisticated and complex. According to the *estrangement defense*, art teaches its audience something about themselves, the world, or art itself. Shocking the viewer is necessary to shatter illusions, to astonish, to disturb, to seduce, or to shake things up. This is similar to the standard of permissiveness toward conscientious offense.

The *formalist defense* insists that it is the job of art to explore form and that the spectator should learn to keep his cool distance and contemplate. The subject is not relevant, only the presentation. Finally, the *canonical defense* looks for continuity in the canon of art. It finds similar works that are respected, points to them, and shows that, logically, if the new work is dismissed, there goes the canon as well. In a way, this is the opposite of the estrangement defense, which relies on shock; the canonical defense puts forward the idea that any shock is fleeting and that many canonical works were seen as shocking when they were first exhibited.

The problem with these defenses is that even those people who believe them must recognize a pervasive game as art in order to apply them. If a game is staged in an art gallery or as part of an artistic festival, then bystanders may be aware that they are in a context

where certain rules can be bent, but if they run into a game event lacking ludic markers in their ordinary life, they cannot recognize any possible artistry.

Conclusion

Pervasive games are a controversial and fragile form of art, politics, play, and business. For many people, when they hear about pervasive games, the thrill of nongameness is not a thrill at all, but a threat. Even though these games are not for everyone, those who do engage in them must be considerate of everyone. This chapter serves as only one contribution to an ongoing discussion on ethics; it is essential that the debate continues.

While all games are forms of expression, freedom of expression cannot be uncritically extended to cover all pervasive games: Performative activity on the far edge of the magic circle is not only expression, but also physical acting in ordinary life. While freedom of expression covers both the magic circle and ordinary life, it can be argued that it is limited to the world of representation and not extended to the physical world. It is one thing to write and stage a play where a person is pushed in front of a car, but claiming that freedom of expression covers shoving a pedestrian into traffic in ordinary life would be preposterous. But where is the line drawn?

Although self-regulation is a must in pervasive games, self-imposed limitations have occasionally reached the point of self-censorship, which has sometimes benefited and sometimes harmed the evolution of game cultures. For example, some *Killer* guilds canceled their games after the Virginia Tech campus shooting in 2007,[10] Posterchild added a discouraging disclaimer to the *Mario Question Blocks* Web site after the Ravenna incident, and The Game community was damaged by the *Shelby Logan's Run* mine accident.[11]

The important thing is for the game designer and the player to take responsibility. If they are willing to break societal norms and laws, they must be prepared to shoulder possible repercussions. It is easier to ask forgiveness than it is to get permission. But just as one might not receive permission, forgiveness is not automatic either.

Finally, there is the question of exclusivity. If pervasive games indeed empower, liberate, and let the player experience the world differently, then who gets to experience that? Whose life is injected with the fun of games and games with the thrill of life? Mary Flanagan (2007) has challenged these promises bluntly: "[I]s locative play merely another problematic appropriation of space and custom—a form of entertainment 'colonization'?" She notes that around the world "the homeless, the prostitutes, and domestic workers possess the streets in a way which speaks to economic and social disempowerment." Simply locating play on a street does not lead to empowerment.

Who gets to play and who is the intended player, the intended transgressor? If participation in *vQuest* costs $25,000, it is hardly a game for the masses. Similarly, reality television shows that employ pervasive games are also exclusive: Players of the globe-spanning *The Amazing Race* undergo a meticulous and mysterious screening process. How much of the appeal of *Mystery on Fifth Avenue* is derived from plain luxury?

An extreme example can be found in Arto Halonen's documentary film *Pavlovin koirat* (2006). It features games staged by Sergei Knyatzev for Russian oligarchs, where the rich pay exquisite prices for the privilege of experiencing the life of the poor—in a relatively controlled environment, of course. They ditch the limousine for a race in the labyrinthine Moscow underground, they compete in begging on a street corner after buying off the local

FIGURE
10.4

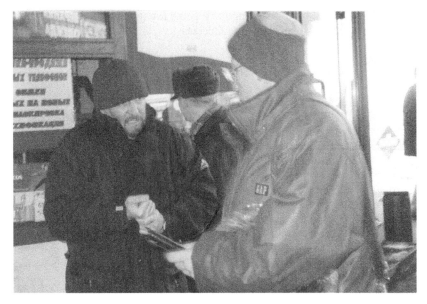

Sergei Knyatzev (left) dressed up as a beggar in a game documented in Arto Halonen's film *Pavlovin koirat.* **Participation in the game costs $3000.**

beggars (see Figure 10.4), or they participate in a money-earning couple game as a prostitute and a pimp (a conveniently available police officer always interrupts the situation before any actual action) (see also Pettersson, 2006).

The problem with this question is that pervasive games are, by definition, located on the border between game and the ordinary. Blurring the boundaries could just as easily be called transgressing—and in order to transgress, something is always violated. Pervasive games are in constant and sometimes unavoidable conflict with ordinary reality.

This chapter presented several perspectives on how to manage that tension. While it is clear that magic circle ethics cannot be applied to people who are not voluntary participants of a game, it is also clear that it is equally impossible to forbid pervasive games ethically or legally. The rules need to be subjected to continuous discussion and need to be evaluated again and again depending on the cultural context.

Notes

1. The first version of this work was published in Montola and Waern (2006) and the second in Montola, Waern, Kuittinen, and Stenros (2006). While this version and the case of *Vem gråter* should cover most of the material from those two publications, a particularly interested reader may want to go back to those sources as well.
2. Stanley Milgram (1974) has researched the ways authority figures can make people do things they otherwise would not do. It appears that the operator of a pervasive game can assume a similar role, making players push their own moral boundaries when playing a game.
3. *Seattle Times*, September 14, 2008, "The Game" by Jonathan Martin.

4. The entire genre of reality television game shows is littered with carte blanche issues. A typical example involves a contestant permitting the production company to use all recorded audio and video footage in the show. Such permission may allow the producers to show footage in a misdirecting manner: Taking audio from a massage scene and video from a make-out scene is a typical example of misrepresenting participants in the interest of drama. Another example is *Big Brother*, which presents clear and detailed rules to the players. However, the most important rule seems to be that *Big Brother* can change the rules at will.

5. www.bladediary.com/questionblocks.

6. "WARNING: NOT EVERYONE HAS THE SAME CULTURAL CONTEXT AND NOT EVERYONE IS RELAXED ABOUT PUBLIC SPACES[.] Five young women put up question blocks in Ohio today (April 1st) and the bomb squad was called in. The women may have to face criminal charges. While I feel this is an unnecessary and extreme response, I understand that sometimes people get frightened when they see something they don't expect. I can't recommend that you put these blocks up yourself in a space you're not responsible for" (www.bladediary.com/questionblocks, ref. September 24, 2008).

7. Based on news stories from the *Seattle Times* ("Big Apple, Big Game, Nearly Big Trouble for Microsofties," July 21, 1999) and *New York Times* ("Software Wizards Test Wits in a City-Spanning Game," July 21, 1999). Accessed from a game-related news clipping archive at www.gamecontrol.com/press/default.htm, ref. September 24, 2008.

8. In all honesty, Maxwell may have taken artistic liberties in writing up the anecdote. However, even if we take it with a grain of salt, it reflects at least *her* values.

9. Lying to a police officer may be illegal in some cases. Ninjalicious (2005) discusses various ways of misleading without lying, which may help avoid legal trouble.

10. *USA Today*: "Students urged to stop playing 'Assassin' game" in www.usatoday.com/news/education/2007-04-24-student-assassin-game_N.htm.

11. Despite the fact that the head organizer Joe Belfiore had planned *Shelby Logan's Run* to be the last Game he organized in any case.

Case K

REXplorer

Rafael "Tico" Ballagas and Steffen P. Walz

It is the peak of summer holiday season, and you are visiting the old town of Regensburg—one of the most visited places in Germany and a UNESCO world heritage site. The old town features a Gothic and Romanesque cityscape with a rich history. A sightseeing game is giving you a trip to the past. You assume the role of a researcher uncovering the secrets behind the paranormal activity linked to a secret language found in the Regensburg Dom Church.

The symbols of this language have special powers: You can use them to summon historical spirits at 30 different sights. A paranormal activity detector helps you detect and communicate with spirits living in the city. As you walk around the town, you meet spirits that need your help in delivering important messages to their counterparts. Your mission is to solve these quests in order to score points, collect experiences, and gain knowledge about the history and culture of this medieval city.

REXplorer[1] is designed to facilitate fun learning for young adults. It belongs to the genre of serious games that aim to channel the engaging quality of games to inspire, educate, and train their audience (Prensky, 2001). In *REXplorer*, the serious game concept is applied to tourism, helping visitors engage with the history and culture of their destination. It is an example of an urban adventure game based on spatially distributed puzzles and story pieces.

In the game world of *REXplorer*, every historical sight is represented by a spirit. These spirits are set in different historical epochs in order to convey the various ways of life and salient moments throughout the history of Regensburg. The stories are linked to other spirits through both space and time. Players must identify and find the corresponding sight to hear the resolution to the narratives and score points for solving quests (see Figure K.1).

As players find a sight, the *paranormal activity detector* displays an excited heartbeat, indicating that there is paranormal energy in the environment. In order to summon the spirit, the player needs to cast a spell through performing the correct gesture with the detector. There are four elemental spells to choose from, and the *REXplorer* map provides hints as to which one is correct. If the summoning is successful, the spirit appears on the screen and begins to speak to the players. A spirit who resides by the Danube, for example, says:

REXplorer! It's nice to see you. I am a salt trader. People like me used horses to pull heavy ships, full of expensive salt, up the river Danube to Regensburg until around 1820 A.D. Usually, the excursions last 4 weeks at a time. Yep, my life is tough and dangerous. Thieves plague the salt trading routes, but I have a loving wife who constantly prays in a nearby church for my safe return. Only the fire of her love keeps me alive. Would you be willing to deliver a message to my woman? Then show me the appropriate gesture.

***REXplorer* map, showing the central sights (and game locations) of Regensburg.**

The player must realize that the appropriate gesture is the "spark" to hearing the rest of the story. Once the gesture has been made, the spirit continues and asks the player to deliver a love letter to his wife at St. Ulrich Church nearby. When the player delivers the letter, she learns more about the content of the letter and how the wife receives it. Each delivery resolves a cliffhanger narrative—the player does not get to know how the story ends until she delivers the message.

Sightseeing in *REXplorer* is nonlinear. Players are in control of the order in which sights are visited and quests are fulfilled. Players can accept up to three quests in parallel, which allows them to go through the game strategically.

The paranormal activity detector provided by the tourist office is actually a mobile phone with a GPS receiver in disguise. The rental model has many advantages in comparison to building a system for customers' own phones. Primarily, it allows the use of camera-based motion estimation required by the spellcasting interaction. The algorithm requires a high-end camera and processor, limiting the range of supported devices. By standardizing this on a single phone, the cross-platform deployment issues can be eliminated. Second, the rental model allows the phone to be skinned so as to look like a paranormal activity detector. This is key in promoting the atmosphere and adding to the mystery of how the gestures are recognized.

Tourists rarely tour a city alone. Instead, they are mostly interested in shared experiences and memories, and *REXplorer* was designed specifically to support these goals (see Figure K.2). In order to promote shared experiences, the paranormal detector contains a loud speaker so that the spirit's story can be heard easily in a small group of two or three. Additionally, the game requires multiple artifacts, including the electronic detector, and a paper map with a gesture guide. This allows each player to participate by taking on a different role in the game, and the roles can be swapped easily during gameplay. To promote shared memories, players' experiences and photos are catalogued automatically to a souvenir travel weblog, which uses

REXplorer **guides the players through the city, adding a ludic component to the touristic activity.**

an interactive map to show the users' path through the city and highlight points of interest they visited. Players can express themselves through commenting on their blogs or taking pictures using the camera in their paranormal activity detector.

Solo players of the game sometimes consider spellcasting with the paranormal detector in a public setting to be awkward. However, the presence of even one other player provides enough social support for the performative gesturing. While the gestures are not the easiest or the most efficient way of interacting with the spirits, this interaction fits best with the story and promotes player engagement.

REXplorer bridges the gap between an aural tourist guide and an urban adventure game.[2] Such games can be played in a variety of places ranging from museums to shopping malls, amusement parks, and outdoor environments. While some such games also include smart street sport elements, their central purpose is to change players' perceptions of the physical space. Their strongest potential lies in the way the virtual can augment the physical.

Notes

1. *REXplorer* was created by Rafael Ballagas from RWTH Aachen University and Steffen P. Walz from ETH Zurich in collaboration with the Regensburg Experience Museum. The game Web site www.rexplorer.arch.ethz.ch features a trailer movie and a full list of related publications. Examples of player blogs can be found on the high score page (www.rexplorer.de/punkte.php). Our earlier research on the game discusses the persuasive elements of gameplay (Walz, 2007) and player-centered iterative design techniques (Ballagas & Walz, 2007).
2. *REXplorer* is certainly not the only game with such a form and function. For example, see Ericsson (2003) for discussion on *Visby Under* and Ding (2007) for *Seek Bou Journey*.

ELEVEN

Marketing the Category of Pervasive Games

Mattias Svahn and Fredrik Lange

On a Friday night, you and your friends are standing at the local theater, choosing between films. The ticketer asks you "Do you want the pervasive game with that, or just the film?" Later, you and your spouse stop at a coffee store to pick up two double low-lactose, zero-fat decaf lattes, two chocolate bran muffins, and the coffee store's own location-based pervasive game and continue strolling through downtown, chasing locations, uploading pictures from your mobile, until the latte is finished and you head home.

Neither scenario is available today. However, both could be and, in fact, could have been for a while now. This chapter takes a look at why they are not and presents possible ways forward by looking at consumer behavior science. It is safe to say that some of the more extreme pervasive games, such as *Momentum* (Case F), can never be mainstream hits. But some genres of pervasive games have very much potential to become highly profitable mass-market products—those are what this chapter is about.

We propose that the way to mass-market a pervasive game successfully is to stop thinking only about mainstream game launches, such as *Halo 3* and *World of Warcraft*, and instead look more to the launches of brands such as iPod, Starbucks, or Jamie Oliver. Pervasive games are not really new. It is just that the mass market cannot really grasp them. They are where the mp3 player was before the iPod, where coffee shops were before Starbucks, or where cooking shows were before Jamie Oliver—they lack the one prototypical product that defines the whole product category for the mass market.

The Power of Categorization

Categorization is fundamental in human life. People categorize things automatically, even without being aware of it. The human ability to group instances into categories is automatic and critical in everyday life. If we treated every instance as unique and new,

we would never remember more than small fragments of our environment (Smith & Medin, 1981). Instead, we would have to spend endless time and effort on individually evaluating each and every object around us.

This trait must not be neglected when planning and executing marketing activities. New products need to establish associations with other brands in the category. Energy drinks must contain ergogenic nutrients and come in smaller bottles than soft drinks do. Moreover, marketers of established products may also use categorization theory to alter or enhance category perceptions (explaining why concepts such as flat screen televisions and sport utility vehicles are intuitively understandable).

It is often difficult to understand how to best conceptualize a new invention as a product. During the technological development of the digital camera, a research study tested consumer perceptions of this invention (Moreau, Markman, & Lehmann, 2001) to see if expectations of and preferences for the new product changed if different category labels were used. Many of the developers thought it was a good idea to position the digital camera as a scanner-like computer accessory, whereas others strived to position it as a new type of pocket camera. We now know what path history took.

Majestic is a less well-known product. This was a pioneering pervasive game, packaged in boxes and sold in conventional retail in 2001. The producer was Electronic Arts, but it was far from the conventional game one expected from such a brand name producer. Although the game required players to install software and sign up for a monthly subscription with Electronic Arts, most of it was expanded geographically. It was played by a system of real-life phone calls, emails, instant messaging, and even faxes. The game's tagline "It plays you" illustrated and emphasized the temporal expansion of the game. The first thing the player experienced was news that the game had stopped, yet the player would receive messages suggesting that there was a conspiracy behind the stoppage, illustrating the emphasis on total illusion and "this-is-not-a-game" aesthetics. It failed commercially and is today a case for the history books. This was not the iPod, Starbucks, or Jamie Oliver of pervasive games.

Product history shows that it is highly important to consider categorization when creating business models for novel products. What use, situations, needs, and solutions already exist that our product is replacing or adding to (Day, Shocker, & Srivastava, 1979; Ratneshwar & Shocker, 1991)? These questions are central to marketing strategy decisions, such as what advertising style to use, what media to advertise in, what forms of packaging to use, and where to put the product on sale. The point-of-purchase in turn defines how much money can be charged for the product: Supermarket games are less expensive than electronics store games. A business and revenue model that is based on selling a limited number of items at a high price cannot succeed if the category the product is perceived to fall into is not considered congruent with that kind of consumer behavior. You would not buy a Macbook Air at a local gas station or *Halo 3* from a McDonald's restaurant. In both cases, the point-of-purchase (convenient & down-market) would be incongruent with the product category (very up-market).

Pricing strategies are also subservient to categorization. You cannot put a premium price tag on a product that has been categorized in a low price category. It is worth highlighting that a product caught in a downward pricing spiral will have a very difficult time getting out of that position (e.g., air travel, mobile content). Thus, a new product should attempt to catch the eye of the market's leading consumers. If the first impression regarding a new product comes from an association with a down-market-associated category, then the new product will inherit the associations from that category. *Designed*

lifestyle products such as the Harley-Davidson motorcycle or the iPod have one common denominator: They tend to be a little bit pricier than their direct competitors, as the consumer is purchasing more than just a functional product.

The following looks at four general principles guiding the process: *cognitive economy* (Rosch, 1978), *perceived world structure* (Rosch, 1978), *category essence* (Smith & Samuelson, 1997), and *category prototype* (Loken & Ward, 1990).

Apples and Oranges: Cognitive Economy

We have limited cognitive resources and tend to use them as effectively as possible. The principle of *cognitive economy* says that people categorize in order to produce maximum information with as little cognitive effort as possible (Lange, 2003; Rosch, 1978). It is a good idea for marketers to use an overall category code (e.g., the packaging, product design, and advertising tone that are customary for a certain kind of product) while simultaneously putting forward the differentiating, distinctive subcategory or brand features that you want to be your unique selling point (Keller, 2007). Marketing pervasive games, our main message might be that pervasive games are still games, but games with a twist—or should the message be something else?

As an exercise, fill in the blanks quickly and spontaneously:

- Red Bull is. . . ?—an energy drink
- McDonald's is. . . ?
- *World of Warcraft* is. . . ?
- *BotFighters* is. . . ?
- *Killer* is. . . ?

The first questions were probably easy, but then things became a little more complex. If you gave the answer "a pervasive game" to the last two questions, you are disqualified—the point of this is to get to the core of what pervasive games are.

The principle of cognitive economy is a double-edged sword. It helps us use cognitive heuristics, such as the aforementioned exercise, to increase the efficiency of our increasingly complex everyday lives. Yet cognitive economy is not a very inviting entity. We are comfortable, even lazy, with our heuristics, and we are not prone to spending time and energy learning new ones (Moreau et al., 2001). Every time we encounter something new as consumers, we have a strong inclination to fit it into existing categories. As a consequence, existing categories always have an advantage over new categories.

When a new product is truly different from existing categories, consumers will have difficulties identifying and applying an existing category. This is why a choice must be made: Pervasive games either need to create a whole new category or fit into an existing one. Creating a new category requires a great deal of effort. Marketing has to motivate consumers to start using the category, while simultaneously disturbing the process of incorporating new information into existing categories. Without very clear signals regarding what the new category stands for and does for you, the consumer will ignore it.

Also, the marketer that chooses to create a new category must take heed of the fact that game players, like any other consumers, will only create new cognitive categories for things that matter. If the new category seems unimportant or difficult to comprehend, the player will simply not bother to learn about it.

I Sort, Therefore I Am: Perceived World Structure

Consumers categorize things based on how they perceive the world (Rosch, 1978). Each category comes with a package of attributes that are not unstructured, arbitrary, or unpredictable. Instances have a high correlational structure, which means that, to a large extent, they share the same attributes, including lacked attributes (Medin & Smith, 1984; Murphy & Medin, 1985). For instance, birds in general have feathers and can fly but do not have fur, whereas the opposite is true for most mammals. This structure of shared attributes and attribute combinations simplifies categorization greatly.

If consumers know that metal cans in supermarkets generally contain beverages and only rarely perfume, whereas paper packages contain dry food such as coffee or cereals, then what should a pervasive game look like? On what shelf should it be put? What would a box contain?

Usually, marketers of a product should be careful not to deviate too much from the perceived world structure of the area they are competing in. However, the launch of a truly new product, a rare opportunity, offers some opportunity to shake up perceptions.

The Best of the Best: Category Essence

The third principle of categorization is *category essence*. Consumers assume that there is an essence or a set of intrinsic underlying principles that make a category what it is (Smith & Samuelson, 1997). Thus, each category has an essential set of attributes that really define what the category is about (Heit, 1997, Murphy & Medin, 1985). When essential attributes are present, nonessential attributes may be very different without loss of category cohesiveness (Lange, 2003; Smith & Samuelson, 1997). Dictionaries began as books, changed into CD-ROMs, and are now being provided as Internet sites. Even though a physical product "book" has changed into a virtual service, the essence of "dictionary" is easily distinguishable whatever the format.

Would it be possible to make a pervasive game out of *Halo 3* while keeping its category essence intact? If the category essence of *Halo 3* is "the thrill and excitement of shooting, chasing, and saving the world," it would be much easier than if it is a "first-person shooter video game." If the category essence of *Halo 3* was "Xbox 360," then the game could not even be transported onto Nintendo Wii, and much less be made into a pervasive game.

One Game to Beat Them All: Category Prototype

Finally, all categories have a *category prototype*, an ideal representation of the category (Loken & Ward, 1990). It can be a real product belonging to the category (Red Bull, iPod, *World of Warcraft*) or sometimes an abstraction of the core features of the category (Barsalou, 1983). A typical category member possesses more of the critical category features than a less typical member, and typical members are perceived to be more representative of the category than less typical members (Lange, 2003; Loken & Ward, 1990). Typicality influences consumer decision making, brand choice, and brand competition in a number of ways (Alba & Hutchinson, 1987). Consumers are more familiar with a typical

brand; they recognize and recall it more easily (Loken & Ward, 1990; Nedungadi & Hutchinson, 1985). They also experience lower perceived risk, lower information costs, and higher perceived quality in typical brands (cf. Erdem & Swait, 1998).

Contrarily, atypical brands and products get harsh judgment from the consumer, regardless of their objective qualities and regardless of anything advertising can do. Typical brands, even weak ones, are preferred over strong brands in atypical situations (Lange, Selander, & Åberg, 2003). An example of a strong brand in an atypical situation is the launch and subsequent failure of the N-Gage in 2003. At that time, Nokia was seen as a strong mobile phone company, but it was an atypical brand for a game console. Contrarily and likewise, Nintendo would need to make a considerable effort should it ever wish to launch a mobile phone.

A category prototype for the quality of pervasiveness in pervasive games has yet to emerge. One reason is that pervasive games are a fragmented group of game products. Some subgenres have—at least from a developer's and designer's perspective—seen their prototypes; most notably alternate reality games, where *The Beast* is sufficiently well known to function as a category prototype. *BotFighters* has played the same role for location-aware pervasive games played with mobile phones. Both prototypes, however, lack sufficient spread to work as category prototypes in the consumer market; the blockbuster is still missing.

Up and Down the Tree: Typicality and Vertical Categorization

Categorization psychology has domino effects, because categories are linked taxonomically to each other. We can define different levels as follows: First, at the highest level are *domains* (superordinate categories), then *product categories*, and, finally, at the lowest level are *brands* (see Figure 11.1).

If we think about the brand *Halo 3*, it belongs in the product category of "console games" and to the superordinate domain of "entertainment." The domain of "entertainment" also includes other product categories such as "films," "sports," and "concerts." The main competitors of "games" are other forms of "entertainment," such as "television" or "rock clubs." "Entertainment" is the environment where *Halo 3* has to compete, and it is also the environment where the entertaining "pervasive games" have to compete, as long as we consider pervasive games to belong to the category of "games."

Categorization research shows that two product categories may both substitute and complement one another (Shocker, Bayus, & Kim, 2004). Once upon a time it was generally thought that television would kill the movie industry. Nowadays, we know that these two industries complement each other. It was not that long ago that the short video clips available on YouTube and other video blogs were considered the bottom of the barrel of moving image production, an anathema to the separated category of artistically qualified productions. Later productions such as *lonelygirl15* challenged that notion. The relations of categories are often much more complicated than being mere substitutes or complements.

Familiar brand names (*The Simpsons*, Jamie Oliver) are often used as carriers across product domains. As people have relationships to brands in existing product categories, they may understand notions of new categories when they are presented by existing brands. In the case of *The Beast*, consumers may have understood the "game" through its association with the then top-of-mind movie *A.I.: Artificial Intelligence* (2001).

FIGURE
11.1

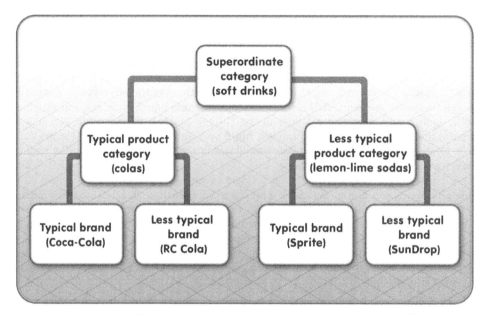

Product taxonomy is made out of domains, product categories, and individual brands.

The less successful *Majestic* was intended to be understood through an association with prime brand games, with which it did not share any defining qualities. The *Majestic* case also demonstrates how important it is to avoid using category essences from a different category (in this case major computer games) if these essences make people perceive the product as something different.

Broadly speaking, "games" belong to the superordinate domain of "entertainment," but, as with all categorizations, their position is in constant flux (see Figure 11.2). "Entertainment" in turn competes with other leisure activities, such as "spending time with family," "doing chores," and so forth. The main competitors of "games" are other forms of "entertainment," such as "watching television" or "going to see a band."

Many phenomena illustrate that computer and video games as commercial products have now become placed into the superordinate domains of entertainment and light culture. In many European countries, games are increasingly reviewed in daily newspapers in ways that are comparable with literature and cinema reviews, emphasizing their categorization as "entertainment and culture." Likewise, Hollywood movies are planned with digital game spin-offs in mind. In Asia, where game competitions are regularly broadcast live on TV, digital games have become entertaining spectator sports.

All of these phenomena move the general conception of computer and console games away from the testosterone-heavy basement category toward a mainstream Friday night category. Party games such as *Singstar* and *Dance Dance Revolution*, together with gaming platforms such as Nintendo Wii, move "digital games" further toward the mainstream.

However, this genrification of games may not apply to pervasive games, which, by their very nature, "pervade, bend, and blur the traditional boundaries of game, bleeding

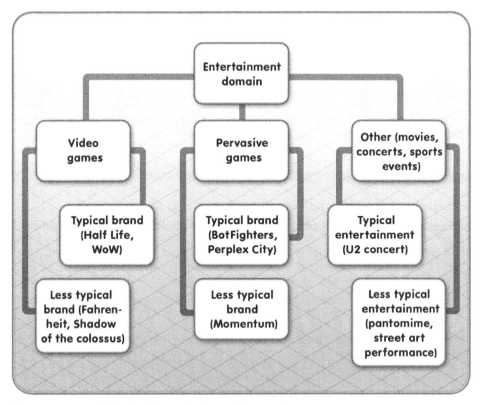

FIGURE
11.2

Games compete with other forms of "entertainment."

from the domain of the game to the domain of the ordinary." Again we have to wonder whether pervasive games should really be presented as games.

Pervasive Game: An Ugly Duckling?

The domain of entertainment has pretty clear-cut definitions and a clear place in everyday thinking. "Entertainment" is the reward that comes after spending time with activities belonging in the domain of "work" or the domain of "chores."

As shown in this book, pervasive games are hard to categorize in the ways of consumer behavior science, as the very nature of pervasive games is to disturb and blend in with other domains. Because of their spatial, temporal, and social expansions, they do not fit easily into a personal time-planning dichotomy of either entertainment or work/chores; for example, many players of *BotFighters* allowed the game to even disturb their sleep. This is a collision that goes some way toward explaining why we have seen so few commercial pervasive games so far. The concept of the magic circle makes it easy to place games outside the domain of ordinary life, but this does not work for pervasive games: It is obvious that *Killer* and *BotFighters* do not fit easily into the contemporary category of "entertainment."

Indeed, just like they challenge the domain of the ordinary as well as the magic circle of gaming, they also challenge the domain of "entertainment," especially the "reward after work" facet. However, that does not mean that *Killer* and *BotFighters* are vague. On the contrary, they still have a very strong categorization, one that they do not blur and bend. The very structures that make these games interesting and worthy of analysis also provide them with the product category of, for lack of a better term, "the specialized interests of game hobbyists." These games fit into an existing category where an activity is allowed to carry over into other areas of life; the domain of "specialized hobbies and interests." Activities included in this category are all-engrossing and pervade the whole of a person's being, whether the activity is ornithology, skateboarding, or playing pervasive games.

"Specialized hobbies and interests" can turn into mass-market products if they manage to establish themselves as "designer lifestyle" products. What differentiates specialized interest products such as *Killer* and *BotFighters* from mass-market designer lifestyle products such as Harley-Davidsons and iPods is that the former have not managed to break out of their (commercially tiny) subculture. They have not become a commercially viable mass-market product, while retaining strong connotations of being a symbol of personal identity. Specialized interest products remain semiotic signifiers that only a small group can decode. They are USB jewelry and hanky codes.

Designer lifestyle products have a particular cognitive economy, perceived world structure, and category essence—one that includes buying a perception of a personal identity of "mainstream success." Consuming, for example, *BotFighters* and *Killer*, is not an act of buying into such a perception and does not meet the expressive needs of large groups in a way that could create new category typicality. Neither one is the iPod or the *Halo 3* of pervasive games.

Pardon Me, Is This the Reality Department?

Game design elements typical of pervasive games might afford a grouping other than "games." Could there be an alternative category, hopefully one that is more comfortable for a mainstream audience?

We can illustrate the problem of pervasive games by discussing unaware participation (Chapter Six); producing game-related events bystanders consider ordinary. From the angle of creativity and expression, this is quite a successful design strategy, but the very same quality that makes it interesting as a design concept—the seamless intrusion of one reality into another, blending frames and domains—also makes it unsuitable for the mass market. Simply speaking, most of us do not enjoy the feeling of having the ground shift under our feet. We want to keep our realities in order. Human consumers carry around a primeval feeling of there being a time and a place for everything and unaware participation goes against that feeling.[1] There is also a practical problem with unaware participation: If we wish to experience it, it is not something that we can just buy from a store or order on the Web. *Majestic* was placed in ordinary game retail, although it was a case of "aware unaware participation," an oxymoron.

Further, as consumers, on what shelf in the store would we find "reality fabrication?" The shelf for *surrealistic suspense*, the shelf for *gut-wrenching realizations that you have lost a point in a game*, or the shelf for *thinking about something else while at work*?

All three expansions have consequences on the categorization of pervasive games as a product. Let's take temporal expansion as an example. In classic games, the players

decide when the game commences, pauses, and finishes. In a temporally expanded game, the clear boundaries of when the game commences, pauses, and finishes are removed and player control over the playtime is reduced in order to enhance the game experience (as was discussed in Chapters Five).[2] However, this also removes the user's choice of when to use the product, creating a product that chooses when it plays the user, not the other way around. This disturbs the consumers' work/play dichotomy.

A game designer cannot remove the innate will of the human brain to categorize. The temporally expanded game will be put into its own category, based either on understanding or on misunderstanding, with the cognitive economy, perceived world structure, and category essence following the category.[3]

How and Where to Market?

Pervasive game marketers have a product with great potential. There is a big and growing audience of devoted video gamers, and it is not at all unlikely that some of these will also enjoy pervasive game experiences. Furthermore, the market for designed lifestyle products is virtually endless. Since what product category pervasive games fit into has not yet been established in people's minds, it is still possible to create clear and positive associations with the category. But this will only be achieved if consumers learn and accept what the category stands for. For this to be a reality, the category must be communicated in a clear and unambiguous way.

One important issue to consider is whether the overall "games" category fits the consumption experience of pervasive games or whether another category label might be better. Another key factor is the balance between *points of parity* and *points of difference* between a pervasive game and other "entertainment" products. In what ways are pervasive games similar to other viable "entertainment" products and in what ways are pervasive games unique and superior to other "entertainment" products? A marketer can communicate pervasive games as a replacement or enhancement of current game activities or, such as the introductory case in which some marketers wanted the digital camera to become an office scanner, may consider whether domains other than the ones we expect may be applicable.

We know what pervasive games are not, but we do not know what they are. Through field studies we have found that a consumer can imagine a pervasive game to be sold in gas stations and coffee shops, that is, places where one would not imagine computer and console games being sold. This is an indication of pervasive games having not only a different category than computer games, but actually having a *unique* category essence that rises from the quality of pervasiveness.

When asked about the issue of the preferred timing of consumption, we found that casual Saturday afternoons were often mentioned. Social factors were also reported as prime motivators. Respondents reported that they preferred playing in direct interaction with friends, with the game being a catalyst and facilitator for, and not the object of, the social interaction. Similarly, respondents reported that pervasive games would be played "while doing other things," indicating a consumption pattern that blends into real life, as opposed to consumption that dominates an entire social occasion. *Majestic* took place in real time and was meant to be played casually. If a game character told you they would send you a fax the next day at a particular time, they would do that. So it can be said that it just had that quality of "while doing other things."

Other activities that have this quality of "while doing other things" include visiting an art gallery, browsing bookshops, having coffee with friends, and shopping in designer stores. These are activities in their own right, and have a cognitive economy, perceived world structure, and category essence of their own, and they also have strong connotations of an appropriate time, place, and social significance. They have a strong lifestyle-expressive element, making them a domain where commercial brands have a stronger foothold than in the previously mentioned domain of specialized interests. One might go so far as to say that visiting an art gallery, browsing bookshops, having coffee with friends, and shopping in designer stores are products in themselves, ergo making them designed lifestyle products.

This quality of "while doing other things" contrasts the domain of entertainment and its members such as literature and the cinema. Such activities are interruptive, taking up a slice of real life—they are the main activity during the time they take place. The example pervasive games in our study blended and blurred into daily life and did not demand to be the players' only activity while the play was ongoing.

There is an emerging continuum here, with the domain of engrossing "entertainment" at one end and something else at the other. At one end there are activities that are engrossing and captivating. This is the domain where we have seen games go into, with reviews appearing in mainstream newspapers together with cinema reviews. At the other end we have activities that blend with real life instead of taking a slice of it. These activities can be bought in nonentertainment retail stores such as coffee shops (and not in game stores), they are done on a casual Saturday afternoon, and they have strong connotations of fashion and style. This is a domain that is related to the domain of entertainment and has a category essence that may be close to that of entertainment but that is still different.

Marketers of pervasive games should thus not only focus on the lower "game" category and the slightly higher "entertainment" category, but it might be even better to "move" to another category.

The Alternative to "Entertainment"

We have already touched upon "entertainment" being an instance of "reward." If "entertainment" is conceived as a remedy for the need to recharge, the need to feel that you are not just toiling in the domain of the serious, we find that the list of similar activities is long. Visiting an art gallery, browsing bookshops, having coffee with friends, shopping in designer stores, going to the cinema or a concert, gathering round a game console, and cheering the player on for 4 hours on a Friday night are suddenly all related. The common denominator is the quality of fun, the need to be unproductive.

Stepping down one branch of the tree, the taxonomy diverges. One branch is the domain of "entertainment" as an interruptive "Friday night" activity, and the other one is the Saturday afternoon domain of "leisure" (see Figure 11.3).

Leisure is an area of postwork/chores reward, which branches wider and maybe less clearly than entertainment, but at the same time has strong connotations to lifestyle, trends, self-expression, and fashion issues, making it fertile ground for turning pervasive games into designed lifestyle products. Many of the strongest brands in the leisure industry (e.g., Nike, adidas) have been built on the concept of consumers moving and

FIGURE
11.3

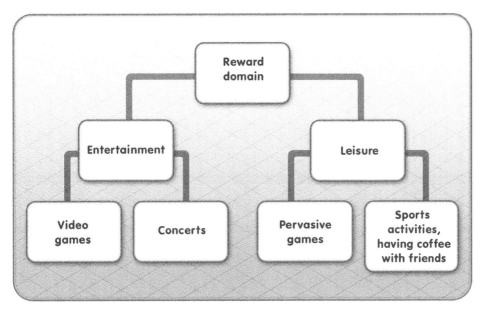

Pervasive games placed in the domain of "leisure."

expressing themselves in an urban environment,[4] a concept that fits very nicely into the intrinsic qualities of a pervasive game.

Conclusions

If it is true that the pervasive game has a place in the domain of "leisure" rather than in the domain of "entertainment," it means that we, whatever the middle and lower level mechanisms of business models for a pervasive game may be (e.g., whether event, mobile, or object based), have found a framework defining what businesses could reasonably be expected to be found in a pervasive games industry. It means that the competitors for the mass-market consumers' wallet and attention are personal fashion items and visiting "fashion-places" rather than newly released titles for PlayStation 3. It means that in the short term it may be wiser to design a pervasive game for the iPhone than for the PlayStation Portable, even if the former is a technologically inferior platform. Finally, it means that of the two introductory scenarios, the one with the coffee shop may be a better way forward than the one with the movie tie-in.

Notes

1. *Candid Camera* style TV shows, such as *Punk'd* (2003), show that watching other people being tricked can be quite enjoyable for the masses.
2. Temporal expansion usually both decreases players' control of the play session by game system interventions and allows it whenever they want to. It is mainly the first of these two that is considered here.

3. A game designer could argue that (at least for hardcore players) a successful categorization has been proved by the success of *The Beast* and especially by *BotFighters*. Some people truly appreciate the disturbance, the loss of control *and the loss of category*. So far this group remains a small minority. There is always a market segment of thrill seekers who appreciate the category of "novel and thrilling experiences," into which many pervasive games fit.

4. See the compared story of adidas and Nike analyzed as identity expressing entities in, e.g., brand leadership (Aaker & Joachimsthaler, 2002).

Case L

Uncle Roy All Around You

Matt Adams

You head out into the city to look for Uncle Roy. He sends you messages on your handheld computer as you walk. First you go to the park, and then you head into the West End of London. Online players start to pop up on your screen with suggestions and advice. Who are you going to trust? Uncle Roy tells you to wait for a woman with black hair and then gently turn and follow her.

As the clock ticks down, you find Uncle Roy's deserted office. As you stare into a surveillance camera, he sends another message. Outside there is a phone box: It rings, telling you to get into a limousine. A man gets into the car and asks you a question: "If someone you'd never met before was having a personal crisis, would you be willing to offer them support?" The man asks you to make a commitment to this stranger for 12 months. You answer yes, he drops you off, and the game ends. The next day you get an email with the name and email address of your stranger.

There are two groups of players in *Uncle Roy All Around You*. Online players log onto a Web site and are dropped into a virtual model of central London. Street players sign in at a gallery in the city, hand over all their possessions, and are given a briefing before heading out into the same area of London (see Figure L.1). Both groups of players need to collaborate together to find the mysterious Uncle Roy within an hour. As the players head out to the streets without their wallets, keys, or phones, trust becomes a central issue.

Using the city, an office, a limousine, and actors, *Uncle Roy All Around You* is a mixed reality game. Created as a collaboration between Blast Theory, the Mixed Reality Lab at the University of Nottingham, and a British Telecom research team, the game was staged in London (2003), Manchester (2004), and West Bromwich (2004). The game can be played by up to 12 street players and 20 online players at the same time. A support team on the street uses walkie-talkies to ensure safety, deal with technical problems, and, occasionally, interact with players.

Street players are given handheld computers that have a map of the area. The interface allows players to update their position, receive cryptic messages from Uncle Roy based on their location, record short audio messages for online players, and receive text messages back. By giving street players a small window onto the map and allowing them to drag an icon representing themselves around the map, the game avoids the need to use any positioning technology.[1] All the messages from Uncle Roy that guide players are highly context specific and would be useless unless the player is in the correct position. Because the gameplay is designed to fit tightly around the limitations of the technology, few players understand that they are indicating their own position, assuming that a high-tech positioning system is being

FIGURE
L.1

The street player moves around the town with a handheld device, while the online players access the game through a Web site.

used discreetly. Clicking a button marked "I Am Here" on the handheld computer would confirm that player's location and announce it to nearby online players.

When *Uncle Roy All Around You* is recreated in a new city, the game messages are researched over many months in order to draw on the social, political, and historical resonances of the game area. In London, for example, the game was staged during the Queen's official birthday and an annual royalist pageant called the Trooping of the Colour so players moved from St. James' Park surrounded by parading horses to Pall Mall, where many gentleman's clubs are based, to the diplomatic area of St. James Square and to the sleazier streets south of Leicester Square. A message on the east side of St. James Square asked the player to stand on the spot where police constable Yvonne Fletcher was shot and killed by an unknown gunman inside the Libyan Embassy in April 1984 and look up at the windows from which the shot came. Uncle Roy describes these places in the first person as he wanders the streets attempting to find someone he once saw on a bus in the area.

Online players see nearby street players. They can hear audio messages from the street players and can send text messages to them in return. By exploring the virtual city, they can discover Uncle Roy's office. By guiding a street player to that location in the physical city, both players get inside the office. The street player is buzzed into a deserted office filled with evidence of Uncle Roy's life, while the online player joins them via a live webcam.

The street player is asked to write a postcard; the online player is asked whether they would be willing to offer support to a stranger who was having a personal crisis at any time in the next 12 months. The street player goes outside to a phone box and is told to get into a white limousine. Inside, an unknown man asks them the same question. The postcard[2] is dropped into a special post box as the limousine pulls up back at the gallery.

All players who affirm that they would offer support to a stranger are placed into random pairs and given each other's details. Some players never contact one another, some meet for dinner, some become friends, and some enter into a sustained and heartfelt quasi-anonymous correspondence.

Uncle Roy All Around You steadily blurs the boundary between the game and ordinary life, between the fantastical terrain of espionage and the quotidian streets of work, tourism, and shopping. The extent of the game area is uncertain, Uncle Roy's presence within it is ambiguous, game messages invoke nonplayers ("Follow the woman with black hair"), and the goal of the game—to find Uncle Roy—can never be satisfied. Many players assume that members of

the public are actors and even accuse them of being Uncle Roy. Some go into office buildings and demand to see him.

The stranger that players are hunting for, in fact, turns out to be another player, and the confusion that results as players comprehend this direct incursion of ordinary life into the magic circle is the critical moment of the piece. How do multiplayer games and other forms of online social space reconfigure our sense of community and trust? If they facilitate new relationships between strangers, what might be the topography of this new social landscape: Does care for others still manifest itself and, if so, in what ways? Deciding which player to trust during the game has a great impact on your likelihood of success: Some online players delighted in giving false directions.

In framing these questions on the streets of the city, *Uncle Roy All Around You* also points to the rise of mobile devices—always on, always connected, intimate, and performative. To talk aloud on a phone while in a public space is to speak to two audiences simultaneously: your interlocutor and surrounding strangers. They change who we can talk to and how, subtly but profoundly adjusting what can be said and to whom.

The city's long history as a site for presentation and representation, protest, and display has prompted a rich history of art works set there. The Situationists with slogans on their clothes mapped the city as a malleable emotional landscape and then upturned it. French artists Sophie Calle and Christian Boltanski, as well as Fiona Templeton's *You–The City*, have proposed ways in which the city's possibilities for delicate, immanent connections between strangers may be generated and articulated. The theatrical nature of *Uncle Roy All Around You*—from the tightly scripted induction to the actor in the back of the limousine—invokes these histories, especially given its siting in cultural contexts such as the Institute of Contemporary Art in London and the Cornerhouse gallery in Manchester. In so doing, it invites players to reflect on the nature of gameplay itself and whether games are a suitable context for art. When we play, when we participate, and are actively engaged, does this disrupt our ability to be engaged at the most profound emotional and intellectual levels?

The piece is less concerned with pleasure—the sine qua non of almost all game design—than with a productive anxiety. To disconcert (literally "to disturb the self possession of") the player is to draw them into a world where normal rules do not apply, where senses are heightened, and new attention is paid to the world around you. Players on the street reported that, at times, this felt close to panic. Steve Dixon played the game in Manchester and later reflected on the experience:

> [R]un up and down the long corridor. Realize this isn't the place, check the map plan again, realize the building you want is a little further up the street, takes the stairs down, run, sweating—two minutes left—see another pair of glass doors to a building that seems deserted, burst in, take the stairs, get out. There's a door. (Dixon, 2007)

But when this confusion and pressure roll into solitude and isolation—alone in the deserted office, seemingly abandoned in a phone box, cruising in silence in a limousine with a stranger—that can lead players into profoundly new experiences when the game is over.

> Go home, reevaluate yourself, the one you once loved and lost, the nature of memory, time's winged chariot, cities and surveillance, "virtual" realities, the fallibility of computers, the boundaries of bodies and space, the nature of life and its relationship to performance, the meaning of art. Cry like a baby. Realize, again, just how new and unprecedented such work is, and how timeless and humbling is the experience of great art. (Dixon, 2007)

Notes

1. Although this might seem a major limitation, our experience with GPS in *Can You See Me Now?* had shown us the significant limitations of the technology and its steep learning curve for users. Tests done during the development of other positioning technologies, such as cell positioning, revealed them to be expensive, slow, and imprecise. See Benford et al. (2004).
2. Postcards from one game are archived at www.uncleroyallaroundyou.co.uk/postcard_search.php.

TWELVE

Art and Politics of Pervasive Games

Matt Adams, Martin Ericsson, and Frank Lantz

When games are discussed as art, the discussion often revolves around the question of whether games are worthy of being considered works of of art. Most digital games are considered to belong in the category of popular culture: They are commercially produced products aimed at wide groups of consumers. Based on this, an implicit or explicit conclusion often dismisses the artistic potential of games.

However, turning the rhetoric around also reverses the conclusion. If we consider whether art—whatever we mean by that—is flexible and polyphonous enough to take the shape of a game, even the strongest advocates of separating "high culture" and "low culture" agree that some games should be considered works of art.

We have invited three award-winning artists to discuss the relationship between art and pervasive games in this chapter. The first artistic statement is written by Matt Adams, who is part of the artist collective Blast Theory based in Brighton, UK. The group uses interactive media to create interactive art that mixes audiences across the Internet, live performance, and digital broadcasting. Adams approaches pervasive games from the point of view of experimental theater. In his piece he explores the relationships among creator–artists, cocreator–participants, and the society around them.

The second statement comes from Martin Ericsson, who works as the creative director at The Company P in Stockholm, Sweden. P makes participant-centered productions that build on the convergence among live action games, television, mobile, and computer technology. Before turning to pervasive games, Ericsson worked with a subsection of larp he calls liminal role-play. This background frames his take on the effect of pervasive games on the player and her perception of the surrounding "consensus reality."

The third statement is by Frank Lantz, who is the creative director at area/code, a New York developer that creates crossmedia, location-based, and large-scale social games. Lantz's piece approaches the subject from the viewpoint of games in general. He uses pervasive games to show something elemental about all games and their relationship to film and other media.

The three takes on the relationship between art and games are not always compatible with each other, but each one offers a valuable perspective on the dilemma.

Mixed Reality Arts

Matt Adams

There is a widespread recognition that certain games may be considered art works, but it is more debatable whether games intrinsically are an art form. In the same way that film and video have been used by artists for many decades without usurping the broader commercial stream of cinematic production, artistic games will probably remain distinguished from the mainstream by a focus on aesthetics, hybridity, and intellectual and emotional subtlety. However, one of the artistic and commercial strengths of cinema has been its readiness to maintain a dialogue between artistic or experimental work and the mainstream through festivals such as Sundance and independent cinemas with bold programs. Despite efforts by, for example, The Independent Games Developers Association,[1] this exchange is still pretty rudimentary in games.

Over the last decade, a generation of game makers has emerged who are not only combining diverse aspects of game design but are busy mixing games with genres such as installation art, performance, and documentary. Serious, political games such as *9-11 Survivor*, *Escape from Woomera*, or *World Without Oil* all use real events to transform our expectations of play. This essay is a personal reflection on three works by Blast Theory—*Desert Rain*, *Day of the Figurines*, and *Rider Spoke*—as examples of, respectively, ethics and decision making, social dynamics in pervasive games, and user-generated content.

My arrival at the world of games was partly a leaping off from experimental theater. Starting in the Russian revolutionary period and further developed by Erwin Piscator and Bertolt Brecht in Germany, the 20th century can be seen as a sustained enquiry into the relationship between the performer and the audience. Piscator's designs for multimedia theaters and Brecht's rethinking of the problems of identification with a protagonist were given a new subversive and iconoclastic impetus in experiments in the sixties by artists such as Allan Kaprow and the Living Theater in the United States and in the seventies by Joint Stock in the United Kingdom. Over the subsequent 40 years, a wide array of different theater makers—including those from performance art and, later, live art—have sought new models for how a performer might relate to an audience member directly and honestly. They have acknowledged the social and political context in which the performing arts take place. They have exposed some of the more specious psychological tricks involved in most conventional theater. Artists such as Franko B have made works in which there is a one-to-one relationship between the audience and the performer. Fiona Templeton's *You–The City* led audience members on a walk through the streets, interacting with strangers who were, in fact, all actors.

But no one has yet engaged with an entire audience in a way that permits scores or hundreds of people to have a voice within the work, and many of the solutions proposed have been esoteric, unconventional, or impenetrable.

During 1998, Ju Row Farr, Nick Tandavanitj, and I were working with the Mixed Reality Lab at the University of Nottingham on a new project called *Desert Rain*[2] that would be set within a virtual environment that was video-projected onto a screen of falling water spray (see Figure 12.1). We reflected on the epistemological crisis wrought by the 1991 Gulf War in which the real, the virtual, the fictional, and the imaginary had collapsed into one another. To dramatize this collapse, we wanted to immerse the audience into a world that was disorientating and ethically loaded. We gradually realized that we

FIGURE
12.1

Press image for *Desert Rain*, showing a performer emerging through the rain curtain.

needed to create a game in order to do so. Games give large numbers of people a motivation to interact, a readily understood means to do so, and a highly varied landscape to explore that allows each player an almost unique experience. That so many computer games had been made about the Gulf War—sometimes using simulation engines provided by the military themselves—only made the prospect of placing our audience inside a game world even more alluring.

In *Desert Rain*, six players at a time enter a large factory or gallery space shrouded in darkness. A performer greets them and briefs them about their "mission," which is to find their target and then help their teammates escape from the virtual world within 20 minutes. Each player then enters a new space and enters one of the six cubicles. Inside they stand alone, facing a water screen, standing on a tilting platform to navigate. The player holds a swipe card with the name and face of their "target" marked on it. They steer around a nighttime desert landscape searching for their target, exploring bunkers, and talking to their team-mates via headsets. Once they find their target, their immersion in the virtual world is rudely disrupted by a hooded performer emerging through the screen of water spray and giving them a new swipe card. Then, as the clock ticks down (announced on the headsets by a hidden performer), they must search for the exit.

The ethical challenge in *Desert Rain* is whether you are willing to help other members of your team rather than simply save yourself. Because the players are separated from one another physically and may never have met before, there is a temptation to abandon the weaker players and head for the exit alone. What none of the players realizes is that as they exit the virtual world the piece is not over; instead they must climb through a long corridor filled with tons of sand into a hotel room. There, as a group, they watch video documentaries on the hotel TV featuring each of their "targets," who

turn out to be real people. Many players attest that, when standing in the confines of the room as the testimony of participants unfold, the consequences of their own actions in what had previously seemed "merely" a game become uncomfortably tangible.

Games require players to make decisions. Most games have tried to solve the enormous ramifications of allowing players to make decisions by dramatically constraining them. From *Pong* to *Grand Theft Auto 3*, they tend to use the laws of physics as the central or only field of behavior. Move the paddle up or down to hit the ball. Drive the right car at the right speed to the right point in space. Will Wright has speculated that this process extends to the player building a mental map of the game through exploration of the game environment.

When engaging with an artwork, we are also invited to make decisions about how the work is operating. We must choose what is salient, explore possible metaphors and reference points, and balance our emotional and aesthetic responses with intellectual or conceptual ones. Given the enormous breadth of this process, games must expand the range of available decisions for a player, not just when considering the game as a whole but as an intrinsic part of the game itself. Might it be possible to introduce new kinds of decision making in which ethics or even politics played a part?

Games set goals. Given their functional and convergent nature, goals seem to militate against artistic expression. Especially as games carve goals into subgoals and microgoals ever downward into shards of the readily apprehensible: reach the door, jump the gap, solve the code, collect the gold. However, as online games have developed it has become clear that for these games to be truly compelling even the most elaborate long-term goals are not enough; they need a social dynamic. Even *America's Army*—an army simulation game centered on shooting—establishes clans of players, and it is these that provide the motivation for play. As one player told me: "If I don't go online tonight, I'm letting the clan down." To date, however, these social structures are ways of organizing gameplay, not of engendering it. A number of players with a range of skills may be required to complete a task, but the tasks themselves are physics-based battles.

Can multiplayer games with developed social dynamics set goals that are tentative, mercurial, and metaphysical? *Day of the Figurines* is an SMS game for up to a 1000 players in which the stated goal of the game is to "help others," but the actual goals are negotiable and subjective so that what is success varies from player to player. It is set in a small decrepit English town over the course of a single day. Players explore the multistory car park, the pubs, the canal, the underpass, and so on by sending text messages. Players can chat with one another, have a small set of objects (such as leather wristbands, cups of tea), and can complete tasks such as liberating animals from the Rat Research Institute. Players' health deteriorates through interactions with the environment, and they must complete missions to restore it.

Over the course of the 24 days of the game, players must also work out why they are in the game and decide for themselves what helping others might mean. This is especially complicated once a small force of Arabic-speaking soldiers arrives in the town and things start getting violent. To be alive as dawn rises over the town is, in some sense, to have "won," but there are no celebrations or rewards for this and—given the long duration of the game—players need to have found some other reason for being there long before this if they are to have engaged fully. In denying what might seem a precondition of any successful game—a clear understanding of what players have to do—*Day of the Figurines* invites players to think about and discuss their reason for being there.

In pervasive games, these kinds of questions are inherent and intractable. Even when a game is clear, concise, and conventionally structured, the chaos and unpredictability of public space complicate things. An inevitable porosity exists between the world of the game and everyday life. While playing *Killer*, for example, I must decide when my behavior may become alarming to nonplayers or might even invite law enforcement. *Uncle Roy All Around You* trades on this confusion and then jumps off from the world of the game altogether to establish new pairings between strangers that are so delicate and negotiable that many never even come into existence while others develop in long ongoing friendships.

In this respect, pervasive games lend themselves to a new level of sophistication. Players interleave their gaming experience with their everyday lives and with those of others. A strong trend in artistic practice in the last decade, called Relational Aesthetics by Nicholas Bourriaud, is for work that exists as a social configuration. It brings the artist and the public into direct contact with one another (by, for example, an artist cooking a meal for others) or it is so contingent on the interactions of the people who experience the work that it only exists through those social relationships. There are clear overlaps with urban games and alternate reality games here, except that in the art world these interventions are often constrained by their context. A bunch of curators eating a meal cooked for them by an artist at a gallery that does not even have a sign outside speaks about quite a narrow set of social relationships. Games and theater are inherently more outward looking and embracing, partly because they both are unashamed to market themselves.

Given that games over the last decades have been defined by technological development, the rise of mobile devices as games platforms provides a fascinating possibility. These new devices are highly personalized, ubiquitous, intimate, and focused on communication. What kinds of social relationships might we explore when games are created on platforms of personal identity?

Rider Spoke is a Blast Theory project from 2007 for cyclists with a handheld computer mounted on their handlebars (see Figure 12.2). As they ride through the city wearing headphones, they are asked questions about their life and are invited to choose somewhere in the city to answer each one. When they find a place they like they stop and record their response. That recording is then "stored" at that location. The second aspect of the experience is to cycle around searching for other participants' answers. Hundreds, even thousands, of answers are recorded over the week or two that the project runs in each city.

When inviting participants to contribute to a work in this way, we must make several crucial decisions about who can speak, what can be said, and in what ways what is said might be meaningful. *Rider Spoke* has been described as a game built on *user-generated content*, a phrase that has three major problems. "User" suggests that people are utilitarian inputs to a system, "generated" posits that they produce things through some basic process (think of a random number generator), and "content" is an awkward and ugly syllogism for the ways in which the public contribute. For these reasons I will use *publicly created contributions* to describe how *Rider Spoke* invites its audience to create the work itself.

Most of the best-known examples of publicly created contributions such as YouTube work on the principle that the vast majority of content will be rubbish and that various systems need to be in place to weed out this rubbish. Typically this involves ranking and voting. In *Rider Spoke*, we established a high threshold to participation (you must

FIGURE
12.2

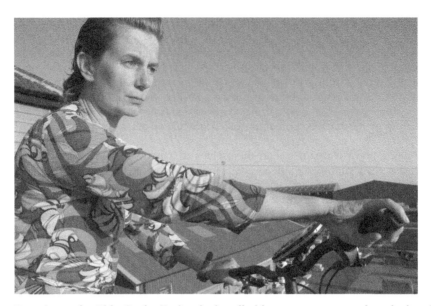

Press image for *Rider Spoke*. Notice the handheld computer mounted on the handlebar.

cycle through the city), a strong sense of mood (through the design of the interface and music), reciprocity (the female voice of the game speaks personally and revealingly), and context (the participant's choose where to record) to increase the likelihood that what is recorded is meaningful. As a result, we have found that there is almost no rubbish created by participants in *Rider Spoke* whatever. Much of the content is repetitive and some of it is expressed awkwardly, but in its given context it is almost always meaningful and heartfelt. Often it is moving and compelling.

Rider Spoke uses the intimacy of personal communication devices to give each particular place used in the work a meaning. While existing on the outer edges of games design, it, along with *Desert Rain* and *Day of the Figurines*, perhaps points toward games in which participation has many layers of complexity. While visual art has explored social configurations within the gallery, pervasive games can pose questions via new social relationships in the wider world. If they can draw diverse groups of citizens into playful real-world encounters that also pack complex emotional, conceptual, and intellectual concerns, then pervasive games will have achieved their full potential.

Tunnels in the Sand: Liminal and Pervasive Role-Playing

Martin Ericsson

The insider has a role to play. The outsider role-plays. What makes you accept the reality of roles such as teacher, cop, boss, and employee, but reject that of your local vampire, orc, and spirit-possessed geek? Think about it.

FIGURE
12.3

Carolus Rex **was a game about the adventures of a retro-futuristic spaceship. The game was played four times in the extremely confined physical space of a submarine. At the same time, the space in which the space ship soared was a limitless virtual space created by an innovative use of technology. The photo shows the crew and their vessel before the game.**

Role-playing is a very, very old phenomenon. Adopting a constructed persona for fun and social profit potentially predates the seven accepted muses by millennia—and yet it is one of the most poorly defined words in the English language. Role-playing is an attitude and an activity transcending platform and format, not a genre of computer games. Still, anyone who has ever engaged in it knows that it's right up there with "freedom" and "evil" in its multiple conflicting definitions. To one player, claiming to be from Middle-Earth while playing *World of Warcraft* is role-playing, to another nothing but complete character immersion, hand-sewn clothes, a forest glade, and a fluid grip of Sindarin cuts the mustard.

The current form of recreational role-playing is the result of a wonderful fluke resurrecting the basic mechanisms of liminal rites in the form of unpretentious gaming such as larp and tabletop, free of the normative baggage of social ritual. Liminality is the threshold stage of a ritual, the meat of the event where participants have left their normal societal roles and have yet to be assigned new ones (Turner, 1982). This is the magical country of myth where heroes go on quests; the realm of human imagination unfettered by social bonds. It is just another word for role-playing (Ericsson, 2004).

Before venturing into pervasive games with the *Prosopopeia* series, my Holy Grail as a game designer and an artist was perfecting the *ecstatic furnace*, the pressure boiler style of *liminal live action role-playing*. These games used an isolated place and time, where extreme dramatic situations and hardcore attitudes were combined in order to make consensus reality vanish completely from the mind of the participants. To achieve this, I used the whole liminal–ritual–cultic bag of tricks including isolation, archetypal characters, elaborate costuming, life-and-death narratives, secrecy, intoxication, and militaristic discipline juxtaposed with wild abandon.

The results in games such as *Carolus Rex* (see Figure 12.3) and *Hamlet* (see Figure 12.4) were amazing.[3] I have seen unbelievable transformations, with players pushing

FIGURE
12.4

**Martin Ericsson (right) as Claudius in *Hamlet*. The game was played twice in a Stockholm
bomb shelter. "To emphasise the political aspects, the action of the Shakespeare play was
moved from one fictive historical setting to another. They imagined a Europe where the
bourgeois French Revolution was unsuccessful and the twentieth century was met by a
world of industrialised feudal societies. The socialist revolution would then have been
aimed at monarchies and at the nobility controlling much of the industries. The game
was set in parallel thirties, during the Spanish civil war and an escalating armed conflict
between red Fortinbras and the Danish Empire" (Koljonen, 2004).**

their limits far beyond sanity and social norms: Macho men crying like babies, paci-
fists torturing the innocent for kicks, atheists experiencing the divine, and absolutists get
stoned into oblivion, all in the name of the game.

This would not be a big deal if we were talking about a computerized or tabletop
role-play, but I am talking about a brand of larp where simulation is kept to an abso-
lute minimum. The magic circle (manifest in venue, costumes, and characters) keeps the
players safe from social blame and encourages trust. Everyone in the game is in the
same boat, sharing an aberrant interpretation of reality, putting all faculties into play to
make it seem real. Also, just like sex play has safe words and codes of conduct designed
to allow players to go crazy without injuring each other, so does liminal role-playing.
This is a very supportive environment: A strong bond of trust is created rapidly between
the players. These may be the safest places to have a psychotic breakdown. The essence
of liminal role-playing is to create a place to go temporarily insane for fun and personal
exploration. The perfect player in a game like this throws all care to the winds and dives
right in; she is a bold explorer of the threshold realm—a liminaut.

In the context of pervasive games, role-playing is the most effective way of commu-
nicating a game structure and making sure players stick to it. Try rephrasing "you are a
secret agent" into non-role-playing instructions and you will see what I mean.

That does not mean that *Metal Gear Solid* is a role-playing game as such, but try actually acting like Solid Snake outside your local Israeli embassy and you may have a different perspective. Physical presence makes all the difference. Designers in this genre will be hard pressed to create engaging narratives without expecting their players to engage in at least some rudimentary role-playing. People do this without being asked to, like the players of *Epidemic Menace* who addressed their contact as "sir" and Cloudmakers of *The Beast* who pretended to believe in artificial intelligences. Designers do not need to convince players that the game is real; the game simply needs to be designed so that players are able to pretend so. No narrative multiplayer game can reach its full artistic potential without role-playing, simply because it is the most effective and intimate way of producing engaging peer-to-peer content.

It was with this mindset that I approached pervasive gaming. My prior experience in this field amounted to a few games of *Killer* in the early 1990s, a stillborn *Masquerade* campaign, a shelf full of Robert Anton Wilson, a small commercial alternate reality game, and 10 years of walking the streets in goth attire. But the most important inspiration to my approach to street games was a battle I waged against the Cathar Demiurge in a raging lightning storm on the battlements of castle Montsegur, France.

No, not in a game. This was as real as deadly struggles with metaphysical entities ever get in this day and age. The drop at the battlements is 1200 meters into a rocky valley, and I was perched right on the edge holding a metal rod, with two mates clinging to my legs when this went down. Then lightning hit the tower across the yard. Anyway, the gist of it is that I called a storm and survived it by using pseudo-Latin incantations from the tabletop role-playing game *Ars Magica*.

The mythological interpretation of events possibly existed "only" in my head, but it manifested physically as lethal forces of nature and changed my perception to the point where I could see the terrible face of God-the-Abusive-Father in the billowing clouds surrounding us on all sides. Coming down from the rock, I realized that a game feeling like that experience was next on my list. Game-myth and physical reality seamlessly intertwined, a life-changing experience of the limitless power of imagination—the closest thing to magic. This is the promise offered by *pervasive role-playing*, and this is why *Prosopopeia* was created.

The most important factor in pervasive role-playing is your personal *reality tunnel*[4] and that of your character. A reality tunnel is an individual's interpretation of nominal reality, constructed by a process of accepting or rejecting ideas until you end up with a static frame of reference that gives you a hopefully functional interface to the world and other people. These ideas are emitted from other reality tunnels, usually those belonging to parents, church, state, friends, and other high-bandwidth meme pushers. A reality tunnel is what you believe to be true and right, and it has to go right out the window in order for you to make a good pervasive role-player.

This is the first rule of pervasive role-playing: *Reality is not objective and external; it is subjective and internal*. Unless you understand and use this fact you will fail, both as a player and as a designer. In other forms of role-playing, the reality of the game is largely externally manifest in the words of the game master, the graphics on screen, or in the propping of the game area. But when you play on the streets, you will see the normal blank faces and fashion victims; very little outside your own mind helps you slip into the game state. Instead, pervasive games must use internal methods to establish the game world, the *diegesis*. External aids such as technology and special effects may give this process a boost, but in the end it is a feat of the imagination. To help switch to

the world-view of the character, the player can take a page from "the method" built on Stanislavski's work, try character-specific mantras, or extreme body language. But the best way to help players is to provide them with a very distinct reality tunnel.

This is why the vampire myth may be the best pervasive model around. Everyone else is either food or a threat. This predatory reality tunnel is very easy to enter and sustain for extended periods of time, especially given the modern readings of vampires that tend to mope and introspect over their lost innocence.

Wilmar Sauter's model of communication for theater reading has A (actor) playing B (character) to C (audience). In a similar way, role-playing games could be described as A (player 1) playing B (character 1) with C (character 2) played by D (player 2). Using the same kind of model for pervasive role-playing would read something like A (player) playing B (character) with C (bystander) who has no idea you are A and not B.

This brings us to the trickiest and, therefore, juiciest aspect of pervasive role-playing: the fine art of playing with nonplayers. The semiotic model quoted earlier, when compared to traditional role-playing, gives us a hint that this is more of a one-sided exercise. In order for the exchange to continue with any kind of fluidity, the player cannot claim to be a vampire, a secret agent, an assassin, or a possessing spirit as this will most likely cause the bystander-come-playmate to call the cops. Luckily, this does not mean playing with muggles and mundanes is hopeless, it just requires a level of subtlety and caution most role-players have no experience of.

All good pervasive characters, like the ones listed earlier, have one thing in common—they want to hide their true identities at all costs. The name of the game becomes subtlety and allusion as the players engage in a careful dance to veil their characters' true selves in mundane disguises. If the player happens to be a vampire or a spirit tormented by atrocities she committed in Nazi Germany, she could tell her story as the actions of a historical figure or relative. This way, neither the character nor the player will freak out the unknowing pub date but still allow the conversation to be emotionally relevant in-game. Also, every time you feel like leveling with the nonplayer and pulling her into the game, just forget about it. The game happens in the nebulous zone where you are true to your character and your nonplaying partner believes you are not playing her. This is the second rule of pervasive role-playing: *Your character is what you can get away with.* When in doubt, just get up and leave. Nonconsensual role-playing is a feature unique to pervasive games and not for the faint-hearted.

The game designer must make sure that the design does not prevent players from applying these rules to their playing style, and, fortunately, there is a very simple guideline. You have to convince your players that your story could be true. It is not about making them believe, just a matter of selling them a compelling "what-if" scenario.

A pervasive game must be about something that takes place in the real world, otherwise it would belong in another format. Fortunately, "the real world" today is as wild as any fantasy extravaganza. Jettison your personal reality tunnel and take a look at what is believed to be true in our world. Environmentalists are planning mass extinction, capitalism is the solution to problems created by capitalism, super-terrorists crash and bring down fireproof skyscrapers, there is a drug that makes you meet aliens, the dead communicate in white noise, shoes with a Nike logo make you successful and attractive, pedophiliac politicians subvert judicial processes, we must drink the blood of a long dead Jew to be saved from demons, when everybody is under surveillance we can all relax, all romantic partnerships are a form of mind-slavery, pervasive games open portals to other realities....

FIGURE
12.5

Liminal Role-Play	Pervasive Role-Play
Ordinary character in an extraordinary world	Extraordinary character in an ordinary world
Fabricated objective reality	Modified subjective reality
External diegesis	Internal diegesis
Ecstatic	Intellectual
Trust	Caution

Liminal and pervasive role-play contrasted.

Take your pick and be ready to face the consequences, because whatever you choose to unleash upon the world will, to some extent, become real. Just like all the memes just cited are real to some people and unreal to others, so will your game be. The universe is a lot stranger than you think, and pervasive role-playing games, just like magic, rock 'n' roll, and entheogens, appear to be a shortcut into weird shit country. When people pretend to believe, reality has a tendency to bend itself to these beliefs—not regularly or measurably, but in bursts of coincidence and fits of synchronicity. The third rule is, thus, really just an extension of the second and is straight from Wilson (1983): *Reality is what you can get away with*.

Ultimately, this is why pervasive role-playing can never, ever be nice, clean, and safe. The very format questions our basic assumptions of truth and social responsibility. The insider has a role to play. The outsider role-plays. One game is sponsored by consensus reality, the other one is not. Both are tunnels dug deep in the ever-shifting sands of unknowable nominal reality. Both are built to the design of archaic maps and intuitive hunches, hoping against hope to reach the surface of truth some day. But consider this: one tunnel is dug for you, the other one you dig yourself (Figure 12.5).

Pervasive Games and the "Art Question"

Frank Lantz

It is a good time to be a scholar, maker, or simply lover of games. Games are thriving and continue to become more and more complex and interesting from the perspective of technology, more successful as commerce, and more beautiful, expressive, and meaningful as culture. And yet among many of the most progressive and thoughtful practitioners in this field there remains a strange sense of anxiety. Will games ever achieve true mainstream acceptance, social importance, and artistic significance? Will games ever be capable of expressing complex ideas and serious emotions? When will we have our breakthrough? When will we be able to point to this or that generally acknowledged

game masterpiece and then relax, no longer worried about the status of games within the pantheon of cultural forms?

I am particularly interested in what pervasive games might be able to tell us about this question. At first glance, it appears that not much. After all, questions about the power and potential of games are normally framed as questions about *video games*. The assumption being that when games wrest the laurel wreath from the brow of cinema, ascend to the throne of *dominant art form of the new century*, and begin the work of articulating the global imagination, it will be via pixels on a screen, representing characters, connected to a controller. This is, after all, what we mean nowadays by the word *game*.

This assumption takes us pretty far away from the layered realities and urban scrimmages and messy, overlapping media of pervasive games. When the great masterpiece of gaming comes, we will experience it sitting on our couches, gazing into a screen, not running around an abandoned industrial park in the middle of the night with a GPS unit or negotiating a temporary truce over a pitcher of beer with the head of a rival assassin's guild or desperately trying to get a working cell phone signal as our plane slowly taxis toward the terminal only to find out that we are a few minutes too late to capture this city.

Looked at from this point of view, it would be easy to assume that pervasive games will continue to occupy the margins of gaming, as art projects, tech demos, and aesthetic experiments, with little to contribute to the profound breakthrough that "real" gaming is poised to make. Maybe, however, there are other points of view. Maybe pervasive games are more than cultural curiosities on the margins of gaming. Maybe they have something central to tell us about what games are, what they are not, and what they can be.

Let us start with what games are not. Pervasive games tell us that *games are not objects*. Pervasive games are ephemeral, distributed, and exist as rules, materials, procedures, players, and events. In this way, regardless of the technology they employ, they are very much like traditional games. It should be obvious that video games, which are made out of that most immaterial of all material—computer code—share this ephemeral quality. But how much like objects they appear to us now. You can hold them in your hand, collect them, lose them. They sit in tidy rectangular rows on the shelf next to our books and movies. But how much longer will the game as object survive in a world rapidly moving toward ubiquitous digital distribution and with more and more games becoming virtual places to which you go or services to which you belong?

More specifically, pervasive games tell us that *games are not products.* Those of us trying to make a living making these strange chimeras know this firsthand. We make do with grants, we make things for free, we get paid to make games that promote other things that *are* well-defined products—movies, television shows, video games. At first this might seem like a radical notion. But the game as product is in fact a rather new invention. *Baseball* is not a product; you do not go the store and purchase *baseball*. Of course you *do* buy equipment, tickets, jerseys, pennants, and so forth. In fact, the interesting thing is that *baseball* is a thriving multibillion dollar industry without itself being a piece of intellectual property, owned by someone and bought by others. You could say this has long been the historical status of games, and it does not seem so preposterous to imagine a future in which games return to a status outside of consumer product, while retaining ways of motivating and rewarding the people who make them.

Finally, pervasive games tell us that *games are not media.* Games are not a conduit through which an author speaks to an audience. Pervasive games are performed, inhabited, and explored, but they are not *consumed*. Here, again, pervasive games seek to pull games farther away from their current similarities to movies and books.

With these three negative statements, pervasive games have told us something quite interesting about our original question regarding breakthroughs, masterpieces, and cultural significance. They ask us to look again at the very premise of this question. Because what, after all, is a masterpiece? It is an object, created by one person and consumed by others, whose greatest value comes from its role as a medium through which profound ideas are communicated. It is not just the expressive power of storytelling that videogames seek to usurp from books and movies, it is their very *form.* It is *this* way of meaning, and no other, that will satisfy the ambitions of those people who yearn for a *Citizen Kane* (1941) of video games.

Again, we can turn to *baseball* to illuminate this point. Is the game of *baseball* meaningful? To an American, it would certainly seem so. It is hard to believe that something that has had such a large, lasting impact on our culture, something that has produced so many metaphors, become such a rich source of our identity, and had such a strong impact on the lives of so many people would be meaningless.

But even if *baseball* is meaningful, it does not appear to *communicate* meaning the way that *Citizen Kane* does (or appears to do). *Baseball produces* meaning. Whatever *baseball* has to tell us about persistence, passion, hope and grief, risk and reward, collaboration, or the numerical quantification of human actions (to name a few of the possible meanings of *baseball*) are not messages passed from a creator to an audience, they are actively created in real time by the participants of the game, players and spectators, both within a framework that the creator provided. Does this diminish their importance, beauty, or power? For me, it does not. It makes them deeply, essentially different, but no less interesting or worthwhile.

Games do not mean the way stories mean. However, they mutate and evolve; stories carry deep in their DNA the fundamental structure of a statement. Statements are messages from a sender to a receiver, and any exploration of meaning within the context of a statement is going to evoke the entire complex context of messages: symbol, signal, noise, etc. But a game is not a statement. Lots of communication takes place in and through games, but it is not communication from a sender to a receiver. Players are not audience. Unlike messages, which *transmit* meaning, games are more like meaning machines, or meaning networks. Players and designers are agents within a system out of which meanings emerge. This may sound a bit like postmodern mystification, but I believe it is true in a straightforward and common-sense way.

And this, for me, is the mode of meaning in which pervasive games operate. Their meanings are not known beforehand, they are ways of *actively discovering* things about ourselves, and the world, through a process that is deeply collaborative—a collaboration among designer, player, observer, and the world itself. Pervasive games seek to take this premodern mode of game meaning, rooted in ancient ritual, public spectacle, passion, and pastime, and apply to it all of the power of modern technology.

Despite being a strong advocate for pervasive games, I do not believe they represent the only, or even the best, direction for games to evolve. What I think is most important about them is their refusal to settle down into the role of object–project–medium in which mainstream video games are attempting to make themselves comfortable, but instead demand the right to continue to try radical new configurations and mutate into surprising new forms. Pervasive games remind us that the mainstream cultural acceptance of video games is also a process of domestication.

I used to be one of those people who proclaimed that games would be to the 21st century what cinema was to the 20th century. Now I am not so sure. This does not,

however, indicate lowered expectations or diminished ambitions. I believe that games are a profoundly beautiful expression of the aesthetics of interactive systems. As the idea of "system" becomes more and more our dominant mode of understanding the world and our place in it, games will become more and more important as ways of discovering and creating meaning and beauty within that world.

But I no longer think that the field of games will establish itself in a way that is recognizable as an analogue to film or any other existing cultural form. I do not think that games will occupy exactly the same kind of cultural space occupied by movies or books or music. Instead, as games continue to grow larger and more important, they will transform our understanding of that cultural space, forcing us to rethink the categories of creator, audience, and work that currently structure our thinking. Instead of becoming a new globally dominant form of message sending and receiving, they will shift our focus away from the idea of broadcasting inherent within that model to a new way of thinking about meaning–creation that is more like a network, like a conversation from which meanings emerge.

In a way, games have always done this. Throughout history, games have occupied a particularly slippery place within culture, a place less well defined and more dangerous than storytelling or picture-making. They have always operated in an ambiguous zone outside the value systems by which we judge the rest of life. They are, in a way, always *about* value systems and are often woven together out of strange combinations of values—some real, some imaginary, some that reflect the world, and some that invert it. The fact that we did not know quite what to think about them is not an indication that there was not much to think about, but a demonstration of their deep and confusing mystery, their need to operate outside of rules of reason and judgment by which we normally evaluate things, in order to make rules, reason, and judgment their subject matter. And now that we are thinking about them a lot more, I expect that mystery to deepen, not dissipate.

I expect for games to get more dangerous, disruptive, and confusing, even as they become deeper and more meaningful. And pervasive games, by directing our attention to the points of connection between game and the world, should highlight this danger and confusion. A good pervasive game is not an attempt to seamlessly integrate a game into everyday life; it is confrontation between game and life, an intrusion that causes players to reexamine their ideas about game, life, and the relationship between them.

A good pervasive game can confront us with any number of metaphysical dilemmas, not merely as contemplation, but as direct experience. To take one example: What's the difference between a thing and the representation of a thing when the thing is *you*? This is a question that only games can ask (and many games, pervasive or not, *do* ask). No amount of movie watching will answer this question, and no amount of *New York Times* articles will ever make this question sit comfortably next to the well-defined works out of which mainstream culture is built.

To repeat, this is not a matter of diminished expectations or lowered ambitions for the cultural power of gaming. It is, in fact, a demonstration of that power. No amount of commercial or artistic success will ever fully overcome game's "outsider" status, a status that is especially well expressed by pervasive games.

Ultimately, I believe we may reach a point when the concept of a masterpiece and the categories of object, product, and media start to feel vaguely 20th-century nostalgic from the perspective of the communal performance systems and meaning networks within which games play. And we may even look back and realize that things like movies,

books, and music are actually themselves best understood on these new terms, and their former status, to which games once aspired, was only temporary.

Notes

1. www.tiga.org.
2. *Desert Rain* was a collaboration with the Mixed Reality Lab at the University of Nottingham. It was first shown at the Now 99 Festival in Nottingham and was subsequently shown at ZKM in Karlsruhe, Riverside Studios in London, Tramway in Glasgow, Industrial Museum in Bristol, KTH in Stockholm, Digital Summer in Manchester, Las Palmas in Rotterdam, Former Red Star Parcel Office in Middlesborough, Artspace in Sydney, Typografie in Prague, and Festival Escena Contemporanea in Madrid.
3. Johanna Koljonen has written about *Hamlet* specifically (2004) and the gaming style generally (2007).
4. The term was coined by Timothy Leary and popularized by Robert Anton Wilson (1983). If you have not gotten around to reading Wilson yet, put this down and read *Prometheus Rising*. It will tell you more about pervasive role-playing than anything else on the planet.

Case M

The Amazing Race

Markus Montola and Jaakko Stenros

Your day starts in the early hours of the morning, as it is your team's turn to leave the pitstop for yet another leg of the race. The weeks of travel make you feel physically and mentally exhausted even after the 12 hours of rest. All you know is the next waypoint, with no idea about which countries you will end up in today or what tasks await you on this leg. All you have is your teammate, a limited reserve of cash, and a backpack full of gear to carry.

The first puzzle is the usual one: procuring the fastest flights from Vilnius to Dubrovnik. As all teams cram into the same airport, using the terminals and finding the best agencies is pivotal: You can easily lose hours due to a bad choice or bad luck. In order to receive clues for the next destinations, you need to perform a series of tasks at a historical fort of Dubrovnik: One person from your team has to solve a masonry puzzle by fitting the right stones into the medieval wall. After that you have to rappel down the walls of the fort and climb them up again, followed by a dash through the confusing streets of the old town. Finally, you have to ride a cab to the Stone Cross overlook site, where the fiercely competitive leg ends and the surviving teams get another 12-hour break.[1]

The Amazing Race is a reality television game show. It is a competition where a dozen[2] teams race around the world, facing all kinds of challenges on the way. Players must conserve money, struggle through airports, navigate in strange places, and overcome various tasks on the way. The race is divided into 12 or so legs, each consisting of traveling from one city to another, searching for the correct locations and carrying out various tasks.

Looking at *The Amazing Race* from the player perspective, it is obviously a pervasive game. It features extreme spatial expansion, as the race literally goes around the globe. The winners usually travel a total of approximately 30,000 miles, taking around 25 flights to reach the finishing line.[3] Once the race is on, it takes place on roads, buses, gas stations, airports, and visually impressive tourist attractions (see Figure M.1).

The players are followed constantly by a cameraman and sound technician, who capture every moment of their month-long journey. Each television episode shows one leg of the race from start to finish: The team who finishes last is usually eliminated from the race. The first team to complete a leg wins a traveling-themed prize, whereas the first team to complete the last leg wins the race and goes home a million dollars richer.

The format was developed in the United States, and the first series based on it was aired in 2001. Reception of the early seasons was lackluster, but gradually the show built up a reputation, a loyal viewership, and won numerous awards. Nowadays, *The Amazing Race* attracts a steady audience of more than 10 million viewers,[4] which makes it one of the most popular pervasive game performances in the world.

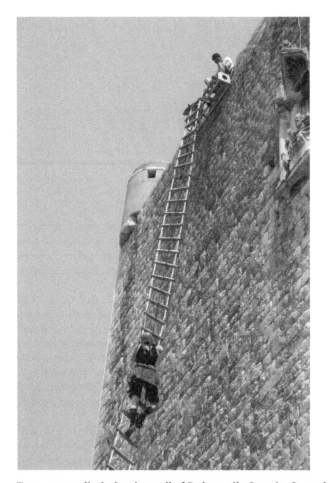

Teams must climb the city wall of Dubrovnik, Croatia. Once they arrive at the top, they make their way to Trg Oruzja where they will receive their next clue. Picture from the 12th season of *The Amazing Race*.

Analyzing the race with the metaphor of a magic circle, there is a peculiar finding regarding the temporal aspect. The race is not a temporally expanded game; it is just a very long continuous game. Even though the filming of a season lasts for a month, the production company does everything in its power to avoid merging of everyday life and game during the game sessions. The play sessions are paused for exact periods between the legs, and the players are forbidden to contact any earlier acquaintances during the trip: Even carrying a mobile phone is forbidden.

Social expansion is also a strong part of the game, as players often need to rely on the help of outsiders: Asking for directions in unknown languages is a typical challenge, and the teams spend a lot of time obtaining plane tickets to strange destinations. Teams that run out of money sometimes have to beg their way through legs, which has led to awkward scenes

where privileged Americans beg for money in third world countries—in order to win a million dollars.

As is typical of reality television shows, a large part of the television program revolves around social dynamics. The casting team screens the candidates meticulously in order to ensure the emergence of interesting reality drama. Dysfunctional, outspoken, and archetypal participants are chosen in order to entertain the viewers. Whether they are relatives, friends, or couples, they are forced to bring their relationship into the game: Stress, sleep deprivation, and boredom combined with the challenges of the race and a month of physical proximity force almost all teams to process their internal relationships on the show. For a large part of the audience, this peer melodrama is the most important reason to follow the series; the melodrama also plays a large part in the way viewers choose to side with the teams and get personally involved in their competition.

The difference between the play experience and the televised interpretation of the events is vast. The play involves a lot of traveling and navigating, which is mostly truncated on television, at least until the stress of travel brings out captivating drama. As *Fear Factor* also demonstrates, a pleasurable game and an entertaining television show are two very different things.

Being a highly commercial and visible product, *The Amazing Race* has been obliged to minimize all legal and physical risks to participants, bystanders, and the production company. The combination of constant surveillance and the risk of being disqualified from winning the prize guarantees that players break the rules only accidentally. The constant temptations of speeding on highways and calling home are hard to keep at bay, and local regulations on activities such as begging are difficult to predict. Even when taking 12-hour breaks between legs, the players are held under constant supervision.

The official rules of *The Amazing Race* are known only to the contestants and the producers of the show, while the viewers are only presented with a barebones version. Many of the hidden rules relate to how the show is produced: For instance, when embarking on a car ride, one contestant drives and the other one has to sit behind her in order to allow the cameraman to ride shotgun and the sound technician to sit behind him. Some of the jealously guarded rules influence the way the game is played and experienced: For example, the production company does not want to openly discuss the monetary prizes awarded to runners-up.[5]

The game rules change from season to season as the production team fine-tunes their concept to keep the show fresh and surprising and to incorporate viewer feedback. Just like in other spectator games (from *NHL Ice Hockey* to *Formula One* racing), the rules are tuned constantly to address audience preferences. The most central changes in *The Amazing Race* have shifted the focus of the show from actual racing toward diplomacy and intrigue. In more recent races, the teams have had the option to *yield* another team, forcing them to wait for a period of time, and there have been *intersection* tasks, which force a team to join forces with another team and overcome a task together.

In the fashion of *La decima vittima* (1965) and *Midnight Madness* (1980), the format and the presentation of *The Amazing Race* have inspired people to play adapted versions of the game themselves. Students have tailored it into a beer-soaked carnival combining fun challenges with seeing sights, whereas outdoorsmen have focused on healthy exercise and competition. *The Real Race*[6] is a commercialized example of the latter—an Australian adventure tour in which teams pay for their own trips, competing in similar challenges for a week or two. Instead of stress and exhaustion, *The Real Race* offers enjoyable recreation, and instead of a million dollars, the prize given to the winners is free participation in the trip (Figure M.2).

As discussed earlier, pervasivity is not always a property embedded in the formal structure of a game: The human behavior surrounding the play can impact pervasivity strongly. In several

The Real Race allows players to compete in the fashion of *The Amazing Race*, but also to pretend to believe that they are participating in the series—This Is Not a Game But a Reality Television Show. Paddling near Sydney, Australia, in 2006.

reality television game shows, the pressure to blur the magic circle has, in fact, come from outside: *Media jammers* critical of the politics of *Big Brother* have struggled to penetrate the magic circle by sending messages to the players with megaphones and airplane banners (see Wilson, 2004; also Jenkins, 2006). While this is not practically possible in *The Amazing Race* (as the race is filmed long before it is screened), it shows how the political nature of reality television game shows can create a two-directional pressure on the production.[7]

Most reality television shows are pervasive for the participants in the way that they blur ordinary life and the artificial structures of creating a format television show (*MTV's The Real World*, *Queer Eye for the Straight Guy*). Many reality television shows are also games, containing rule-based systems for competing (*American Idol*). Yet few of them are pervasive games in the sense discussed in this book: A number of the shows that eliminate contestants each week have a ludic structure, but if the tasks are not expanded spatially, temporally, or socially (like they are in *The Apprentice*), the games are not necessarily "pervasive."

Notes

1. Example from the sixth episode of the 12th season of the show.
2. Details such as the number of teams and the exact length of the trip change from season to season. See www.cbs.com for more detailed information.
3. http://alpha.cbs.com/primetime/amazing_race12/faq.shtml
4. According to Christopher Rocchio, the finale of *The Amazing Race 7* in May 2005 attracted altogether 16 million viewers. www.realitytvworld.com/news/the-amazing-race-12-premiere-delivers-best-ever-debut-ratings-6050.php, ref. September 24, 2008.

5. Fans of the show have tried to piece together the complete set of rules based on the shows, production information, and contestant interviews. The examples given here are from *The Amazing Race 6*, as discussed in *The Amazing Race FAQ* at the *TARflies Times* Web site: www.tarflies.com, ref. September 24, 2008.

6. www.therealrace.com, ref. September 24, 2008.

7. Similarly, in relation to the reality television show *Survivor*, Henry Jenkins (2006) has documented a subculture that seeks to "spoil" the show by figuring out where it takes place, who the contestants are, and what happens on the show—before the episodes are aired. According to Jenkins "the spoilers are just having fun on a Friday night participating in an elaborate scavenger hunt involving thousands of participants who all interact in a global village."

THIRTEEN

Pervasive Games in Media Culture

Jaakko Stenros, Markus Montola,
and Frans Mäyrä

We have sought to cover the entire broad spectrum of pervasive games in this book. Some of these games are played for a short duration by a single player, whereas others last for months and have thousands of participants. Some games utilize careful designs and sophisticated technologies, whereas others rely on the simple elegance of children's play. Purposes of play range from recreation to education, and budgets from nonexistent to millions of dollars. A pattern emerges from the one common denominator, the expanded magic circle: A group of features, strategies, and challenges that makes the family of pervasive games distinctive. In this final chapter, we situate pervasive games in a wider context and discuss trends and processes that have made society receptive to pervasive gaming.

In the process of mapping out pervasive phenomena, we have consciously distanced ourselves from an approach based on technological determinism. We see that information technology is an enabler and a catalyst in the development of pervasive games, but while it certainly is a powerful tool, the understanding of pervasive gaming cannot be reduced to a discussion on technological development.

Pervasive games are not new human activities. Children play wherever they are and whenever they can: Play becomes *pervasive* only in a modern society that erects boundaries to be pervaded by such games. Johan Fornäs (1996) describes modernity as a set of economical, cultural, and political processes, such as the rise of capitalism, industrialization, urbanization, democratization, and secularization. Leisure time, for example, in the way that we recognize it today, was shaped in that time, as ideas regarding time, progress, and material rewards of work changed (Veal, 2004). Similarly, the cramped urban environment of the age of industrialization did not offer sufficient natural space for leisure, so public parks, marketplaces, and streets became living rooms. This need was aggravated by the push toward individualism in the modern era.

Our discussion on pervasivity is meaningful only in this context: Dichotomies such as work versus leisure, sacred versus secular, public versus private, and factual versus fictional are central to our understanding of the magic circle and the dichotomy of playful

versus ordinary. The way we understand temporal expansion, for instance, is dependent on the separation of work and leisure, a distinction typical to the industrial age. The late modern society makes both the pervasivity and the gameness of pervasive games significant: They draw their power from the supposed exactness of modern classifications by simultaneously recognizing and questioning them. In this sense, pervasive games toy with the boundary of modern and postmodern.

We have identified three growing cultural trends that have influenced and given birth to pervasive games: the *blur of the real and the fictive*, the continuous *struggle over public space* in urban areas, and the *rise of ludus in society*. All of these trends date back at least to the 1960s, yet it is only recently that they have been moving from the sidelines toward the mainstream, cross-pollinating each other in the process.[1]

Blur of the Real and the Fictive

The proliferation of electronic media has hastened the blurring of fact and fiction in Western culture. In modern society, factual truths were supposedly easy to find: A certain truth that was printed in a newspaper or an encyclopedia was held as an objective truth until refuted by newer knowledge. Fiction, the polar opposite of fact, was clearly marked wherever it was found. With the emergence of the global village, with its ever faster communication, multiculturalism, and cultural relativism, this is becoming increasingly difficult. Truth is being replaced by a perspective, an opinion, a third class between truth and fiction.[2]

Popular culture reflects this shift. In discussing the historical influences of pervasive games, we mentioned ludic literature, playful texts, and started that discussion with satire. Jonathan Swift's *A Modest Proposal* (1729) is a classic example of satire. The essay was presented as an actual argument for eating poor children, and the trick was that the reader was supposed to realize that it was fiction, while seeing the political comment hidden in its revealingly cruel irony. Similarly, when Orson Welles adapted H. G. Wells' *War of the Worlds* into a radio play (1938), he staged it as a news report. Welles used the format of news to tell a story, appropriating for fiction a stage reserved for real. Welles' use of the format was seen as a threatening and taboo-breaking infringement of trust: The *New York Times*[3] headline declared, "Radio Listeners in Panic, Taking War Drama as Fact."[4]

Both of these cases show that while it has always been possible to play with the categories of fiction and nonfiction, it has also been important—and possible—to place a work unambiguously in either category. This is no longer the case; the gray area between fact and fiction is widening.

Mediated Reality

Reality television, an important trend for contemporary media culture, places ordinary people in fabricated environments. Whether they are racing around the world, passing time in a house, or being invaded by interior decorators, the subjects of these shows are supposedly normal people reacting to a manufactured situation. Yet these shows are also staged, at least up to a point: Directors, screen writers, and film editors are working

hard in order to present a clear storyline. The ordinary people who star in these shows are great pretenders, who have been screened from thousands of candidates, if not full-fledged celebrities,[5] from other walks of life. Some of these ordinary people turn into reality TV celebrities, who are paid separately to go from one show to another. Yet many viewers watch these shows and believe (or pretend to believe) that what they are watching is somehow real—and the yellow press reports from the shows are real news.

Although reality television can be traced back to *Candid Microphone* (1947), *Candid Camera* (1948), quiz shows, and the brilliantly titled MTV's *The Real World* (1992), it was not born as a major phenomenon until the explosion of *Survivor*[6] (2000), *Big Brother* (1999), and *American Idol*[7] (2002). These shows are the most obvious examples of the ongoing trend of the blurring realities in television culture.

Judd Winick, who starred in *MTV's The Real World: San Francisco* (1994), has since created a comic-book autobiography *Pedro and Me*, which supposedly reveals what really happened on the show. He comments on the confession camera:

> We lived in the house for the total of six months. It was the most exhausting six months of my life. There is an unspoken pressure to be interesting. We had an ongoing internal mantra of "Oh, God, don't let me be boring..."

> And at the end of each week, we would sit down and give an interview. These are the looking-at-the camera types that narrate the shows with opinions and reflective accounts of what happened. [...] It was like therapy without the help. (Winick, 2000)

Celebrities constantly take part in events that are carefully scripted, not just on the talk show circuit, but also in various publicity events and parties. After the video recordings are edited and the pictures photoshopped, these events are reported as real. Jean Baudrillard (1998) discusses mediated images as *simulacra* that no longer bear any relation to any reality. It is not rare to spend more time with an Oprah Winfrey simulacrum than with one's own relatives—the simulacrum is a mediated acquaintance that only exists as media images.

The simulacra are now reaching for a new level of (un)reality through interactivity. Bree, the fabricated video-blogger of *lonelygirl15*, responds to your emails (see Figure 13.1), Claire Bennet of *Heroes* has her own MySpace page, and Adrijanna Klinga of *Sanningen om Marika* could be met in person. This places considerable demands on the actors pushing the envelope: To keep Bree's secret, Jessica Rose had to stay home as much as possible and disguise herself when going out.[8] To maintain the seamless life/game merger of *Sanningen om Marika*, Adriana Skarped had to be prepared to invoke Adrijanna at a moment's notice at any time while the drama series was being produced and aired.[9]

Similarly, news channels no longer report on what has happened or even what is happening, but are regularly awash with experts and pundits speculating before first-hand information has been acquired. The proliferation of political spin has underlined the theatrical nature of politics in general. These examples do not fit in either category; they are neither fact nor fiction. They are in the gray area in between, and viewers who understand this also accept it.

The gray area is expanding at the expense of the factual. Turning again to popular entertainment, there was an explosion in paranoid fiction in the 1990s, with numerous films from *The Truman Show* (1998) to *The Matrix* (1999) telling stories where the world

FIGURE
13.1

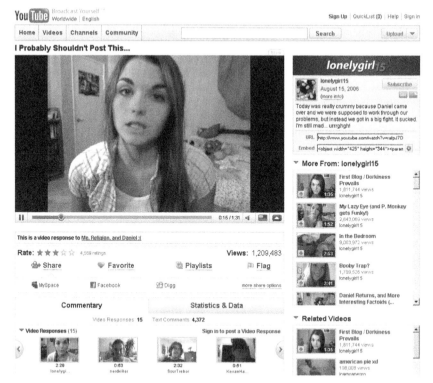

Screen capture from *lonelygirl15* video blog on YouTube. In the beginning, Bree's videos were a fabrication, fiction pretending to be real. Bree even replied to emails—or rather, the responses were written by Amanda Goodfried, not by Bree or her visual actress Jessica Rose. The fictional status of the blog was revealed in the fall of 2006.

we recognize turns out to be a fabrication. Distrust in the real world is echoed in conspiracy theories, which have also had a prominent role in popular entertainment during the last two decades. The gratification of conspiracy fiction is captured in the slogan of *The X-Files*: "I Want to Believe." As Jane McGonigal (2003b) discusses, playing along and pretending to believe is enjoyable. Since we do not know what the world is really like, we might as well indulge ourselves in thinking about what it might be like.

Projected Identity

One of the side effects of urbanization was the beginning of identity play. The high urban population density granted inhabitants a certain level of anonymity. This made it possible for an individual to present different aspects of herself as real in different cultural spheres; an option that was unavailable in the agrarian society. During the 1990s, the proliferation of the Internet allowed people an even greater freedom of identity.

In the physical world, the act of fabricating an identity was always a conscious and transgressive choice. On the Internet, the tables have been turned; anonymity, pseudonyms, and identity play are encouraged at every turn. In virtual worlds, instant messengers, chat rooms, IRC channels, social networks, and other Web sites relative anonymity is commonplace. Discussion boards, blog networks, and other forums are filled with heated debate conducted with pseudonyms. In dating ads, everyone presents themselves in a positive light, but at some point that becomes outright lying. Of course, there are also those who post fabricated ads just for kicks. Whole Web sites are also at times built for these desired identities, such as in the case of the *lonelygirl15* videos on YouTube, which were produced by a team and which were, in the beginning, perceived as real.

Another interesting case is *scambaiting*: pretending to be interested in and scammed by an email spammer's fraudulent scheme to see how far the scammer is prepared to go to finish her swindle. The activity emerged as a reply to the so-called 419 scams, which start with an unsolicited bulk email from an alleged third-world official promising millions of dollars. Down the line, one simply needs to provide a little advance fee for taxes, bribes, and other fees. Scambaiters pretend to play along in order to eat up the scammer's time, make them lose money, and fool them into sending embarrassing pictures of themselves, which the scambaiters then publish online.[10]

A peculiar and much more commonplace form of online identity play is performing the opposite gender. Gender swapping in virtual worlds dates back to the 1970s (Bartle, 2003). It is still common (Yee, 2003) and more and more accepted. Generally, tolerance toward playing with identity has increased; what Shelly Turkle (1995) once described as *misrepresenting oneself* is nowadays considered part of normal play. There are levels to the performances of personas: The avatar can be regarded as non-gendered even when its sex is clear. The gender (and the character or persona) can be role-played in the context of the virtual world. Finally, the *masqueraders* (Bartle, 2003) enjoy pretending to be *gamers* of the opposite sex. Similarly, some contexts and even styles of writing can be seen as more fictitious than others: Ludic virtual worlds are built for play, but political blogs are not. Yet the social bonds built in massively multiplayer online games are no less real than the ones built in serious discussion forums—and there certainly is enough performative posturing on political sites to merit the use of the term *playful*.

In the end, whether these personas are real or deliberately created performances ceases to be an issue, as participants in the communication realize that the personas they encounter are always fabricated to some extent. The general consciousness regarding roles that people play has increased—both in the sociological and in the theatrical meanings of "role" (see also De Zengotita, 2005). The development fosters reflectivity and self-awareness, and the proficiency in performance, as well as the sensitivity to fabrication, is increasing. Play with meanings and fluid identity are becoming ubiquitous in everyday life. Truth becomes an opinion, and, in a perverse twist, opinion becomes truth.

As we have learned to treat what we read and see as a performance, something located in the fabricated gray area between truth and fiction, we have learned that we can play the same game. It can be argued that in late modern society, identity has become almost like a toy we can play with, but this play is also a utilitarian activity. As we are faced with endless choice and unlimited optionality, the act of self-definition becomes not only challenging, but also universal. Each choice is a part of identity construction and maintenance. As the perception of self is tied to a cultural context,

understanding the constructed nature of identity leads to understanding that the cultural context is just as malleable. There is a continuous struggle to establish and reestablish hegemonic truths. Even though the effects of historical determinants such as race, gender, or ethnicity do not disappear from the social sphere, room for their symbolic (re)negotiation in media-saturated environments becomes larger.[11]

Struggle over Public Space

Just as truth has become something an individual must determine for herself, the usage of shared space has been challenged. The struggle over who determines what is acceptable in shared public space is becoming increasingly visible. The methods and reasons for appropriating public space for alternative uses are diversifying continuously.

The roots of the struggle lie deep in urbanization: In order for there to be public space, there must also be private space. Cultural norms and legal regulations determine the acceptable uses of public areas: Parks are for leisure, sidewalks are for traveling. All of these concepts assumed shapes that we today recognize as part of modernization.

There has always been some room to negotiate what constitutes accepted and tolerated activities in public space. Street theater and other forms of busking have been accepted, and begging is tolerated. Children have also historically been allowed to play in streets and backyards. Yet as public spaces have become more standardized, increasingly privatized, and subjected to constant surveillance, the range of accepted behavior has been shrinking. At the same time, disruptive challenges to hegemonic use have increased. There is already a history of alternative forms of travel in cityscapes from *skateboarding* and *roller skating* to *train surfing* and *parkour*. These forms are playful, athletic, and performative; the efficiency of moving from one place to another is not at the forefront. These activities also exhibit a tendency to become standardized, moving from paidia toward ludus on Caillois' continuum. *Skateboarding*, for example, which used to be a free and playful way of traveling and was later about trespassing empty backyard pools, has developed into a sport with skate parks, sponsors, and formal competitions.

Parkour is a more recent addition to this tradition. In it the performer–athlete, the *traceur*, travels through cityspace in the most direct and fluent way possible. She overcomes physical obstacles by adapting her movements to them. On the surface, the activity is all about efficiency: The traceur is supposed to get from start to finish via the most direct route and is supposed to do this as fast as possible and with the least effort. However, running over buildings and climbing fences are only rarely the fastest ways to travel through town. The traceur uses urban landscape as a found playground[12] (Feireiss, 2007).

The difference to the detached late 19th-century *flâneur*, who strolled through the city observing and gazing instead of engaging with it, is striking. The concept of the flâneur has been used to explain the relationship between the city and the city-dweller after modernization, but it has also been criticized thoroughly. It was used as a starting point for the Letterists and Situationists, who founded *psychogeography* in order to study "the precise laws and specific effects of the geographical environment, consciously organized or not, on the emotions and behavior of individuals" (Debord, 1955). The idea was to raise awareness regarding one's surroundings and encourage an empowering, playful connection to the city, and, as the surroundings influence a person, a combination

of psychology and geography was deemed needed. The detached flâneur was to be replaced with an active one, the aristocratic one with a political actor (Flanagan, 2007). The ultimate aim was to transform life into an exciting game, to put the Huizinganian play principle before work (Wollen, 2001).

Although born in the 1950s, psychogeography is still vital today. There are numerous festivals on the subject, and both artists and scholars work actively in the field. The easiest way to experience psychogeography is to go on an observational *drift*, to walk in the city in a new way. There are many ways to do this. One way is to take the map of one city and then follow it in another or draw a figure on a map and walk sticking to the line, in the fashion of *Abstract Tours*.

Urban exploration can be seen as extreme psychogeography. The explorer attempts to slip behind the scenes of a city, to see the backyards, tunnels, and warehouses. For her, every door and manhole cover is an invitation to an adventure. Explorers also infiltrate private areas, effectively questioning the concept of public space. Although the term usually means a place where anyone and everyone are welcome, as gathering places are increasingly owned and policed by private companies, some activists are also challenging these limitations and demanding that rules governing public spaces should be extended to semipublic or even private spaces.

The drifter or flâneur who moves through public space is not only gazing around herself, but is also the object of scrutiny. Moving through, or indeed standing still in public space, is a performative action. There is a long tradition of street performance, sometimes combined with begging, ranging from street musicians to jugglers, living statues, and puppet shows. The more obtrusive forms of street performance include message-heavy plays of guerrilla theater (Doyle, 2002) and invisible theater.[13]

Rather than taking participants to unexpected places, *flash mobs* alter the spaces that people move in. Flash mobs are advertised online, the participants gather at the determined meeting point, where the final destination is revealed, and then move en masse to the flash mob site. The target location can be any place that is open to the public: a public square, a shop, or the lobby of a hotel. The mobs can engage in all kinds of activities from dancing (*Whirling Dervishes*) to taking photographs with flashes (*flash flash mob*) and in all kinds of playful fighting from hitting each other with pillows (*pillow fight club*) to huge cream pie fights. Similar events are *silent raves* (people listening to the same sound file or radio station and dancing to it or following instructions) and *zombie walks* (zombies roaming the streets, assaulting and zombifying participants who pretend to be bystanders; see Figure 13.2).[14]

Although all of these activities are visually striking, their primary audience is made up of the participants themselves. The community built by the shared experience of transgression is important. Simultaneously, most of these events are documented carefully with photographs, videos, and blog posts. Thus, it cannot be said that these events do not produce anything: The video documentation spreads rapidly on the net, serving both as an advertisement of the activity and the people organizing them, but also as a way of bragging about the cool stunt that was pulled. Viral videos are in no way limited to flash mobs, but are common for many of the stunts listed in this chapter. For example, *train surfing*, riding on top of a train, has spread due to Internet video clips. Of course, transgressive videos were not born with the Internet; racing films showing cars driving recklessly through cities have been made at least since Claude Lelouch's 8-minute dash through Paris in *C'était un rendez-vous* in 1976.

FIGURE
13.2

Zombie walks **have been staged in countless cities around the world. Picture from** ***Zombie Walk Detroit,*** **staged in September 2007.**

Visual Arts in Concrete Jungle

Just as the streets can function as a stage, they also function as a canvas and a gallery. Since the 1970s, the *graffiti* movements have questioned who decides how an urban area is to be used, decorated, and developed and who gets to decide the correct usages. Should the people inhabiting an area, not just the owners, have a say in all this?

Although often branded as simple-minded vandalism, writing on walls has been a medium for political discourse for millennia, contemporary graffiti displays clear and established aesthetic styles, and a number of graffiti artists from Keith Haring (Sussman, 1997) to Banksy (Banksy, 2005; Bull, 2008) have started from street culture before being also accepted as high culture by being exhibited in galleries and museums (see Figure 13.3).

In response to the lack of tolerance toward graffiti, various softer approaches have sought to physically alter public space as well. *Knitta*, knitted graffiti, is one example. Instead of leaving permanent marks, these knitters tag lamp poles, railings, door handles, and other such places with warm and cozy pieces of knitwear.[15] In *reverse graffiti*, a text or an image is created by partially cleaning up a dirty surface; this activity runs the gamut from writing "wash me" with your finger on a filthy car window to creating complex murals on blackened walls with cleaning equipment. While removing a reverse graffiti may be as expensive as removing a regular graffiti, the practice places a dilemma on the legislation as well: Is it forbidden to *clean* a picture on a wall you do not own? *Guerrilla gardening* also asks the same questions as *graffiti* and seeks to transform urban space for a longer time than just for the duration of an event. It is meant to reclaim public space for the public good using plants (Tracey 2007)—basically replacing wall paintings with botany.

FIGURE
13.3

Banksy's works are often political and contextual. This piece was painted in London in 2008, but lasted only a few months before being painted over. In *Banging Your Head Against a Brick Wall*, Banksy (2001) writes: "Bus stops are far more interesting and useful places to have art than in museums. Graffiti has more chance of meaning something or changing stuff than anything indoors. Graffiti has been used to start revolutions, stop wars and generally is the voice of people who aren't listened to. Graffiti is one of the few tools you have if you have almost nothing. And even if you don't come up with a picture to cure the world poverty you can make someone smile while they're having a piss."[16]

Similar to graffiti in their confrontational politics are the Reclaim the Streets movement and *squatting*. However, both of these have become institutionalized in their own ways. Street parties, where a part of a road is invaded without permission and claimed for partying, and Critical Mass events, where a huge number of bicyclists replace cars on streets and cycle with little regard for traffic laws and stopping other traffic, have become new tools in the demonstrators' arsenal, next to marching, sit-ins, and civic disobedience. *Squatting*, the act of occupying an abandoned or otherwise empty space without permission, is common, particularly in poorer urban areas. It is illegal, but has occasionally brought real change, as it is condoned retroactively by the general public or local government.

The constant and increasing drive to renegotiate accepted and tolerated uses of public space (or indeed what space is to be considered public) is a struggle to wrestle the defining power from the hegemony to the countercultural movements and the individual. Although these activities are political, practical, artistic, and performative in nature, playful activities are the central tool and, at times, even the aim of many of these movements.

Rise of Ludus in Society

There is a third, more recent trend that has paved the way for pervasive games: The general rise in ludic activities in society. Although the roots of this trend can be tracked to the 1960s, it was the emergence of digital games in the 1970s and their mainstream success a decade later that kicked off the trend. The generations that grew up with computer and console games have never really stopped playing. The social stigma of adult play is diminishing while the economical significance of digital games continues to increase. One can argue that this has created a generation that has the gaming impulse permanently ingrained.

Proponents of gamer generations argue that enhanced abilities in problem solving, multitasking, and increased reliance on one's own initiative as key features set these young people apart from earlier generations. Possible downsides of suggested cognitive changes include shortened attention spans and increased impatience toward slow, deliberative modes of engagement (Beck & Wade, 2004; Gee, 2003; Prensky, 2001). A key element that all these authors agree upon is the rise of a playful, trial-and-error-based attitude among the gamer generations.

The increasing popularity and economic significance of digital games have given a boost to other forms of gaming. The design space for games has grown; activities that used to be categorized as paideic have started to be regarded as increasingly ludic. The concept of "game" is evolving: Just as work and leisure or public and private, game is also a cultural concept prone to change over time.[17]

Examples of this shift abound. The combination of ludic war games and paideic storytelling leads to role-playing games. Similarly, computer games are a mix of rigid ludic structures and storytelling or simulation. Even performative activities that clearly lack a winning condition, such as singing, dancing, and playing instruments, have been formalized into ludic activities in games such as *Singstar*, *Dance Dance Revolution*, and *Rock Band*. Nowadays, these activities can be won and lost, even though many participants find victory, defeat, and the score inconsequential. Even so, the applications are considered games.

The same applies to persistent online worlds such as *World of Warcraft* and *EVE Online*, where play goes on perpetually with no winning or losing in sight. There are temporary victories and setbacks, and the players do measure success in various ways, but there is no permanent closure. These online worlds are also called games, even if they are more like environments where play occurs. This is underlined by the fact that for many players social interactions and intercharacter role-play are among the most important reasons for play. Yet neither is coded into the game engine, and there are not even any strict rules of conduct. It is easy, and commonplace, to appropriate the virtual worlds for activities that they were not designed for originally.

People play in other activities, too, not just those that are recognized as games. The ludic attitude, the mindset and logic that we use to play games, is employed in ordinary life as well. Contemporary keywords for industrial leaders nowadays include *the experience economy*, where "work is theater and every business a stage" (Pine & Gilmore, 1999). The field of economics is generally moving toward a more playful structure: In quartile economics, the value of a company is measured in the stock market by the minute based on future expectations, analyst reports, and gossip. Fundamental use value has been replaced: The new economics is based on image and performance and should

be analyzed with semiotics or iconography (Sternberg, 1999). It can even be argued that the only way to make sense of the stock market is to view it as a game.

There are countercurrents as well, of course. Johan Huizinga (1938) described play as an activity that yields no material profit, which does not hold true for all games today. Perhaps it never did, but in contemporary society it is increasingly easy to make a living by playing. Professional sports are a big business, not just in traditional physical activities, such as *baseball* and *basketball*, but all kinds of digital e-sports are emerging. Gambling has been institutionalized in many places, and online *poker* in particular has made this an accessible way to at least try to earn money. *Gold farming*, the practice of playing in an online world in order to create virtual currency or goods and then selling them to other players, is common in most online worlds, even though it is usually forbidden. The various people who engage in these activities, whether they are superstar e-athletes with huge salaries or teenagers earning real money in virtual environments, cannot claim to pretend that the games they play are any less real than ordinary life. These are examples of how ordinary everyday life is appropriating games.

It should be emphasized that ludic society does not mean the same thing as the dominance of entertainment as a way of life. The latter trend has long been the focus of criticism by thinkers such as Neil Postman, who has written numerous books about the dangers of entertainment mixing and confounding serious issues, particularly through the rise of television as the dominant medium (see, e.g., Postman, 1982, 1985, 1993). The critics argue that the passive reception of entertainment does not help in creating active individuals and critical citizens. However, what these critics often overlook is the increasingly active nature of involvement with media culture that has begun to alter the character of media, including television. Henry Jenkins has analyzed this development under the concept of *convergence culture*: Increasingly media-savvy consumers are turning into participants and creators of their own knowledge communities (Jenkins, 2006). Taken seriously, the playful mentality of gamer generations holds the potential to change society to an even greater degree. A society informed by the spirit of play and games may lead to collective reconsideration of life's priorities and the development of a new kind of ethic in organizing the relationship of work and other areas of life (cf. Himanen, 2001; Kane, 2005).

The Playful and the Serious

In the contexts of these three cultural trends we have discussed countless playful activities in an attempt to paint a bigger picture and to position pervasive games in a wider media cultural environment (see Figure 13.4). Play is brought to ordinary spaces, times, and social situations in a multitude of ways that all relate to pervasive games.

To understand this fully we need to first distinguish between *playful* and *ordinary contexts* of activities. As Huizinga (1938) describes in his study of play, clearly visible borders often surround the magic circle: The clearest form of demarcating a playground is building a fence around it, as is often done. The temporal border of the playful context is equally often represented by the everyday rituals commencing the play, ranging from the shuffling and dealing of cards to switching on a game console. Such contexts are always socially constructed, sometimes explicitly, sometimes through metacommunication (Bateson, 1955; see Chapter One). As playful contexts can be physical or temporal, they are sometimes

FIGURE
13.4

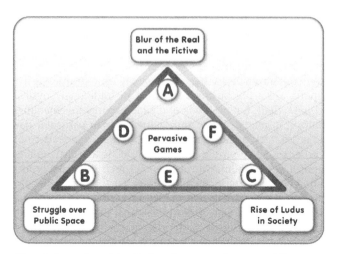

Blur of the real and the fictive, the struggle over public space, and the rise of ludus in society are all manifest in pervasive games. While not shown in the illustration, this development has been catalyzed by advances in communication technologies. Other related phenomena: (A) *Blair Witch Project,* **(B)** *graffiti* **movement, (C)** *Dance Dance Revolution,* **(D)** *zombie walks,* **(E) competitive** *skateboarding,* **and (F)** *Big Brother.*

permanent structures that can be entered (sandbox) and sometimes temporary structures that can be erected (setting up a board game).

The possibility of engaging in pervasive gaming is rooted in fundamental social and psychological aspects of our being. The frame analysis of sociologist Erving Goffman (1974) offers a more refined way of approaching the interplay between playful and ordinary social context. Partially inspired by Bateson's metacommunication, he talks about keys and keying:

> [T]he set of convention by which a given activity, one already meaningful in terms of some primary framework, is transformed into something patterned on this activity but seen by the participants to be something quite else. The process of transcription can be called keying. A rough musical analogy is intended. (Goffman, 1974)

Goffman generalizes Bateson's idea and builds upon it. His primary framework is the natural or social frame that is perceived as the ultimate serious context for actions. A queen overtaking a pawn in a game of chess would be perceived in the primary framework as a removal of a piece from the board and it being replaced by another piece from the same board performed by an entity. Keying of these actions "performs a crucial role in determining what it is we think is really going on" (Goffman, 1974).

Keying is not limited to play and games, although that was where Goffman started. Make-believe, contests, ceremonials, technical redoings (such as simulations), and regroupings (e.g., doing things for uncommon reasons, such as a politician working at a soup kitchen before an election) are all based on keying. Furthermore, it is possible to rekey an already keyed activity—and keying is not the only way to transform an activity.

FIGURE
13.5

These two images from Danish larp *System Danmarc 2* illustrate overlapping magic circles. In the image on the left, the border of the nonpervasive game is visible; the cyberpunk village built in the center of town is separated from the rest of the city (although some passersby did toss a bicycle over the fence into the game area, hitting a player on the inside). Within the larp, some players participated in boxing matches within a boxing ring. That magic circle is shown in the image on the right.

Fabrication, "the intentional effort of one or more individuals to manage activity so that a party of one or more others will be induced to have a false belief about what is going on" (Goffman, 1974), is also possible.

There are multiple frames present in a given situation, and it is possible to shift between these. Complex games feature numerous frames. Many games have multiple overlapping magic circles (think of players on a basketball field, players waiting on the bench, ancillary functions such as cheerleaders, and the chanting audience with painted faces; see Figure 13.5), and these can all be seen as frames (just like play time and time-out time are separate, differently keyed frames). The rules of a game also have different levels of forbidden actions, and sometimes it is possible to even play the rules instead of the game (if you get away with doping you get an edge; if you get caught, you can try 4 years later). A player of a pervasive game often has to negotiate the ludic frames as well as the frames of ordinary life.

Shifting between frames is called in Goffman's terminology *upkeying*, movement away from the primary framework, and *downkeying*, movement toward the real. Shifting the focus between ludic and ordinary changes the frame, but also looking at the same event from the point of view of an individual, the community (of, say, players), and the society may require a keying. Interestingly, the choice of point of view can also change something that appears as downkeying into upkeying. For example, a player who gets so excited about the game that she momentarily is not actively aware of the ludic nature of the events is experiencing downkeying (the game is now real), whereas in the primary framework she is upkeying (moving further into the ludic frame).

The problem is that in the context of frame analysis we need to make a choice between the experience of the player and the primary framework. Looking at play only from the outside is ultimately a dead end, as finding out "what is really going on" obfuscates the experiences and personal motivations of the participants.

This brings us to the second necessary distinction. In addition to differentiating between the different contexts, we need to differentiate between the mentalities of an

FIGURE
13.6

A division into playful and serious activities does not suffice when actor mindsets contradict the cultural context. Two new categories emerge: Instrumental play is utilized for external purpose, while pervasive play is taken into the context of ordinary life.

activity. Here we are guided by reversal theory and the work of psychologist Michael J. Apter (1991). He separates activities into broad categories based on the mindset: Whether a task is performed in a *playful mindset* or a *serious mindset* (see Chapter Five).[18] While serious activities are undertaken in order to reach an external goal, playful activities are their own purpose, as the activity is rewarding in itself. Thus, all forms of entertainment ranging from playing mobile phone games to singing drinking songs imply a playful mindset, whereas obligatory chores ranging from working to traveling imply a serious mindset.

Like Goffman's frames and a look from the outside, Apter's mindsets are an equally insufficient way of understanding these new forms of play. A look from the inside is dependent on intention, and thus it is impossible to catch a moment of playfulness and inspect it. In the end, who can tell if a professional athlete is having a playful or a serious experience at a given time or how many times she changes her stance during the game. It is, after all, much easier to experience playfulness while winning an important match than when trying to endure another hour of hopeless struggle against insurmountable odds.

Pervasive games are about both Apterian inner processes and Goffmanian social frames, often toying with the contradiction of these two. Utilizing the distinctions of mindsets and contexts,[19] we can construct four categories showing how different activities fit into a bigger picture (see Figure 13.6).

Ordinary life. The simplest and most straightforward category is that of ordinary, everyday life. While engaged in this activity, a serious mindset is employed in an ordinary context. Work done in the workplace is a clear example of a goal-oriented pursuit taking place outside the magic circle. Cleaning up at home, shopping for groceries, and commuting to work are other examples.

Classic play. The opposite of ordinary life is classic play. This is the activity where a playful mindset is used in a playful context: Playing *basketball* or *Monopoly* are typical examples. As our definition of a playful mindset is very broad, going to a rock concert and watching a movie fit in here as well. Classic play and ordinary life are the two modes that exist on each side of the Huizinganian magic circle. In the context of this book, the contradictory categories are more interesting.

Pervasive play. Most of the activities discussed in this book fall into the category of pervasive play. When a playful mindset is used in an ordinary context we find ourselves discussing not only pervasive games, but also all kinds of pervasive paideic activities.

Bringing play to city streets, daily routines, and social environments is exactly what pervasive gaming is about. This is also where the street culture factors in, lending its influence to pervasive games. *Parkour, graffiti, train surfing, buildering*, and all sorts of transgressive forms of entertainment are obvious examples of pervasive play.

Instrumental play. In pervasive play, ordinary contexts are appropriated for playful activities. When the opposite happens and ordinary life—work most often—takes over a playful setting, we are faced with instrumental play. Examples of using a serious mindset in a playful context include activities where the context of play is utilized for an external purpose: Professional sports and professional gambling are examples of bringing serious attitudes to ludic structures. While a *golf* star might also enjoy winning a round, she is also motivated by wealth, fame, ambition, and so on. *Gold farming* (see, e.g., Dibbell, 2007; Steinkuehler, 2006) is another topical example. Simulations, especially longer ones such as crisis management exercises used by militaries and rescue workers, also often fall into this category as they use the form of play for very serious activities.[20]

Practices in the transgressive categories are hardly left unnoticed by society. In an interesting manner, both pervasive play and instrumental play suffer from societal resistance. *Gold farming* is opposed by online game players and operators, *graffiti* by property owners and city officials, and *train surfing* by people who want to coerce train surfers to not risk their lives. During the previous decades, many activities have been liberated: Professional athletes have been allowed in Olympic Games since the 1970s and the rise of Internet *poker* has liberated *gambling* in many parts of the world. Others have been constrained: The *Mario Question Blocks* performance in Ravenna suffered from the so-called War on Terror, whereas *Killer* games have suffered from the various school shootings in the United States (see Chapter Ten).

Fabrication and Pretence

The distinction between serious and playful mindsets and contexts made previously is not sufficient for understanding the entire ecosystem: It omits the constantly growing phenomena of *fabrication* and *pretence*, which exist in the gray borders of playfulness.[21] In the asymmetric cases of *fabricated context* and *pretending mindset* one party is oblivious to the playfulness of the situation: *Candid Camera* is the prime example, where a person is put into a situation without metacommunicating its artificiality. Intentional secrecy and misrepresentation are the building blocks of such experiences, which can be aimed to please either the unaware participant or an outside audience. While *Candid Camera* aims to please the television audience, *lonelygirl15* serves as an example of using fabrication in order to please the fooled subject.

Expanding earlier categorization with fabricated context and pretending mindset teases out a more complex image, one that is more accommodating toward the diverse forms of pervasive media expression (Figure 13.7). We have refrained from coining new terms for each of these categories.

A pretending mindset in a playful context is a typical case faced by participants in reality television. While people are filmed in the *Big Brother* house or on a *Survivor* island in order to capture the genuine behavior of normal people facing real challenges, the truth is completely inverse: The participants enter a playful context, where they perform for the cameras and each other, while pretending not to perform.

FIGURE
13.7

	Playful Mindset	Pretending Mindset	Serious Mindset
Playful Context	Classic play	Participants of Big Brother, doped-up professional athletes	Instrumental play
Fabricated Context	Playful investigators of lonelygirl15, witnesses to flash mobs	Scambaiters, scambaited scammers, show wrestling, playing the stock market	Targets of Candid Camera, Vem gråter or surprise parties
Ordinary Context	Pervasive play	Candid Camera actors, political spin doctors, PR agencies	Ordinary life

Pretence and fabrication lead to asymmetrical play situations, where some participants do not understand their full context. The middle square is almost like a spy movie, where participants pretend to believe each other's fabrications in order to succeed in a counterscam.

A playful mindset in a fabricated context is perhaps most uncommon of the five gray areas. It happens when people correctly suspect fabrication and decide to engage with it in a playful fashion. People who suspected that *lonelygirl15* was a fabrication and sought to prove it for fun encountered this category. Players encounter this category especially when fake cancellations and rabbit holes are used in order to provide players with an engaging entry to the game (*The Majestic, Momentum, The Beast*).

A pretending mindset in a fabricated context is the ultimate gray area, where two people are trying to fool each other. This happens when a scambaiter receives a scam email and starts to toy with the scammer: Both parties lie to each other with different goals. The scammer wants to rob her perceived victim, while the scambaiter wants to see how far she can push the scammer.

A serious mindset in a fabricated context is what generally happens in unaware participation. *Candid Camera, Momentum,* and *Vem gråter* all put bystanders into this state of unaware participation. While there are ethical issues particular to all transgressive categories, the ones related to this category are so common and serious that they were central in our ethical discussion (Chapter Ten).

A pretending mindset in an ordinary context is the category of all sorts of misrepresentation in ordinary life. The wide range of phenomena includes everything from political spin and image building to masquerading on the Internet. In pervasive media culture, game operators often position themselves here: An actor playing in a *Candid Camera* scene pretends in an ordinary context.

As we see, pretence and fabrication are linked phenomena: Usually one party pretends and, through misrepresentation and false metacommunication, creates a fabricated

FIGURE
13.8

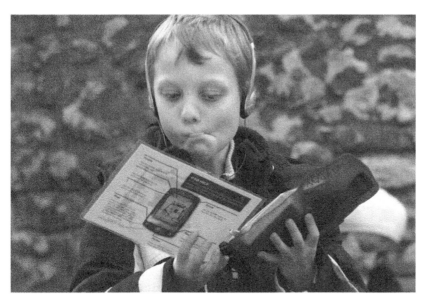

Navigating the intricacies of contemporary media culture requires numerous skills pervasive games can help teach. Picture from the pervasive game *Prisoner Escape from the Tower*, where players are supposed to smuggle virtual escapees past the real Beefeaters.

context for another. This asymmetry in information also creates an asymmetry in power and control. The person within the fabricated context cannot break out of the situation easily, while the person behind the pretence can alter or break the fabrication with ease.[22]

Pervasive Games in Ludic Society

Pervasive games break the magic circle of play. They transgress on tradition and blur the spatial, temporal, and social contexts that have limited games. But they also shatter the boundary between serious and ludic mindsets, and the compartmentalization between people in playful and serious mindsets. They thrive in the area between fact and fiction, being fertilized by uncertainly and ambiguity. They challenge societal norms and codes relating to behavior, especially in regards to what is acceptable in a public space. Finally, in this process they bring the thrill of immediacy and tangibility of ordinary life to games and the pleasure of game to ordinary life.

Navigating this complicated terrain is an acquired skill. For example, both the pretender and the target of fabrication engage in a delicate contest over control and understanding of the situation. It takes a new kind of literacy to enable one to read the nuances and symbols involved in fabrications (see Figure 13.8). Recognizing a 419 scam, a rabbit hole, or an Internet masquerader requires deep understanding of one's cultural environment.

Christy Dena discusses the demands of alternate reality gaming literacy as follows:

> *Establishing what is in-game in an ARG—what is within what historian Johan Huizinga (1950) originally described as the 'magic-circle' (within the game space)—requires specific skills such as discourse analysis; checking for in-game referrals; observing the number of links to and from other sites; Who Is will discern the date the website domain was registered and who the website was registered by; checking the depth in the site archives. This takes time, and so there are many sites that are not part of the game that are considered and analyzed for plot relevance. Discussion about, and lists of, sites deemed 'OOG' (out-of-game) are therefore essential for experiencing what the [puppet masters] intended, and for sanity. (Dena, 2008)*

This literacy also works in a collective process:

> *What is also worth noting is the role ARG players play in providing fictional cues. [Puppet masters] embed the fictional world shoulder to shoulder with real-life artifacts and remove cues to fictionality. With their extensive lists, ARG players put the cues back in to define the 'magic-circle,' the realm of gameplay. Player-production is the frame. (Dena, 2008a)*

While most scam letters are easy to spot, finding a rabbit hole takes both luck and skill. Communities playing pervasive games, especially alternate reality games, collaborate in order to ease this process. Pervasive gaming literacy is not only personal, it is also communal.

Successful pervasive gamers must be able to shift through all the aforementioned nine categories rapidly and easily. Different games try to confuse players in different ways, using their particular variety of zones to do so.

Killer players keep moving between serious and pretending mindsets, depending on whether they are actively seeking to conduct a murder or performing their everyday tasks. They stick to the ordinary context until lured into fabrication. Players equipped with sufficient paranoia and *Killer* literacy can even take the game to the middle zone: Noticing a murderer allows the player to play along in order to surprise their would-be assassin.[23]

In *Momentum* the players both created and were subjected to *invisible theater*. In the merge of life and game, the larpers sometimes performed *invisible theater* to outsiders, often experienced it from game masters, and were very often uncertain of which of these cases were true. However, the game also featured the two-edged sword of living a double life: While double life allows the game to enter one's everyday life, it also allows everyday life to enter one's playing.

Epidemic Menace provided diegetic roles and simulated a mission in an area where bystanders could observe the play. *The Beast* pretended to pretend to be real so that the players could pretend the game was real as well. For many pervasive games, the question of what is ludic and what is ordinary is one of the central questions. In *Shelby Logan's Run* and *Mystery on Fifth Avenue* one could not always know where the signal of the puzzle ended and the noise of the real started. In *Vem gråter* even the question of whether there is a game at all was relevant.

Playing games such as *BotFighters*, *PacManhattan*, and *Insectopia* intensely forces the player to confront her limits. What is she prepared to do in a public space? *Uncle Roy All*

Around You and *REXplore*r can do the same, but in addition they weave together strands of history and inventive storytelling and parade the city from a foreign point of view. In *The Amazing Race* it is not just the city that is a playground, but the whole world. The line between actual and performed is a mere line in the sand. One can even go so far as to claim that whole cultures are reduced to puzzles to be solved and toys to be played with in a game that, for the duration of the experience, becomes life for the participants.

The literacy that pervasive games require and foster is not only relevant when playing. The blurring of boundaries has gone so far that the same skills that one uses in the games profiled in this book are relevant in ordinary life. A person who once participated in an alternate reality game is likely to spot rabbit holes and spoofs, and to check them up on the Internet whenever she feels ambiguous about whether she is involved in a game or not. For reading news, watching advertisements, taking a walk in the park, surfing social networking sites, and even everyday face-to-face interactions are but stages where playing takes place. We are all players in a ludic society.

Toward a Pervasive Gaming Culture

If the three trends identified in this chapter continue to grow stronger, media culture—and indeed the world—will become a different place. As the ludic structures of gaming pervade ordinary life, we no longer require technical aids, or indeed games, to play. Traveling through the city can already be an adventure, as can collecting friends, spotting hidden messages in the cityscape, or mastering the secret spaces of one's home neighborhood. In a way, as pervasive elements spread and infect ordinary activities, an element of playfulness becomes incorporated in ordinary life. Pervasive play becomes a pair of interpretative spectacles through which we can choose to view the world. In this world any action could be framed as ludic, just as a child might make walking more fun by inventing a rule that she is not allowed to step on cracks in the pavement. Play becomes an attitude to life.

Conversely, if the struggle for public space becomes increasingly visible to reach a critical point, it may change the way pervasive games can be played. So far most of the actions used in reclaiming space have had their roots in playfulness. If this were to change, it would have a serious repercussion on how the struggle is perceived and on the tolerance for appropriative play in public space. There are already spaces where any kind of deviant or transgressive behavior is interpreted as dangerous and threatening.

The ambiguity between game and life is a defining characteristic of pervasive games, but it is difficult for these games to achieve mainstream appeal unless the borderline is disambiguated enough for players to feel safe, comfortable, and oriented in a pervasive experience (Stewart, 2008). Players need to develop a new kind of media and gaming literacy. The increased blurring of the real and the fictive in media culture in general also places ever greater demands on literacy. However, as alternate reality games, reality television shows, and all kinds of hoaxes, mockumentaries, and spin become more widespread, the player–spectator has to be both observant and skilled at understanding what it is that she is witnessing or taking part in. It is also possible that as the real and fictive blur, they will finally merge. In a fragmented world, truth is also fragmented. Already, Web communities emerge fast and die out fast, and no one is able to understand all the memes being propagated over the Internet.

It also becomes harder to surprise or shock the audience. The demands for increasingly extreme experiences—or at least experiences that seem extreme today—are growing. In the age of reality television and shock videos that spread on the Internet, there is growing longing for something real, some sort of immediacy. In a perverted way, pervasive games can offer tangible and real experiences.

Of course, we cannot be sure that all, or indeed any, of these trends will continue to strengthen. Still, pervasive games may have emerged in the form that we have identified in this book due to favorable alignment of the three cultural trends, but it remains to be seen what kind of foothold they will have as the environment that birthed them evolves into something else. We believe that the position of games as mainstream culture will grow stronger as the gamer generations grow older. Just like the gamer generations did not stop playing when they grew up, they will not stop playing when they are put in old folks' homes. In fact, in all likelihood they will play more: Virtual life, both single and multiplayer, offers a substitute for perpetual youthfulness.

The further development of information technologies will continue to open up the design space of pervasive games and catalyze further forms of pervasive gaming. However, the future of pervasive games remains open. If the boundaries around traditional play continue to blur and break, and numerous more activities continue to incorporate pervasive elements, a separate category of pervasive games may lose relevance soon after it has been defined.

Classic games will not disappear, but pervasive features will become a de facto part of new games, or at least gaming platforms. Each gaming console generation has had more connectivity and more controllers; as a result they are less and less separated from other activities. At the same time the number of mobile devices that people carry everywhere with them is increasing; all of those devices can be and indeed have been used for playing.

Arnold Pacey (1985), a historian of technology, identifies three aspects of technology: technical, social, and organizational. Whereas the technical aspect only deals with the dimension of technology that makes things physically work or not, social and organizational aspects are related to the way we actually make use of our machines and how those practices are combined with the values, norms, and other structures of society.

The enculturation of digital information and communication technologies has just started, and within the emerging practices like those of pervasive gaming we might just be seeing the first steps of a new kind of culture being created through the human use of these new tools rather than just humans blindly accepting the uses these technocratic systems impose on them.

This progression will require further pervasive media and digital literacy from members of society, both gamers and nongamers. Fortunately, demand also produces supply, as navigating in an increasingly complex environment is the natural way of learning. Yet the division between the (media) literate and the illiterate will continue to grow.

One way to view pervasive games, and their sudden emergence in the past 10 years, is to see them as a societal response to the need for advanced media literacy. Play has always had an enculturing function, and pervasive games teach players media literacy skills that are vital in coping with the demands of the converging media culture. As long as these kinds of skills are required, pervasive games will be available as one appropriate field of expression and response to the increasingly mediated and complex surrounding social realities.

Notes

1. This chapter builds upon Stenros et al. (2007a).
2. The history of the term *fiction* would be an interesting digression. When did such an ontological category emerge? *The Oxford English Dictionary* traces the contemporary use of the concept to the 17th century, to the writings of scholars such as Bacon, Hobbes, and later to Shaftesbury.
3. October 31, 1938. The subheading reads: "Many Flee Homes to Escape 'Gas Raid From Mars'—Phone Calls Swamp Police at Broadcast of Wells Fantasy." While *The New York Times* may have exaggerated the scope of the panic, the headlines are illustrative of the attitudes prevalent at the time.
4. See Chapter Ten on the very similar reception of the *Sanningen om Marika* ARG 70 years later.
5. Some reality shows recruit celebrities rather than ordinary people. The appeal of these shows is similar to that of gossip magazines, another well-established form of blurring between fact and fiction. Ironically, many of these are people made well known through their participation in earlier reality shows.
6. Originally *Expedition: Robinson* (1997) in Sweden.
7. Originally *Pop Idol* (2001) in the United Kingdom.
8. Joshua Davis of *Wired* covered *lonelygirl15* in "The Secret World of Lonelygirl" in December 2006. www.wired.com/wired/archive/14.12/lonelygirl.html.
9. Laia Salla of *The Beast* did not face this challenge, as her writers were protected by the anonymity of the Internet—an important design consideration when lending one's likeness to a simulacrum.
10. For example the Web site www.419eater.com is devoted to documenting the email exchanges and embarrassing trophy pictures, as well as discussion and tips on the practice of *scambaiting*.
11. On this, see, for example, Lisa Nagamura's (2002, 2008) work.
12. The difference between *parkour* and *freerunning* is that in the latter the traceur also performs flashy moves.
13. Sacha Baron Cohen's comedy film *Borat: Cultural Learnings of America for Make Benefit Glorious Nation of Kazakhstan* (2006), with its clear political messages, is an interesting combination of *Candid Camera* with the techniques of *invisible theater*. Also, Cohen's character Borat Sagdiyev is another example of a hyperreal simulacrum.
14. *Carrot mobs* combine flash mobs with an environmentalist message; the organizers of these events challenge businesses to earmark a certain percentage of their income to a set cause (such as eco-friendly improvements like switching to energy conservation light bulbs), and the mob then goes shopping in the place that promised the largest donation. (See, e.g., Chris Smith's story "Ready? Set. Shop." in *San Francisco Online* in June 2008. www.sanfranmag.com/story/ready-set-shop-0.)
15. Knitta has been covered in numerous newspaper articles. See, for example, a piece in *The Stranger* (August 1, 2006) by Kurt B. Reighley: "Daylight Broads: Knitta Breaks the Laws of Breaking the Law." www.thestranger.com/seattle/Content?oid = 45208, ref. September 24, 2008.
16. Image cited from www.banksy.co.uk.
17. See also Juul (2003), who claims that the era of classic games lasted until the 1960s, at which point games started to diverge. Juul implies that, since then, games have changed in ways that no longer always fit his definition of a classic game.
18. Playful mindset and serious mindset are our terms; Apter discusses them as *telic* and *paratelic* mindsets. Similarly, Katie Salen and Eric Zimmerman (2004) discuss games as *autotelic* activities since their goal (*telos*) is self-contained.
19. These social contexts are Goffmanian frames, but we call them contexts to differentiate them from other relevant frames of interaction. An assassin murders her victim within a *Killer* frame, but the game frame is situated within a broader frame—social context—of everyday life.
20. Note that educational games and other serious games do not fit easily into a single category. The goal of the designers of these games is often that the player would be in a playful mindset in a playful setting and would learn effortlessly. However, often the games—or the situations where playing takes place—are tedious or the act of playing is made obligatory. Thus, educational games can be situated in any area as they even fall into the category of ordinary life.

21. Fabrication and pretence cover only one aspect of the gray area between playful and serious. While there are others, this dimension is the most interesting one for the purposes of this book.

22. In reality television this is *in addition* to the considerable use of power in postproduction. The producers of *The Amazing Race* create and control the scenes as they happen, but they also get to pick, choose, and contextualize all the footage afterward.

23. In fact, the entire plot of *La decima vittima* (1965) revolves around such a situation.

References

In a book discussing the converging media culture, it would be pointless to draw a line in the sand among games, films, books, and pieces of art. Thus, all creative works and media products are listed under one heading. Academic references are listed in the bibliography after the list of creative works. We have not listed traditional games and folk activities such as *I Ching, boxing*, and *tag*. Stories in magazines and newspapers are usually listed in chapter endnotes.

All Internet references were confirmed on January 5, 2009.

Creative Works

9-11 Survivor (2003). Jeff Cole, Mike Caloud, and John Brennon. A mod for *Unreal Tournament*. www .selectparks.net/911survivor

A.I.: Artificial Intelligence (2001). Film directed by Steven Spielberg.

Abstract Tours (1997). Laura Ruggeri, Berlin. www.spacing.org/abstract.html

AIBO (1999–2006). Robotic pet, several versions. Sony.

Alias (2001–2006). Television series created by J. J. Abrams. ABC.

Alias Online Adventure (2001–2002). ABC. A.k.a. "Alias Web Puzzle," "Alias Web Game." First season in 2001–2002, second in 2002. http://abc.go.com/primetime/alias/adv.html

Alice's Adventures in Wonderland (1865). Novel by Lewis Carroll. Written under pseudonym by Charles Lutwidge Dodgson. Also known as *Alice in Wonderland*.

Amazing Race, The (2001–). Reality television show created by Elise Doganieri and Bertram van Munster and produced by Jerry Bruckheimer Television.

America's Army (2002). U.S. Army. www.americasarmy.com

American Idol (2002–). Reality television show produced by Fremantle Media and others. Based on British *Pop Idol*.

Animal Crossing (2001). Nintendo. www.animal-crossing.com

Apprentice, The (2004–). Reality television show produced by Trump Productions LLC and others.

Ars Magica (1987). Jonathan Tweet and Mark Rein-Hagen. Lion Rampant Games. Various editions.

Art of the H3ist, The (2005). McKinney and Audi. A.k.a. "Stolen A3." www.mckinney-silver .com/A3_H3ist

Backseat Gaming (2001–2002). Liselott Brunnberg et al. The Interactive Institute. www.tii.se/mobility/ Backseat/backseatgamesBSG.htm

BARF V: Mission Impossible (1990). Ric Simmons, Ron Kesing, and James Porter. San Francisco.

baseball Various versions. Unknown origins, possibly designed by Abner Doubleday in 1839.

basketball Various versions, originally developed by James Naismith in 1891.

Beast, The (2001). Jordan Weisman, Elan Lee, Sean Stewart, and others. Microsoft. A.k.a. "The A.I. Web Game," "The A.I. Web Puzzle."

Big Brother (2000–). Reality television show produced by Evolution Film & Tape. Original Dutch version produced by John de Mol Produkties.

Big Urban Game (2003). Nick Fortugno, Frank Lantz, and Katie Salen. University of Minnesota Design Institute, USA. A.k.a. "B.U.G." http://design.umn.edu/go/project/TCDC03.2.BUG

Blair Witch Project, The (1999). Film directed by Daniel Myrick and Eduardo Sánchez.

Borat: Cultural Learnings of America for Make Benefit Glorious Nation of Kazakhstan (2006). Film directed by Larry Charles.

BotFighters (2001, 2005). It's Alive, Sweden. *BotFighters 2* released in 2005.

C.S.I.: Crime Scene Investigation (2000–). Television series created by Anthony E. Zuiker. CBS.

Can You See Me Now? (2001–2005). Blast Theory & University of Nottingham Mixed Reality Lab.

Candid Camera (1948–1950). Reality television show created by Allen Funt.

Candid Microphone (1947). Radio show created by Allen Funt.

Capricorn One (1978). Film directed by Peter Hyams.

Carolus Rex (1999). Martin Ericsson, Karim Muammar, Henrik Summanen, Thomas Walsh, Emma Wieslander, and others. Sweden.

CarrotMob (2008). Brent Schulkin.

Cathy's Book: If Found Call (650) 266-8233 (2006). Sean Stewart and Jordan Weisman. www.cathysbook.com

C'était un rendez-vous (1976). Short film by Claude Lelouch. Eng. "It Was a Date."

Chasing the Wish (2003). Dave Szulborski. www.chasingthewish.net

Choose Your Own Adventure (1979–). Various books, first one written (and original concept) by Edward Packard. First published by Bantam Books, later by Chooseco.

Citizen Kane (1941). Film directed by Orson Welles.

Cluedo (1949). Anthony E. Pratt. Waddingtons. Numerous editions. A.k.a. *Clue*.

Colossal Cave Adventure (1976). Will Crowther. A better known version in 1977 with Don Woods.

Command & Conquer (1995). Westwood Studios. Published by Electronic Arts.

ConQwest (2004–2005). area/code, USA.

Coup (2006). Nokia Research Center and University of Tampere. IPerG Prototype.

Cruel 2 B Kind (2006). Jane McGonigal and Ian Bogost, USA. www.cruelgame.com

Da Vinci Code (2003). Novel by Dan Brown.

Dance Dance Revolution (1998–). Also known as *DDR* and *Dancing Stage*. Konami.

Day of the Figurines (2005, 2006). Blast Theory and University of Nottingham Mixed Reality Lab. IPerG prototype.

Desert Rain (1999). Blast Theory.

Dogtowns and Z-Boys (2001). Film directed by Stacy Peralta.

Dragonbane (2006). Timo Multamäki and a large group of volunteers. www.dragonbane.org

Dungeons & Dragons (1974–). Gary Gygax and Dave Arneson. TSR. Various editions published by various authors and companies.

Eagle Eye (2008). Film directed by DJ Caruso.

Eagle Eye: Free Fall (2008). Paramount. www.eagleeyefreefall.com

End Is Nigh, The (2001). Itamar Parann, Yair Samban, Itay Horev. Tel Aviv, Israel.

Ender's Game (1985). Novel by Orson Scott Card.

Entropia Universe (2003–). MindArk.

Epidemic Menace (2005). Fraunhofer FIT and Sony Network Services. IPerG prototype.

Escape from Woomera (2003). A mod for Half-Life by Kate Wild, Stephen Honegger, Ian Malcolm, Andrea Blundell, Julian Oliver, Justin Halliday, Matt Harrigan, Darren Taylor, and Chris Markwart. www.selectparks.net/archive/escapefromwoomera

EVE Online (2003–). CCP Games.

Everquest (1999–). Verant Interactive. Published by Sony Online Entertainment. www.everquest.com

eXistenZ (1999). Film directed by David Cronenberg.

Exocog (2004). Jim Miller. www.miramontes.com/writing/exocog/index.php

Expedition: Robinson (1997–). Reality television show created by Charlie Parsons and produced by Strix Television and others.

Fallout 2 (1998). Black Isle Studios. Published by Interplay.

Fear Factor (2001–2006). Reality television show produced by Endemol Entertainment and others. Based on a Dutch show *Now or Neverland.*

Feeding Yoshi (2005). Matthew Chalmers, Louise Barkhuus, Marek Bell, Steve Benford, Barry Brown, Malcolm Hall, Duncan Rowland, Scott Sherwood, and Paul Tennent. Equator.

Fight Club (1996). Novel by Chuck Palahniuk.

Fight Club (1999). Film directed by David Fincher.

Final Fantasy (1987–). Square Enix. Video game series.

Formula One (1950–). Fédération Internationale de l'Automobile.

Funeral Ceremony of the Anti-Procès for Exorcising the Spirit of Catastrophe (1960). Happening performance by Jean-Jacques Lebel. Venice, Italy.

Game, The (1973). Donald L. Luskin and Patrick Carlyle. Los Angeles.

Game, The (1997). Film directed by David Fincher.

Game 2 (1975). Donald L. Luskin, Patrick Carlyle, and Cherie Chung. Los Angeles.

Game 3:7878 (1978). Donald L. Luskin, Patrick Carlyle, and Cherie Chung. Los Angeles.

Game 4 (1979). Donald L. Luskin and Patrick Carlyle. Los Angeles.

Geocaching (2000–). Originally proposed by Dave Ulmer.

Go Game, The (2002–). Wink Back, Inc. www.thegogame.com

Gotcha! (1985). Film directed by Jeff Kanew.

Grand Theft Auto (1997–). Video game series. Developed and published by Rockstar.

Grand Theft Auto III (2002). Rockstar North. Published by Rockstar Games.

Great Dalmuti, The (1995). Richard Garfield. Wizards of the Coast.

Great Scavenger Hunt, The (2006–). www.thegreatscavengerhunt.com

Gulliver's Travels (1926). Book by Jonathan Swift. A.k.a. *Travels into Several Remote Nations of the World, in Four Parts.* By Lemuel Gulliver, first a surgeon, and then a captain of several ships.

Habbo Hotel (2000–). Sulake Labs, Finland.

Halo 3 (2007). Bungie. Published by Microsoft.

Hamlet (2002). A larp by Martin Ericsson, Anna Ericson, Christopher Sandberg, Martin Brodén et al. Interaktiva Uppsättningar, Sweden.

Helsingin Camarilla (1995–2004). Suvi Lehtoranta and others. Greater Helsinki area, Finland.

Heroes Evolutions (2007). NBC. A.k.a. *Heroes 360 Experience* during season 1.

Histoire d'O (1954). Novel by Pauline Réage, written under pseudonym by Anne Desclos, a.k.a. Dominique Aury. Eng. *The Story of O.*

Hitch-Hiker's Guide to the Galaxy, The (1978). Radio play written by Douglas Adams. BBC.

Hitch-Hiker's Guide to the Galaxy, The (1985). *The Original Radio Scripts* by Douglas Adams.

Hollywood Stock Exchange (1996–). Max Keiser and Michael Burns. www.hsx.com

House of Stairs, The (1974). Novel by William Sleator.

Human Blackjack (2008). Lindsey McCosh, Eleanor Lovinsky, Jacquie Jordan, and Sherry Smith. www.comeoutandplay.org/2008_humanblackjack.php

Human Pacman (2003). Adrian Cheok and others.

I Like Frank (2004). Blast Theory. www.blasttheory.co.uk/bt/work_ilikefrank.html

I Love Bees (2004). 4orty2wo Entertainment. Published by Microsoft. A.k.a. "ilovebees."

Il Pendolo di Foucault (1988). Novel by Umberto Eco. Eng. *Foucault's Pendulum.*

Illumintus! Trilogy, The (1975). Robert Shea and Robert Anton Wilson. A trilogy of novels consisting of *The Eye in the Pyramid*, *The Golden Apple*, and *Leviathan*.

In the Groove (2004). Roxor Games.

In These Rooms of Wood and Stone (2007). Unique one off book produced for the *Mystery on Fifth Avenue*. 212box LLC, New York.

Insectopia (2006). Johan Peitz, The Interactive Institute. IPerG Prototype.

Interference (2007). Jean-Paul Bichard, Annika Waern, and others, The Interactive Institute. IPerG Prototype.

Interstellar Pig (1984). Novel by William Sleator.

Invisibles, The (1994–2000). Comic book series by Grant Morrison and others. Later collected into *Say You Want a Revolution*, *Apocalipstick*, *Entropy in the UK*, *Bloody Hell in America*, *Counting to None*, *Kissing Mister Quimper*, and *The Invisible Kingdom*.

Jagd nach Mr. X A group in Bremen. www.mobilegames-hb.de

JFK (1992). Film directed by Oliver Stone.

Journey, The (2004). Andreas Jaki, Mopius. http://journey.mopius.com

Kejsartemplet (2005). Jimmy Janlén, Petter Kraftling, Mikael Dellgar Hagström, Tobias Johansson, Per Bolinder, and Jenny Kraftling. Sweden.

Kidnap (1998). Blast Theory. www.blasttheory.co.uk/bt/work_kidnap.html

killer.berlin.doc (1999). Film directed by Bettina Ellerkamp and Jörg Heitmann.

Killer: The Game of Assassination (1981). Steve Jackson, Steve Jackson Games. Ref. 4th edition, 1998. Based on traditional forms of play, known as *Assassin*, *Deathgame*, and *Circle of Death*.

La decima vittima (1965). Film directed by Elio Petri. Eng. *The 10th Victim.*

Lap Game New Games Movement. Original date and designer unknown.

Laser Tag Various versions, originally used by the U.S. Army. First arena game, *Photon*, was opened in 1984 by George Carter III in Dallas, Texas.

Last of Sheila, The (1973). Directed by Herbert Ross.

Last Starfighter, The (1984). Film directed by Nick Castle.

Le tour du monde en quatre-vingts jours (1873). Novel by Jules Verne. Eng. *Around the World in Eighty Days*.

Leisure Suit Larry in the Land of the Lounge Lizards (1987). Al Lowe. Sierra On-Line.

Letterboxing (1854–). Originated by James Perrott, although rules have changed through the years.

Lineage II: The Chaotic Throne (2003–). NCsoft.

Lockjaw (2002). Created by a Cloudmaker group.

Logan's Run (1976). Film directed by Michael Anderson.

lonelygirl15 (2006–2008). Fabricated vlog series created by Miles Beckett, Mesh Finders, Greg Goodfried, and Amanda Goodfried. EQAL.

Lord of the Rings, The (2001–2003). Film trilogy directed by Peter Jackson.

Lost Experience, The (2006). ABC. www.thelostexperience.com

Magus, The (1965). Novel by John Fowles.

Majestic, The (2001). Origin. Published by Electronic Arts.

Manhattan MegaPUTT (2006). Dave Warth and Dustin D'Addato. http://megaputt.blogspot.com

Manhattan Story Mash-Up (2006). SensorPlanet. www.storymashup.org

Mario Question Blocks (2005). Posterchild. www.bladediary.com/questionblocks

Masquerade (1979). Illustrated Puzzle Book by Kit Williams. Schocken Books, New York.

Masquerade, The (1993, 1994). White Wolf. Various editions. Later editions published with the name *The Laws of the Night*.

Matrix, The (1999). Film directed by Andy and Larry Wachowski.

Memento (2000). Film directed by Christopher Nolan.

Meridian 59 (1995). Archetype Interactive. Published by The 3DO Company.

Metal Gear Solid (1998). Konami.

Metrophile (2008). Leah Gilliam, Kate Hartman, Charley Miller, Derek Stoops, and Scott Varland.

Midnight Madness (1980). Film directed by Michael Nankin and David Wechter.

Minority Report (2002). Film directed by Steven Spielberg.

MLSN Sports Picks (2005). Digital Chocolate.

A Modest Proposal: For Preventing the Children of Poor People from Ireland from Being a Burden to Their Parents, and for Making Them Beneficial to the Publick (1729). Book by Jonathan Swift.

Mogi (2003). Newt Games, www.mogimogi.com.

Monopoly (1935). Charles Darrow and others. Parker Brothers.

Monopoly Live (2005). Hasbro, UK. www.monopolylive.com

MTV's The Real World (1992–). Reality television show produced by Bunim-Murray Productions.

Multi-User Dungeon (1978). Roy Trubshaw and Richard Bartle.

Myst (1993). Robyn and Rand Miller, Cyan Worlds. Published by Brøderbund.

Mysterious Stranger: A Book of Magic (2002). Book by David Blaine. Villard, New York. (Note that the instructions for the *Blaine's Challenge* are not printed in later editions, although the clues are.)

Mystery on Fifth Avenue (2008). Eric Clough and others. 212box LLC.

My Man Godfrey (1936). Film directed by Gregory La Cava.

Mythical: The Mobile Awakening (2007). Nokia Research Center, University of Nottingham, University of Tampere, Gotland University, and The Interactive Institute. IPerG Prototype.

NetHack (1987–). Various versions and creators. www.nethack.org

NIT 2000 (1999). J. Allard, James Gwertzman, Chris Jones, Ben Jones, Joe Petersen, and David Treadwell. New York City.

Nokia Game (1999). Produced by Human-I EuroRSCG for Nokia.

Ocular Effect (2006). ABC.

Omnifam (2005). A semianonymous grassroots group; see http://followersoframbaldi.com/credits.php

Pac-Lan (2005). Lancaster University. www.pac-lan.com

Pac-Man (1980). Namco.

Pacman@Lyon (2007–). Lyonnese Urban Pacman Team. Lyon, France.

PacManhattan (2004). Student project supervised by Frank Lantz, New York University. www .pacmanhattan.com

Pavlovin koirat (2006). Film directed by Arto Halonen. Eng. "Pavlov's dogs."

Payphone Warriors (2006). Abe Burmeister, Gregory Trefry, Cory Forsyth, and others. www .payphonewarriors.com

Pelageya: Clarissie (2005). This-is-how-it's-done productions. Loimaa, Finland.

Perplex City (2005–2007). Mind Candy.

Pervasive Clue (2001). Jay Schneider and Gerd Kortuem.

Plundr (2007). area/code. www.playareacode.com/work/plundr

Pong (1972). Allan Alcorn. Atari.

Pop Idol (2001–2003). Reality television show created by Simon Fuller.

Principia Discordia (1965). Malaclypse The Younger and Omar Khayyam Ravenhurst. Various differing editions. Written under pseudonyms by Greg Hill and Kerry Thornley.

Prisoner Escape from the Tower (2006). Historic Royal Palaces, mscape Team.

Project MU (2003). Andy Aiken, Bruce Cain, Clay Chiment, Jeff Macy, Steve Peters, Sean C. Stacey, Brooke Thompson, Krystyn Wells, and others. www.metacortechs.com

Prosopopeia Bardo 1: Där vi föll (2005). Martin Ericsson, Staffan Jonsson, Adriana Skarped, and others. The Interactive Institute & SICS. IPerG prototype.

Prosopopeia Bardo 2: Momentum (2006). Staffan Jonsson, Emil Boss, Martin Ericsson, Daniel Sundström, Henrik Esbjörnsson, and others. The Company P, The Interactive Institute & SICS. IPerG prototype.

Publius Enigma (1994–1997). Unknown.

Punk'd (2003–2007). Reality television show created by Ashton Kutcher and Jason Goldberg.

Push, Nevada (2002). A television series intertwined with an alternate reality game game. Created by Ben Affleck, Sean Bailey, Matt Damon, and Chris Moore. ABC.

Queer Eye for the Straight Guy (2003–2007). Reality television show created by David Collins and David Metzler.

Real Race, The (2006–). Adventure tourist game series. www.therealrace.com

ReGenesis Extended Reality (2005). Crowe et al. Xenophile Media, Canada.

REXplorer (2007). Regensburg Experience. www.rex-regensburg.de/stadtspiel/rexplorer

Rock Band (2007). Harmonix. Published by Electronic Arts.

Running Man, The (1982). Novel by Richard Bachman. Written under pseudonym by Stephen King.

Saint, The (1962–1969). Television series produced by Bamore.

Sanningen om Marika (2007). A television series intertwined with a game. Series created by Richard Jarnhed, SVT. Game by Martin Ericsson, Andie Nordgren, Christopher Sandberg, and others, The Company P. Eng. "The Truth about Marika."

Savannah (2004). Futurelab.

Scen 3 (2001–2004). Interacting Arts, Sweden.

Schindler's List (1993). Film directed by Steven Spielberg.

Scotland Yard (1983). Ravensburger.

Secretary (2002). Film directed by Steven Shainberg.

Seek Bou Journey (2006–). Changxun.

Second Life (2003). Linden Lab.

Seventh Victim, The (1953). Short story by Robert Sheckley. Originally published in *Galaxy* magazine and in 1954 in a collection of Sheckley's work, *Untouched by Human Hands*.

Shadowbane (2003–). Wolfpack. Published by Ubisoft.

Shelby Logan's Run (2002). Created by Kristina Belfiore, Joe Belfiore, Chee Chew, Scott Shell, Kevin Shields, and Walter Smith. Las Vegas. www.shelbylogansrun.com

Simpsons, The (1989–). Animated television series created by Matt Groening.

SingStar (2004–). Karaoke-style video game series developed by London Studio. Published by Sony Computer Entertainment.

Snake (1997). Taneli Armanto for Nokia mobile phones. Based on a video game *Worm* by Peter Trefonas in 1978.

Solitaire (1989). Wes Cherry for Microsoft Windows. Based on *Klondike* solitaire card game.

Songs of North (2005). Petri Lankoski et al. Hypermedia Laboratory, University of Tampere, Finland. www.uta.fi/hyper/projektit/mogame

Space Wars (1977). Larry Rosenthal, Cinematronics.

Spacewar! (1962). Steve Russell, Martin Graetz, Wayne Wiitanen, Alan Kotok, Dan Edwards, and Peter Samson. Massachusetts Institute of Technology.

SpyGame (2002). Game concept designed by Rob Anastasi, Steve Benford, Martin Flintham, Dimitris Riggas, and Tobias Rydenhag. Staged in 2003.

Star Trek: The Next Generation (1987–1994). Television series created by Gene Roddenberry.

Star Wars (1977). Film directed by George Lucas.

Star Wars: Knights of the Old Republic (2003). BioWare. Published by LucasArts.

Super Mario Bros (1985). Nintendo.

Survivor (2000–). Reality television show directed by Mark Burnett.

System Danmarc 2 (2005). Peter S. Andreasen and others. Opus. Copenhagen, Denmark.

Tag: The Assassination Game (1982). Film directed by Nick Castle.

Takkar (2003). Laust Juul Christensen, Thomas Tae-Yang Jørgensen, and Anker Helms Jørgensen.

Tamagotchi (1996). Developed by Aki Maita. Bandai.

Tetris (1985). Countless versions, originally by Alexey Pajitnov. Soviet Academy of Sciences.

Tre grader av uskyld (2006). Troels Barkholt-Spangsbo, Dennis Asanovski, and Tim Dencker. Copenhagen, Denmark. Eng. "Three Grades of Innocence."

Treasure (2005). University of Glasgow.

Tremendous Adventures of Major Brown, The (1905). G. K. Chesterton. A short story in *The Club of Queer Trades* collection.

Truman Show, The (1998). Film directed by Peter Weir.

Twister (1966). Developed by Charles F. Foley and Neil Rabens. Hasbro.

Ubik (1969). Novel by Philip K. Dick.

Ultima Online (1997–). Origin Systems.

Uncle Roy All Around You (2003–2004). Blast Theory, University of Nottingham & British Telecom.

Uplink (2001). Introversion Software.

Urban Hunt (2004). Dave Szulborski.

Vampire: The Masquerade (1991, 1992, 1998). Mark Rein •Hagen. White Wolf.

Vanishing Point (2007). 4orty2wo Entertainment. Microsoft.

Visby under (2002). The Interactive Institute. Visby, Sweden.

Vem gråter (2005). Student project supervised by Martin Ericsson. Sweden. Eng. "Who's Crying."

vQuest (2000). John Tippett, Mark Malamud, Susan Hautala, and Vision Youth volunteers.

Wanderer (2006). Jonas Hielscher and Jiri Heitlager.

War of the Worlds (1938). Radio play directed by Orson Welles.

WarGames (1983). Film directed by John Badham.

Werewolf Various editions. Originally developed as *Mafia* by Dimma Davidoff at Moscow State University, 1986.

Whirling Dervishes (2003). A flash mob by San Francisco Mob Project, USA.

White Road, The (2007). Troels Barkholt-Spangsbo, Pia Basballe, Kristin Hammerås, Lars Munck, Bjarke Pedersen, and Linda Udby. Copenhagen and Fredericksund, Denmark.

Wing Commander (1990–). Video game series. Origin Systems.

World of Warcraft (2004). Blizzard Entertainment.

World Without Oil (2007). Ken Eklund and others.

X-Files, The (1993–2002). Television series created by Chris Carter.

YOU–The City (1988, 1989, 1990). Fiona Templeton. New York, London, and The Hague.

Zork (1980). Infocom.

Bibliography

212box LLC (2008). The Residence and "In These Rooms of Wood and Stone" Answer Book. 212box LLC, New York.

Aaker, D.A., & Joachimsthaler, E. (2002). *Brand leadership*. New York: Free Press.

Aarseth, E. (1997). *Cybertext: Perspectives on ergodic literature*. Baltimore/London: John Hopkins University Press.

Åkesson, K.-P., & Waern, A. (2007). *Enhanced reality larp final report*. IPerG Deliverable D11.8. www .pervasive-gaming.org/Deliverables/D11.8-Final-Elarp-Report-v1.0.pdf

Alba, J.W., & Hutchinson, W.J. (1987). Dimensions of consumer expertise. *Journal of Consumer Research, 13*, 411–454.

Alexander, B.N. (2006). Antecedents to alternate reality games. In A. Martin, B. Thompson, & T. Chatfield (Eds.), *Alternate reality games white paper*. International Game Developers Association IGDA, http://igda.org/arg/resources/IGDA-AlternateRealityGames-Whitepaper-2006.pdf

Alpern, A. (1993). *Luxury apartment houses of Manhattan: An illustrated history*. Dover Publications.

Altman, R. (1999). *Film/genre*. London: BFI Publishing Ref. Finnish translation (1999), Elokuva ja genre. Vastapaino, Tampere.

Apter, M.J. (1991). A structural-phenomenology of play. In J.H. Kerr & M.J. Apter (Eds.), *Adult play: A reversal theory approach*. Amsterdam: Swets & Zeitlinger.

Arrasvuori, J., Lehikoinen, J. T., Ollila, E. M. I., & Uusitalo, S. (2008, July 22–24). A model for understanding online communities. In *IADIS international conference, ICT, society and human beings*. Amsterdam, The Netherlands.

Ballagas, R., Kuntze, A., & Walz, S.P. (2008). Gaming tourism: Lessons from evaluating REXplorer, a pervasive game for tourists. In J. Indulska, D. Patterson, T. Rodden, & M. Ott (Eds.), *Pervasive computing* (pp. 244–262). *Proceedings of the 6th International Conference on Pervasive Computing. LNCS*, Springer.

Ballagas, R., & Walz, S.P. (2007). REXplorer: Using player-centered iterative design techniques for pervasive game development. In C. Magerkurth & C. Röcker, (Eds.), *Pervasive gaming applications: A reader for pervasive gaming research:* Vol. 2. Aachen: Shaker.

Banksy. (2001). *Banging your head against a brick wall*. Aeroholics.

Banksy. (2005). *Wall and piece*. Wemding, Germany: Century.

Barkhuus, L., Chalmers, M., Tennent, P., Hall, M., Bell, M., & Brown, B. (2005). Picking pockets on the lawn: The development of tactics and strategies in a mobile game. In: *Proceedings of UbiComp 2005*. Tokyo, Japan: Springer (pp. 358–374).

Barsalou, L.W. (1983). Ad hoc categories. *Memory & Cognition, 11*(3), 211–227.

Bartle, R.A. (2003). *Designing virtual worlds*. Boston, MA: New Riders.

Bateman, C., & Boon, R. (2006). *21st century game design*. Hingham, MA: Charles River Media.

Bateson, G. (1955). A theory of play and fantasy. *Psychiatric Research Reports, 2*.

Baudrillard, J. (1998). Simulacra and simulations. In M. Poster (Ed.), *Jean Baudrillard, selected writings* (pp. 166–184). Stanford University Press, Referred from the web www.egs.edu/faculty/ baudrillard/simulacra-and-simulations.html

Beck, J.C., & Wade, M. (2004). *Got game: How the gamer generation is reshaping business forever*. Boston, MA: Harvard Business School Press.

Bell, M., Chalmers, M., Barkhuus, L., Hall, M., Sherwood, S., Tennent, P., et al. (2006). Interweaving mobile games with everyday life. In *CHI 2006 Conference on Human Factors in Computing Systems*. Montreal, Canada. http://portal.acm.org/citation.cfm?id=1124835

Benford, S. (Ed.), (2007). *Evaluation of day of the figurines II*. IPerG Deliverable D12.6. www.pervasive-gaming.org/Deliverables/D12.6-DOF-Evaluation.pdf

Benford, S., Capra, M., Flintham, M., Drozd, A., Crabtree, A., Räsänen, M., et al. (2008). *Evaluation of the first city as theatre public performance*. IPerG Deliverable D12.4. www.pervasive-gaming.org/ Deliverables/D12.4-City-as-Theatre-Evaluation.pdf

Benford, S., Crabtree, A., Reeves, S., Flintham, M., Drozd, A., Shedidan, J., et al. (2006). The frame of the game: Blurring the boundary between fiction and reality in mobile experiences. In *CHI 2006 Conference on Human Factors in Computing Systems*. Montreal, Canada. www.blasttheory.co.uk/ bt/documents/The_Frame_of_The_Game.2005.pdf

Benford, S., & Giannachi, G. (2008). Temporal expansion in blast theory's day of the figurines. *Performance and Art Journal, 30*(3), 60–69.

Benford, S., Seagar, W., Flintham, M., Anastasi, R., Rowland, D., Humble, J., et al. (2004). The error of our ways: The experience of self-reported position in a location-based game. In: *Proceedings of the 6th international conference on ubiquitous computing.* Nottingham: Springer. www.blasttheory.co.uk/bt/documents/The_Error_of_our_Ways_paper_2004.pdf

Bergman, M., & Paavola, S. (Eds.), (2003). *The commens dictionary of Peirce's terms: Peirce's terminology in his own words.* www.helsinki.fi/science/commens/dictionary.html

Bey, H. (1985). The temporary autonomous zone, ontological anarchy, poetic terrorism. Ref. 1991 version via www.hermetic.com/bey/taz_cont.html. Written under a pseudonym or Peter Lamborn Wilson.

Bichard, J., Brunnberg, L., Combetto, M., Gustafsson, A., & Juhlin, O. (2006). Backseat playgrounds: Pervasive storytelling in vast location based games. In R. Harper, M. Rauterberg, & M. Combetto (Eds.), *Entertainment computing* (pp. 117–122). Springer, www.tii.se/mobility/Files/BSPshort_OJ_060414.pdf.

Bichard, J.-P., & Waern, A. (2008). Pervasive play, immersion and story: Designing *interference.* In: *Proceedings of the 3rd international conference on digital interactive media in entertainment and arts.* New York: ACM. http://portal2.acm.org/citation.cfm?id=1413634.1413642

Bjerver, M. (2006). *Player behaviour in pervasive games: Using the city as game board in BotFighters.* Master's Thesis, Stockholm: Royal Institute of Technology. www.nada.kth.se/utbildning/grukth/exjobb/rapportlistor/2006/rapporter06/bjerver_martin_06125.pdf

Björk, S. (2007). Changing urban perspectives: Illuminating cracks and drawing illusionary lines. In F. von Borries, S.P. Walz, & M. Böttger (Eds.), *Space time play. Computer games, architecture and urbanism: The next level* (pp. 276–279). Berlin: Birkhäuser.

Björk, S., Eriksson, D., Holopainen, J., & Peitz, J. (2004). *Guidelines for socially adaptable games.* IPerG Deliverable D9.1. In www.pervasive-gaming.org/Deliverables/D9.1-Guidelines-for-Socially-Adaptable-Games.pdf

Björk, S., & Holopainen, J. (2005). *Patterns in game design.* Hingham, MA: Charles River Media.

Björk, S., Holopainen, J., Ljungstrand, P., & Åkesson, K.-P. (2002). Designing ubiquitous computing games: A report from a workshop exploring ubiquitous computing entertainment. *Personal and Ubiquitous Computing, 6*(5–6), 443–458. http://portal.acm.org/citation.cfm?id=592600.592616.

Boal, A. (2002). *Games for actors and non-actors* (2nd ed.). London: Routledge. First published in 1992.

Borden, I. (2001). *Skateboarding, space and the city: Architecture and the body.* Oxford/New York: Berg.

Brown, D. (2007). *Pervasive games are not a genre! (they are a sub-genre).* Master's Thesis, Georgia Institute of Technology. www.avantgaming.com/papers/dakota_brown_appropriative_games.pdf

Bull, M. (2008). *Banksy locations and tours: A collection of graffiti locations and photographs in London* (3rd ed.). Shellshock Publishing.

Caillois, R. (1958). *Man, play and games.* Chicago: Free Press.

Calleja, G. (2007). *Digital games as designed experience: Reframing the concept of immersion.* Doctoral Dissertation, Victoria University of Wellington. www.gordoncalleja.com/phdthesis.html

Cameron, L. (2004). *The geocaching handbook.* USA: The Globe Pequot Press.

Carr, C. (1993). *On edge: Performance at the end of the twentieth century.* Middletown, CT: Wesleyan University Press.

Chalmers, M., & MacColl, I. (2003). Seamful and seamless design in ubiquitous computing. In *Technical Report Equator-03-005, Equator.* www.equator.ac.uk/var/uploads/ChalmersTech2003.pdf

Chandler, D. (2006). *Semiotics: The basics.* London: Routledge.

Cheok, A.D., Fong, S.W., Goh, K.H., Yang, X., Liu, W., & Farzbiz, F. (2003). Human Pacman: A sensing-based mobile entertainment system with ubiquitous computing and tangible interaction. In: *Proceedings of the 2nd workshop on network and system support for games, Redwood, California.* New York: ACM (pp. 106–117). http://portal.acm.org/citation.cfm?id=963900.963911

Christensen, L. J., Jørgensen, T. T.-Y., & Jørgensen, A. H. (2003). Developing a hybrid of MMORPG and LARP using usability methods: The case of Takkar. In M. Copier & J. Raessens (Eds.), *Level up. Digital games research conference, Proceedings.* November 4–6. Universiteit Utrecht, Utrecht: DiGRA. www.digra.org/dl/db/05150.45031

Clark, D., & Glazer, S. (2004). *Questing: A guide to creating community treasure hunts*. USA: University Press of New England.

Costikyan, G. (2005). Game styles, innovation, and new audiences: An historical view. In: *Proceedings of DiGRA 2005 conference: Changing views—Worlds in play*. Vancouver: Digital Games Research Association. www.digra.org/dl/db/06278.11155.pdf

Crabtree, A., Benford, S., Capra, M., Flintham, M., Drozd, A., Tandavanitj, N., et al. (2007). The cooperative work of gaming: Orchestrating a SMS game www.pervasive-gaming.org/Publications/Cooperative-Gaming-Orchestrating-Mobile-SMS-Game-2007.pdf. *Computer Supported Cooperative Work, 16*(1–2), 167–198.

Crawford, G. (2006). The cult of the champ man: The culture and pleasures of championship manager/football manager gamers. *Information, Communication & Society, 9*(4), 496–514.

Csikszentmihalyi, M. (1975). Beyond boredom and anxiety. In: *The experience of play in work and games*. San Francisco: Jossey-Bass.

Dancer, P.L., Kleinplatz, P.J., & Moser, C. (2006). 24/7 SM slavery. *Journal of Homosexuality, 50*(2/3), 81–101.

Dansey, N. (2008, April). Facilitating apophenia to augment the experience of pervasive games. Presented in *Breaking the Magic Circle seminar*. Tampere, Finland.

Day, G.S., Shocker, A.D., & Srivastava, R.K. (1979). Customer-oriented approaches to identifying product-markets. *Journal of Marketing, 43*(4), 8–19.

Debord, G. (1955). Introduction to a critique of urban geography. Originally published in Les Lèvres Nues #6. September 1955. Accessed from http://library.nothingness.org/articles/SI/en/display/2

Dena, C. (2008a). Emerging participatory culture practices: Player-created tiers in alternate reality games. *International Journal of Research into New Media Technologies, 14*(1), 41–57.

Dena, C. (2008b). Online augmentation to "emerging participatory culture practices: Player-created tiers in alternate reality games." www.christydena.com/research/Convergence2008/TieringandARGs.html

Denward, M., & Waern, A. (2008). Broadcast culture meets role-plying culture. In M. Montola & J. Stenros (Eds.), *Playground worlds: Creating and evaluating experiences of role-playing games* (pp. 248–261). Jyväskylä: Ropecon. www.ropecon.fi/pw

De Zengotita, T. (2005). Mediated. In: *How the media shapes your world and the way you live in it*. Bloomsbury.

Dibbell, J. (2007 17). The life of the Chinese gold farmer www.juliandibbell.com/texts/goldfarmers.html. *The New York Times Magazine*.

Ding, Z.C. (2007). Playing with friends and families: Current scene of reality-based games in Beijing. In F. von Borries, S.P. Walz, & M. Böttger (Eds.), *Space time play. Computer games, architecture and urbanism: The next level* (pp. 186–189). Berlin: Birkhäuser.

Dixon, S. (2007). Digital performance. In: *A history of new media in theater, dance, performance art, and installation*. Cambridge: MIT Press.

Douglas, N. (1931). *London street games* Second revised and enlarged edition. Project Gutenberg Australia. http://gutenberg.net.au/ebooks03/0300281.txt

Doyle, M. W. (2002). *Staging the revolution: Guerrilla theater as a countercultural practice, 1965–1968*. Ref. www.diggers.org/guerrilla_theater.htm

Drozd, A., Benford, S., Tandavanitj, N., Wright, M., & Chamberlain, A. (2006). Hitchers: Designing for cellular positioning. In *Proceedings of the 8th international conference on ubiquitous computing*. September 17–21. UbiComp 2006. Orange County, California.

Ducheneaut, N., Yee, N., Nickell, E., & Moore, R. J. (2006). "Alone together?" Exploring the social dynamics of massively multiplayer online games. In *ACM Conference on human factors in computing systems* (pp. 407–416). CHI 2006.

Ejbye-Ernst, J. (2007). Contemporary urban performance-intervention: An aesthetic perspective. Presented at *The Limits of Aesthetics*, May–June 2007 in Aarhus, Demark. Available online at www.aestetik.au.dk/gr/papers/johanne_ejbye_ernst

Ellis, A. (1984). Offence and the liberal conception of the law. *Philosophy and Public Affairs, 13*(1).

Erdem, T., & Swait, J. (1998). Brand equity as a signaling phenomenon. *Journal of Consumer Psychology, 7*(2), 131–157.

Ericsson, M. (2003). Enchanting reality: A vision of big experiences on small platforms. In M. Copier & J. Raessens (Eds.), *Level up. Digital games research conference proceedings*. 4–6 November. Universiteit Utrecht, Utrecht: DiGRA 2003.

Ericsson, M. (2004). Play to love. In M. Montola & J. Stenros (Eds.), *Beyond role and play: Tools, toys and theory for harnessing the imagination* (pp. 15–27). Vantaa: Ropecon, www.ropecon.fi/brap.

Ermi, L., Heliö, S., & Mäyrä, F. (2004). Pelien voima ja pelaamisen hallinta. Lapset ja nuoret pelikultturien toimijoina. University of Tampere, Hypermedialaboratorio verkkojulkaisu. http://tampub .uta.fi/tup/951-44-5939-3.pdf

Ermi, L., & Mäyrä, F. (2005). Fundamental components of the gameplay experience: Analysing immersion. In: *Proceedings of DiGRA 2005 conference: Changing views—Worlds in play*. Vancouver: Digital Games Research Association. www.uta.fi/~frans.mayra/gameplay_experience.pdf

Eyles, M., & Eglin, R. (2007). Entering an age of playfulness where persistent, pervasive ambient games create moods and modify behaviour. In: *Proceedings of the 3rd international conference on games research and development 2007 (CyberGames 2007)*. United Kingdom: Manchester Metropolitan University.

Eyles, M., & Eglin, R. (2008). Ambient games, revealing a route to a world where work is play? *International Journal of Computer Games Technology, 8*(3).

Feinberg, J. (1984). *The moral limits of the criminal law 1: Harm to others*. New York: Oxford University Press.

Feinberg, J. (1988). *The moral limits of the criminal law 4: Harmless wrongdoing*. New York: Oxford University Press.

Feireiss, L. (2007). Urban free flow: The individual as an active performer. In F. von Borries, S.P. Walz, & M. Böttger (Eds.), *Space time play. Computer games, architecture and urbanism: The next level* (pp. 280–281). Berlin: Birkhäuser.

Fine, G.A. (1983). *Shared fantasy: Role-playing games as social worlds*. Chicago: University of Chicago Press.

Finkel, M. (2001 16). Clueless in Seattle {or} 28 hours in the life of team khaki as it faces the ultimate geek-o challenge. *Rolling Stone*.

Fischer, J., Lindt, I., & Stenros, J. (2006). *Epidemic menace II evaluation report*. IPerG Deliverable D8.8 part II. www.pervasive-gaming.org/Deliverables/D8.8-Part-II.pdf

Fischer, J.E., Lindt, I., & Stenros, J., et al. (2007). Evaluation of crossmedia gaming experinces in epidemic menace. In C. Magerkurth (Ed.), *Proceedings of the 4th international symposium on pervasive gaming applications*. Salzburg, Austria: PerGames 2007.

Flanagan, M. (2007). Locating play and politics: Real world games & activism. In *Digital arts and culture 2007 proceedings*. www.maryflanagan.com/articles/RealWorldGames.pdf

Flintham, M., Smith, K., Benford, S., Capra, M., Green, J., Greenhalgh, C., et al. (2007). Day of the Figurines: A slow narrative-driven game for mobile phones using text messaging. In C. Magerkurth (Ed.), *Proceedings of the 4th international symposium on pervasive gaming applications*. Salzburg, Austria: PerGames 2007.

Fluegelman, A. (Ed.). (1976). *The new games book*. Menasha: The Headlands Press.

Fornäs, J. (1996). *Cultural theory and late modernity*. Referred from Finnish translation, Kulttuuriteoria. Vastapaino, Tampere.

Friedl, M. (2003). *Online game interactivity theory*. Hingham, MA: Charles River Media.

Fullerton, T., Swain, C., & Hoffman, S. (2004). *Game design workshop: Designing, prototyping, and playtesting games*. San Francisco, CA: CMP Books.

Galanter, M. (1989). *Cults: Faith, healing and coercion*. Oxford: Oxford University Press.

Gallagher, H.L., Jack, A.I., Roepstorff, A., & Frith, C.D. (2002): Imaging the intentional Stance in a competitive game. In *NeuroImage* 16(3P + 1): 814–21.

Gaver, W.W., Beaver, J., & Benford, S. (2003). Ambiguity as a resource for design. In: *Proceedings of the SIGCHI conference on human factors in computing systems*. New York: ACM. http://portal.acm. org/citation.cfm?id=642653

Gee, J.P. (2003). *What video games have to teach us about learning and literacy*. New York: Palgrave Macmillan.

Goffman, E. (1961). *Encounters: Two studies in the sociology of interaction*. Indianapolis: Bobbs-Merrill.

Goffman, E. (1974). *Frame analysis: An essay on the organization of experience*. Boston, MA: Northeastern University Press.

Grayson, K., & Martinec, R. (2004). Consumer perceptions of iconicity and indexicality and their influence on assessments of authentic market offerings. *Journal of Consumer Research, 31*, 296–312.

Gustafsson, A., Bichard, J., Brunnberg, L., Juhlin, O., & Combetto, M. (2006). Believable environments: Generating interactive storytelling in vast location-based pervasive games. In: *Proceedings of the 2006 ACM SIGCHI International Conference on Advances in Computer Entertainment Technology. ACE 2006.* ACM. http://portal.acm.org/citation.cfm?id=1178852

Hall, R. (2004). *The letterboxer's companion*. USA: Globe Pequot Press.

Harding, T. (2007). Immersion revisited: Role-playing as interpretation and narrative. In J. Donnis, L. Thorup, & M. Gade (Eds.), *Lifelike*. Copenhagen: Projektgruppen KP07, www.liveforum.dk/kp07book

Harviainen, J. T. (2003). The multi-tier game immersion theory. In: M. Gade, L. Thorup, & M. Sander (Eds.), *As larp grows up*. (Only in the digital edition.) Copenhagen: Projektgruppen KP03. www.laivforum.dk/kp03_book/thats_larp/multi-tier_immersion.pdf

Harviainen, J.T. (2007). Live-action, role playing environments as information systems: An introduction. *Information Research, 12*(4).

Harviainen, J.T. (2008). Kaprow's scions. In M. Montola & J. Stenros (Eds.), *Playground worlds: Creating and evaluating experiences of role-playing games* (pp. 216–231). Jyväskylä: Ropecon. www.ropecon.fi/pw

Harviainen, J. T., & Lieberoth, A. (forthcoming). A magical interface: The cognitive significance of social information processes in games and rituals.

Heit, E. (1997). Knowledge and concept learning. In K. Lamberts & D. Shanks (Eds.), *Knowledge, concepts and categories* (pp. 7–42). Hove: Psychology Press.

Herbst, I., Braun, A.-K., McCall, R., & Broll, W. (2008). TimeWarp: Interactive time travel with a mobile mixed reality game. In *Proceedings of the 10th international conference on human computer interaction with mobile devices and services*. MobileHCI 2008. ACM. http://portal.acm.org/citation.cfm?id=1409240.1409266

Herodotus (2001). *An account of Egypt*. (G. C. Macaulay Translated by). Accessed from Project Gutenberg www.gutenberg.org/etext/2131

Hielscher, J., & Heitlager, J. (2006). Wanderer: Location independent GPS game. In: *Proceedings of the 3rd international workshop on pervasive gaming applications*. PerGames (pp. 55–60). www.ipsi.fraunhofer.de/ambiente/pergames2006/final/PG_Hielscher_Wanderer.pdf

Himanen, P. (2001). *The hacker ethic*. New York: Random House.

Holmila, E., Kovanen, L., & Saarenpää, J. (2007). Troolattua saimaannorppaa ja 124 muuta. Art House, Juva: Teekkarijäynien historiaa.

Holopainen, J. (2008). *Mythical: The mobile awakening final report*. IPerG Deliverable D13.6. www.pervasive-gaming.org/downloadsub1.html

Howell, A. (2000). *The analysis of performance art: A guide to its theory and practice* (second printing with corrections). Singapore: Harwood Academic.

Huber, W. (2003). Ka as Shomin-geki: Problematizing videogame studies, In M. Copier & J. Raessens (Eds.), *Level up. Digital games research conference* proceedings. 4–6 November. Universiteit Utrecht, Utrecht: DiGRA 2003.

Huizinga, J. (1938). *Homo ludens: Versuch einer bestimmung des spielelements der kultur. Published originally in 1944. Ref. English translation (1955): Homo ludens: A study of play element in culture*. Boston, MA: Beacon Press.

Jarkiewicz, P., Frankhammar, M., & Fernaeus, Y. (2008). In the hands of children: Exploring the use of mobile phone functionality in casual play settings. In *Proceedings of the 10th international*

conference on human computer interaction with mobile devices and services. Amsterdam, The Netherlands: MobileCHI.

Järvinen, A. (2007). *Games without frontiers: Theories and methods for game studies and design. Doctoral Dissertation,* University of Tampere.

Jenkins, H. (1998). "Complete freedom of movement": Video games as gendered play spaces. In J. Cassell & H. Jenkins (Eds.), *From Barbie to Mortal Kombat: Gender and computer games* (pp. 262–297). Cambridge: MIT Press, http://web.mit.edu/cms/People/henry3/complete.html

Jenkins, H. (2006). *Convergence culture: Where old and new media collide.* New York: New York University Press.

Joffe, B. (2005). Mogi: Location and presence in a pervasive community game. In *UbiComp 2005 Workshop on Ubiquitous Gaming and Entertainment.* www.techkwondo.com/external/pdf/reports/ubicomp2005/workshop_w5/BJ%20-%20Ubicomp2005%20-%20Mogi.ppt

Johnson, J.W. (1981). *A Scholar looks at Killer: Afterword in* Killer: The game of assassination. Steve Jackson Games.

Jonsson, S., Montola, M., Stenros, J., & Boss, E. (2007a). Five weeks of rebellion: Designing momentum. In J. Donnis, L. Thorup, & M. Gade (Eds.), *Lifelike.* Copenhagen: Projektgruppen KP07, www.liveforum.dk/kp07book

Jonsson, S., Montola, M., & Waern, A. (2006). Prosopopeia: Experiences from a pervasive larp. In: *Proceedings of the 2006 ACM SIGCHI international conference on advances in computer entertainment technology.* ACM. http://portal.acm.org/citation.cfm?id=1178823.1178850

Jonsson, S., & Waern, A. (2008). The art of game-mastering pervasive games. In: *Proceedings of ACE'08: The international conference on advances in computer entertainment technology.* Yokohama, Japan: ACE (pp. 224–231).

Jonsson, S., Waern, A., Montola, M., & Stenros, J., et al. (2007b). Game mastering a pervasive larp: Experiences from Momentum. In C. Magerkurth (Ed.), *Proceedings of the 4th international symposium on pervasive gaming applications* (pp. 31–39). Salzburg, Austria: PerGames 2007.

Julius, A. (2003). *Transgressions: The offences in art.* Italy: The University of Chicago Press.

Juul, J. (2003). *Half-real: Video games between real rules and fictional worlds.* Doctoral Dissertation, IT University of Copenhagen.

Juul, J. (2005). *Half-real: Video games between real rules and fictional worlds.* Cambridge: MIT Press.

Kallio, K., Kaipainen, K., Mäyrä, F. (2007). *Gaming nation: Piloting the international study of games cultures in Finland.* University of Tampere: Hypermedialaboratorion verkkojulkaisuja 14. http://tampub.uta.fi/tup/978-951-44-7141-4.pdf

Kane, P. (2005). *The play ethic: A manifesto for a different way of living.* London: Macmillan.

Kaprow, A. (1966). *Assemblage, environments & happenings.* New York: Harry N. Abrams.

Kaptelinin, V., & Cole, M. (2002). *Individual and collective activities in educational computer game playing.* http://lchc.ucsd.edu/People/MCole/Activities.html

Keller, K.L. (2007). *Strategic brand management: Building, measuring, and managing brand equity* (3rd ed.). Upper Saddle River, NJ: Pearson Prentice Hall.

Kerr, J.H. (1991). Sport: Work or play?. In J.H. Kerr & M.J. Apter (Eds.), *Adult play: A reversal theory approach.* Amsterdam: Swets & Zeitlinger.

Klein, N. (2000). *No logo.* New York: Picador.

Koljonen, J. (2004). "I could a tale unfold whose lightest word would harrow up thy Soul." Lessons from Hamlet. In M. Montola & J. Stenros (Eds.), *Beyond role and play: Tools, toys and theory for harnessing the imagination* (pp. 191–201). Vantaa: Ropecon, www.ropecon.fi/brap

Koljonen, J. (2007). Eye-witness to the illusion: An essay on the impossibility of 360° role-playing. In J. Donnis, L. Thorup, & M. Gade (Eds.), *Lifelike* (pp. 175–187). Copenhagen: Projektgruppen KP07, www.liveforum.dk/kp07book

Koljonen, J. (2008). The dragon was the least of it: Dragonbane and larp as ephemera and ruin. In M. Montola & J. Stenros (Eds.), *Playground worlds: Creating and evaluating experiences of role-playing games.* Jyväskylä: Ropecon. www.ropecon.fi/pw

Koljonen, J., Kuustie, T., & Multamäki, T. (2008). Dragonbane: The legacy. In *Project Report.* http://stuff.wanderer.org/DB_the_Legacy.pdf

Korhonen, H., & Saarenpää, H. (2008). *Mythical: The mobile awakening evaluation report.* IPerG Deliverable D13.5. www.pervasive-gaming.org/Deliverables/D13.5.pdf

Koster, R. (2002). *Online world timeline.* www.raphkoster.com/gaming/mudtimeline.shtml

Kuittinen, J., Kultima, A., Niemelä, J., & Paavilainen, J. (2007). Casual games discussion. In: *Proceedings of the 2007 conference on future play.* ACM (pp. 105–112). http://portal.acm.org/citation.cfm?id=1328202.1328221

Lancaster, K. (1999). *Warlocks and warpdrive: Contemporary fantasy entertainments with interactive and virtual environments.* Jefferson, NC/London: McFarland & Company Inc..

Lancaster, K. (2001). Immersion through an interface in The Blair Witch Project. In K. Lancaster & T. Mikotowicz (Eds.), *Performing the force: Essays on immersion into science fiction, fantasy and horror environments.* London: McFarland.

Lange, F. (2003). *Brand choice in goal-derived categories: What are the determinants?* Stockholm: EFI.

Lange, F., Selander, S., & Åberg, C. (2003). When weaker brands prevail. *Journal of Product & Brand Management, 12*(1), 6–21.

Lankoski, P., Heliö, S., Nummela, J., Lahti, J., Mäyrä, F., & Ermi, L. (2004). A case study in pervasive game design: The Songs of North. *Proceedings of the third nordic conference on human-computer interaction.* NordiCHI 2004. ACM. http://portal.acm.org/citation.cfm?doid=1028014.1028083

Lastowka, G. (2007). *Rules of play.* Ref. rough draft dated at October 16, 2007, in http://terranova.blogs.com/RulesofPlay.pdf. Also presented in AoIR 8.0 conference.in Vancouver, October 2007.

Lindley, C. A. (2005). Game space design foundations for trans-reality games. In *Proceedings of the 2005 ACM SIGCHI international conference on advances in computer entertainment technology.* ACE 2005, ACM. http://portal.acm.org/citation.cfm?id=1178569

Lindley, C.A., & Eladhari, M. (2005). Narrative structure in trans-reality role-playing games: Integrating story construction from live action, table top and computer-based role-playing games. In: *Proceedings of DiGRA 2005 conference: Changing views—Worlds in play.* Vancouver: Digital Games Research Association. www.digra.org/dl/db/06278.23092.pdf

Lindt, I. (2007). *Final crossmedia report.* IPerG Deliverable D8.8. www.pervasive-gaming.org/Deliverables/D8.8-Part-I.pdf

Lindt, I., Fischer, J., Wetzel, R., Montola, M., & Stenros, J. (2007a). *Design kit: Crossmedia games.* IPerG Deliverable D5.6. www.pervasive-gaming.org/Deliverables/D5.6-Design-kit-Crossmedia-Games.pdf

Lindt, I., Ohlenburg, J., Pankoke-Babatz, U., & Ghellal, S. (2007b). A report on the crossmedia game epidemic menace. *Computers in Entertainment, 5*(1).

Lindt, I., Ohlenburg, J., Pankoke-Babatz, U., Ghellal, S., Opperman, L., & Adams, M. (2005). Designing cross media games. In: *Proceedings of 2nd international workshop on pervasive gaming applications.* PerGames. www.ipsi.fraunhofer.de/ambiente/pergames2005/papers_2005/Designing%20Cross%20Media%20Games%20final.pdf

Lindt, I., Prinz, W., Ohlenburg, J., Ghellal, S., & Pankoke-Babatz, U. (2006). Combining multiple gaming interfaces in epidemic menace: Experience report. In *CHI '06 extended abstracts on human factors in computing systems* (pp. 213–218). CIH 2006. ACM. http://portal.acm.org/citation.cfm?id=1125451.1125496

Loken, B., & Ward, J.C. (1990). Alternative approaches to understanding the determinants of typicality. *Journal of Consumer Research, 17*(2), 111–126.

Loponen, M., & Montola, M. (2004). A semiotic view on diegesis construction. In M. Montola & J. Stenros (Eds.), *Beyond role and play: Tools, toys and theory for harnessing the imagination* (pp. 39–51). Vantaa: Ropecon, www.ropecon.fi/brap

Mackay, D. (2001). *The fantasy role-playing game.* Jefferson: McFarland.

Martin, A., Thompson, B., & Chatfield, T. (Eds.), (2006). *2006 alternate reality games white paper.* International Game Developers Association IGDA.http://igda.org/arg/resources/IGDA-Alternate-RealityGames-Whitepaper-2006.pdf

Mason, P. (2004). In search of the self: A survey of the first 25 years of Anglo-American role-playing theory. In M. Montola & J. Stenros (Eds.), *Beyond role and play: Tools, toys and theory for harnessing the imagination* (pp. 1–14). Vantaa: Ropecon, www.ropecon.fi/brap

Maxwell, E. (1957). *How to do it, or the lively art of entertaining.* Rizzoli.

293

McGonigal, J. (2003a). "This is not a game": Immersive aesthetics & collective play. *Digital arts & culture 2003 conference proceedings*. DAC 2003. Melbourne, Australia. www.seanstewart.org/beast/mcgonigal/notagame/paper.pdf

McGonigal, J. (2003b). A real little game: The performance of belief in pervasive play. In M. Copier & J. Raessens (Eds.), *Level up. Digital games research conference proceedings*. 4–6 November. Universiteit Utrecht, Utrecht: DiGRA 2003.

McGonigal, J. (2006a). This might be a game: Ubiquitous play and performance at the turn of the twenty-first century. Doctoral Dissertation, University of California, Berkeley.

McGonigal, J. (2006b). The puppet master problem: Design for real-world, mission based gaming. In P. Harrigan & N. Wardrip-Fruin (Eds.), *Second person*. Cambridge: MIT Press.

McGonigal, J. (2006c). The puppet master problem: Design for real-world, mission based gaming. In *Lecture given at the University of Art and Design Helsinki on January 24, 2006 as part of the Games and Storytelling lecture series*. Available at www.gamesandstorytelling.net/McGonigal-lecture-2006.html

McGonigal, J. (2007). Amplified intelligence games: How massively collaborative play supports the development of science+policies for the future. In *speech given at international institute for applied systems analysis (IIASA) 35th anniversary conference*. 14–15 November. Vienna, Austria. Available online at www.iiasa.ac.at/iiasa35/docs/speakers/speech/videos/macgonigal.wmv

McGonigal, J. (2008). Why I Love Bees: A case study in collective intelligence gaming. In K. Salen (Ed.), *The ecology of games: Connecting youth, games, and learning* (pp. 199–228). Cambridge: MIT Press.

Malaby, T.M. (2007). Beyond play: A new approach to games. *Games and Culture, 2*(2), 95–113.

Medin, D.L., & Smith, E.E. (1984). Concepts and concept formation. *Annual Review of Psychology, 35*, 113–138.

Milgram, S. (1974). *Obedience to authority*. New York: Harper.

Montola, M. (2005). Exploring the edge of the magic circle: Defining pervasive games. In *DAC 2005 Conference Proceedings*. IT University of Copenhagen. www.iki.fi/montola/exploringtheedge.pdf

Montola, M. (2007a). Tangible pleasures of pervasive role-playing. In A. Baba (Ed.), *Proceedings of DiGRA 2007 Situated Play Conference* (pp. 178–185). University of Tokyo. www.digra.org/dl/db/07312.38125.pdf

Montola, M. (2007b). Breaking the invisible rules: Borderline role-playing. In J. Donnis, M. Gade, & L. Thorup (Eds.), *Lifelike* (pp. 93–100). Copenhagen: Projektgruppen KP07, www.liveforum.dk/kp07book/lifelike_montola.pdf

Montola, M. (2008). The invisible rules of role-playing: The social framework of role-playing process. *International Journal of Role-Playing, 1*(1), 22–36.

Montola, M., & Jonsson, S. (2006). Prosopopeia: Playing on the edge of reality. In T. Frizon & T. Wrigstad (Eds.), *Role, play, art: Collected experiences of role-playing* (pp. 85–99). Stockholm: Föreningen Knutpunkt, http://jeepen.org/kpbook

Montola, M., Stenros, J., & Waern, A. (2007). *Design kit: Pervasive larp*. IPerG Deliverable D5.8. www.pervasive-gaming.org/Deliverables/D5.8.pdf

Montola, M., Waern, A. (2006a). Ethical and practical look at unaware game participation. In M. Santorineos (Ed.), *Gaming realities: A challenge for digital culture* (pp. 185–193). Mediaterra 2006 Festival. Fournos Centre for the Digital Culture.

Montola, M., & Waern, A. (2006b). Participant roles in socially expanded games. In T. Strang, V. Cahill & A. Quigley (Eds.), *Pervasive 2006 workshop proceedings* (pp. 165–173). PerGames 2006, *Workshop of Pervasive 2006 Conference*. University College, Dublin.

Montola, M., Waern, A., Kuittinen, J., & Stenros, J. (2006). *Ethics of pervasive gaming*. IPerG Deliverable D5.5. www.pervasive-gaming.org/Deliverables/D5.5%20ethics.pdf

Montola, M., Waern, A., & Nieuwdorp, E. (2006). *The domain of pervasive gaming*. IPerG Deliverable D5.3B. www.pervasive-gaming.org/Deliverables/D5.3b-Domain-of-Pervasive-Gaming.pdf

Moreau, C.P., Markman, A.B., & Lehmann, D.L. (2001). "What is it?" Categorization flexibility and consumers' responses to really new products. *Journal of Consumer Research, 27*, 489–498.

Morton, B. (2007). Larps and their cousins through the ages. In J. Donnis, L. Thorup, & M. Gade (Eds.), *Lifelike* (pp. 245–260). Copenhagen: Projektgruppen KP07, www.liveforum.dk/kp07book

Mulligan, J., & Patrovsky, B. (2003). *Developing online worlds: An insider's guide*. Indianapolis: New Riders.

Murphy, G.L., & Medin, D.L. (1985). The role of theories in conceptual coherence. *Psychological Review, 92*, 289–316.

Murray, J.H. (1997). *Hamlet on the Holodeck: The future of narrative in cyberspace*. Cambridge: MIT Press.

Nagamura, L. (2002). *Cybertypes: Race, ethnicity, and identity on the Internet*. New York: Routledge.

Nagamura, L. (2008). *Digitizing race: Visual cultures of the Internet*. Minneapolis, MN: University of Minnesota Press.

Nedungadi, P. (1990). Recall and consumer consideration sets: Influencing choice without altering brand evaluations. *Journal of Consumer Research, 17*(3), 263–276.

Nedungadi, P., & Hutchinson, J.W. (1985). The prototypicality of brands: Relationships with brand awareness, preference and usage. *Advances in Consumer Research, 12*(1), 498–503.

Nieuwdorp, E. (2005a). The pervasive interface: Tracing the magic circle. In: *Proceedings of DiGRA 2005 Conference: Changing views—Worlds in play*. Vancouver: Digital Games Research Association. www.digra.org/dl/db/06278.53356.pdf

Nieuwdorp, E. (2005b). *The pervasive gaming genre: A contradiction in terms*. Master's Thesis, University of Utrecht.

Nieuwdorp, E. (2007). The pervasive discourse: An analysis. *ACM Computers in Entertainment, 5*(2).

Ninjalicious. (2005). *Access all areas: A user's guide to the art of urban exploration*. Infiltration, Canada: Written under a pseudonym by Jeff Chapman.

Norman, D.A. (1988). *The psychology of everyday things*. New York: Basic Books.

Norman, D.A. (2007). *The design of future things*. New York: Basic Books.

North, A.S. (1990). *The urban adventure handbook*. Berkeley: Ten Speed Press.

Örnebring, H. (2007). Alternate reality gaming and convergence culture: The case of Alias. *International Journal of Culture Studies, 10*(4), 445–462.

Pacey, A. (1985). *The culture of technology*. Cambridge: MIT Press.

Pargman, D., Jacobsson, P. (2006). The magic is gone: A critical examination of the gaming situation. In M. Santorineos (Ed.), *Gaming realities: A challenge for digital culture* (pp. 15–22). Mediaterra 2006 Festival. Fournos Centre for the Digital Culture.

Partridge, A. (2007). *Creating casual games for fun & profit*. Hingham, MA: Charles River Media.

Pearce, C., Fullerton, T., Fron, J., & Morie, J. (2005). Sustainable play: Towards a new games movement for the digital age. In *DAC 2005 Conference Proceedings*. IT University of Copenhagen.

Pedersen, B., & Munck, L. (2008). Walking the white road: A trip to the hobo dream. In M. Montola & J. Stenros (Eds.), *Playground worlds: Creating and evaluating experiences of role-playing games*. Jyväskylä: Ropecon. www.ropecon.fi/pw

Peirce, C.S. (1867). On a new list of categories. In J. Hoopes (Ed.), *Peirce on signs: Writings on semiotic by Charles Sanders Peirce* (pp. 23–33). Chapel Hill, NC: University of North Carolina Press, Originally published in Proceedings of American Academy of Arts and Sciences 7, May 1867.

Peirce, C.S. (1885). One, two, three: Fundamental categories of thought and of nature. In J. Hoopes (Ed.), *Peirce on signs: Writings on semiotic by Charles Sanders Peirce* (pp. 180–185). Chapel Hill, NC: University of North Carolina Press.

Peitz, J., Saarenpää, H., & Björk, S. (2007). Insectopia: Exploring pervasive games through techology already pervasively. In: *Proceedings of ACE 2007 conference*. Salzburg: ACM Press.

Peters, J.W. (2004). *The complete idiot's guide to geocaching*. USA: Groundspeak.

Pettersson, J. (2005). *Roolipelimanifesti*. Jyväskylä: Like.

Pettersson, J. (2006). Parempien piirien pelejä. In *Roolipelaaja No. 2*. H-Town.

Pine, B.J., & Gilmore, J.H. (1999). *The experience economy: Work is theatre and every business a stage*. Boston, MA: Harvard Business School Press.

Pohjola, M. (2004). Autonomous identities: Immersion as a tool for exploring, empowering and emancipating identities. In M. Montola & J. Stenros (Eds.), *Beyond role and play: Tools, toys and theory for harnessing the imagination*. Helsinki: Ropecon, www.ropecon.fi/brap.

Poremba, C. (2007). Critical potential on the brink of the magic circle. In: A. Baba (Ed.), *Proceedings of DiGRA 2007 situated play conference* (pp. 772–778). University of Tokyo. www.digra.org/dl/db/07311.42117.pdf

Postman, N. (1982). *The disappearance of childhood*. New York: Delacorte.

Postman, N. (1985). *Amusing ourselves to death: Public discourse in the age of show business*. New York: Penguin.

Postman, N. (1993). *Technopoly: The surrender of culture to technology*. New York: Vintage.

Prensky, M. (2001). *Digital game-based learning*. New York: McGraw-Hill.

Rabin, S. (Ed.). (2005). *Introduction to game development*. Hingham, MA: Charles River Media.

Rashid, O., Bamford, W., Coulton, P., Edwards, R., & Scheible, J. (2006). PAC-LAN: Mixed reality gaming with RFID-enabled mobile phones www.mobilenin.com/gr/pac-lan_cie.pdf. *ACM Computers in Entertainment, 4*(4).

Ratneshwar, S., & Shocker, A.D. (1991). Substitution in use and the role of product usage context in product category structures. *Journal of Marketing Research, 28*, 281–295.

Ravaja, N., Saari, T., Turpeinen, M., Laarni, J., Salminen, M., & Kivikangas, M. (2006). Spatial presence and emotions during video game playing: Does it matter with whom you play? *Presence: Teleoperators and Virtual Environments, 15*(4).

Reeves, S., Benford, S., O'Malley, C., & Fraser, M. (2005). *Designing the spectator experience*. In *Proceedings of the SIGCHI conference on human factors in computing systems* (pp. 741–750). CHI 2005. Portland, OR.

Reid, J. (2008). Design for coincidence: Incorporating real-world artifacts in location-based games. In: *Proceedings of ACM International Conference on digital interactive media in entertainment and arts*. Athens, Greece: DIMEA.

Rheingold, H. (1993). *The virtual community: Homesteading on the electronic frontier*. Digital edition in www.rheingold.com/vc/book

Rosch, E. (1978). Principles of categorization. In E. Rosch & B.L. Lloyd (Eds.), *Cognition and categorization* (pp. 28–49). Hillsdale, NJ: Erlbaum.

Ruggeri, L. (2001). Abstract Tours and Dérives. www.spacing.org/writing_abstract.html

Ryan, M.-L. (1994). Immersion vs. interactivity: Virtual reality and literature theory http://people.cs.uct.ac.za/~dnunez/reading/papers/ryan.pdf. *Postmodern Culture, 5*(1).

Salen, K., & Zimmerman, E. (2004). *The rules of play: Game design fundamentals*. Cambridge: MIT Press.

Salen, K., & Zimmerman, E. (2006). *The game design reader: A rules of play anthology*. Cambridge: MIT Press.

Sandberg, C. (2004). Genesi. In M. Montola & J. Stenros (Eds.), *Beyond role and play: Tools, toys and theory for harnessing the imagination* (pp. 191–201). Vantaa: Ropecon, www.ropecon.fi/brap

Schechner, R. (2002). *Performance studies: An introduction* Ref. Second Edition (2006). London: Routledge.

Schneider, J., & Kortuem, G. (2001). How to host a pervasive game: Supporting face-to-face interactions in live-action roleplaying. In *Workshop on designing ubiquitous computer games*. September–October. Ubicomp 2001. Atlanta.

Seppänen, L. (2001). Designing mobile games for WAP. In *Gamasutra GDC 2001 proceedings archive*. www.gamasutra.com/view/feature/3475/designing_mobile_games_for_wap.php?print=1

Shocker, A.D., Bayus, B.L., & Kim, N. (2004). Product complements and substitutes in the real world: The relevance of "other products." *Journal of Marketing, 68*(1), 28–40.

Sihvonen, T. (1997). Pieni johdatus live-roolipelaamisen psykologiaan. In N. Vainio (Ed.), *Larppaajan käsikirja*. Suomen live-roolipelaajat, Tampere.

Smart, J., Cascio, J., & Paffendorf, J. (2008). Metaverse roadmap. In: *Pathways to the 3D Web: A Cross-Industry Public Foresight Project*. Acceleartion Studies Foundation. www.metaverseroadmap.org/MetaverseRoadmapOverview.pdf

Smith, E.E., & Medin, D.L. (1981). *Categories and concepts*. Cambridge, MA: Harvard University Press.

Smith, L.B., & Samuelson, L.K. (1997). Perceiving and remembering: Category stability, variability and development. In K. Lamberts & D. Shanks (Eds.), *Knowledge, concepts and categories* (pp. 161–196). Hove: Psychology Press.

Sotamaa, O. (2002). All the world's a BotFighters stage: Notes on location-based multi-user gaming. In F. Mäyrä (Ed.), *Computer games and digital cultures conference proceedings*. Tampere: Tampere University Press.

Starner, T., Leibe, B., Singletary, B., & Pair, J. (2000). MIND-WARPING: Towards creating a compelling collaborative augmented reality game. In *Proceedings of the 5th international conference on intelligent user interfaces*. IUI'2000. ACM. www.cc.gatech.edu/ccg/publications/mind-warping-iui2000.pdf

Steinkuehler, C. (2006). The mangle of play. *Games and Culture, 1*(3).

Stenros, J., Montola, M., & Mäyrä, F. (2007a). Pervasive games in ludic society. In *Proceedings of the 2007 conference on Future Play* (pp. 30–37). FuturePlay 2007. ACM.

Stenros, J., Montola, M., & Waern, A. (2007b). Post mortem interaction: Social play modes in Momentum. In J. Donnis, L. Thorup, & M. Gade (Eds.), *Lifelike* (pp. 131–146). Copenhagen: Projektgruppen KP07, www.liveforum.dk/kp07book

Stenros, J., Montola, M., Waern, A., & Jonsson, S. (2007c). *Momentum Evaluation Report*. IPerG Deliverable 11.8 Appendix C. www.pervasive-gaming.org/Deliverables/D11.8-Appendix-C-Momentum-Evaluation-Report.pdf

Stenros, J., Montola, M., Waern, A., & Jonsson, S. (2007d). Play it for real: Sustained seamless life/game merger in Momentum. In A. Baba (Ed.), *Proceedings of DiGRA 2007 situated play conference* (pp. 121–129). University of Tokyo. www.digra.org/dl/db/07313.58398.pdf

Sternberg, E. (1999). *The economy of icons: How business manufactures meaning*. Westport, CT: Praeger.

Struppek, M., & Willis, K.S. (2007). BotFighters: A game that surrounds you. In F. von Borries, W. Friedrich, P. Steffen, & M. Böttger (Eds.), *Space time play. Computer games, architecture and urbanism: The next level* (pp. 226–227). Berlin: Birkhäuser.

Suits, B. (1990). Construction of a definition. In K. Salen & E. Zimmerman (Eds.), (2006): *The game design reader: A rules of play anthology*. Cambridge: MIT Press.

Sussman, E. (1997). *Keith Haring*. New York: Whitney Museum of American Art.

Svahn, M., Kullgard, P., Waern, A., Holopainen, J., Koivisto, E., Stenros, J., et al. (2006). *Business opportunities and business structures*. IPerG Deliverable D4.5: www.pervasive-gaming.org/Deliverables/D4.5-Business-opportunities-and-business-structures.pdf

Szulborski, D. (2005). *This is not a game: A guide to alternate reality gaming*. Exe Active Media Group.

Talvitie, D. (2004). *A manual for city-based live-action roleplaying*. Version 0.3 beta. http://users.utu.fi/aletal/roolipelaaja/citygamer

Talvitie, D. (2007): Kaupunkipelin järjestäjän opas. In T. Rantanen (Ed.), *Larpinjärjestäjän käsikirja*. Suomen liveroolipelaajat ry, Helsinki.

Tan, P. (2003). *Tensions in live-action roleplaying game design: A case study with the MIT Assassins' Guild*. Master's Thesis, Massachusetts Institute for Technology.

Taylor, T.L., & Kolko, B. (2003). Boundary spaces: Majestic and the uncertain status of knowledge, community and self in a digital age www.itu.dk/~tltaylor/papers/TaylorKolko-Majestic.pdf. *Information, Communication & Society, 6*(4), 497–522.

Templeton, F. (1990). *YOU–The City*. New York: Roof Books.

Tracey, D. (2007). *Guerilla gardening: A manualfesto*. New Society Publishers.

Turkle, S. (1995). *Life on the screen: Identity in the age of the Internet*. New York: Simon & Schuster.

Turner, F. (2006). Why study new games?. *Games and Culture, 1*(1), 1–4.

Turner, V. (1982). *From ritual to theatre, the human seriousness of play*. New York: PAJ Publications.

Turtiainen, R. (2007). Kahden kaukalon välissä: Fantasialiigojen maailmaa kartoittamassa. *Lähikuva, 20*(4), 39–59.

Ulmer, D. (2004). Foreword. In L. Cameron (Ed.), *The geocaching handbook*. Guildford, CT: Falcon Guide.

VanDeVeer, D. (1979). Coercive restraint of offensive actions. *Philosophy and Public Affairs, 8*(2), 175–193.

Veal, A.J. (2004). A brief history of work and its relationship to leisure. In J.T. Haworth & A.J. Veal (Eds.), *Work and leisure*. New York: Routledge.

Waern, Annika, Montola, Markus & Stenros, Jaakko (2009): The Three-sixty Illusion: Designing for Immersion in Pervasive Games. In the proceedings of Ch1'09 conference.

Walther, B.K. (2005). Atomic actions—Molecular experience: Theory of pervasive gaming http://portal.acm.org/citation.cfm?id=1077258. *Computers in Entertainment, 3*(3).

Walz, S.P. (2007). Pervasive persuasive play: Rhetorical game design for the Ubicomp world. In B.J. Fogg & D. Eckles (Eds.), *Mobile persuasion: 20 perspectives on the future of behavior change* (pp. 101–108). Stanford, CA: Stanford Captology Press.

Watts, D.J., Peretti, J., & Frumin, M. (2007). Viral marketing for the real world http://cdg.columbia.edu/uploads/papers/watts2007_viralMarketing.pdf. *Harvard Business Review*.

Weiser, M., & Brown, J. S. (1995). *Designing calm technology. Xerox parc*. Available as http://people.csail.mit.edu/rudolph/Teaching/weiser.pdf.

Werkman, R. (2001). Vampire: The Masquerade—A countercultural performance. In K. Lancaster & T. Mikotowicz (Eds.), *Performing the force*. Jefferson: McFarland & Company Inc..

Widing, G. (Ed.), (2007). Verklighetsspel. Special issue on reality games. In *Interacting Arts No. 5*. Sverok, Stockholm.

Wilson, P. (2004). Jamming Big Brother USA: Webcasting, audience intervention, and narrative activism. In S. Murray & L. Ouellette (Eds.), *Reality TV: Remaking television culture* (pp. 323–343). New York: New York University Press.

Wilson, R.A. (1983). *Prometheus rising*. New Falcon Publications.

Winick, J. (2000). *Pedro and me: Friendship, loss and what I learned*. New York: Henry Holt and Company.

Wollen, P. (2001). Situationists and architecture. *Published originally in New Left Review #8*. Accessed from http://newleftreview.org/A2315

Yee, N. (2006). The demographics, motivations and derived experiences of users of massively-multiuser online graphical environments. *Presence: Teleoperators and Virtual Environments, 15*(3), 309–329.

Personal Communication

Luskin, D. L. (2008). Personal email correspondence.

Parann, I. (2008). Personal email correspondence.

Ruggeri, L. (2008). Personal email correspondence.

Stewart, S. (2008). Personal email correspondence.

Source of Illustrations

Considerable effort has been made to trace copyright holders of images. The authors and the publisher apologize for any errors or omissions, and, if notified, will endeavor to correct these at the earliest available opportunity.

A.1 — Publicity photo from the film *La decima vittima*, courtesy of Finnish National Audiovisual Archive. Film copyright © Surf Film.

A.2 — *Deathgame*. Photograph and copyright © Hampus Isaksson.

1.1 — *Sumo*. Photograph and copyright © Alisdair McDiarmid.

1.2 — *Manhattan MegaPUTT*. Photographer and copyright © Amanda Bernsohn.

1.3 — Illustration from *Killer: The Game of Assassination*. Illustrator Denis Loubet Copyright © Steve Jackson Games.

1.4 — *Big Urban Game*. Photograph and copyright © Frank Lantz.

B.1 — *The Beast*. Screen capture copyright © Microsoft. Cited from www.cloudmakers.org.

B.2 — *The Beast*. Photograph and copyright © James Calentino.

B.3 — *The Beast*. Screen capture copyright © Microsoft. Cited from www.cloudmakers.org.

2.1a and 2.1b — *Perplex City*. Photographs and copyright © Andy Darley.

2.2 — *Deathgame*. Photograph and copyright © Signe Sjöberg.

2.3 — *Helsingin Camarilla*. Photograph and copyright © Suvi Lehtoranta.

2.4 — *I Love Bees*. Photograph and copyright © Andrew Sorcini.

2.5 — *Can You See Me Now?* Courtesy and copyright © Blast Theory.

2.6 — *Big Urban Game*. Photograph and copyright © Frank Lantz.

2.7 — *Visby Under*. Photograph by Peter Knutson. Copyright © Interactive Institute.

C.1 — *Shelby Logan's Run*. Photograph and copyright © Joe Belfiore.

C.2 — *Shelby Logan's Run*. Photograph and copyright © Walter Smith.

C.3 — *Shelby Logan's Run*. Photograph and copyright © Walter Smith.

3.1 — Reclaim the Streets, Canberra. Photograph and copyright © by Daniel Robinson.

3.2 — *Lap Game*. Copyright © Illinois Parks and Recreation Magazine.

3.3 — *Funeral Ceremony of the Anti-Procès*. Picture by Cameraphoto, quoted from Kaprow (1966).

3.4 — *Uplink*. Copyright © Introversion software.

3.5 — *System Danmarc 2*. Picture and copyright © Michel Winckler-Krog, Intense, www.intense-images.dk.

D.1a and D.2b — *BotFighters 2*. Screen capture copyright © Gamefederation Studio/ Digiment Games.

4.1 — *Abstract Tours*. Copyright © Laura Ruggeri.

4.2a and 4.2b — *Momentum*. Photographs and copyright © Staffan Jonsson.

4.3 — *Songs of North*. Illustration by Jani Nummela © University of Tampere.

12.1 *Desert Rain.* Courtesy and copyright © Blast Theory.
12.2 *Rider Spoke.* Courtesy and copyright © Blast Theory.
12.3 *Carolus Rex.* Photograph and copyright © Olle Sahlin.
12.4 *Hamlet.* Photograph and copyright © Bengt Liljeros.
M.1 *The Amazing Race.* Photograph by Chris Castallo. Copyright © CBS/Cris Graves/Landov.
M.2 *The Real Race.* Courtesy and copyright © The Real Race.
13.1 *lonelygirl15* in YouTube. Screen capture copyright © EQAL.
13.2 *Zombie Walk Detroit.* Photograph and copyright © Wigwam Jones.
13.3 Graffiti. Copyright © Banksy. Cited from www.banksy.co.uk.
13.5a *System Danmarc 2.* Photograph and copyright © Ebbe Valbak.
13.5b *System Danmarc 2.* Photograph and copyright © Winckler-Krog, Intense, www.intense-images.dk.
13.8 *Escape from the Tower.* Photograph Vanessa Bellaar Spruijt. Copyright © Hewlett-Packard Ltd.

Figures 1.5, 5.4, 11.1, 11.2, 11.3, 12.5, 13.4, 13.6, and 13.7 by Jani Nummela.

Index

Note: "*n*" has been used for the terms found in Note Section of the text.

Printed and bound by CPI Group (UK) Ltd, Croydon, CR0 4YY

23/10/2024

01778073-0001